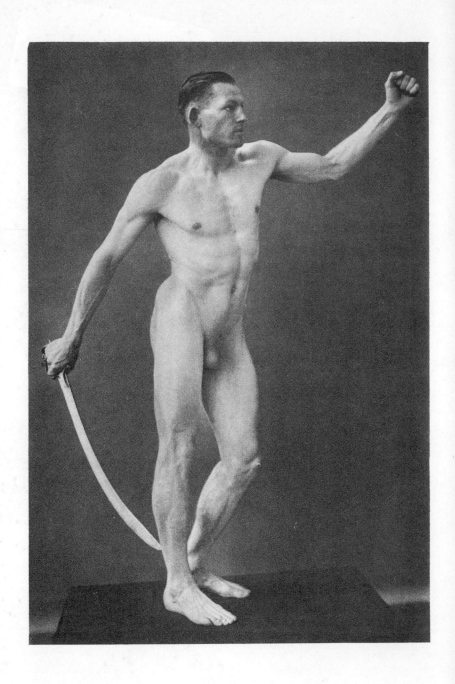

A HANDBOOK OF ANATOMY
FOR ART STUDENTS

by

ARTHUR THOMSON

with numerous illustrations

<small>FIFTH EDITION</small>

Dover Publications, Inc., New York

Published in Canada by General Publishing Company, Ltd., 30 Lesmill Road, Don Mills, Toronto, Ontario.

Published in the United Kingdom by Constable and Company, Ltd., 10 Orange Street, London WC 2.

This Dover edition, first published in 1964, is an unabridged and unaltered republication of the fifth (1929) edition of the work first published by the Oxford University Press in 1896.

This edition is published by special arrangement with Oxford University Press.

Standard Book Number: 486-21163-0
Library of Congress Catalog Card Number: 64-15507

Manufactured in the United States of America
Dover Publications, Inc.
180 Varick Street
New York, N.Y. 10014

DEDICATED

TO THE

MEMORY OF MY FATHER

JOHN THOMSON, M.D.

FLEET SURGEON, R.N.

PREFACE TO THE FIFTH EDITION

AN artist, of some repute, said to me, on the occasion of our first meeting, 'The first thing I did after passing my exam. was to burn your book'. Naturally I was somewhat abashed and inclined to be resentful, but, on thinking matters over, and especially in view of having to write a preface to a new edition of this distasteful book, I began to realize that there was something to be said for my artist friend's point of view.

Given a model, a skeleton, a blackboard, and a few intelligent students, there is some chance of interesting them, and enlightening them on the bearings of Anatomy on the subject of their studies, but substitute for these, plates, figures, and diagrams, and replace the fluidity of verbal description by the rigid phrases of descriptive Anatomy, and the subject is at once converted into a task instead of a pleasure. To those who lack the opportunity of such individual instruction there is, unfortunately no other way out of it, than to have recourse to such a volume as this affects to be.

After a long experience as an examiner, I am amazed at the ability displayed by candidates in memorizing the details of complicated figures and diagrams, but alas, when they come to draw the figure they fail to appreciate the application of the facts they have already memorized, for the very simple reason that they have never taken the trouble to verify these facts on their own person, or, still better, on a model.

It is of little service to the student to familiarize himself with the details of the skeleton by copying the illustrations provided by textbooks of this class. He should rely on first-hand knowledge acquired by handling and sketching the actual bones, and should endeavour to acquire some accurate information regarding the position of these same bones in his own person. Then he will have a reliable framework on which to build, and so become familiar with the appropriate proportions assigned to the various bones

in the construction of the figure, whilst at the same time he will have satisfied himself as to the form and position of the surface contours which are directly due to the shape of the underlying bones. These are the 'landmarks' around which the softer tissues, fat, fascia, muscle, and ligaments, must be appropriately grouped.

The photographic plates and key plates in this volume are in some measure intended as a substitute for a model. This is in no sense a 'picture book', it is designed and carried out with the intention of enabling the student with its aid to determine for himself the significance of the varied and varying contours and forms displayed by the human figure in action and repose. They are in fact designed and selected to enable the student to analyse and realize the nature of the different tissues involved in divers attitudes and postures. Their committal to memory is no evidence of applied knowledge, it merely represents but one stage in the elucidation of the complex changes of form involved. They are like the mere outlines of a map, the contents of which may change from time to time through the influx of fresh populations or the spread of political influences, though their landmarks remain stable.

If it is to be of real use, it is in this sense that the student must approach the present volume, and not with the intention of merely committing its contents to memory. Then I trust he will not have to satisfy his conscience by committing it to the flames.

Some slight additions have been made to the text, and several plates have been replaced by better photographs, whilst some new illustrations have been added, these being mainly taken from photographs of University athletes to whose kindly co-operation I am greatly indebted. So too my thanks are due to the members of the Staff of the Clarendon Press who have spared no effort to carry out my every wish.

A. T.

OXFORD, 1929.

PREFACE TO THE FIRST EDITION

THE experience which I have had as a teacher and my acquaintance and sympathy with the requirements of students of Art have led me to the conclusion that hitherto too much stress has been laid on the nomenclature and technical details of Human Anatomy, and too little emphasis placed on the relation of these details to the surface forms. What the student requires is not a minute description of every bone, muscle, and joint, but only such an account as will enable him to appreciate their influence on the modelling of the figure. Names convey little to his mind, forms alone interest him.

In the following pages, which are based on the lectures which I have had the honour of giving at the Royal College of Art, South Kensington, I have endeavoured to carry out as far as possible these principles. With this intention every effort has been made to avoid unnecessary detail, and to rid the text as far as possible of technicalities. Where there are English equivalents for the scientific terms more commonly employed, they have been made use of; but unfortunately their number is limited, and the student is left with no other alternative than to accept the scientific nomenclature.

In place of adopting, as is usual, the method of furnishing a complete description of the bones, succeeded by an equally detailed account of the joints and muscles, I have incorporated them in the description of regions. As each region—a limb for instance—is considered, its bones, joints, and muscles are described in so far as they have special

reference to the moulding of the surface forms. In this way it is hoped that the student may attain a better grasp of the subject than by the study of isolated descriptions of the various structures involved.

In order to carry out such an idea it was necessary that the descriptions given should be supplemented by frequent reference to the model or by copious illustration. In the present work photography has been employed for this purpose. I am well aware of the drawbacks of such a method, yet it seems to me that these are counterbalanced by the truth of the resulting figures. The plates lay no claim to artistic excellence ; their value depends on their fidelity to nature. Artists, I feel sure, will sympathize with me in regard to the defects of some of the forms represented, knowing as they do how difficult it is to obtain universal excellence in a model. Apart from the professional models employed, I am largely indebted to some of the better known athletes of this University for the facilities which have enabled me to take the photographs. For obvious reasons it is unnecessary for me to name these gentlemen, but I wish none the less to express my indebtedness to them.

In the production of most of the keys which accompany the plates I have received much valuable assistance from my friend and pupil, Mr. Cecil W. Pilcher, B.A., of Keble College, who has also drawn a few of the illustrations in the text : to him my best thanks are due. For the rest of the figures I am alone responsible. Two or three have been borrowed from other sources, and in constructing the plates illustrative of the entire skeleton I have availed myself of the proportions laid down by the late Professor John Marshall, in his work entitled, *A Rule of Proportion for the Human Figure.* In the cuts with which the text is illustrated I have endeavoured to lay particular stress on those points which are of importance to the artist, and,

in spite of their shortcomings as drawings, I trust that they may appeal to the reader on account of their direct application to the subject-matter.

A word or two as to how the subject should be studied. Let the student in the first place familiarize himself with the forms of the bones by rapid sketches of them in different positions. Especially is this necessary where the limbs are foreshortened. Having acquired this knowledge, let him then proceed to the study of the model. It is hoped that with the aid of the plates and their accompanying keys he will be able to determine for himself the form and position of the structures on which the surface contours depend. Assist the eye where possible with the hand, and by rapid and sudden changes of position ascertain precisely the nature of the underlying cause.

In conclusion I have to thank Professor R. Howden, of the University of Durham, for the trouble and care which he has bestowed on the revisal of the proof-sheets, as well as for the many valuable hints he has given me.

A. T.

OXFORD:
August 10, 1896

CONTENTS

CHAPTER V.

THE SHOULDER-GIRDLE AND THE MUSCLES WHICH INFLUENCE ITS MOVEMENTS.

CHAPTER VI.

THE UPPER ARM.

CHAPTER VII.

THE FORE-ARM.

CHAPTER VIII.

THE HAND.

CHAPTER IX.

THE GLUTEAL REGION.

CHAPTER X.

THE THIGH.

CHAPTER XI.

THE LEG AND FOOT.

CHAPTER XII.

THE NECK.

CHAPTER XIII.

THE HEAD, FACE, AND EXPRESSION.

CHAPTER XIV.

PROPORTION.

PLATES

PAGE

ANATOMY FOR ART STUDENTS

CHAPTER I

THE INFLUENCE OF POSTURE UPON THE FORM OF MAN

'MAN alone stands erect.' The least observant amongst us cannot have failed to recognize the fact that man owes much of his dignity to the erect posture. In this respect he differs from all other animals. If we compare him with the man-like apes, his near relations, they suffer much by contrast. The gait of these creatures is shuffling, and the balance of the figure unsteady; while their whole appearance, when they attempt to walk upright, suggests but a feeble imitation of the grace and dignity of man's carriage.

The assumption by man of the erect position has led to very remarkable changes in the form of his skeleton and the arrangement and development of his muscles.

In his growth from the ovum to the adult, he passes through many stages. In some of these his ascent from lower forms is clearly demonstrated. This statement holds good not only in regard to structure, but also as regards function.

To take a case in point. The child at birth is feeble and helpless, and the limbs are as yet unsuited to perform the functions they will be called upon to exercise when fully developed. Dr. L. Robinson has clearly proved that the new-born child possesses a remarkable grasping power in its hands. He found that infants, immediately after birth, were able to hang from a stick, for a short time, by clutching

it with the hands. With this exception, we may regard
the movements of the limbs as ill controlled and imperfect.
At first the legs are not strong enough to support the body.
It is only after a considerable time has elapsed that the
child makes efforts to use them as means of progression.
These first attempts are confined to creeping, an act in which
the fore limbs play as important a part as the hind. With
advancing age, however, the legs become longer and the
muscles more powerful. In course of time they are suffi-
ciently strong to support the body-weight. In the earlier
stages of the assumption of the erect posture the child
assists itself by laying hold of any object which it can conve-
niently grasp with its hands; as yet its efforts are ungainly
and unsteady, but practice, and the exercise of a better
control over the muscles of the legs, soon enable it to stand
upright and walk without the aid of its upper limbs.

There are thus three stages in the development of this
action: first, the use of 'all fours'; secondly, the employ-
ment of the upper limbs as means to steady and assist the
inadequately developed lower limbs — this mode of pro-
gression is comparable to that of the man-like apes; and,
thirdly, the perfected act wherein the legs are alone suffi-
cient to support and carry the body.

The growth and development of the legs are not the
only changes that are associated with the assumption of the
erect position. If the back-bone of an infant at birth be
examined and compared with that of an adult, other differ-
ences than those of size and ossification will be observed.
As will be afterwards explained, the adult back-bone is
characterized by certain curves, some of which we fail to
notice in the child. These latter, therefore, are developed
at a period subsequent to birth, and are described as
secondary curves, whilst those which exist at birth and
are maintained throughout life are called primary curves.
The primary curves are those associated with the forma-

tion of the walls of the great visceral cavities, whilst the secondary curves are developed coincident with the assumption of the erect position, and are compensatory in their nature. The advantage of this arrangement is that the curves are not all bent in the same direction, but alternate, so that the column is made up of a succession of backward and forward curves. In this way the general

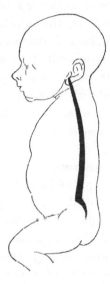 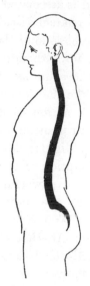

FIG. 1. Diagram to show the curves in the back-bone of an infant.

FIG. 2 displays the curves in the back-bone of the adult. This figure has been reduced to the same size as Fig. 1 so as to render comparison easier.

direction of the back-bone is vertical, which it could not possibly be if the curves did not so alternate, for then all the curves would be directed forwards, and a vertical line would fall either in front of, across, or behind the bent column in place of cutting it at several points, as happens in the column with the alternating curves. This becomes a matter of much importance when the vertical line coin-

cides with the direction of the force exercised by gravity, as in standing upright.

These facts may be proved by looking at a baby. The back displays a uniform curve from the shoulders to the hips; as soon as the child begins to walk, however, the development of a forward curve in the region of the loins is observed, a curve which ultimately becomes permanent and is associated with the graceful flowing contours which are characteristic of the back of the adult. This lumbar curve is one of the most remarkable features of man's back-bone, for, although the curve is exhibited to a slight extent in the columns of the apes, in none does it approach anything like the development met with in man. On the other hand, in four-footed animals, where the column is horizontal in position, there is either no such curve present, or it is only slightly developed.

The assumption of the erect posture necessarily involves the growth of powerful muscles along the back to uphold and support the back-bone and trunk in the vertical position, as is proved by the changes which take place in old age. At that time of life the muscular system becomes enfeebled, and is no longer strong enough to hold the figure erect; the consequence of which is the bent back and tottering gait of the aged, who, in their efforts to avail themselves of every advantage, seek the assistance which the use of a staff affords. Thus history repeats itself within the span of our own existence. It has been seen how the young child avails itself of the assistance of its upper limbs in its first attempts to walk; and it is noteworthy how, in that ' second childhood', the weak and aged seek additional support by the use of their arms and hands.

It is, however, to neither of these types that our attention must be especially directed, but rather to the examination of man in the full exercise of his strength, after he has

outgrown the softness and roundness of youth, and before he has acquired any of the weakness dependent on advancing years.

Starting, then, with the fundamental idea that the erect posture is essentially a characteristic of man, it is necessary to study in some detail the various modifications in his bony framework and muscular system which are associated with this posture.

As a vertebrate animal, man possesses a *back-bone* or *spinal column* made up of a series of bones placed one above the other. Around this central column are grouped the parts of the skeleton which protect and support the trunk. On the upper end of this axis is poised the head, and connected with the trunk are the two pairs of limbs—the arms and legs.

For convenience of description it will be necessary to consider the body in its several parts :

(1) The trunk.

(2) The lower limbs.

(3) The upper limbs.

(4) The head and neck.

In regard to the trunk, as has been already stated, the *vertebral column,* so called because it is composed of a number of separate bones or *vertebrae,* forms the central axis around which the other parts are grouped. Comparing the position of this chain of bones in man with that observed in a four-footed animal, it will be noted that in man its axis is vertical, whilst in a quadruped it is more or less horizontal ; moreover, the column in man is curved in a more complex manner than is the case in animals. It is on these curves that the column is mainly dependent for its elasticity. It would, however, be unable to sustain the weight of the trunk unless some provision had been made whereby it could be held erect. This is supplied by the powerful groups of muscles which lie in the grooves

on either side of, and behind, the back-bone. An inspection of the back of a model will enable the student to recognize these fleshy masses on either side of the middle line, particularly in the lower part of the back, in the region of the loins. These groups of muscles are called the *erectores spinae*, a name which sufficiently explains their action, and may well be compared to the 'stays' which hold a mast upright. How much depends on the action of these muscles is, as has been said, amply demonstrated in the case of the feeble and aged,

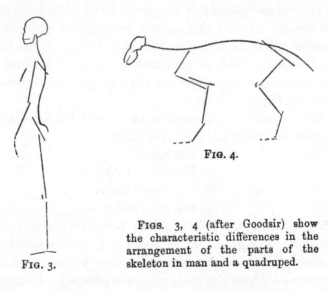

Fig. 4.

Figs. 3, 4 (after Goodsir) show the characteristic differences in the arrangement of the parts of the skeleton in man and a quadruped.

Fig. 3.

in whom the muscles are no longer able properly to perform their function, with the result that the persons so affected are unable to hold themselves erect for any time without fatigue.

The column supports the weight of the head, and by its connexion with the ribs, enters into the formation of the chest-wall. The upper limbs are connected with the chest-wall in a way which will be subsequently described. It is thus evident that this central axis is a most important factor in the formation of the skeleton of the trunk. Through it the entire weight of the head, upper limbs, and trunk is

transmitted to the lower limbs, which necessarily have to support their combined weight in the erect position.

It is to the structure of these limbs that our attention must next be directed. In considering them it must be borne in mind that the legs serve two purposes: first, they afford efficient support, and, secondly, they are adapted for the purposes of progression. The limbs are connected with the trunk by means of bones arranged in a particular way. These are termed the limb girdles. There are two such girdles — the *shoulder-girdle*, connecting the upper limbs with the trunk, and the *pelvic girdle*, connecting the lower limbs with the trunk. As the latter is concerned in transmitting the weight of the trunk to the lower limbs, it is well first to examine it.

From its function it is essential that the pelvic girdle should be firmly united to the vertebral column or central axis by means of an immovable joint. In order to effect this union the segments or vertebrae, of which the column is made up, undergo certain modifications in the region where the girdle-bones of the lower limb are attached. This modification consists in the fusion of a number of these vertebrae, which are separate in the infant, and their conversion into one large wedge-shaped bone called the *sacrum*. This bone, built up by the union of five vertebrae, is, in man, remarkable for its width and stoutness. It acts not only as a strong

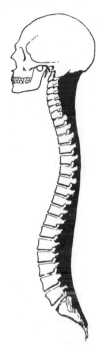

FIG. 5. A diagram to show the arrangement of the muscles which support the back-bone. The muscles, which are represented in solid black, are seen to be thick in the regions of the loins and neck, and comparatively thin in the mid-dorsal region.

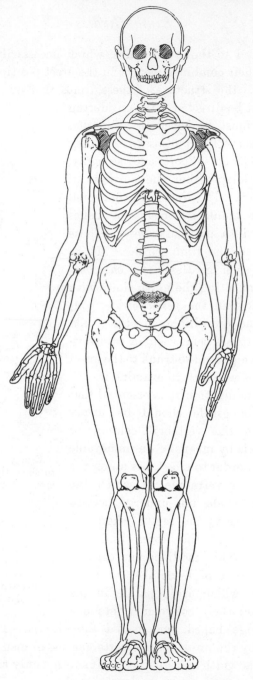

MALE SKELETON, FRONT VIEW

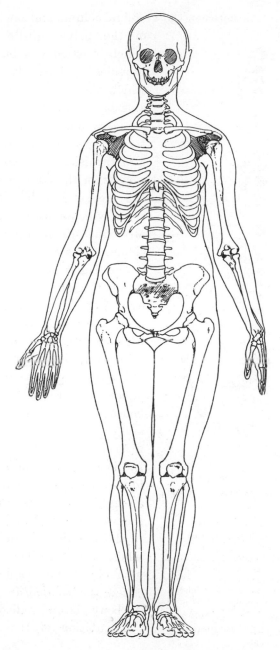

FEMALE SKELETON, FRONT VIEW

connecting link between the vertebral column and the bones of the pelvic girdle with which it articulates, but also provides a fixed base on which the upper and movable segments of the central axis are placed. The posterior aspect of the sacrum also furnishes an extensive surface for the attachment of the erector muscles of the spine, which assist so materially in maintaining the column in its erect position.

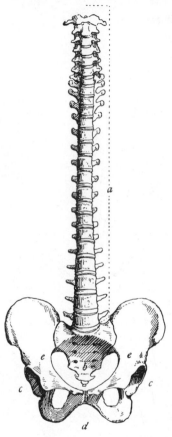

Fig. 6. The back-bone and pelvis.

a. Includes the twenty-four movable vertebrae.

b. Is placed on the sacrum and coccyx, made up of five vertebrae each, which are fused together; the sacrum articulates with

e. The haunch-bone (os innominatum), on the outer side of which at

c. Is the socket (acetabulum) for the reception of the head of the thigh-bone.

d. The pubic arch and symphysis pubis.

The bones of the pelvic girdle, though separate at an early period of life, are in the process of growth fused together to form a large stout irregular bone called the *haunch-bone (os innominatum)*. There are two such bones—one for either limb—and these are united behind to each side of the sacrum by means of an immovable joint. The girdle is further strengthened by the union of the two bones with each other in the middle line in front, where they are bound together by an immovable joint called the *symphysis pubis*. A bony basin, called the *pelvis*, is thus formed by the articulation of these two

haunch-bones in front, and their union with the sacrum behind. There is no movement between the several parts of this osseous girdle, and it is firmly united with the lower part of the vertebral column. It helps to form the lower part of the trunk, and, by its expanded surfaces, assists materially in supporting the abdominal contents. This form of pelvis is very characteristic of man. As a result of the assumption of the erect posture the abdominal viscera are no longer supported entirely by the abdominal walls, as in four-footed animals, but rest to a very consider-able extent on the expanded wings of the pelvic bones. In

addition, the outer surfaces of these expanded plates of bone are utilized to provide attach-ment for the powerful muscles which pass from and connect this pelvic girdle with the thigh-bone, a group of muscles which in man attains a remark-able development.

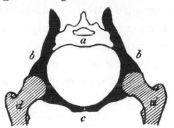

Fig. 7. A diagrammatic repre-sentation of the pelvic girdle.

a. Sacrum.
b. Haunch-bone (os innominatum).
c. Symphysis pubis.
d. Upper end of thigh-bone (femur).

The fact must be emphasized that no movement is possible between the pelvic girdle and the sacrum, and that all the weight transmitted down the vertebral column through the sacrum is equally distributed between the two haunch-bones.

If the outer surface of each of these bones be examined, a deep cup-shaped cavity will be noticed, into which the rounded head of the thigh-bone or *femur* fits, thus forming the movable articulation called the hip-joint. The bones of the thigh and leg are remarkable for their length [1]. Combined they equal in length the measurement of the head and trunk. This relative development is not

[1] The terms 'thigh' and 'leg' are applied respectively to the parts of the limb above and below the knee.

attained by any other animal. In addition, the thigh-bone
of man possesses an extremely long and well-marked neck.
The neck is that part of the bone which supports the
rounded articular head, and connects it in an oblique
direction with the upper end of the shaft. The length
of the neck of the femur is peculiar to man, and permits
a freedom of action of the limb not attainable by any
other animal, the movements in the lower animals being
more or less limited to a backward and forward direction.
By means of the neck of the thigh-bone we have in man
an arrangement which fulfils all the conditions necessary
to ensure stability, and permits a more extended range
of movement, not only from before backwards and from
side to side, but also in an inward and outward direction.
This latter is the movement of rotation, whereby we are
enabled to turn the front of the limb inwards or outwards
as desired.

The muscles to which reference has been already made in
connexion with the outer surfaces of the haunch-bones are
inserted into the upper part of the thigh-bone. As they
are immediately concerned in the control of certain impor-
tant movements of the hip-joints, through which the entire
weight of the trunk is transmitted to the lower limbs, they
necessarily acquire a very great development, a develop-
ment on which is dependent the prominence of the
buttocks. This appearance was justly regarded by Aris-
totle as eminently characteristic of man.

The thigh-bones, separated above by the width of the
pelvis, are placed obliquely so that they lie side by side
in the region of the knees.

The bones of the leg are two in number. They are
immovably united to each other, since any movement
between them would interfere with their stability and
thus weaken the limb as a means of support. One only
of these bones, the *shin-bone* or *tibia,* enters into the

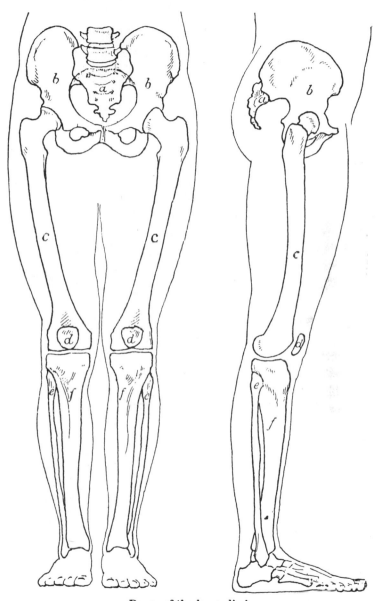

Bones of the lower limb.

FIG. 8. Front view. FIG. 9. Side view.

The lettering is the same in both figures.

a. Sacrum. *d.* Knee-pan (patella).
b. Haunch-bone (os innominatum). *e.* Fibula.
c. Thigh-bone (femur). *f.* Shin-bone (tibia).

g. Bones of foot (tarsus, &c.).

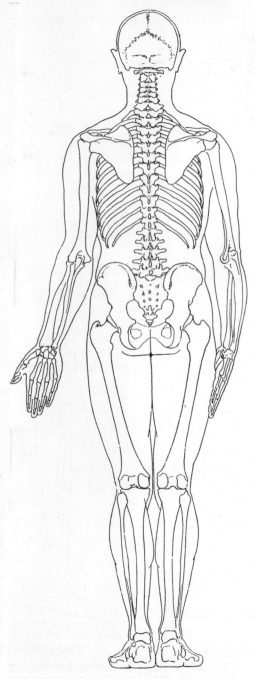

MALE SKELETON, BACK VIEW

formation of the knee-joint; by its expanded upper extremity it affords a broad surface not only for the support but also for the movements of the *condyles*, or articular surfaces, of the thigh-bone. The slender outer bone, the *fibula*, furnishes extensive attachments for numerous muscles.

The fleshy masses which move the leg on the thigh at the knee-joint clothe both the front and back of the thigh-bone; in man the extensor group of muscles, viz. that placed on the front of the thigh, which extends or straightens the leg, attains a relatively greater development than the flexor group, which is situated on the back of the limb. This is just the reverse of what is found in animals, and is associated in man with the power he possesses of bringing his leg into a direct line with his thigh, that is to say he can straighten or extend his limb at the knee-joint in a way which no other animal can effect.

Man's foot is a very characteristic member. It possesses the qualities essential to strength and solidity combined with elasticity and movement. When standing upright the axis of the foot is placed at right angles to the axis of the leg.

The bones which enter into the formation of the foot are disposed so as to form a series of arches. The advantage of this arrangement is that the soft parts on the sole are protected from pressure, while at the same time considerable elasticity is imparted to the foot. The slight play of the bones which form the arches allows the latter to act like a series of curved springs.

The form of the heel-bone, or *os calcis*, is characteristic: to its posterior part is attached that group of muscles which determines the form of the calf. The development of these muscles is very great; and it is noteworthy that they are quite typical of man, as no animal equals him in this

respect. This is explained by the fact that not unfrequently they are called upon to support the entire weight of the body, as in the acts of standing or dancing on tiptoe, while at other times they are required to project the body forward, as in springing or leaping.

The bones of the toes are shorter than those of the fingers. The great toe is united to the others and lies side by side with them; it has no such power of separation and closing on the other toes as is possessed by the thumb. Thus the stability of the foot is not interfered with by an excess of mobility such as we see in the apes, where this power of movement is necessary. In them the foot is employed as a grasping organ, a modification which greatly assists the animal in its arboreal habits.

From what has been stated it will be apparent that the lower limb of man displays in its structure those modifications which are essential to the combination of support and mobility.

In the upper limb, the same influences lead to modifications in its structure which enhance its usefulness. As already stated, the child dispenses with the use of his arms as aids to progression as soon as his legs become strong enough to support him. This relieves the upper limb of one function, and permits a development of that member rather in the direction of freedom of motion. So extensive is the range of movement of this limb that man can touch any part of his body with one or other hand.

An examination of the bones of the shoulder-girdle—the bones by which the upper limbs are connected with the trunk—at once reveals a remarkable difference between their mode of articulation with the skeleton of the trunk and that which has been already described in connexion with the pelvic girdle.

The *shoulder-girdle* consists of two bones on either side, the *collar-bone* or *clavicle*, and the *shoulder-blade* or *scapula*.

These two bones are united by a small joint which permits limited movement in certain directions, but the girdle is only connected with the skeleton of the trunk by one joint on either side, viz. that between the upper end of the *breast-bone* or *sternum* and the inner extremity of the collar-bone. The range of movement of this joint is not extensive. The shoulder-blade, on the other hand, is not directly connected with the skeleton of the trunk, but only indirectly, through its articulation with the collar-bone. At the same time the blade-bone is attached by numerous muscles to the framework of the chest-wall. By this means, though the range of movement in the two joints just named is limited, the combination of these movements and the looseness of the connexion of the shoulder-blade with the chest-wall impart a very extensive range of movement to the entire girdle. When it is remembered that this girdle is articulated with the bone of the upper arm, the student will recognize how important a part it plays in increasing the freedom of movement of the upper limb.

As has been shown, the shoulder-girdle in man is modified in order to increase the range of movement of a limb used for prehensile purposes, and this is correlated with an alteration in the form of the *chest-wall*. In animals in which the fore limb is used as a means of support, the form of the chest-wall is laterally compressed, that is to say the depth of the chest cavity is greater than its width. In man, on the other hand, in whom the limb is not habitually made use of to uphold the trunk, the chest-wall, relieved from pressure, expands laterally; hence the *thoracic* or *chest cavity* in man is wider from side to side than from before backwards.

The joint between the shoulder-girdle and the upper extremity of the *humerus*, or bone of the upper arm, requires a brief description. The union of the limb bone with the girdle is effected by means of a relatively small shallow

socket on the shoulder-blade in which the large rounded head of the humerus rests. The fibrous bands, called ligaments, which surround this joint are lax, so that they limit

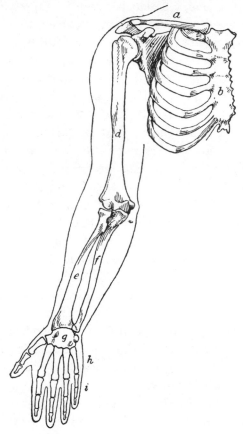

FIG. 10. Bones of the right upper limb, front view.

a. Collar-bone (clavicle).	*e.* Radius.
b. Breast-bone (sternum).	*f.* Ulna.
c. Shoulder-blade (scapula).	*g.* Wrist-bones (carpus).
d. Humerus.	*h.* Metacarpus.

i. Finger-bones (phalanges).

but slightly the range of movement possible. This is in striking contrast to what we have seen in the articulation of the hip, where the hollow for the reception of the head

of the thigh-bone is deep and surrounded by a prominent margin. A moment's consideration will at once explain the difference in the nature of the two joints. The shoulder-

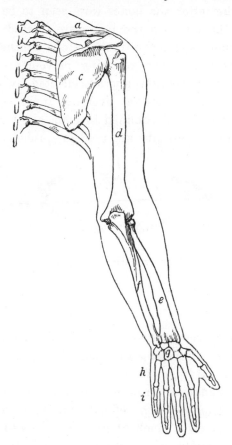

FIG. 11. Bones of the right upper limb, back view

a. Collar-bone (clavicle).
c. Shoulder-blade (scapula).
d. Humerus.
e. Radius.

f. Ulna.
g. Wrist-bones (carpus).
h. Metacarpus.
i. Finger-bones (phalanges).

joint is adapted to permit very free movement, and is, relatively speaking, a weak joint, as demonstrated by the frequency with which it is dislocated, whilst the hip-joint

combines great strength with a more limited range of movement.

There are two bones in the fore-arm as in the leg, but, whilst in the latter the bones were seen to be immovably united, in the fore-arm the bones are jointed together in such a manner as to move freely on one another in certain definite directions. The resulting movements are termed pronation and supination, and are effected by the rotation of the outer bone or *radius* over the inner bone or *ulna*. These movements, not confined to man, but found in those animals whose fore-limbs are used for prehensile purposes,

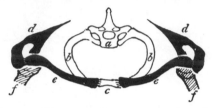

FIG. 12. Diagrammatic representation of the shoulder-girdle.

a. First dorsal vertebra.	*d*. Shoulder-blade (scapula).
b. First rib.	*e*. Collar-bone (clavicle).
c. Breast-bone (sternum).	*f*. Humerus (bone of upper arm)

are extremely serviceable and greatly enhance the value of the hand as a grasping and tactile organ.

The terminal segment of the human upper limb is marvellously adapted for performing the most delicate manipulations. Man has been defined as a 'tool-using' animal, and no doubt owes much of his supremacy to the facility which he possesses of 'turning his hand' to almost anything. This power he owes largely to the freedom of movement and power of opposition of the thumb, the most useful, as it is the most important in regard to size and strength, of all the digits.

The *skull* must now be considered: this consists of two portions, one which encloses the brain, the other which supports and protects the soft parts of the face. If the

human skull be compared with that of a man-like ape, it will be observed that the development of that portion which contains the brain in man is far in excess of the corresponding part in the anthropoid. In the latter the bones of the face are always more prominent, forming the projection which is familiarly known as the muzzle, whilst in man the face underlies the expanded brain-case, and projects but slightly in front. This difference gives rise to modifications in the manner in which the head is

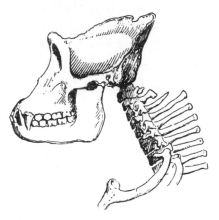 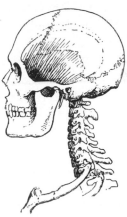

FIG. 13. Skull and cervical vertebrae of a gorilla, showing projecting muzzle, small brain-case, and elongated cervical spines.

FIG. 14. Skull and cervical vertebrae of man, showing small face bones, large brain-case, and short cervical spines.

supported on the vertebral column. In a dog the skull is slung at the anterior extremity of a more or less horizontal spinal column; in man the head is poised on the upper end of a vertical column; whilst in the man-like apes an intermediate condition is observed, the column here being more or less oblique in direction. Owing to the fact that in quadrupeds and apes the muzzle is very large, special provision, in the form of an elastic ligament, is necessary to assist in supporting the head. In man, however, the parts are so distributed, owing to the absence

of muzzle and the greater development of the back and upper part of the head, that the skull, when placed upon its articular surfaces on the upper end of the vertebral column, nearly balances itself. The importance of this arrangement is evident, because it enables us to keep the head erect with comparatively slight muscular effort. The contrary would have been the case had we been called upon to support a large and heavy muzzle. The elastic ligament present in other animals is thus rendered unnecessary. At the same time there is proof that some slight muscular effort is required to keep the head upright, for, if a drowsy person be watched, the forward nodding of the head is an indication that the muscles which support it are becoming relaxed. It may be noted that the position of the skull exerts an influence on the plane of vision in man: in the erect position the visual axis is directed towards the horizon, 'He looks the whole world in the face'; and the occasional remark that one has a 'hang-dog' expression has more significance in it than at first appears.

So far we have dealt generally with the physical attributes of man. It is unnecessary here to dwell upon those higher mental and moral developments which distinguish him from the brutes.

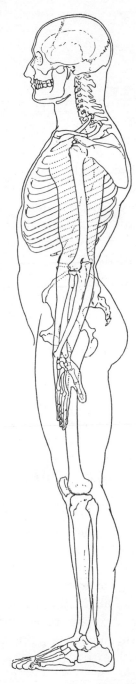

MALE SKELETON, SIDE VIEW

CHAPTER II

In the previous chapter great stress was laid on the influence exerted by posture on the bodily framework of man. The reader must now consider some points connected with the skeleton as a whole, before proceeding to study it in detail. Fortunately for the art student, a minute description of all the bones is unnecessary, as many of them have little or no influence on the surface forms.

The term 'skeleton' is applied to the solid framework of the body. This consists largely of bone, but also includes cartilage or gristle, and ligaments. An examination of a skeleton as ordinarily prepared is somewhat misleading. In the process of maceration, to which for the purposes of preparation it is subjected, the cartilaginous and ligamentous elements of this framework have disappeared, being more easily disintegrated than the osseous parts. The result is that the dried bones convey but a poor impression of the delicacy and precision with which the several portions of this skeletal framework are jointed together.

It would appear at first sight almost hopeless to attempt to classify the bones of the body, but a closer examination will prove that there are many points of resemblance between them, not only in regard to structure, but also in regard to function. There are bones which are characterized by their length; these we find in the limbs, for example, the bones of the upper arm, fore-arm, thigh, and leg. Such are clearly associated with movement, for their extremities are moulded into smooth articular surfaces, which fit more

or less accurately on the corresponding areas of adjacent bones. Of the joints so formed each is specially adapted for particular movements. To these long bones the muscles are attached, which move them and convert them into levers of different kinds, examples of which will be easily recognized by the student of mechanics. This lever principle is not confined to the long bones. If one of the irregularly-shaped bones of which the vertebral column is built up be examined it will be seen to possess a number of prominent processes. Some of these afford attachment to muscles and act as levers, enabling these muscles to operate with greater mechanical advantage. In addition to the use of the long bones as levers, it must also be borne in mind that they act as supports. Having reference to what has been already stated in the previous chapter, we see that the bones of the lower limb are stouter and stronger than those of the upper; moreover, their articular surfaces are more expanded, and, if the range of movement of the joints which unite them be less, there is this advantage, that the articulations are stronger and better fitted to bear the strain to which they are subjected.

Another group of bones are those which are more or less flattened and expanded—plate-like bones they are called. Generally speaking, these serve as protective coverings for the more delicate structures which are lodged beneath them. On examining that part of the skull which contains the brain, it is seen that the oval case which envelops it is made up of a number of such expanded bones firmly united together. So also, in the pelvic region, the bones which constitute the girdle of the lower limb afford protection to the viscera which are lodged within its cavity. But nature takes advantage of these expanded surfaces in other ways; besides protecting the organs which they overlie, they afford extensive surfaces for the attachment of muscles on their outer or exposed surfaces. Thus,

in the head, the region of the temple, which in the skeleton
is formed of expanded portions of the *temporal, parietal,
frontal,* and *sphenoid* bones, affords attachment to one of the
powerful muscles of mastication—the temporal muscle, which
raises the lower jaw. It has been already noted how the
outer surface of the pelvic girdle furnishes wide areas for
the origin of the muscles which pass to the thigh-bone
and control the movements of the hip-joint.

In the examples above cited the protective bones are
firmly united to each other, no perceptible movements
taking place between them. In the animal economy it is,
however, sometimes necessary to provide an arrangement
which, whilst protective, will also be capable of certain
movements: such, for instance, is the chest-wall. This
consists of an osseous framework composed, on either side,
of the curved ribs united in front with the breast-bone
and connected behind with the vertebral column by a series
of movable joints. This bony framework, combined with
cartilage, membrane, and muscle, forms a highly elastic,
movable, yet relatively strong protecting case for the heart
and lungs which are placed within its cavity. Movement
in this instance is required in order to provide for the
bellows-like action which is necessary to draw in and expel
the air from the lungs. Here again, advantage is taken
of the extensive outer surface of the chest-wall to provide
attachment for the numerous muscles which pass from the
trunk to the upper limb, another example of the economy
of space and material practised by nature.

The remaining bones may be classed as those of irregular
shape: such are the bones of the face, which are very com-
plicated in their structure. These are admirably adapted
for the protection of the various delicate organs of special
sense which are lodged in this region, while at the same
time they afford attachment to the muscles of expression.
Further, the bones which form the vertebral column are

of irregular shape. When articulated together, they afford complete protection for the delicate nervous centre, the spinal cord, which lies within the osseous canal formed by their neural arches, whilst their outstanding processes not only furnish attachments to the muscles which directly control their movements, but also provide points of origin for many other muscles which act upon the limbs and head and neck. Again, the small bones of the hand and foot are examples of irregularly-shaped bones; they will be considered when these members are described.

As has been stated, the appearance of the dried skeleton conveys little idea of its perfection in the living body. The bones have been denuded of the soft parts which bind them together and form the joints. It is necessary therefore to say something generally regarding these articulations.

If the bones entering into the formation of the hip-joint be examined, it will be noticed that the rounded head of the thigh-bone fits loosely into the cup-shaped cavity of the haunch-bone; but, if a recent specimen be inspected, these articular surfaces are seen to be covered by a layer of smooth gristle or cartilage. If these cartilage-covered surfaces be placed in contact with one another they will be found to fit with remarkable accuracy. Moreover, the opposed surfaces are so smooth that the bones can be moved on each other with the least possible amount of friction. So accurate, indeed, is the fit of these articular surfaces that it is possible, in some instances, to keep them in contact by the influence of atmospheric pressure alone.

But some arrangement is necessary whereby the opposed surfaces may be held together. This is provided for by structures called *ligaments.* These ligaments are bands of fibrous tissue which completely surround the joint forming its capsule. The thickness of this capsule

varies on different aspects of the joint; and in some situations the thickening of the capsule forms specialized bands which are described and named as separate ligaments. At other points the capsule is so thin as merely to consist of the layer to be next described. This is a delicate membrane which lines the interior of the capsule, called the *synovial membrane.* It secretes an oily fluid called *synovia,* which lubricates the articular surfaces of the joint and so reduces friction to a minimum. Such is the structure of a movable joint: its strength depends on the form of its articular surfaces and the stoutness of its ligaments; but, whilst these ligaments are useful in binding together the joint, they also, in many instances, limit or check its movements, especially when such an effect is not produced by the locking of the bones themselves.

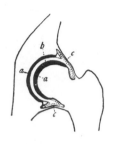

FIG. 15. Diagrammatic section through a movable joint.

a. The thick black lines represent the cartilage-covered articular surfaces.
b. The joint cavity.
c. The ligaments around forming the capsule, the interior of which is lined by synovial membrane represented by dotted lines.

The accompanying figure may assist in explaining the details above described.

But there are other varieties of movable joints: the type mentioned above possesses a joint cavity, and a wide range of movement. The next class includes those joints in which there is no joint cavity, and in which the movement is limited in its extent. If a fresh vertebral column be examined, the bodies or solid parts of the vertebrae are seen to be united by means of pads of laminated fibrous tissue and pulp matter, which bind them together and permit only a limited movement between any two segments. The movement between the individual bones is small, but if the number of such segments be taken into account the

amount of movement possible in the column as a whole is very considerable. The arrangement may be better understood if we compare the back-bone to a number of wooden disks cemented together by pads of india-rubber ; the movement between any two disks will be slight ; but, supposing we have a chain of such disks similarly united, the column so formed will acquire a remarkable flexibility. As will be seen hereafter, these intervertebral disks, as they are called, not only allow of movement, but also serve the useful purpose of acting as buffers to reduce the shocks which are from time to time transmitted along the chain of bones which they unite.

FIG. 16. Section through a joint possessing no joint cavity.

a a. The bodies of two vertebrae united by

b. The intervertebral disk, the central part of which is softer and more pulpy than the circumference.

Fig. 16 represents the general appearance of such a joint.

There are other kinds of joints in which there is no movement. These may be compared to the dove-tailed joints employed in carpentry ; they are of little importance from our standpoint, as we are only concerned with the forms produced by their union. A word or two is, however, necessary in regard to these particular forms of joints, because without a knowledge of their structure it would be impossible to account for the growth of certain parts of the body. The most typical examples are met with in the skull. The several bones which cover in and protect the brain are seen to be united at their borders by a series of interlocking teeth. If we examine a fresh specimen, or, better still, the skull of an infant, it will be observed that there is a layer of membrane between the opposed borders of the bones ; so long as this membrane persists growth may take place, but on its disappearance osseous union occurs between the contiguous bones.

In this way it is possible to understand how increase in size takes place, and how the bony walls of the cranial box expand to allow the growth of the brain. When growth is complete the necessity for this expansion no longer exists;

FIG. 17. Shows the arrangement by which the bones of the top of the skull are united by serrated joints called sutures.

and if the skulls of old people be examined it will not unfrequently be found that all trace of these joints, or *sutures* as they are called, has disappeared, the bones having become ossified together.

CHAPTER III

It will now be necessary to take up in detail the consideration of the various parts of the body.

For descriptive purposes it is no doubt convenient to furnish a separate account of the bones, joints, and muscles, and such a method possesses great advantages in the study of scientific anatomy; but a knowledge of much of the detail which it is necessary the medical student should possess is altogether useless to the student of art. The bones, joints, and muscles all form part of one great system, and it will, it is hoped, serve our purpose better to consider them together as the various regions of the body are studied.

Although the divisions of the body suggested in Chapter I are not, strictly speaking, scientific, yet they are convenient, and for the purpose in view may be adopted with advantage.

Commencing with the description of the trunk, it will be necessary to examine the central axis or vertebral column, the chest-wall, and the pelvis; though, as we have seen, the pelvis is, properly speaking, the girdle of the lower limbs. The trunk corresponds pretty closely with what, in artistic language, is called the torso, with this difference, that the latter includes portions of the upper and lower limbs.

An examination of the back of the trunk involves a more detailed description of the vertebral column than has hitherto been given. The back-bone, represented in the accompanying figures, is seen to consist of thirty-four bones placed one on the top of another. This statement,

however, requires some qualification, for, if the skeleton be

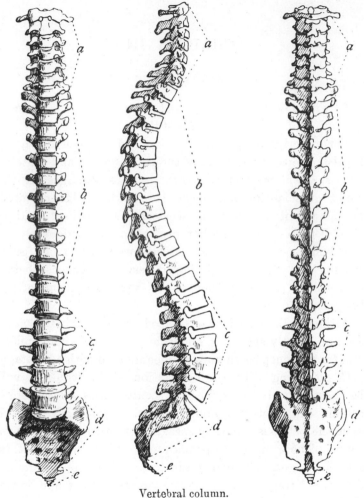

Vertebral column.

FIG. 18. Front view. FIG. 19. Side view, FIG. 20. Back view.
 showing curves.

a. Cervical vertebrae, seven in number. *d.* Sacrum, formed by fusion of five
b. Dorsal or thoracic vertebrae, twelve segments.
 in number. *e.* Coccyx, made up of four or five seg-
c. Lumbar vertebrae, five in number. ments.

more carefully examined, the lower ten of these segments

are seen to have become fused together in the process of growth to form two separate bones each consisting of five segments: these two bones are not unfrequently more or less united. They are **the** *sacrum*, to which reference has been already made, and the *coccyx*, which is formed of the dwarfed tail vertebrae of man.

The remaining twenty-four vertebrae are separate and distinct, so that we have an easy means of subdividing the column into (*a*) the region in which the vertebrae, twenty-four in number, are movable, and (*b*) the part comprising the sacral and coccygeal portions of the column, formed by the fusion of ten segments, in which the vertebrae are immovable.

Proceeding with the examination of one of the movable vertebrae, it is seen to consist of a solid part in front, more or less disk-shaped, which varies in size and thickness according to the part of the column from which the specimen has been taken. Fused on to the posterior aspect of this solid portion or body, there is an osseous arch which thus includes between it and the body a more or less circular hole. Connected with this arch are a number of processes, some of which are articular and assist in the union of the various vertebrae together; others are long and outstanding, and form levers to which muscles are attached. Of the latter, one springs from either side of the arch and forms the *transverse process*, the third or remaining one juts out from the centre of the arch behind and is known as the *spinous process*. The length and direction of these spines vary in different regions of the vertebral column, and, as will be presently shown, have an important influence on the surface contours of the back. If two or three of these vertebrae be taken from the same region, and placed one on the top of the other, it will be seen that the bodies or solid parts rest on each other, whilst the arches form an interrupted osseous

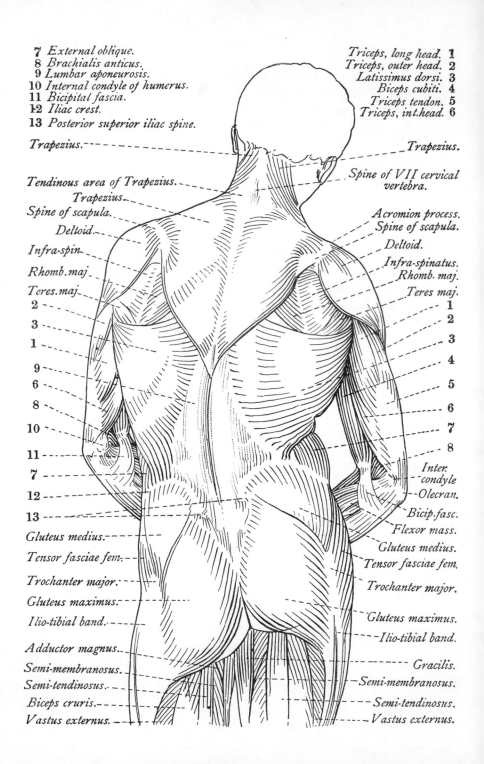

7 *External oblique.*
8 *Brachialis anticus.*
9 *Lumbar aponeurosis.*
10 *Internal condyle of humerus.*
11 *Bicipital fascia.*
12 *Iliac crest.*
13 *Posterior superior iliac spine.*

Triceps, long head. 1
Triceps, outer head. 2
Latissimus dorsi. 3
Biceps cubiti. 4
Triceps tendon. 5
Triceps, int.head. 6

Trapezius.

Trapezius.

Tendinous area of Trapezius.

Spine of VII cervical vertebra.

Trapezius.
Spine of scapula.
Deltoid.

Acromion process.
Spine of scapula.
Deltoid.

Infra-spin.
Rhomb. maj.
Teres.maj.

Infra-spinatus.
Rhomb. maj.
Teres maj.

2
3
1
9
6
8
10
11
7
12
13

1
2
3
4
5
6
7
8

Inter. condyle
Olecran.
Bicip.fasc.
Flexor mass.

Gluteus medius.
Tensor fasciae fem.
Trochanter major.
Gluteus maximus.
Ilio-tibial band.

Gluteus medius.
Tensor fasciae fem.
Trochanter major.
Gluteus maximus.
Ilio-tibial band.

Adductor magnus.
Semi-membranosus.
Semi-tendinosus.
Biceps cruris.
Vastus externus.

Gracilis.
Semi-membranosus.
Semi-tendinosus.
Vastus externus.

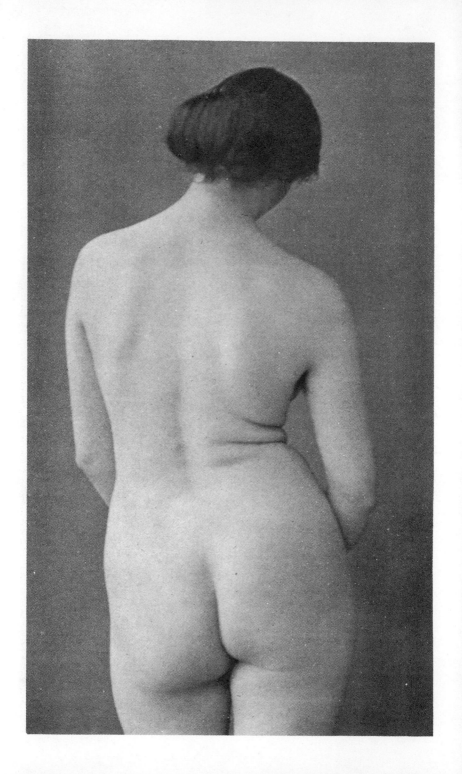

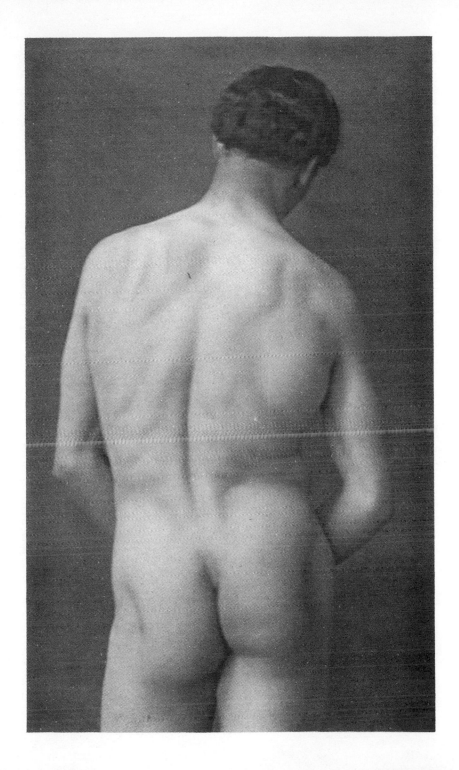

canal which contains and protects the spinal cord. At the same time the muscular processes fall in line, the spines forming a series of projections in the middle, the lateral or transverse processes being arranged in a similar series of projections on either side. The lateral rows of projections are separated by a groove from the mesially-placed row of spines. This groove varies in width and depth in different parts of the column, and is of great importance, as herein are placed

FIG. 21. View of a dorsal vertebra as seen from above.

FIG. 22. View of two dorsal vertebrae articulated together as seen from the side.

a. Body or centrum.
b. Transverse process.
c. Spinous process.
d. Articular surface on transverse process for tubercle of rib.
e. Articular processes by means of which adjacent vertebrae are jointed together.

f. Articular facets for head of rib.
g. Neural arch, in which the spinal cord is lodged.
 In Fig. 22 the space between the bodies *a a* of the two vertebrae is, in the recent condition, occupied by an intervertebral disk.

the erectores spinae muscles, of which mention has been already made as helping to hold the column upright.

Thus the column consists of a series of solid parts in front, an intermediate series of arches which enclose a canal, and three more or less distinct rows of processes at the sides and behind; but, as has been stated in Chapter II, the bodies of the vertebrae are united by fibrous disks, so that in this way a column is formed possessing stability combined with flexibility. If we consider the functions this part of the column is called upon to discharge, we find (first) that it supports not only the framework of the chest-wall

and, through it, the upper limbs, but also carries the head on its upper extremity. In addition to upholding the weight of these structures, it has also (secondly) to reduce the effect of any shocks to which it may be subjected. Every step we take is accompanied by a jar which, if not reduced in intensity, would render such acts as leaping and running an impossibility; for, if there were not some such arrangement, the shocks would be transmitted direct to the head and give rise to disturbance and injury of the delicate nervous centres lodged therein. As has been already explained, the reduction of the shock is largely due to the buffer-like action of the intervertebral disks. As will be seen, however, from an inspection of the articulated skeleton, the vertebrae are not placed one on the top of the other in a straight line, but are arranged in a series of curves which, acting after the manner of bent springs, likewise tend to reduce the transmission of these shocks. Before describing the character of these curves, it is necessary first to subdivide the movable vertebrae according to the regions in which they are placed. The twenty-four movable vertebrae are thus apportioned: seven are found in the neck, and are hence called the *cervical* vertebrae; twelve enter into the formation of the chest or thoracic wall, and are known by the name of the *thoracic* or *dorsal* vertebrae; the remaining five are situated in the region of the loins, and are termed *lumbar* vertebrae. The results can now be tabulated as follows:—

VERTEBRAE.

34

Movable = 24			Immovable = 10	
Cervical	Dorsal	Lumbar	Sacral	Coccygeal
7	12	5	5	5

There are four curves in the column—a forward curve in the cervical region, a backward in the dorsal region, a forward in the lumbar region, and a backward in the

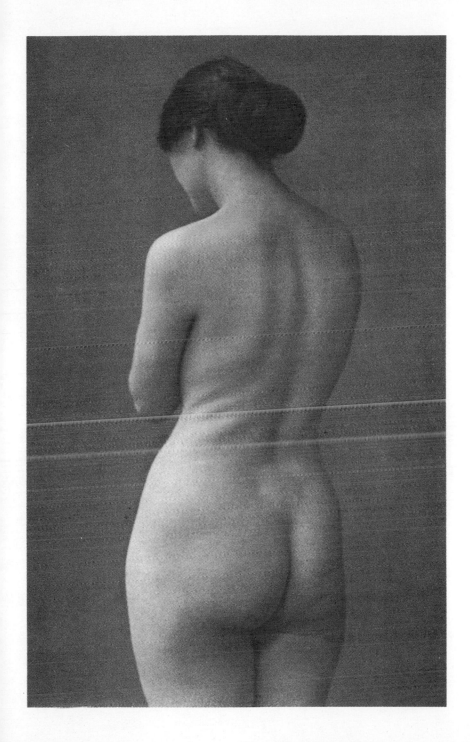

sacral region. Of these four curves, as has been already stated, two only exist at birth, viz. those associated with the formation of the thoracic and pelvic cavities; these are the primary curves, and are both directed backward. The secondary curves are those in the cervical and lumbar regions; they are forward curves, and, as has been explained in Chapter I, they only attain their full development after the assumption of the erect posture. As will be seen by a reference to Fig. 20, these curves pass imperceptibly into one another, with the exception of the lumbar and sacral curves; in these the transition from the forward to the backward curve is sudden and abrupt, and forms the projection known to anatomists as the sacro-vertebral angle—the bony promontory which overhangs the cavity of the pelvis.

The curves formed by the bodies of the vertebrae are, to a certain extent, repeated by the line connecting the tips of the spinous processes. The latter have a very important relation to the surface contours of the back, for, if the fingers be carried firmly down the middle line of the back from the lower part of the neck to the inferior extremity of the column, the tips of these processes can be distinctly felt and in some positions seen (Pl., p. 50). It is well to examine them carefully in the skeleton to see how far they accurately repeat the curves of the anterior outline of the column. As has been said, the length of these spinous processes varies in different situations; not only so, but their direction alters considerably; in some cases they are directed almost horizontally backwards, in other instances they are very obliquely placed (see Fig. 20). These facts have a very important influence in modifying the contour which is formed by the line connecting their tips, and we find that, whilst they repeat generally the curves of the solid part of the column, they are neither so prominent nor so well marked; thus in the neck the spines of the cervical vertebrae are short, with the exception of the second and last, and the curve formed

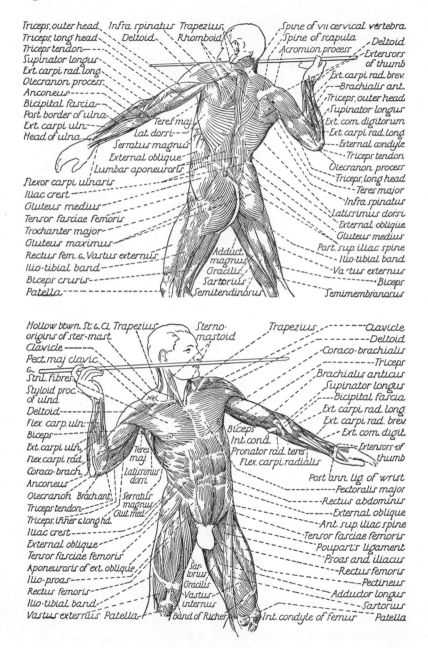

Triceps, outer head · Infra spinatus · Trapezius
Triceps, long head · Deltoid · Rhomboid
Triceps tendon
Supinator longus
Ext. carpi rad. long.
Olecranon process
Anconeus
Bicipital fascia
Post. border of ulna
Ext. carpi uln.
Head of ulna
Teres maj.
Lat. dorsi
Serratus magnus
External oblique
Lumbar aponeurosis
Flexor carpi ulnaris
Iliac crest
Gluteus medius
Tensor fasciae femoris
Trochanter major
Gluteus maximus
Rectus fem. & Vastus externus
Ilio-tibial band
Biceps cruris
Patella

Adduct. magnus
Gracilis
Sartorius
Semitendinosus

Spine of VII cervical vertebra
Spine of scapula · Deltoid
Acromion process
Extensors of thumb
Ext. carpi rad. brev.
Brachialis ant.
Triceps, outer head
Supinator longus
Ext. com. digitorum
Ext. carpi rad. long.
External condyle
Triceps tendon
Olecranon process
Triceps, long head
Teres major
Infra spinatus
Latissimus dorsi
External oblique
Gluteus medius
Post. sup. iliac spine
Ilio-tibial band
Vastus externus
Biceps
Semimembranosus

Hollow btwn. St. & Cl. · Trapezius
origins of ster-mast.
Clavicle
Pect. maj clavic. &
Stnl. fibres
Styloid proc. of ulna
Deltoid
Flex. carp. uln.
Biceps
Ext. carpi uln.
Flex. carpi rad.
Coraco-brach.
Anconeus
Olecranon · Brach. ant.
Triceps tendon
Triceps, inner & long hd.
Iliac crest
External oblique
Tensor fasciae femoris
Aponeurosis of ext. oblique
Ilio-psoas
Rectus femoris
Ilio-tibial band
Vastus externus · Patella

Sterno-mastoid

Teres maj.
Latissimus dorsi
Serratus magnus
Out. med.

Biceps
Int. cond.
Pronator rad. teres
Flex. carpi radialis

Sartorius
Gracilis
Vastus internus
Band of Richer

Trapezius
Clavicle
Deltoid
Coraco-brachialis
Triceps
Brachialis anticus
Supinator longus
Bicipital fascia
Ext. carpi rad. long.
Ext. carpi rad. brev.
Ext. com. digit.
Extensors of thumb
Post ann. lig of wrist
Pectoralis major
Rectus abdominis
External oblique
Ant. sup. iliac spine
Tensor fasciae femoris
Poupart's ligament
Psoas and iliacus
Rectus femoris
Pectineus
Adductor longus
Sartorius
Int. condyle of femur · Patella

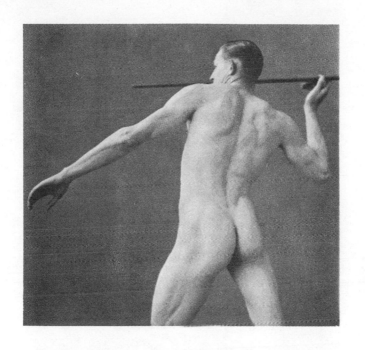

by a line passing through their tips is irregular and does not correspond accurately to that on the front of the column in this region; but the posterior curve is of little importance in relation to the surface contour of the back of the neck, as the short spines lie imbedded in the fleshy muscles of the back of the neck at some considerable depth from the surface, a fact which can easily be verified by the difficulty one experiences in feeling them. The spine of the last (seventh) cervical vertebra forms a striking exception to this arrangement. Owing to the unusual length of the spine of this vertebra it has been called the *vertebra prominens.* Its projection on the surface of the back just at the junction of the neck with the upper dorsal region forms a very characteristic landmark (see Pls., pp. 34, 94, 104, 138). Below this point the curve of the middle line of the back depends on the projection of the spines of the thoracic vertebrae, but, owing to the varying length and altered degrees of obliquity of these processes, the curve so produced is flatter and less pronounced than the curve formed by the anterior outline of the column in this region. In like manner the curve formed by the spines in the region of the loins is shallower than that displayed on the anterior surface of the column in the corresponding situation, and there is no sudden interruption in the flow of the curve from the lumbar to the sacral region such as we have seen exists anteriorly. The backward thrust of the sacrum is diminished owing to the fact that the thickness of the bone is rapidly reduced, a circumstance which naturally reacts on the prominence of its curvature.

As will be seen, therefore, the contour of the middle line of the back, whilst repeating to a certain extent the outline of the front of the column, yet displays considerable modifications, particularly in the direction of exhibiting these curves to a less marked degree. These details are evident in Fig. 23.

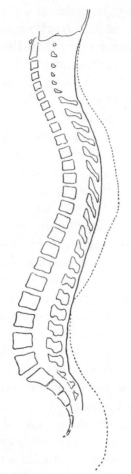

Fig. 23. Diagram to show that the curves formed by the line connecting the tips of the spinous processes do not correspond to the curves produced by the anterior outline of the column.

The strong black line corresponds to the contour of the back in the middle line; the dotted line represents the profile outline of the back, which differs from the foregoing, owing to the thickness of the fleshy muscles around the shoulder-blade above, and the development of the muscles of the buttock below.

The grooves which lie on either side of the central ridge of spines require further notice, particularly if a skeleton be examined in which the ribs and pelvic bones are articulated with the vertebral column. The two haunch-bones are seen to be united to either side of the sacrum, and their upper and back parts project considerably behind the surfaces of their attachment to that bone; the result is that they limit externally these lateral grooves as they run down the back of the sacrum. In this way the groove in this region on each side is much deepened, and an extensive surface for the attachment of muscles thus formed.

On tracing the groove upwards, into the mid-dorsal region, it is found to become very shallow from the fact that the spines are not so prominent; owing to the articulation of the ribs with the vertebrae, however, the groove though shallow is much wider, for the shafts of the ribs, as far as their angles (the points at which they bend forward), assist in forming its floor. Above the mid-dorsal point it again deepens.

Lying in this groove, on either side of the median spines, is the great fleshy column of the *erector*

spinae muscle, which takes origin from the posterior surface and spines of the sacrum, the spines of the lumbar, and some of the lower dorsal vertebrae, and in addition receives fibres of origin from the posterior border of the haunch-bone, and from the *posterior superior iliac* (or haunch) *spine*[1], as well as from the upper border of that bone in its posterior fourth. This muscle, which is very complicated in the arrangement of its fibres, breaks up into a number of subsidiary muscles, which have been separately described and named by anatomists: from our point of view, however, it may be

[1] The posterior superior iliac spine is the name given to the prominent posterior extremity of the upper border of the haunch-bone.

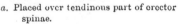

a. Placed over tendinous part of erector spinae.
b. Posterior superior iliac spine.
c. Haunch-bone (os innominatum).
d. Socket (acetabulum) for head of thigh-bone.
e. Tuberosity of the ischium.
f. Placed over fleshy part of erector spinae.
g. Splenius muscle.
h. Mastoid process of temporal bone.
i. Complexus muscle and superior curved line of occipital bone.

FIG. 24. Shows the great erector spinae mass of muscles. The muscles are shown only on one side, the groove in which they are lodged is seen on the right side of the figure.

regarded as one muscle having many attachments, being reinforced by additional slips as it ascends, and at the same time furnishing tendons of insertion to the ribs and trans-

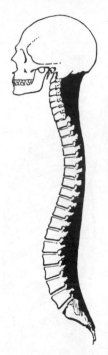

verse processes. As the groove in which it lies becomes shallower in the dorsal region, the muscle spreads out and thins, to become again more fleshy and more powerfully developed as it is continued into the upper dorsal region and the back of the neck as far as the base of the skull, to which it is ultimately attached. The fleshy mass at the back of the neck is further increased by the addition of muscles which need not here be particularized; these are immediately concerned with the movements of the head and neck.

A glance at the accompanying diagram will enable the reader to recognize that the lower part of this muscular column is particularly concerned with the control of the movements of the lower two-thirds of the back-bone, whilst the upper part is more immediately associated with the movements of the head on the column, as well as those of the upper part of the column itself.

FIG. 25. A diagram to show the arrangement of the muscles which support the back-bone. The muscles, which are represented in solid black, are seen to be thick in the regions of the loins and neck. and comparatively thin in the mid-dorsal region.

Whilst the *erector spinae* has a free admixture of tendinous fibres throughout its entire length, these form a dense layer on the superficial aspect of the muscle at its lower attachment, and this requires special attention. It extends as high as the second lumbar spine, close to the middle line, and, further, passes up as a pointed

process over the middle of the fleshy column, as far as the mid-dorsal region. The outer margin of this tendinous area describes a curve of varying outline, which terminates below at the posterior superior iliac spine. (See Fig. 24.)

This arrangement of the fleshy and tendinous fibres of the muscle, in a well-developed figure, affects the surface contours, the fleshy fibres of the muscle forming, during powerful contraction, a more distinct elevation than the tendinous portion (Pls., pp. 44, 50). Whilst this fleshy mass is not, strictly speaking, superficial, the muscles which over-lie it, particularly at the lower part of the back, consist merely of thin tendinous layers; at a higher level, though fleshy, they are sheet-like muscles, and their thickness, if considerable, is not sufficient to entirely obliterate the rounded form which the underlying muscular column imparts to the surface. It is on account of the development of these erectores spinae that the middle line of the back is converted into a furrow, the muscles bulging up on either side (Pls., pp. 34, 36). This is particularly noticeable when these muscles are in a powerful state of contraction, as when a person is supporting a heavy weight on the head or shoulders, or is bending backwards (Pls., pp. 38, 44, 52, 98, 138, 182). If, on the other hand, we examine the back of a model when the figure is bent forwards, we notice that the median groove to a large extent disappears and, in many cases, the spines of the vertebrae may be observed forming a prominent ridge (Pl., p. 50).

It will thus be observed how misleading the appearance of the skeleton is, for it by no means follows that because a prominent process of bone is near the surface its position is indicated by a surface projection. In fact, as we shall see hereafter, such bony ridges or projections frequently correspond to furrows or depressions on the surface of the body. The depth of the median furrow of the back will therefore depend largely on the development of these

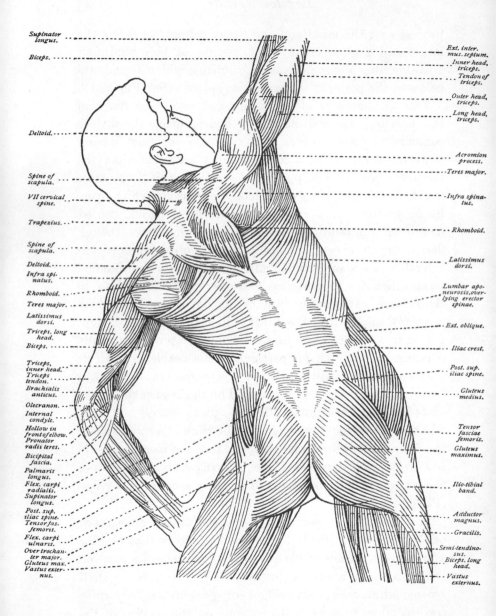

Supinator longus.

Biceps.

Deltoid.

Spine of scapula.

VII cervical spine.

Trapezius.

Spine of scapula.

Deltoid.

Infra spinatus.

Rhomboid.

Teres major.

Latissimus dorsi.

Triceps, long head.

Biceps.

Triceps, inner head.
Triceps tendon.
Brachialis anticus.

Olecranon.
Internal condyle.
Hollow in front of elbow.
Pronator radii teres.

Bicipital fascia.

Palmaris longus.
Flex. carpi radialis.
Supinator longus.

Post. sup. iliac spine.
Tensor fas. femoris.

Flex. carpi ulnaris.

Over trochanter major.
Gluteus max.
Vastus externus.

Ext. inter. mus. septum.
Inner head, triceps.
Tendon of triceps.

Outer head, triceps.

Long head, triceps.

Acromion process.
Teres major.

Infra spinatus.

Rhomboid.

Latissimus dorsi.

Lumbar aponeurosis, overlying erector spinae.

Ext. oblique.

Iliac crest.

Post. sup. iliac spine.

Gluteus medius.

Tensor fasciae femoris.

Gluteus maximus.

Ilio-tibial band.

Adductor magnus.

Gracilis.

Semi-tendinosus.
Biceps, long head.

Vastus externus.

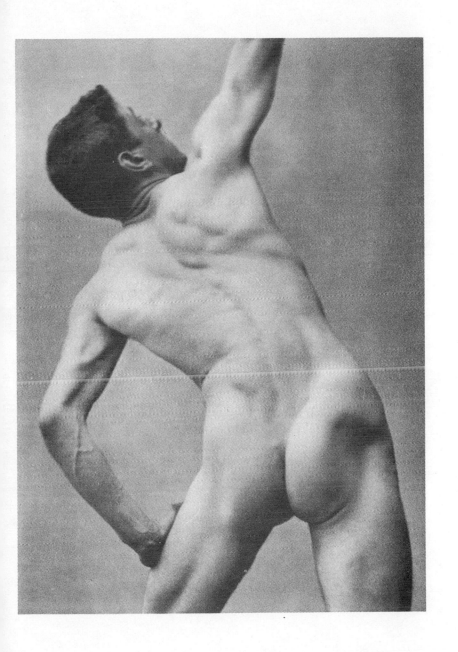

muscles, their state of contraction, and the posture of the body. We have only to examine the back of a weakly person and compare it with that of an athlete to see at once the extent to which these muscles influence the surface contours.

On tracing the median groove downward, we find that it not unfrequently ends in a depression or dimple, which usually corresponds to the position of the second sacral spine ; below this point the furrow fades insensibly into the cleft between the buttocks. The groove itself is best marked in the region of the loins, in which situation there are often indications of the presence of the lumbar spines, as demonstrated by the unevenness of the bottom of the furrow ; it becomes shallower again above, where it is interrupted by the outline of some of the more superficial muscles (Pls., pp. 34, 52, 182).

The lower attachment of the *erector spinae* is associated with two distinct depressions on either side ; one corresponds to the outer border of the attachment of its fleshy fibres to the posterior fourth, or so, of the iliac crest (Pls., pp. 34, 44, 52, 94). As Richer has pointed out, this is only seen in men ; in women the more abundant deposition of fat in this region obliterates this little hollow (Pls., pp. 36, 52, 142, 278). The other depression corresponds to the position of the posterior superior iliac spine, from which the tendinous fibres of the muscle spring, and this little dimple is common alike to male and female. These two latter depressions combined with the furrows on either side, corresponding to the posterior border of the haunch-bones and the outer converging margins of the sacrum, mark off a somewhat depressed triangular area, overlying in part the posterior surface of the sacrum. It is this area which is, as it were, wedged in between the prominences formed at either side and below by the projection of the buttocks. It should be noted that the angles of this triangle are all fixed points, and, whatever be the relation of the

surrounding parts as influenced by change of posture, the limits of this area remain always the same (Pls., pp. 34, 52, 94, 98).

In the lumbar region, in the male the outer margin

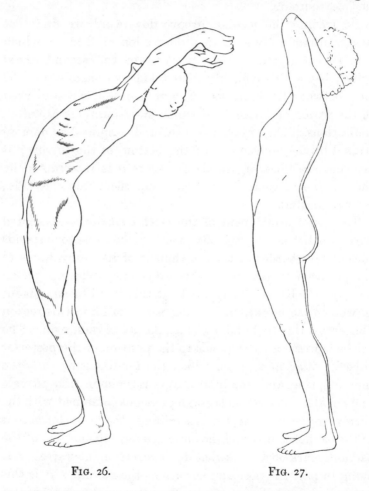

FIG. 26. FIG. 27.

of the erector mass is indicated by a shallow depression, which separates it from the flank (Pls., pp. 34, 38, 44, 50, 94, 98, 162).

The movements of the column are exceedingly complicated.

In attempting to analyse them, the student should bear in mind the facts already stated, viz. that the column consists of a part made up of separate segments, and a part in which the originally separate segments have become fused together in the process of growth. The latter comprises the sacrum and coccyx, the former includes the parts of the column which lie in the neck, thorax, and loins. Movement can alone take place in those parts of the column in which the vertebrae are separate. Further, it is well to note, for reasons already explained, that the sacrum is firmly and immovably connected with the haunch-bones, to form the pelvis. In this way a fixed base is provided for the upper and movable part of the 'back-bone', and any movement of the pelvis as a whole, either at the hip-joints or by rotation on the thighs, necessarily involves an alteration in the position of the base on which the movable part of the column rests.

As has been shown, the upper or movable part of the vertebral axis displays certain curves : a forward curve in the lumbar region, a backward in the thoracic region, and a forward in the cervical region.

These curves are necessarily much modified, though not to the extent we might imagine, when the back is bent forwards and backwards; these movements are termed flexion and extension respectively and are freest in the lumbar and cervical regions. They are not so free in the thoracic region, for here the cage-like structure of the chest-wall limits the range of these movements. The power of bending forward in this part of the column is checked by the compression of the thoracic wall, whilst the extent of the backward movement in this region is limited by the resistance of the chest-wall to further expansion; again, the overlapping of the spines of the dorsal vertebrae mechanically checks extension of the column in this situation.

Flexion is freest in the loins, extension in the neck. As

has been already pointed out, the spines of the cervical vertebrae are short, hence they do not interfere with the movement of extension, as is the case with the spines of the dorsal vertebrae.

In throwing back the head and trunk, the curve described is not a uniform one, on account of the limited range of extension in the dorsal region, as shown in Figs. 26, 27.

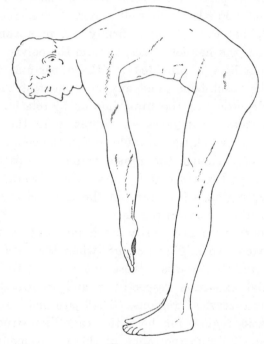

FIG. 28.

It is to be noted that when the body is bent forward the hollow in the lumbar region disappears, and for it is sub-stituted a curve, which blends above with that of the thorax, thus leading to a more flowing and uniform outline.

It will be observed, however (Fig. 23), that the outline of the figure in exact profile does not correspond to the curve of the median line of the back, from the fact that

the muscular projections on either side of the column, particularly in the region of the shoulder-blades, conceal from view the middle line of the figure.

Lateral movements of the column are also possible, the trunk being bent to one or other side. This movement is freest in the neck, extremely limited in the lumbar region, and not great in the thoracic region, for here it

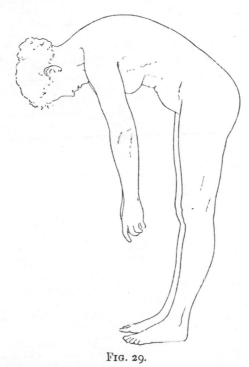

FIG. 29.

is necessarily associated with a compression of the chest-wall on the side towards which the body is bent, and an extension or stretching of the same structure on the opposite side. The range of this side-to-side movement is greatly increased by altering the position of the pelvis. The alteration in the position of the pelvis shifts the plane of the base (sacrum) upon which the movable part of the

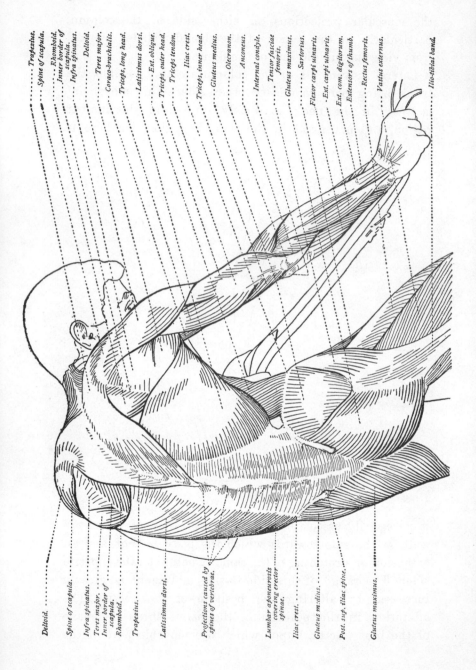

Trapezius.
Spine of scapula.
Rhomboid.
Inner border of scapula.
Infra spinatus.
Deltoid.
Teres major.
Coraco-brachialis.
Triceps, long head.
Latissimus dorsi.
Ext. oblique.
Triceps, outer head.
Triceps tendon.
Iliac crest.
Triceps, inner head.
Gluteus medius.
Olecranon.
Anconeus.
Internal condyle.
Tensor fasciae femoris.
Gluteus maximus.
Sartorius.
Flexor carpi ulnaris.
Ext. carpi ulnaris.
Ext. com. digitorum.
Extensors of thumb.
Rectus femoris.
Vastus externus.
Ilio-tibial band.

Deltoid.
Spine of scapula.
Infra spinatus.
Teres major.
Inner border of scapula.
Rhomboid.
Trapezius.
Latissimus dorsi.
Projections caused by spines of vertebrae.
Lumbar aponeurosis covering erector spinae.
Iliac crest.
Gluteus medius.
Post. sup. iliac spine.
Gluteus maximus.

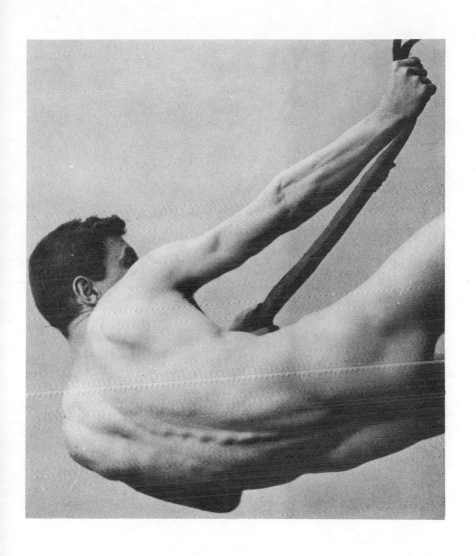

column rests. The movement of the pelvis is effected by the straightening of the leg on the side from which the body is bent, and the bending of the leg on the side towards which the trunk is inclined. This causes one side of the pelvis to fall lower than the other, and thus alters the position of the base of the column (sacrum) from a horizontal to an oblique plane.

Further, when the movable parts of the column are bent from side to side, there is a slight rotation of the individual

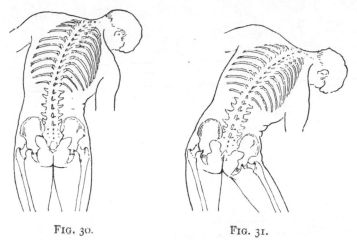

Fig. 30. Fig. 31.

Figs. 30, 31 show how the lateral inclination of the body is increased by shifting the pelvis from a horizontal to an oblique position.

vertebrae, which causes their spines to be turned away from the side towards which the body is bent. This explains why the surface furrows produced do not correspond precisely to the middle line of the bent column (Pl., p. 44).

Whilst speaking of these lateral curves of the column, it is well to note the existence of a slight degree of lateral curvature which is sometimes seen in the backs of persons standing upright. This curve when present is found in the dorsal region, and has its convexity directed towards the

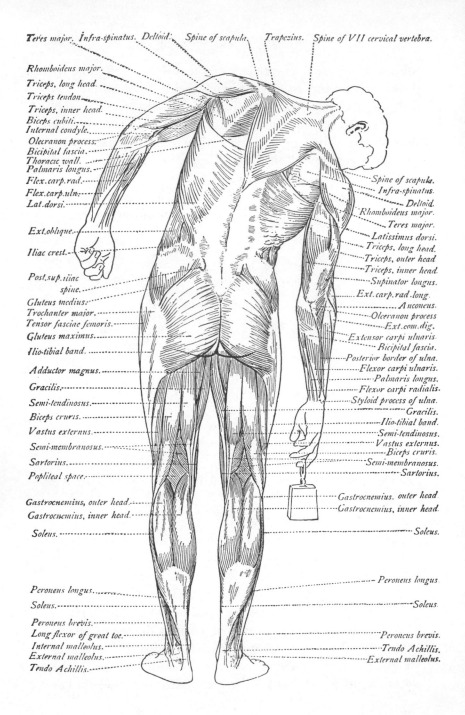

Teres major. Infra-spinatus. Delloid. Spine of scapula. Trapezius. Spine of VII cervical vertebra.

Rhomboideus major.
Triceps, long head.
Triceps tendon.
Triceps, inner head.
Biceps cubiti.
Internal condyle.
Olecranon process.
Bicipital fascia.
Thoracic wall.
Palmaris longus.
Flex. carp. rad.
Flex. carp. uln.
Lat. dorsi.

Ext. oblique.

Iliac crest.

Post. sup. iliac spine.

Gluteus medius.
Trochanter major.
Tensor fasciae femoris.
Gluteus maximus.

Ilio-tibial band.

Adductor magnus.

Gracilis.

Semi-tendinosus.

Biceps cruris.

Vastus externus.

Semi-membranosus.

Sartorius.

Popliteal space.

Gastrocnemius, outer head.
Gastrocnemius, inner head.

Soleus.

Peroneus longus.

Soleus.

Peroneus brevis.
Long flexor of great toe.
Internal malleolus.
External malleolus.
Tendo Achillis.

Spine of scapula.
Infra-spinatus.
Delloid.
Rhomboideus major.
Teres major.
Latissimus dorsi.
Triceps, long head.
Triceps, outer head.
Triceps, inner head.
Supinator longus.
Ext. carp. rad. long.
Anconeus.
Olecranon process.
Ext. com. dig.
Extensor carpi ulnaris.
Bicipital fascia.
Posterior border of ulna.
Flexor carpi ulnaris.
Palmaris longus.
Flexor carpi radialis.
Styloid process of ulna.
Gracilis.
Ilio-tibial band.
Semi-tendinosus.
Vastus externus.
Biceps cruris.
Semi-membranosus.
Sartorius.

Gastrocnemius, outer head.
Gastrocnemius, inner head.

Soleus.

Peroneus longus.

Soleus.

Peroneus brevis.
Tendo Achillis.
External malleolus.

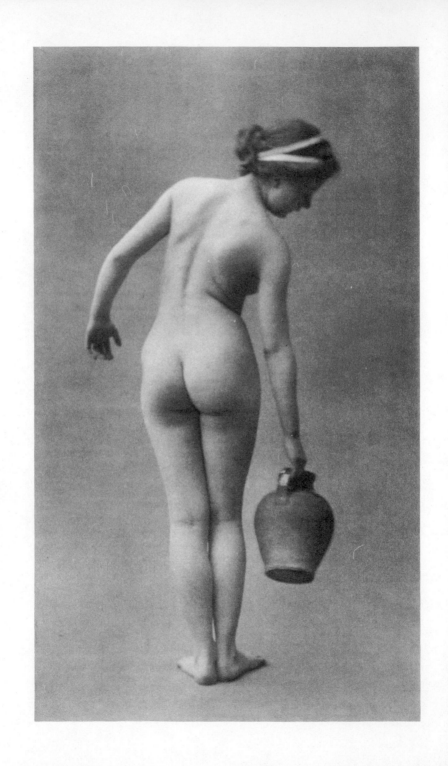

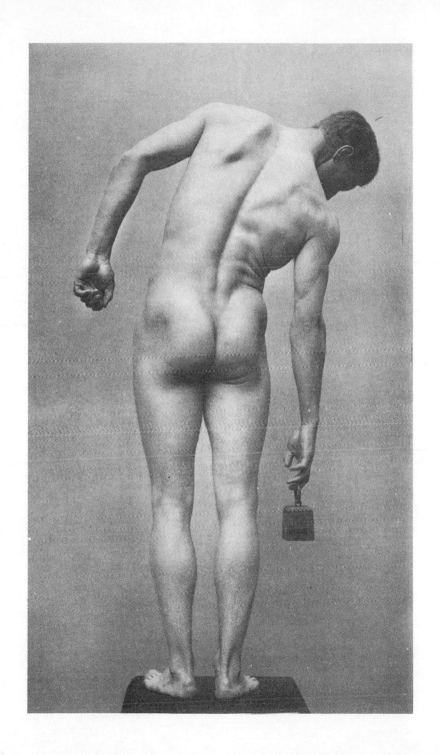

right side. It is probably due to the greater use of the right arm as compared with the left, and is associated with a more pronounced development of the muscles of the right upper limb.

Below this curve there is often a slight compensatory curve in the opposite direction, which imparts a sinuous aspect to the back and relieves it of its appearance of stiffness.

Movements of rotation may take place in the cervical and also slightly in the dorsal region. As we have seen, these movements are combined with the lateral flexion in the side-to-side movements. The power which we possess of turning the head round, so as to cast the eyes in a direction opposite to that in which the toes point, is mainly due to the existence of a special joint between the top of the column and the base of the skull, combined with the rotation of the pelvis (which supports the base of the column), on the upper extremities of the thigh-bones. This can be demonstrated in the following way. Standing erect, fix the pelvis by placing the hands on the haunches, turn the head to one or other side, without causing any perceptible movement of the column, then rotate the column, still keeping the pelvis fixed: if these directions be followed, it

FIG. 32.

will be found that the eyes can be directed across the point of the shoulder. If now the pelvis be released, the further movement in a backward direction will be seen to be effected by the rotation of the pelvis on the thigh-bones, the one hip being advanced, whilst the other is directed backwards.

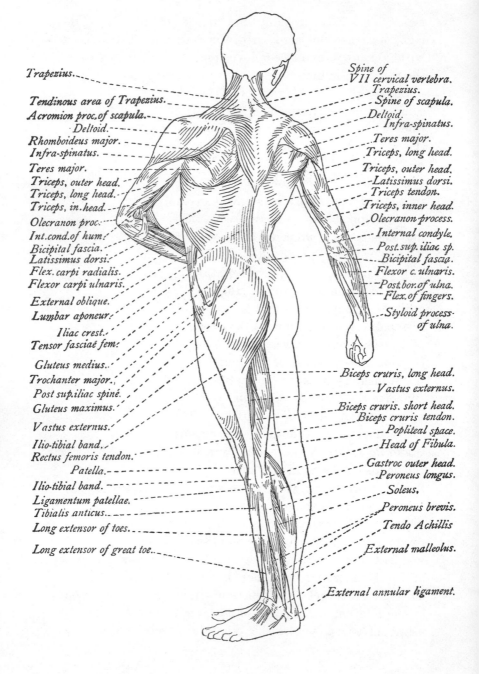

Trapezius.

Tendinous area of Trapezius.
Acromion proc. of scapula.
Deltoid.
Rhomboideus major.
Infra-spinatus.
Teres major.
Triceps, outer head.
Triceps, long head.
Triceps, in. head.
Olecranon proc.
Int. cond. of hum.
Bicipital fascia.
Latissimus dorsi.
Flex. carpi radialis.
Flexor carpi ulnaris.

External oblique.
Lumbar aponeur.

Iliac crest.
Tensor fasciae fem.

Gluteus medius.
Trochanter major.
Post sup. iliac spine.
Gluteus maximus.

Vastus externus.

Ilio-tibial band.
Rectus femoris tendon.
Patella.

Ilio-tibial band.
Ligamentum patellae.
Tibialis anticus.

Long extensor of toes.

Long extensor of great toe.

Spine of
VII cervical vertebra.
Trapezius.
Spine of scapula.
Deltoid.
Infra-spinatus.
Teres major.
Triceps, long head.

Triceps, outer head.
Latissimus dorsi.
Triceps tendon.
Triceps, inner head.
Olecranon process.
Internal condyle.
Post. sup. iliac sp.
Bicipital fascia.
Flexor c. ulnaris.
Post. bor. of ulna.
Flex. of fingers.

Styloid process
of ulna.

Biceps cruris, long head.
Vastus externus.

Biceps cruris. short head.
Biceps cruris tendon.
Popliteal space.
Head of Fibula.

Gastroc outer head.
Peroneus longus.

Soleus.

Peroneus brevis.

Tendo Achillis

External malleolus.

External annular ligament.

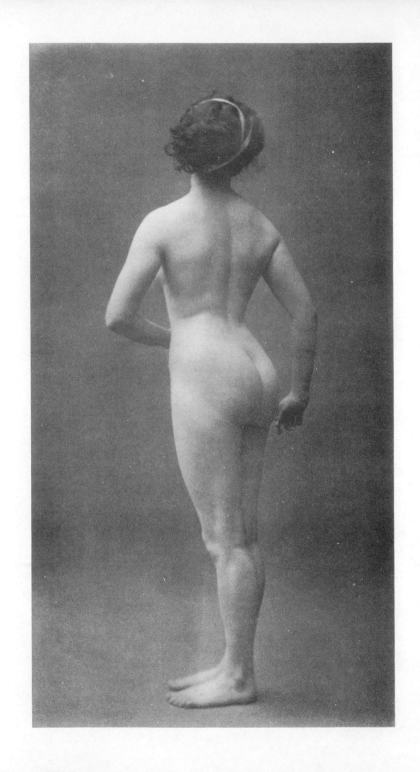

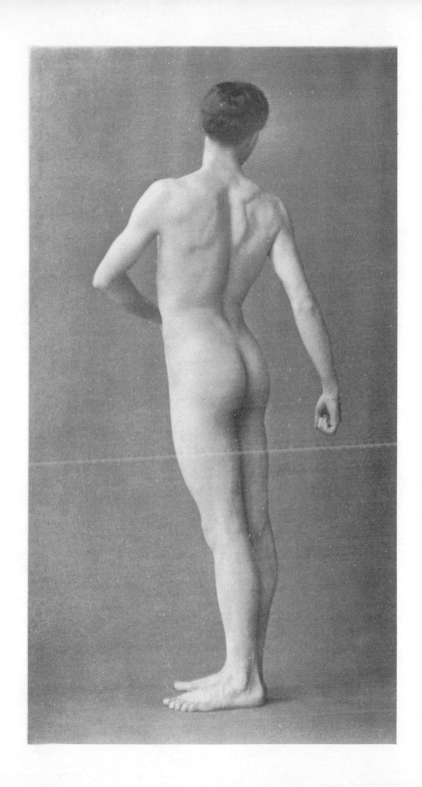

This sufficiently proves how limited the movement of rotation is when strictly confined to the column, and demonstrates how much the range of this movement depends upon the rotation of the pelvis on the thighs, for the head is now turned so that the eyes may be directed straight behind the figure, instead of across the shoulder, as happened when the movement was confined to the trunk alone (Pls., pp. 52, 54, 86).

In considering these movements of the column we may here lay stress on certain essentials which must be borne in mind in connexion with all sorts of muscular movements. The vertebral column with the muscles associated with it may well be compared with the rigging of the mast of a ship. The stays which support the main mast are comparable to the lower and greater part of the erector spinae on either side of the middle line. The rigging which supports the top mast on the main mast may be likened to the upper continuation of the erector spinae to the head. In the muscular action involved in any movement of the column, the analogy still holds good, for whilst the muscles are contracted on the side *towards* which the column is bent, those on the side *from* which it is inclined will be stretched but not relaxed, just as in regulating the position of the mast we may tighten one stay, whilst we 'pay out' another stay to the extent required, in order to prevent the mast from falling. It is this contraction and 'pay out' of the muscles involved which regulates, controls, and determines the amount of movement desired in any muscular act. It will be obvious, therefore, that, in any given action, whilst one group of muscles may be actively contracted, the antagonizing or opposing muscles need not be relaxed, but may be contracted only in such a way as to limit and control the action of the actively contracted group. In other words, they may be said to put a drag on the active muscles.

CHAPTER IV

ALTHOUGH the chest-wall comes into immediate relation with the surface of the body at comparatively few points, it is an extremely important factor in determining the general outline of the upper part of the trunk, because it forms the framework which supports the bones of the shoulder-girdle. These bones impart a varying width to the shoulder, according as they are placed upon a narrow or a broad chest, a difference which is characteristic of the two sexes, the comparatively narrow thorax of the female contrasting with the broad expanded chest of the male.

In examining the structures which enter into its formation, it is necessary to consider what are the requirements of the chest-wall. In the first place it must be capable of movement. This depends on its association with the respiratory function. The chest-wall expands and contracts with a bellows-like action, which is effected by means of a series of jointed bones acted on by muscles.

But, in addition, it is necessary that the chest-wall should form a protective covering for the vital organs which are lodged within its cavity; for this reason, besides being movable, it must combine strength with elasticity. Its structure is admirably adapted to meet these requirements; bone, cartilage, ligament, muscle, and membrane, all enter into its formation.

The osseous framework consists of twelve pairs of ribs which vary in length and in degree of curvature, according to the position they occupy. A typical specimen exhibits

a shaft which is more or less curved and twisted; the
posterior extremity or head articulates with the dorsal
vertebrae ; and the anterior end is connected in front with
the breast-bone by means of a bar of cartilage.

If an articulated skeleton be examined, it will be noticed
that all the ribs are not similarly connected with the breast-
bone. The first seven pairs are joined to it directly by

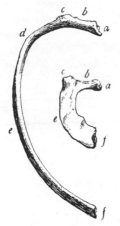

FIG. 34. Shows how the ribs articulate
with a vertebra as seen from above.

FIG. 33. The first and
sixth ribs.

a. Head. b. Neck.
c. Tubercle. d. Angle.
 e. Shaft.
f. Extremity of shaft which
 articulates with the rib
 cartilage.

a. Head of rib articulating with body of vertebra.
b. Neck of rib.
c. Tubercle of rib articulating with transverse
 process of vertebra.
d. Body of vertebra.
e. Articular processes of vertebra.
f. Neural ring for lodgement of spinal cord.
g. Transverse processes of vertebra.
h. Spinous process of vertebra.

means of their cartilages; the next three pairs, namely
the eighth, ninth, and tenth, are only indirectly united
with it by pieces of cartilage which are blended together,
but which fuse above with the cartilages of the seventh
pair of ribs; while the two lowest, viz. the eleventh and
twelfth pairs, are not connected with the breast-bone at all.
The ribs are thus classified, according to their relation to
the sternum, into the *true ribs*, which include the first seven

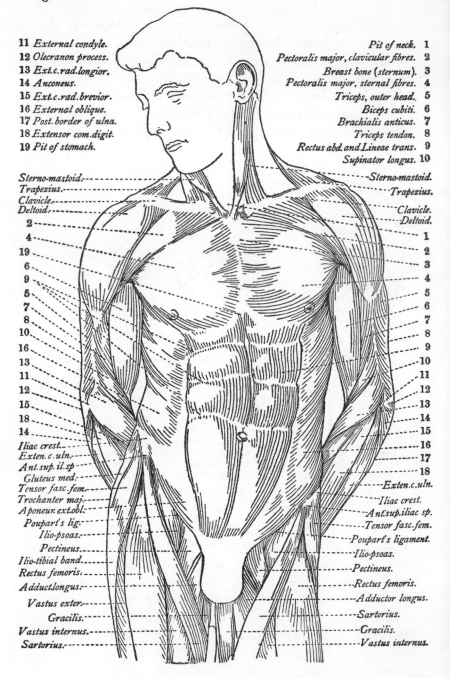

11 *External condyle.*
12 *Olecranon process.*
13 *Ext.c.rad.longior.*
14 *Anconeus.*
15 *Ext.c.rad.brevior.*
16 *External oblique.*
17 *Post. border of ulna.*
18 *Extensor com.digit.*
19 *Pit of stomach.*

Pit of neck. 1
Pectoralis major, clavicular fibres. 2
Breast bone (sternum). 3
Pectoralis major, sternal fibres. 4
Triceps, outer head. 5
Biceps cubiti. 6
Brachialis anticus. 7
Triceps tendon. 8
Rectus abd. and Lineae trans. 9
Supinator longus. 10

Sterno-mastoid.
Trapezius.
Clavicle.
Deltoid.

Sterno-mastoid.
Trapezius.
Clavicle.
Deltoid.

2
4
19
6
9
5
7
8
10
16
13
11
12
15
18
14

1
2
3
4
5
6
7
8
9
10
11
12
13
14
15
16
17
18

Iliac crest.
Exten.c.uln.
Ant.sup.il.sp
Gluteus med.
Tensor fasc.fem.
Trochanter maj.
Aponeur.ext.obl.
Poupart's lig.
Ilio-psoas.
Pectineus.
Ilio-tibial band.
Rectus femoris.
Adduct.longus.
Vastus exter.
Gracilis.
Vastus internus.
Sartorius.

Exten.c.uln.
Iliac crest.
Ant.sup.iliac sp.
Tensor fasc.fem.
Poupart's ligament.
Ilio-psoas.
Pectineus.
Rectus femoris.
Adductor longus.
Sartorius.
Gracilis.
Vastus internus.

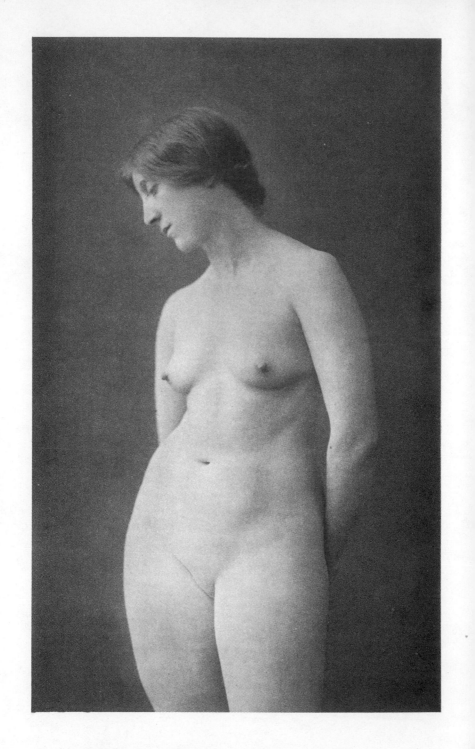

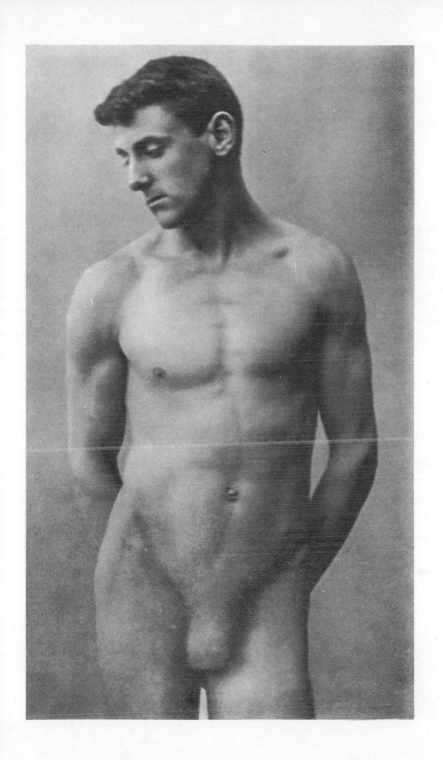

pairs, and the *false ribs*, which comprise the lower five pairs. The latter group thus includes the two last pairs, which are generally known as the *floating ribs*.

Arranged one above the other, these arched bones form a cage-like structure by their union with the breast-bone in front, and the column behind. The shape of the framework so formed has been referred to as a truncated cone, or it may be described as barrel-shaped. It is narrowest above where it lies in relation to the root of the neck, broadest about the level of the pit of the stomach, or lower end of the breast-bone. Below this level it again narrows slightly. The length and curvature of the ribs naturally vary according to their position; thus the first pair of ribs is the shortest and the most bent, the seventh or eighth pairs are the longest and most open in their curve. The ribs are not uniformly curved : if one of the middle ribs be examined, it will be seen to possess two curves ; these are not in the same plane, but in planes placed obliquely to each other, so that where the curves meet an angle is formed not only between the curves themselves but between the planes of the curves; this angle has been already referred to in connexion with the study of the vertebral column; the part of the shaft of the rib behind it has been seen to assist in the formation of the groove in which the erector muscles of the back are placed; the part of the shaft of the rib in front of the angle forms the curve of the side and front of the chest-wall. The adaptation of the ribs to the barrel shape of the chest-wall necessarily involves a slight twisting of their shafts, so that the flattened surfaces of these bones are brought into harmony with the general outline of the thorax.

The *breast-bone* or *sternum*, in the adult, consists of three pieces, the middle one of which has been formed by the fusion of several elements. These three parts of the breast-bone may be inseparably united, but it is usual to

find the highest one detached from the others in the
macerated skeleton. As the joints which unite these parts
in life are so firm that there is practically no movement in
them, we may for present purposes regard the sternum as
one bone consisting of three parts, an upper, a middle, and
a lower. Viewed from the front the upper part appears

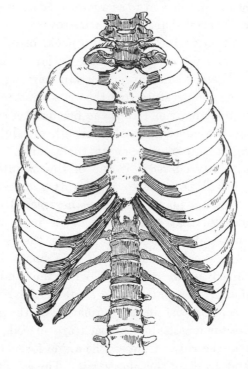

FIG. 35. Front view of skeleton of thorax. The costal cartilages
are shaded.

the largest and most expanded ; the middle portion displays
much variety of shape in different individuals : it varies
in width, and is often considerably wider below than above.
The joint between the upper and middle parts of the bone,
if fusion has taken place, is marked by a transverse ridge.
The lowest part consists in early life of cartilage, which

becomes ossified later; it also varies much in shape, and its
anterior surface does not come as far forward as the level
of the front of the middle part.

If we examine the bone from the side, we note that it is
slightly curved, a curve which corresponds to that of the
front of the chest-wall in the middle line; above, this

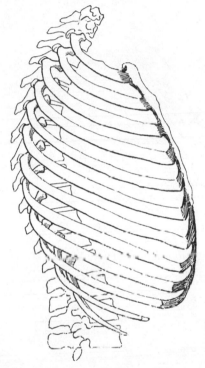

Fig. 36. Side view of skeleton of thorax. The costal cartilages
are shaded.

curve is interrupted at the point of junction of the upper
and middle portions by a slight angle formed by the
articulation between the two. This is known to anatomists
as the sternal angle. (See Fig. 38.)

As has been already seen, the breast-bone is of great
service in forming a support for the ribs in front, being

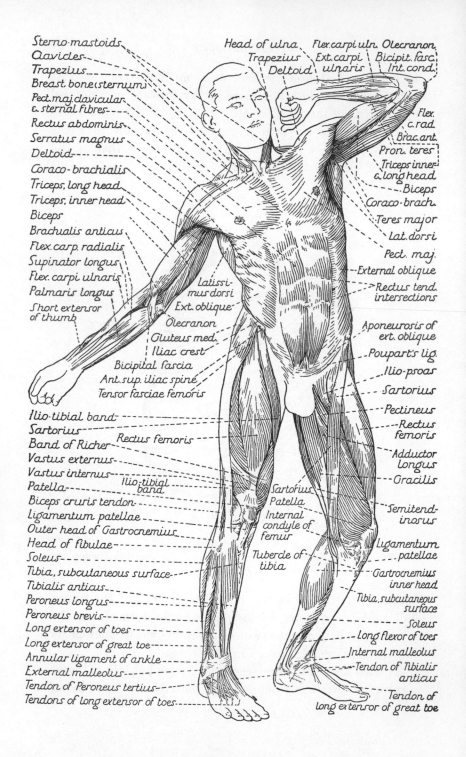

Sterno-mastoids
Clavicles
Trapezius
Breast bone (sternum)
Pect. maj. clavicular
& sternal fibres
Rectus abdominis
Serratus magnus
Deltoid
Coraco-brachialis
Triceps, long head
Triceps, inner head
Biceps
Brachialis anticus
Flex. carp. radialis
Supinator longus
Flex. carpi ulnaris
Palmaris longus
Short extensor
of thumb

Head of ulna
Trapezius
Deltoid

Flex. carpi uln. Olecranon
Ext. carpi Bicipit. fasc.
ulnaris Int. cond.

Flex.
c. rad.
Brac. ant.
Pron. teres
Triceps inner
& long head
Biceps
Coraco-brach.
Teres major
Lat. dorsi
Pect. maj.
External oblique
Rectus tend.
intersections

Latissi-
mus dorsi
Ext. oblique
Olecranon
Gluteus med.
Iliac crest
Bicipital fascia
Ant. sup. iliac spine
Tensor fasciae femoris

Aponeurosis of
ext. oblique
Poupart's lig.
Ilio-psoas
Sartorius
Pectineus
Rectus
femoris
Adductor
longus
Gracilis

Ilio-tibial band
Sartorius
Band of Richer
Vastus externus
Vastus internus
Patella
Biceps cruris tendon
Ligamentum patellae
Outer head of Gastrocnemius
Head of fibulae
Soleus
Tibia, subcutaneous surface
Tibialis anticus
Peroneus longus
Peroneus brevis
Long extensor of toes
Long extensor of great toe
Annular ligament of ankle
External malleolus
Tendon of Peroneus tertius
Tendons of long extensor of toes

Rectus femoris

Ilio-tibial
band

Sartorius
Patella
Internal
condyle of
femur
Tubercle of
tibia

Semitend-
inosus
Ligamentum
patellae
Gastrocnemius
inner head
Tibia, subcutaneous
surface
Soleus
Long flexor of toes
Internal malleolus
Tendon of Tibialis
anticus
Tendon of
long extensor of great toe

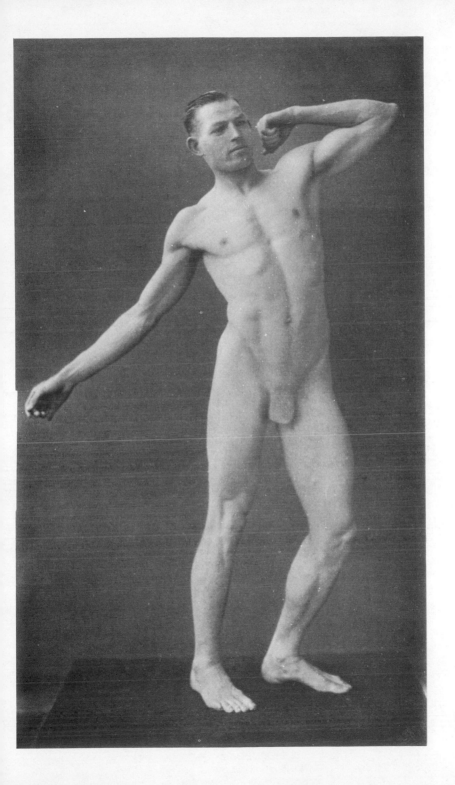

united to them by the rib cartilages already referred to. The first pair of ribs articulates with this bone at the upper angles of the highest portion; the second pair of ribs, by means of their cartilages, unites with the bone on either side, at a level with the line of articulation, or it may be of fusion, of the highest segment with the middle portion. The third, fourth, fifth, and sixth pairs of ribs

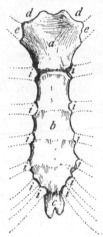

Breast-bone (sternum).

FIG. 37. Front view. FIG. 38. Side view.

a. Upper part of breast-bone (manubrium sterni).
b. Middle part of breast-bone (body, or gladiolus).
c. Lower part of breast-bone (ensiform process).

d. Surfaces for articulation with collar-bones.
e. Surfaces for articulation with cartilage of first rib.
i. Surfaces for articulation with cartilages of second to seventh ribs inclusive.

are united to the middle part of the bone along its outer border, and the seventh pair of ribs, i. e. the last pair directly connected with the sternum, is wedged in between the middle and lowest portions of the bone.

In addition to its connexion with the ribs, the breast-bone also articulates with the collar-bones; the surfaces for these may be seen at the upper angles of the first

portion, just above the point where the first ribs are attached. The upper border of the first part of the breast-bone between these two articular surfaces for the collar-bones is thick and rounded and slightly hollowed ; it forms the lower limit of that depression familiarly known as the pit of the neck (Pls., pp. 58, 148, 152, 382). From this point downwards along the middle line the bone is quite superficial and corresponds to a groove, noticeable on the model, the sides of which are formed by the bulging of the powerful muscles which arise from the lateral surfaces of this bone. If the finger be run down this groove, the sternal angle, formed, as has been said, by the articulation of the highest and middle portions of the breast-bone, can always be recognized by touch, and in the male not unfrequently by sight. Inferiorly the groove ends in a more or less well-marked depression over the situation of the lowest segment of the bone, or *ensiform* cartilage as it has been named. This depression is called the pit of the stomach, and its sides are formed by the slight projection of the carti-lages of the seventh pair of ribs as they pass upwards to the breast-bone (Pls., pp. 58, 62, 72, 158, 382).

In the female these details are obscured by the large deposition of fat in this region, due to the presence of the breasts (Pls., pp. 72, 86, 132, 298). The extent to which these points can be observed in persons of either sex will largely depend on the degree of muscular development and the amount of fat. In an emaciated person not only can the outline of the whole breast-bone be seen, but the ribs and rib cartilages may with ease be counted.

From the fact that the ribs are articulated with the back-bone in such a way that their posterior extremities always lie on a higher level than their anterior ends, the shaft of each bone lies in a plane oblique to, and not at right angles with, the vertical plane. In consequence of this, the upper end of the breast-bone does not lie on a level with the

first thoracic vertebra, but at a point considerably below, corresponding it may be to the lower border of the second, or the upper border of the third, thoracic vertebra; the level varies slightly according as the breast-bone is raised or lowered during the respiratory movements (Fig. 39). It is due to this obliquity of the first rib that the neck appears longer in front than behind. In like manner the lower end of the middle segment of the sternum corresponds usually to the level of the ninth or tenth thoracic vertebra. Of course this will vary according to the length of the bone, which differs considerably in dif-
ferent individuals. The angle which the bone forms with a horizontal line drawn through its inferior extremity ranges from about 70° to 75°; in the female the bone approaches more nearly the vertical position. In the male, the upper part of the breast-bone is relatively shorter and broader than in the female, whilst the middle part is proportionately longer and narrower in the male than in the female. The absolute measurements will of course vary with the heights of the individuals

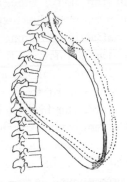

FIG. 39 (after Quain). Illustrates the rise and fall of the chest-wall in the movements of respiration.

examined. In regard to the proportionate length of the sternum, Duval has pointed out that, including the upper and middle portions only, it corresponds pretty closely to the length of the collar-bone or to the length of the hand less the third joint of the middle finger.

Taken as a whole, the thorax in the female is of slighter build and relatively shorter and more rounded than in the male; in the female, too, the upper ribs are more movable than in the male, an arrangement which allows of greater expansion of this part of the female chest during violent

inspiratory movements, such as are very frequently employed
on the stage to indicate suppressed emotion. The lower
margin of the thorax plays an important part in the
moulding of the surface contours. The eleventh and
twelfth ribs may be disregarded, for their shafts and ex-
tremities are deeply imbedded in the fleshy muscles of the
flank, but the cartilages of the tenth, ninth, and eighth
ribs, as they curve forward and upward to join the cartilages
of the seventh ribs, and thus become indirectly united with
the breast-bone, are very clearly indicated on the surface
of the body, though their outline may be concealed to
a greater or less extent by the development and state of
contraction of some of the muscles which form the wall
of the abdomen in front (Pls., pp. 72, 148, 152, 158).

The form of the outline so described sweeps downward
and outward from the pit of the stomach, in a direction
towards the highest point of the crest of the haunch-bone;
the convexity of the curve being directed inwards and
downwards. As will be shown hereafter, the acuteness of
the angle between the two converging borders of the
thoracic wall is to a great extent concealed by the presence
of two of the muscles which form the wall of the abdomen
in front. These are called the *recti abdominis* muscles, and
are placed one on either side of the middle line.

As already stated, the expanded outer surface of the
thoracic wall affords extensive attachment, not only to
the muscles of the abdomen, but also to the muscles of the
upper limb. In this way the outer surface of the ribs is
clothed with fleshy layers, which conceal the form of these
bones, whilst the shoulder-girdle above, with its associated
muscles, entirely modifies the shape of the upper part of the
trunk.

The region of the abdomen, which we have next to
consider, lies between the lower thoracic margin above and
the pelvis below. It extends round the sides of the trunk,

where it forms the flanks, and there its surface-form blends behind with that produced on either side by the erectores spinae muscles. A longitudinal furrow along the outer border of that fleshy mass in the lumbar region serves to define the hinder limit of the flank (Pls., pp. 38, 44, 50, 98).

The cavity of the abdomen, however, is not so limited, but extends upwards beneath the thoracic wall for a considerable distance, its roof being formed by a dome-shaped partition, the *diaphragm*, which separates it from the thoracic cavity.

The anterior aspect of the abdominal wall is limited above, in the middle line, by the pit of the stomach, a depression which corresponds to the ensiform cartilage. From this point its margin is defined by the cartilages of the seventh, eighth, ninth, and tenth ribs in the manner already described; the eleventh and twelfth ribs, though not discernible, and as a rule with difficulty felt, carry this curve towards the back.

The lower boundary of the abdominal wall is formed by the haunchbones. These bones will be more fully described when the anatomy of the thigh and buttock is considered,

Fig. 40. Diagram showing the boundaries of the abdominal region.

a. Anterior superior iliac spines
b. Symphysis pubis.
c. Poupart's ligament.
d. Outline of lower thoracic margin.
e. Ensiform process corresponding to the pit of the stomach.

but it is necessary here to mention some points connected with their structure. As was stated in an earlier chapter, the haunch-bone is formed by the fusion of three smaller bones, the *ilium*, the *pubis*, and the *ischium*. With the first two only are we at present concerned. The *ilium* forms the upper expanded wing-like portion of the haunch-bone, and by its inner hollow surface furnishes a support for the contents

of the abdominal cavity, while the outer aspect affords attachment to the muscles of the buttock. These two surfaces meet above, and form the upper curved margin of the bone, which is termed the *crest*. This ' iliac ' crest ends, in front and behind, in two well-marked projections or spines, called respectively the *anterior* and *posterior superior iliac spines*. The relation of the latter we have already studied in connexion with the surface forms of the lower part of the back (vide Chapter III). The anterior superior iliac spine will be found to have a like importance in relation to the anterior region (Pls., pp. 58, 62, 72, 86, 148, 152, 158, 216, 298, 318, 366, 438).

The *pubis* is that portion of the haunch-bone which lies in front and below. The pubis of the one side is united to its fellow of the opposite side by an immovable joint called the *symphysis pubis*, which corresponds in position to the lower part of the abdomen, in the middle line. An inch or so from the middle line (somewhat more in the female), the upper border of this bone forms a projection, called the *spine of the pubis*. Stretching between the anterior superior spine of the ilium, which lies at a considerably higher level, and the pubic spine there is a band of fibrous tissue, called *Poupart's ligament*. This band, which is in reality formed by the lower fibres of the sheet-like tendon of one of the abdominal muscles, is curved between its points of attachment. The convexity of the curve is directed downward, and corresponds to the furrow which separates the lower abdominal region from the front of the thigh; the furrow is commonly known by the name of the fold of the groin.

Such are the boundaries of the abdominal wall. Now this wall is made up of a number of expanded sheet-like muscles attached by their edges to these boundaries, and in order to understand better the arrangement of these structures it will be of advantage to study a dia-

grammatic representation of a cross-section of the trunk (Fig. 41).

Connected with the lumbar vertebrae are sheets of condensed fibrous tissue (*aponeuroses*). These layers, which spring from the spines and transverse processes in the manner represented in Fig. 41, unite wide of the middle line, and just external to the erectores spinae muscles so as to encase these muscles in a fibrous sheath. From the strong

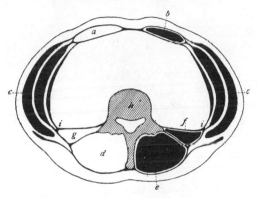

Fig. 41. Diagram of a section across the trunk to illustrate the arrangement of the muscles of the abdominal wall.

a. The sheath of the rectus abdominis formed by the tendinous aponeuroses of the muscles of the flank.
b. The rectus abdominis muscle in situ.
c. The external oblique muscle, the most superficial of the three muscles of the flank.
d. The compartment formed by the splitting of the lumbar aponeurosis, within which is lodged
e. The erector spinae muscle.
f. The quadratus lumborum muscle, lying within
g. Another compartment formed by the splitting of
i. The lumbar aponeurosis.
h. The body of a lumbar vertebra.

aponeuroses so constituted, certain of the muscles of the flank take origin. Their fleshy fibres are so disposed that three muscular layers are formed, the direction of the fibres of which vary widely. The outer layer constitutes the muscle known by the name of the *external oblique*; the other two layers are from without inwards, the *internal oblique*, and *transversalis*. The fleshy fibres of these three muscles do not reach far forwards on the abdominal wall,

but are again replaced by tendinous sheets or aponeuroses ;
as we approach the middle line in front, the aponeurosis
of the intermediate muscle splits, the split layers being
united in front and behind with the aponeuroses of the
outer and inner muscle respectively. The layers so formed

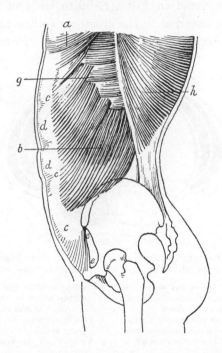

FIG. 42. Side view of muscles of the trunk.

a. Pectoralis major muscle.
b. External oblique muscle of abdomen.
c. Aponeurosis of external oblique, cor-
 responding to linea semilunaris.
d. Aponeurosis of external oblique, pass-

ing in front of rectus abdominis
muscle.
e e. Anterior superior iliac spine, Pou-
part's ligament, and spine of pubis.
g. Serratus magnus muscle.
h. Latissimus dorsi muscle.

enclose a muscle which is here represented in section, the
fibres of which are directed longitudinally. This is the
straight or *rectus muscle* of the abdominal wall. At the side
of this muscle, nearest the middle line, the layers which
overlie it back and front again unite, and become blended

with a similar layer from the opposite side of the body. As both sides of the trunk are symmetrical, there is formed in this way a fibrous cord, which lies in the middle line in front, extending from the cartilage of the breast-bone above

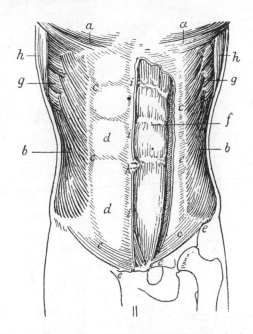

FIG. 43. Front view of muscles of the abdominal wall.

a. Pectoralis major muscle.
b. External oblique muscle of abdomen.
c. Aponeurosis of external oblique, corresponding to linea semilunaris.
d. Aponeurosis of external oblique, passing in front of rectus abdominis muscle.
e e. Anterior superior iliac spine, Poupart's ligament, and spine of pubis.
f. Rectus abdominis muscle, exposed by the removal of the front of its sheath, and showing its tendinous intersections.
g. Serratus magnus muscle.
h. Latissimus dorsi muscle.
i. Linea alba, formed by the fusion of the tendinous aponeuroses of the muscles of the flank in the middle line.
k. Umbilicus or navel.

to the symphysis pubis below; this is called the *linea alba*. On either side of this are the longitudinal recti muscles, which also stretch from the thoracic margin above to the pubis below. These muscles are ensheathed in the manner just described.

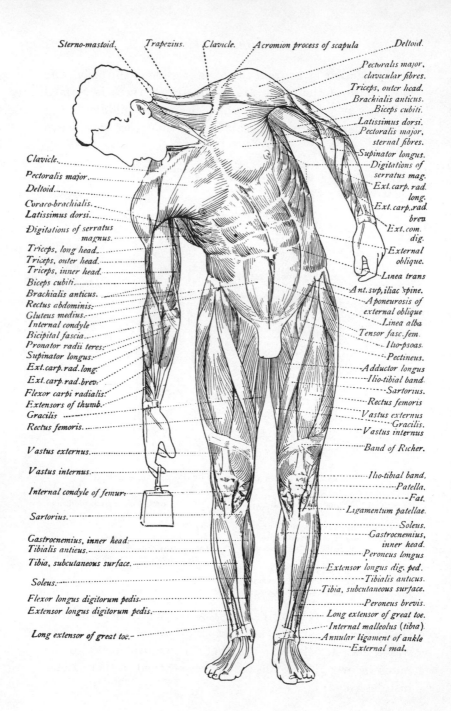

Sterno-mastoid. Trapezius. Clavicle. Acromion process of scapula Deltoid.

Pectoralis major,
clavicular fibres.
Triceps, outer head.
Brachialis anticus.
Biceps cubiti.
Latissimus dorsi.
Pectoralis major,
sternal fibres.
Supinator longus.
Digitations of
serratus mag.
Ext. carp. rad.
long.
Ext. carp. rad.
breu
Ext. com.
dig.
External
oblique.
Linea trans
Ant. sup. iliac spine.
Aponeurosis of
external oblique
Linea alba
Tensor fasc. fem.
Ilio-psoas.
Pectineus.
Adductor longus
Ilio-tibial band.
Sartorius.
Rectus femoris
Vastus externus
Gracilis.
Vastus internus
Band of Richer.
Ilio-tibial band,
Patella.
Fat.
Ligamentum patellae.
Soleus.
Gastrocnemius,
inner head.
Peroneus longus
Extensor longus dig. ped.
Tibialis anticus.
Tibia, subcutaneous surface.
Peroneus brevis.
Long extensor of great toe.
Internal malleolus (tibia).
Annular ligament of ankle
External mal.

Clavicle.
Pectoralis major
Deltoid.
Coraco-brachialis.
Latissimus dorsi.
Digitations of serratus
magnus.
Triceps, long head.
Triceps, outer head.
Triceps, inner head.
Biceps cubiti.
Brachialis anticus.
Rectus abdominis.
Gluteus medius.
Internal condyle
Bicipital fascia.
Pronator radii teres.
Supinator longus.
Ext. carp. rad. long.
Ext. carp. rad. brev.
Flexor carpi radialis.
Extensors of thumb.
Gracilis
Rectus femoris.
Vastus externus.
Vastus internus.
Internal condyle of femur.
Sartorius.
Gastrocnemius, inner head.
Tibialis anticus.
Tibia, subcutaneous surface.
Soleus.
Flexor longus digitorum pedis.
Extensor longus digitorum pedis.
Long extensor of great toe.

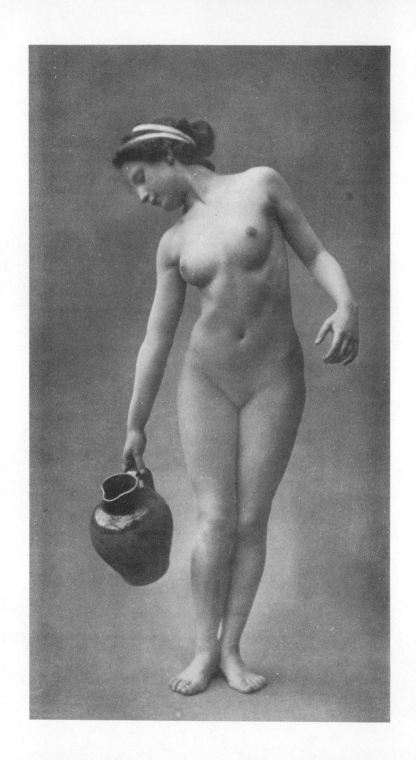

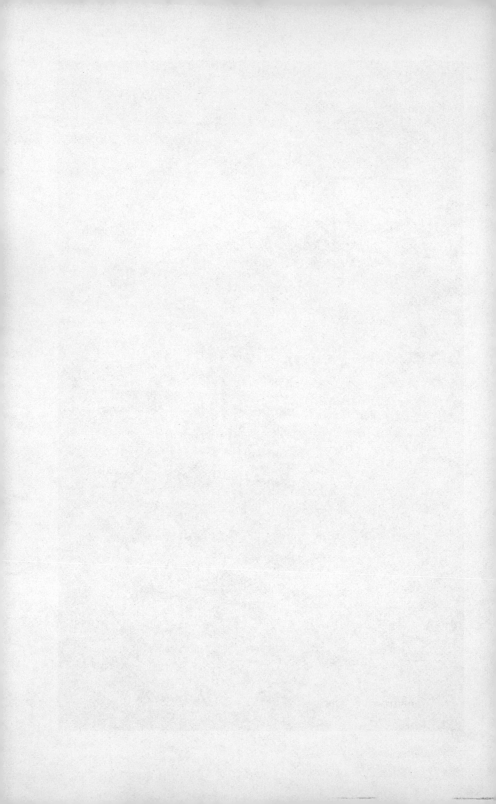

We are only concerned with the most superficial of the muscles of the flank and abdominal wall. This is the *external oblique*; as its name implies, its fibres have an oblique direction. The muscle consists of a broad sheet of fleshy fibres which takes origin from the outer surfaces of the eight lower ribs, by a series of slips or digitations. The hinder fibres, almost vertical in direction, pass down to be attached to the anterior half of the crest of the ilium or haunch-bone. In front of this attachment the fleshy fibres are inserted into the most superficial of the aponeurotic layers just described. These anterior fibres are directed forwards with varying degrees of obliquity. Through the medium of its aponeurosis the muscle becomes attached to Poupart's ligament (which has been already described as passing between the anterior superior iliac spine and the spine of the pubis), to the whole length of the linea alba, extending from the symphysis pubis below to the cartilage of the breast-bone above, and to the fascia covering the large muscle which arises from the front of the chest-wall on either side of the middle line, viz. the muscle called the *great pectoral.* A line let fall vertically from the middle of the collar-bone to meet a transverse line carried across between the two anterior superior spines of the ilia, with the angle between the two rounded off, will fairly accurately define the anterior and lower limits of the fleshy portion of the muscle (Figs. 42, 43).

The *recti muscles* of the abdomen lie on either side of the middle line; they are attached above to the cartilages of the fifth, sixth, and seventh ribs, as well as to the cartilage of the breast-bone; below they are connected with the pubes and pubic symphysis; their lower attachments are very much narrower than their upper. These muscles do not lie immediately beneath the skin and superficial fatty layer, but are ensheathed, in the manner already stated, by the aponeuroses of the muscles of the flank. When the anterior

layer of these sheaths is removed, the muscles are exposed. The arrangement of their fleshy fibres is peculiar. In place of extending the whole length of the muscle, they are interrupted by tendinous intersections which usually occupy certain definite positions. In this way the muscle is not composed of one fleshy belly, but of four or five segments firmly united to each other by short tendinous fibres. These tendinous intersections, or *lineae transversae*, as they are called, are usually three in number, and are situated, the lowest, a little above the level of the navel ; the highest, a short distance below the pit of the stomach ; the intermediate one, midway between the other two. The latter is usually continuous, towards the outer side, with the broad shallow furrows which surround the sides of the trunk, and which mark the position of the waist (Fig. 43, and Pls., pp. 58, 62, 86, 148, 152, 158).

The inner borders of the two muscles lie side by side, being separated merely by their sheaths and the linea alba, which is wider above the navel than below. The outer border is gently curved from the upper broad attachment to the more pointed lower origin from the pubis.

We must now examine the influence these structures have upon the surface contours. A median furrow is seen running from the pit of the stomach downwards towards the symphysis pubis; this corresponds to the position of the linea alba. The prominence of the rectus muscle on either side assists in deepening the groove. About midway between the cartilage of the breast-bone and the symphysis pubis is placed the *navel*. Below this point the median furrow becomes less distinct, and finally disappears owing to the closer approximation of the recti muscles and the more abundant quantity of fat in this region (Pls., pp. 58, 62, 72, 86, 148, 152, 158).

The outer borders of the recti muscles are marked by the existence of furrows, sometimes called the *lineae semilunares*

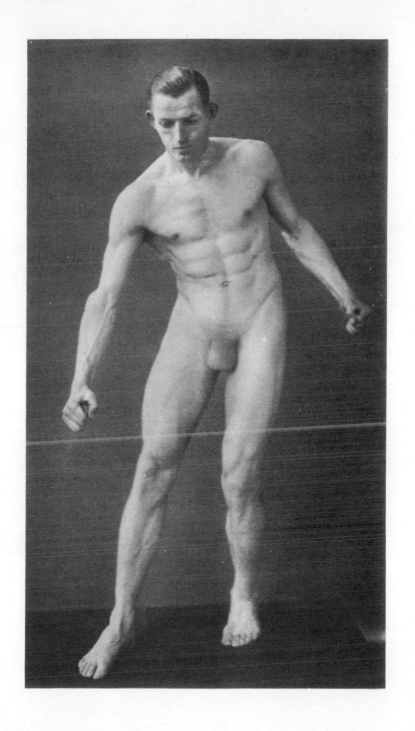

These separate the anterior abdominal region from those of the flanks. Commencing above at the costal margin, just wide of the attachment of the recti muscles to the ribs, these furrows are narrow, as here the fleshy parts of the recti and external oblique muscles lie close together. At the level of the navel the furrows begin to widen, and ultimately spread out to form smooth areas of triangular shape. These areas correspond to the surface of the abdominal wall immediately above the folds of the groin. Here the fleshy parts of the superficial muscles of the abdominal wall are separated by a wide interval composed of tendinous fibres. The outer border of the rectus, as it curves in to be attached to the pubis, limits this region on the inner side. Its lower boundary is marked by Poupart's ligament. Above and to the outer side, the fibres of the external oblique form its outer limit. These details may not in every case be clearly recognized, as their sharpness depends on the quantity of fat beneath the skin (Pls., pp. 58, 62, 148, 152, 158).

A glance at Fig. 43 will enable the reader to realize that this triangular area corresponds to the lower part of the aponeurosis of the external oblique muscle, which here has a form somewhat resembling the shape of an arrowhead, the point being directed towards the spine of the pubis; the sides, to the outer border of the rectus and Poupart's ligament respectively; the tang, or part where the arrow-head is connected with the shaft, corresponding to the insertion of the fibres of the external oblique.

The prominences formed by the recti muscles as they lie between the median and lateral furrows are interrupted by transverse grooves. Above the level of the navel these grooves are due to the presence of the lineae transversae which were described in connexion with the recti. The sheaths of these muscles are not thick enough to obscure the influence of these tendinous intersections; besides, there

is an intimate union between the anterior part of the sheath and those tendinous fibres, so that their position is rendered very evident by the occurrence of transverse grooves on the surface of the body when the muscles are powerfully contracted. Their position has been already sufficiently indicated, but it may be well to refer to their modifying influence on the outline produced by the lower thoracic margin. Where the recti muscles are attached to the cartilage of the fifth, sixth, and seventh ribs, they necessarily overlie the cartilages of the seventh ribs, and according to the varying thickness of the muscles (dependent on the degree of their development) the surface form produced by the cartilages of the seventh ribs will be obscured. This accounts for the fact that the angle formed by the converging margins of the chest-wall at the lower end of the breast-bone is not so evident as a mere inspection of the skeleton might lead us to suppose. On the other hand, the highest of these transverse furrows which cross the recti lies some distance below the pit of the stomach. Its outer extremity usually corresponds to the junction of the eighth rib cartilage with the seventh; and the two furrows, one on either side, form an arch across the middle line, the convexity of which is directed upwards. This arch cuts off the acute angle formed by the converging cartilages of the seventh ribs. Externally this furrow joins the lateral abdominal furrow, or the furrow between the rectus and the external oblique, which here corresponds to the lower costal margin, and it is the contour so produced which obscures the form of the lower costal border on the anterior aspect of the trunk. The extent to which this occurs will of course depend on the muscular development of the model (Pls., pp. 58, 148, 152).

The fold of the groin, as has been seen, corresponds to the position of Poupart's ligament. Owing to the fact that this band is very intimately connected with the fascia or

investing fibrous sheath of the thigh, it is found to undergo considerable modification according to the position of the limb. Thus, when the thigh is extended or straightened on the trunk, the fascia which invests it will necessarily be drawn down, and as one of the attachments of this fascia is Poupart's ligament the result is that the ligament

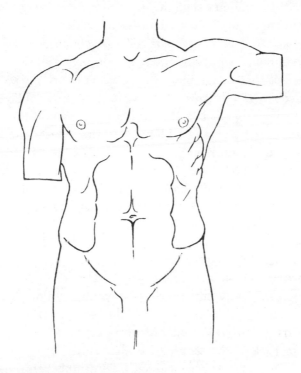

Fig. 44. Diagrammatic representation of the various furrows and depressions on the anterior surface of the trunk.

is rendered more tense at the same time that its downward curve is increased. If, however, the thigh be bent upon the trunk, the ligament is relaxed and tends to become straighter ; these facts react on the surface form (Pls., pp. 38, 382). When the limb is extended the fold of the groin will be seen to best advantage and will display a more or

less curved outline, a form which is always accentuated in
the antique (Pls., pp. 148 152, 158). The outer end of this
furrow corresponds to the position of the anterior superior
iliac spine, at which point it forms an open angle with
the transverse furrow of the flank; the inner extremities
of the folds of the groin are not unfrequently lost in the
fat in this region, though in many cases they become
blended with a shallow depression which curves down-
wards across the lower part of the abdominal wall and
the prominence which overlies the symphysis pubis. Owing
to the fact that in the male the pelvis is relatively narrower
and deeper, the furrow of the groin is more oblique and
more nearly approaches the vertical, whereas in the female
with the shallower and wider pelvis the furrow inclines to
be more horizontal in position (Pls., pp. 72, 148, 158, 216,
298, 434). Just above the furrow, in the female, there is
frequently a second shallow curved depression, as seen
in the Townley Venus, and in Fig. 45, and Pls., pp. 72,
298.

Distinct from the above, and due to the flexion of the
thigh at the hip-joint, there is a crease or superficial folding
of the skin which lies below the fold of the groin, and is
best seen in the plump thigh of a young child. This line
is most distinct internally, by the side of the genitals,
and curves upwards and outwards across the upper and
anterior part of the thigh to be lost in the general round-
ness of the limb or accentuated by a dimple overlying the
interval between the sartorius and tensor fasciae muscles
of the thigh immediately below the anterior superior iliac
spine (Pl., p. 298). In the adult it is best seen in the
female, in whom its inner extremity is not concealed, as
in the male. Brücke has pointed out that in the female
this line appears in two distinct forms. In the one, as
shown in Fig. 46, the hollow of the curve is directed
upwards, the outer extremity of the furrow is turned

towards the anterior superior iliac spine, and it usually blends with the fold of the groin about its middle. In the other type (Fig. 45) the line curves outwards across the thigh, the hollow of the curve being directed downwards. Externally the line is in some cases but faintly seen on the general rounded surface of the front of the thigh (Pls., pp. 72, 158) ; in other instances, as above mentioned, it is emphasized by a dimple (Pl., p. 298), but if the thigh be flexed the fold is rendered more distinct.

The abdomen in the male should be small ; that of the

FIG. 45. FIG. 46.

female, which is relatively larger, should be of rounded form and slightly more prominent, owing to the presence of a thicker fatty layer ; in the female also the surface contours dependent on muscles are obscured, and display a smoother and more rounded appearance. For the same reason the navel in women is usually more depressed, owing to the presence of the surrounding fat (Pls., pp. 72, 86, 158). One need not here dilate on the baneful influence of the pressure exerted by the use of corsets on the shape of the abdomen, it is sufficient merely to note the fact and put the student on his guard against the artificial forms

so produced. In some models, however, an indulgence in athletic exercises may lead to such a development of the abdominal muscles as may modify the form of the abdomen and so render it more conformable to the masculine type. The model figured in plates, pp. 54 and 438, displays this appearance, and it is interesting to note that, according to her own statement, she never wore corsets.

Turning next to that portion of the abdominal wall which lies between the lateral abdominal depression in front (i. e. the furrow corresponding to the interval between the rectus and external oblique) and the lateral dorsal depression behind, this is found to include the region known as the flank. Above, the thoracic margin limits this region; below, the crest of the ilium or haunch-bone serves to define it from the buttock. The lower half of the sheet of fibres of the external oblique, already described, constitutes the most superficial muscle in this region (Pls., pp. 50, 54, 86, 126, 152, 162, 308).

The surface of the flank is rounded from before backwards, and is marked off from the prominence of the buttock below by a furrow which is well defined in the muscular male, less so in the female (Pls., pp. 54, 86, 262, 270, 318, 438). The position of this furrow corresponds in front to the anterior superior iliac spine and also to an inch or two of the iliac crest; behind this point, however, as indicated by Richer, the attached fleshy fibres of the external oblique overlap the iliac crest so that the furrow, which depends largely on the development of these fibres, does not overlie the iliac crest, but is placed at a somewhat lower level. The furrow, which assumes towards its termination a somewhat upward curve, gradually fades away and is lost in the rounded form produced by the accumulation of a considerable amount of fat; this obscures the outline of the posterior border of the external oblique muscle. In the female, on account of the greater amount of fat in this region, all trace of the

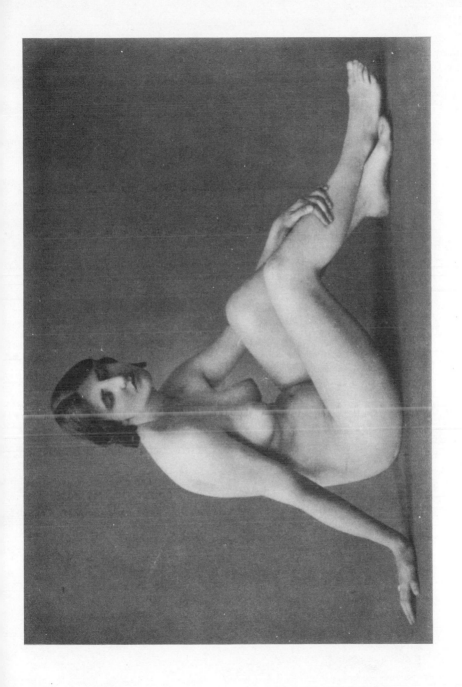

upper lateral depressions, which we saw overlay the point of
attachment of the fleshy fibres of the erector spinae to the
hinder end of the iliac crest in the male, disappears (p. 45)
(Pls., pp. 34, 52, 54). Owing to the obliteration of the
iliac furrow—as the groove we
are just describing is called—by
the presence of this pad of fat,
the rounded surface of the pos-
terior part of the flank is not so
clearly defined from the general
swelling of the buttock as in front,
but is insensibly blended with it
—a condition which maintains to
a greater extent in the female. As
will be seen in the accompanying
figure (Fig. 47), the iliac furrow
displays a double curve. Its an-
terior extremity corresponds to
the position of the anterior supe-
rior iliac spine, a point occasion-
ally more or less prominent, where
it forms an angle with the furrow
of the groin, as has been already
stated.

The upper limit of the flank
corresponds to the waist, the
narrowest transverse diameter of
the trunk. Above this level the
figure increases in breadth owing
to the enlargement of the thoracic

FIG. 47 (after Richer).
Shows the relation of the
iliac furrow to the iliac crest.

framework, and the muscles connected with the upper
limb. Below, the outline is carried down by a gentle
curve which increases the breadth of the trunk until the
iliac crest is reached; at this point, owing to the over-
lapping of the iliac crest by the fleshy fibres of the external

oblique, the curve is much accentuated as it dips down into the iliac furrow. In the female the outline is softer and more flowing, and the iliac furrow not so well marked. The waist, therefore, corresponds to a broad shallow furrow which lies between the wider parts of the trunk above and below; in front this shallow depression becomes blended with the lateral abdominal furrow or linea semilunaris, at

FIG. 48.

a point corresponding to the junction of the tenth rib cartilage with the ninth, at some distance above the level of the navel, and a trifle below the level of the middle transverse intersection of the rectus (Pls., pp. 62, 86). At this point, where there is a slight general hollowing of the surface, the thoracic margin formed by the cartilages of the false ribs can be distinctly felt, and corresponds to a

depression which is accentuated in certain positions (Pl., p. 38), and is well displayed in the figure of Theseus from the pediment of the Parthenon. As is seen in many of the antiques, this furrow of the waist is carried round the front of the figure in correspondence with the furrows produced by the middle tendinous intersections of the recti (Pls., pp. 58, 148, 158).

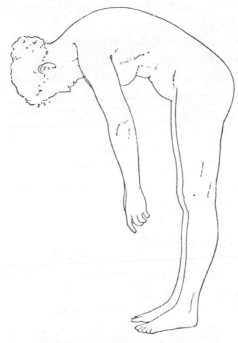

FIG. 49.

The abdominal muscles above described are of great use in supporting the contents of the abdominal cavity, and also assist in the movements of respiration. When any violent muscular effort is about to be made, these muscles are thrown into a state of contraction to brace up the abdominal walls, and so resist the strain to which they would otherwise be subjected. If the vertebral column be

not fixed, these muscles will assist in bending the trunk forwards if the muscles of both sides act at the same time. If only those of one side are brought into play they will effect a lateral movement of the trunk towards the side on which they are contracted. It may happen that the upper part of the trunk is fixed, as in climbing or hanging by the hands; in this case the muscles will assist in drawing upwards and forwards, or to one or other side, the pelvis and lower limbs.

These movements give rise to very considerable modifications in the surface forms. When the trunk is bent forward the tissues of the anterior abdominal wall become infolded (Figs. 48, 49; Pls., pp. 72, 382). The deepest of these transverse folds passes across the belly a little above or just on a level with the navel. Laterally this fold corresponds to the inferior thoracic margin, and the compression of the abdominal contents leads to a greater distension of the abdominal wall below this line of flexion than is the case in the erect position. Secondary folds may appear either above or below the one already mentioned, and in extreme flexion the furrow, usually very shallow, which connects the two furrows of the groin above the pubis, becomes emphasized and converted into a deep line. At the same time the furrow of the groin is deepened and the fore part of the iliac furrow rendered more distinct. The position of the afore-mentioned folds is often indicated on the surface of the abdomen, in the ordinary erect position, by delicate lines which merely affect the skin and do not in any way influence the surface contours. Consequent on the alteration in the form of the abdominal wall in the flexed position there is a disappearance of some of the most characteristic furrows, most notably the lateral abdominal furrows, which correspond to the outer borders of the recti; these disappear, and the rounded form of the flank becomes continuous with the general roundness of the front of the belly

which lies below the best marked line of flexion. The most noticeable effects of extension of the trunk on the surface forms of the abdominal wall are a distinct flattening and stretching of that region, and a marked projection of the

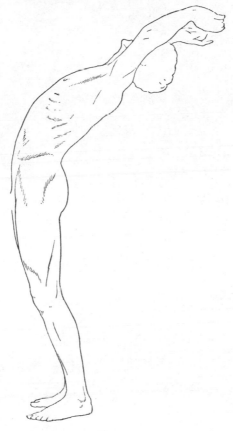

FIG. 50.

surface corresponding to the outline of the lower thoracic margin due to the forward thrust of that portion of the chest-wall (Fig. 50; Pls., pp. 152, 158, 434). The anterior superior iliac spines are rendered more prominent, and the anterior part of the iliac furrow is obliterated, whilst its posterior part

Sterno-mastoid.

Trapezius.
Pit of neck.

Breast bone.
Deltoid.

Pectoralis major.
Pit of stomach.
Biceps cubiti.
Brachialis anticus.
Rectus abdominis.

External oblique.

Brachialis anticus.

Bicipital fascia.
Int. cond of hum.
Supinator longus.

Flexor carpi rad.
Ext. carp. rad. long.
Exts. of thumb.
Extensor com.
digitorum.
Aponeurosis of.
ext. oblique.
Poupart s lig.
Sartorius.
Rectus femoris.
Vastus internus.
Band of Richer.
Rectus femoris.
Vastus internus.
Internal condyle of femur.

Patella.
Lig. patellae.
Tibia, subcut. surface.
Gastrocnemius.

Sterno-mastoid.
Trapezius.
Clavicle.

Acromion process.
Pectoralis major.
Deltoid.
Serratus mag.
Brachialis ant.
Biceps cubiti.

Latissimus dorsi.
Triceps.

Supinator long.
Olecranon.
Anconeus.
Ext. c. rad. long.
Ext. carpi uln.
Ext. c. rad. brev.
Gluteus medius.
Extensor commun.
digitorum.
Extensors of thumb
Gluteus maximus.
Trochanter major.

Rectus femoris.
Band of Richer.
Biceps cruris.
Vastus externus.
Rectus femoris.
Ilio-tibial band.
Patella.
Biceps cruris.
Head of fibula.
Tubercle of tibia.
Gastrocnemius.
Peroneus longus.
Tibialis anticus.
Soleus.
Tendo Achillis.
Peroneus brevis.
Long extensor of great toe.
Long extensor of toes.
External malleolus.

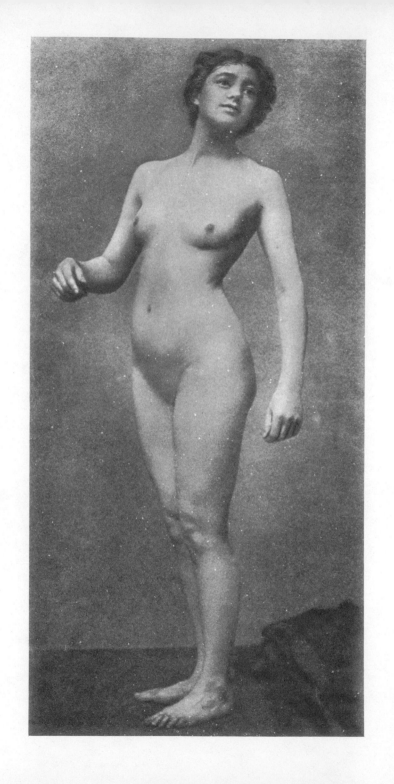

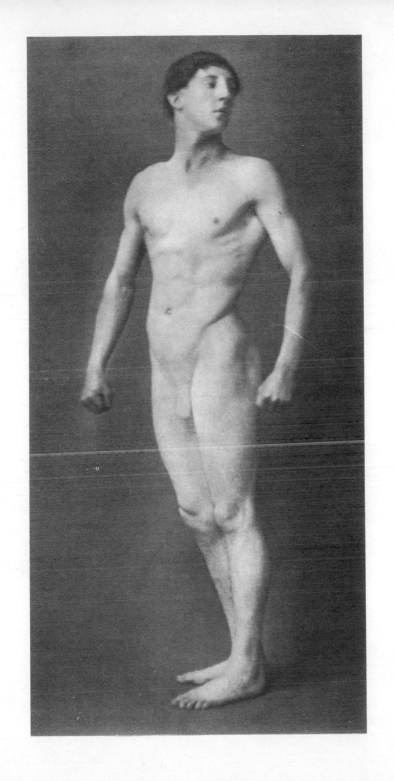

is somewhat deepened. Above, the flank is characterized
by the deepening behind of the furrow which corresponds
to the waist, and the flank itself is naturally more com-
pressed and rounded behind, where it lies between the
deepened furrows afore-mentioned, than in front, where it
is continuous with the stretched tissues of the anterior
abdominal wall. The lateral movements of the trunk
naturally affect differently the forms of the flanks from or
towards which the movement is made. The flank on the
side opposite that towards which the body is bent is
naturally stretched, and the furrows which define it above
and below are obliterated, their places being taken by
reliefs which correspond to the thoracic margin and the
crest of the haunch-bone respectively. On the side to-
wards which the movement takes place these furrows are
deepened, and, owing to the compression of the tissues of
the side of the body, the flank forms a prominent pad or
elevation, the surface of which is traversed by numerous
skin folds which are usually more distinct behind than in
front (Pls., pp. 34, 44, 52, 72).

The surface forms of the abdomen and flank are likewise
affected by the movements of rotation, of which mention
has been already made (p. 53) in connexion with the move-
ments of the vertebral column. Their principal influence
is to cause an obliquity of the longitudinal furrows, and to
intensify the transverse furrows, namely those of the waist
and crest of the haunch-bone, on the side toward which the
body is twisted, whilst leading to their effacement on the
side from which the body is turned (Pls., pp. 54, 86).

For the convenience of the reader, representations of
the male and female figures in these lateral and rotatory
movements have been placed side by side, in order not only
to afford a comparison of the surface contours produced,
but also to emphasize the characteristics of the two sexes.
Whereas, owing to the difference in the pelvic form, the

distance between the iliac crest and costal margin is greater in the female, with a consequent increase in the length of the flank, it will be noted that the position of the waist, owing to the greater pelvic width, is more pronounced and placed higher in the female than in the male. Or, put in another way, the plates show how the longer flank in the female is disposed with a greater outward slope than is the case in the male.

Combinations of these movements will necessarily be associated with modifications in the surface forms, but, bearing in mind the main points as they have been described in the simplest forms of movement, the student will be enabled to analyse more correctly the complex contours associated with combinations of these movements.

CHAPTER V

WE have next to study the manner in which the upper
limb is connected with the trunk. This is effected in the
skeleton by means of the shoulder-girdle, which is made
up of two bones on either side, the collar-bone or clavicle,
and the shoulder-blade or scapula. The striking difference
between the arrangement of the bones of the shoulder and
pelvic girdles has been already referred to in Chapter I, so
that it is not necessary again to emphasize the character-
istics peculiar to these portions of the skeleton. It will be
sufficient to keep clearly in view the fact that the shoulder-
girdle is particularly modified, in order to permit great
freedom of movement between the upper limb and trunk.

The *collar-bone* (Figs. 53, 54) may be compared to a rod
bent into the form of the italic letter *f*. It possesses two
extremities, the inner of which is enlarged and articulates
with the upper end of the breast-bone, just above the
junction of the first rib cartilage, to which the collar-bone is
also firmly attached by ligament. The outer extremity is
flattened from above downwards, and slightly expanded ; it
is called the *acromial end* of the bone, because it articulates
with the acromion process of the shoulder-blade. This end
of the bone corresponds to the summit of the shoulder, and
in the male lies at a slightly higher level than the inner
or *sternal end*. The curves of the bone are so arranged
that the part of the shaft near the breast-bone is bulged
forward, whilst the outer half of the bone describes a curve,

the convexity of which is directed backwards. These curves impart a certain amount of spring to the bone, so that the shock of blows falling on the shoulder is reduced by the

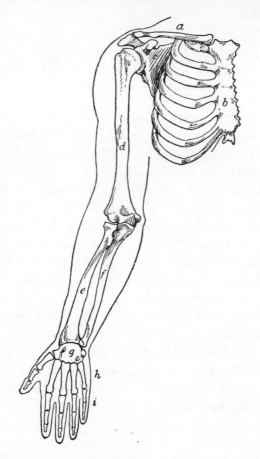

FIG. 51 A. Bones of the right upper limb, front view.

a. Collar-bone (clavicle).	*d.* Humerus.	*g.* Wrist-bones (carpus).
b. Breast-bone (sternum).	*e.* Radius.	*h.* Palm-bones (metacarpus).
c. Shoulder-blade (scapula).	*f.* Ulna.	*i.* Finger-bones (phalanges).

slight yielding of the curves, a condition which would not hold good had the bone been straight.

The curves of the collar bone vary considerably in

different individuals. The variations are due in great part to the exercise or use to which the limb has been put. In persons who have to live by hard manual labour the

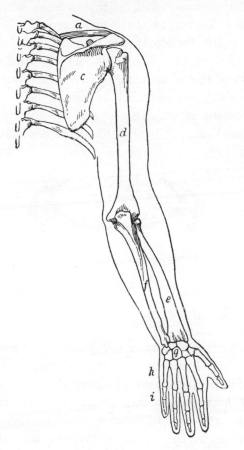

FIG. 51 B. Bones of the right upper limb, back view.

a. Collar-bone (clavicle).	*e.* Radius.	*h.* Palm-bones (metacarpus).
c. Shoulder-blade (scapula).	*f.* Ulna.	*i.* Finger-bones (phalanges).
d. Humerus.	*g.* Wrist-bones (carpus).	

curves are more pronounced than in those whose occupation is sedentary, a difference which is to a greater or less extent also characteristic of the sexes. The curvatures of the bone

may therefore be regarded as affording some indication of the muscular development of the person to whom the bone belonged. As men are usually more muscular than women, the inference will be that a bone which displays well-marked curves is that of a male. Differences in length may also be noted as having an important relation to the width of the shoulders. As the inner enlarged extremities of the collar-bones rest upon the upper extremity of the breast-bone, they are separated by a notch, the lower boundary of which is formed by the upper margin of the breast-bone. Passing across from one clavicle to the

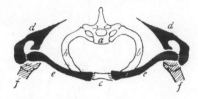

FIG. 52. Diagrammatic representation of the
shoulder-girdle.

a. First dorsal vertebra.	*d.* Shoulder-blade (scapula).
b. First rib.	*e.* Collar-bone (clavicle).
c. Breast-bone (sternum).	*f.* Humerus (bone of upper arm).

other, there is a strong band called the *interclavicular ligament*; this ligament smooths off the angles of the notch, which is thus converted into a rounded, well-marked depression between the extremities of the collar-bones on either side and the breast-bone below (Fig. 55). It is this which causes the surface depression known as the pit of the neck, the distinctness of which is further increased by the attachment of one of the neck muscles, to which reference will be made in a future chapter.

From what has been stated regarding the collar-bone and its articulations it will be easy to understand how it acts as a prop or fulcrum on which the shoulder-blade moves. This action of the bone may be readily demon-

strated if we compare its position when the limb is thrown forward and when it is drawn back. In the former case the collar-bone is pulled forward from the chest-wall, whilst in the latter action the bone is brought into closer relation with it. Fig. 56 represents, in a diagrammatic way, these actions.

The *shoulder-blade or scapula* (Figs. 57, 58, 59) is a thin plate-like bone of triangular form, with certain outstanding processes. It is placed on the upper and posterior aspect of the chest-wall, overlying the second to the seventh ribs inclusive. In the upright position with the arms by the side, the interval between the two blade-bones usually corresponds to the width of the neck. As a triangle, the bone possesses

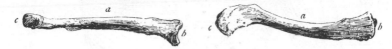

Right collar-bone (clavicle).

FIG 53. As seen from the front. FIG. 54. As seen from above.

a. Shaft. c. Acromial end, with articular surface
b. Sternal end. for acromion process of scapula.

three sides and three angles. The borders are described as inner, outer, and superior. It may be well here to add some explanation of the use of these terms in anatomy. The body being symmetrical on the two sides, we can divide it by an imaginary plane, which we term the mesial plane. As this plane bisects the trunk in front and behind, it corresponds to the middle lines of these regions. In comparing the position of one structure with another in relation to this mesial plane we describe as internal that which lies closer to it, whilst that which is placed wider from it is accounted external; thus the ear is external in position to the eye.

When therefore we examine the shoulder-blade in position on the back of the chest-wall, that border which

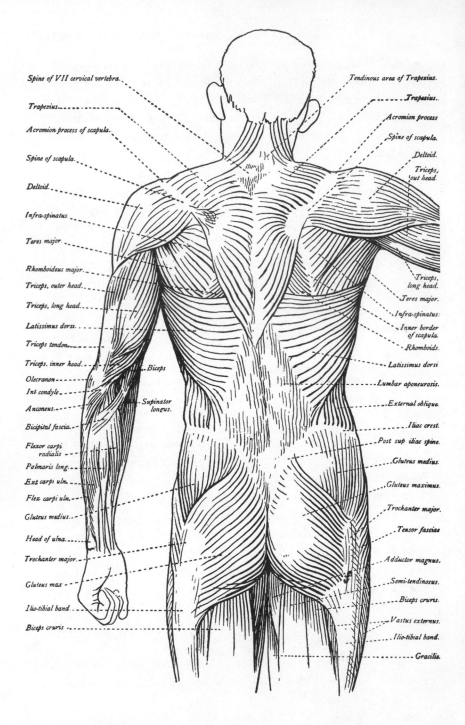

Spine of VII cervical vertebra.

Trapezius.

Acromion process of scapula.

Spine of scapula.

Deltoid.

Infra-spinatus.

Teres major.

Rhomboideus major.

Triceps, outer head.

Triceps, long head.

Latissimus dorsi.

Triceps tendon.

Triceps, inner head.

Olecranon.

Int condyle.

Anconeus.

Bicipital fascia.

Flexor carpi radialis.

Palmaris long.

Ext carpi uln.

Flex carpi uln.

Gluteus medius.

Head of ulna.

Trochanter major.

Gluteus max.

Ilio-tibial band.

Biceps cruris.

Biceps.

Supinator longus.

Tendinous area of Trapezius.

Trapezius.

Acromion process.

Spine of scapula.

Deltoid.

Triceps, out head.

Triceps, long head.

Teres major.

Infra-spinatus.

Inner border of scapula.

Rhomboids.

Latissimus dorsi.

Lumbar aponeurosis.

External oblique.

Iliac crest.

Post sup iliac spine.

Gluteus medius.

Gluteus maximus.

Trochanter major.

Tensor fasciae.

Adductor magnus.

Semi-tendinosus.

Biceps cruris.

Vastus externus.

Ilio-tibial band.

Gracilis.

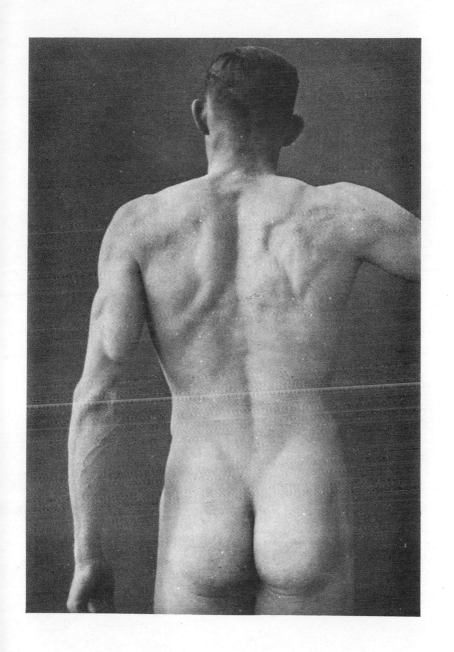

lies nearest the middle line is called the internal, that margin which lies in relation to the back of the armpit is called the external, and the third side of the triangle, which is placed above, is called the upper or superior border. In like manner the angles of the bone are described as external and internal; the latter, two in number, are placed at the upper and lower ends of the internal border of the bone, and are distinguished the one from the other as the superior internal and inferior internal angles of the bone; more frequently, however, these are spoken of as the superior and inferior angles. Of the borders the

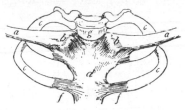

FIG. 55. Showing articulation of the collar-bones (clavicles) with the breast-bone (sternum).

a Collar-bones (clavicles).
b. Sternal ends of collar-bones.
c Placed on the first and second ribs.
d. The upper piece of the breast-bone (manubrium sterni).
f. Rib cartilages.

g. Placed over the body of the first dorsal vertebra, lies in the interval between the sternal ends of the collar-bones, a space which corresponds to the surface depression at the root of the neck, called the pit of the neck.

most important, from our standpoint, are the internal and external. The latter can readily be felt, covered though it is by muscle, by firmly grasping the tissues which lie behind the armpit. The inner border, overlaid by much thinner muscles, is readily seen, particularly if we move the arm about so as to rotate the shoulder-blade. Of the angles, the superior and inferior are easily distinguishable, particularly the latter, which can be observed to advance across the chest-wall when we raise the arm over the head. The external angle, which furnishes the shallow socket for the lodgement of the head of the humerus, is obscured by the structures

around the shoulder-joint. It will be described at greater length when the anatomy of that joint is considered.

Arising from the posterior surface of the shoulder-blade is the process called the *spine*. This is somewhat triangular in form. It is attached by one of its borders to the blade-bone, the posterior surface of which it thus divides into two unequal fossae, called respectively the *supra-* and *infra-spinous fossae*, according as they lie above or below the spine which separates them. The remaining two sides of the spine form free borders, that is to say, they are not attached by osseous union to any other parts of the bone; one, the longest or posterior

FIG. 56. On the left side of the figure the girdle is shown pulled back, on the right side drawn forward.

a. Collar-bone (clavicle). c. Breast-bone. e. First rib.
b. Shoulder-blade (scapula). d. First dorsal vertebra.

border, is superficial throughout its entire extent, and forms an important factor in the modelling of the surface contours over it. The external border is short and curved, connecting the external extremities of the attached and the posterior borders. The plane of this triangular spinous process is oblique to the plane of the blade-bone in an upward direction, a fact which is best displayed on making a section of the bone. Its upper surface forms part of the floor of the supra-spinous fossa, its under surface part of the infra-spinous fossa.

The inner angle of this spine, formed by the convergence of the posterior and attached borders, corresponds to the point of junction of the upper with the middle third of the

internal border of the blade-bone. There are two external angles, one anterior, which corresponds to the outer end of the attached border, the other posterior, which is formed by the fusion of the external with the posterior border. At this point the spine becomes continuous with a process called the *acromion process*, which is carried upwards and outwards for some distance, in line with the posterior border of the

The right shoulder-blade (scapula).

FIG. 57. Back view, FIG. 58 External view. FIG. 59. Front view.

a. Glenoid fossa, for head of humerus.	*g.* Inferior angle.
b. Spine.	*h.* External or axillary border.
c. Acromion process.	*i.* Internal or vertebral border.
d. Facet for outer end of collar-bone.	*k.* Superior border.
e. Coracoid process.	*l.* Supra-spinous fossa.
f. Superior angle.	*m.* Infra-spinous fossa.

n. Ventral or anterior surface.

spine. It then turns somewhat suddenly forwards, and becomes compressed and flattened, so that its surfaces are directed upwards and downwards. It arches over the shoulder-joint, and is furnished on its inner border near its extremity with a small facet, by means of which it articulates with the outer end of the collar-bone. This process is of great importance in relation to the surface contours, as it forms the summit of the shoulder, and is superficial

98

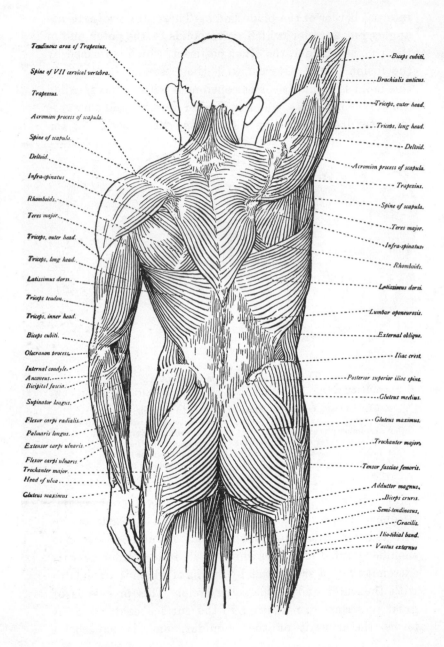

Tendinous area of Trapezius.

Spine of VII cervical vertebra.

Trapezius.

Acromion process of scapula.

Spine of scapula.

Deltoid.

Infra-spinatus.

Rhomboids.

Teres major.

Triceps, outer head.

Triceps, long head.

Latissimus dorsi.

Triceps tendon.

Triceps, inner head.

Biceps cubiti.

Olecranon process.

Internal condyle.
Anconeus.
Bicipital fascia.

Supinator longus.

Flexor carpi radialis.

Palmaris longus.

Extensor carpi ulnaris.

Flexor carpi ulnaris.
Trochanter major.
Head of ulna.

Gluteus maximus.

Biceps cubiti.

Brachialis anticus.

Triceps, outer head.

Triceps, long head.

Deltoid.

Acromion process of scapula.

Trapezius.

Spine of scapula.

Teres major.

Infra-spinatus.

Rhomboids.

Latissimus dorsi.

Lumbar aponeurosis.

External oblique.

Iliac crest.

Posterior superior iliac spine.

Gluteus medius.

Gluteus maximus.

Trochanter major.

Tensor fasciae femoris.

Adductor magnus.

Biceps cruris.

Semi-tendinosus.

Gracilis.

Ilio-tibial band.

Vastus externus.

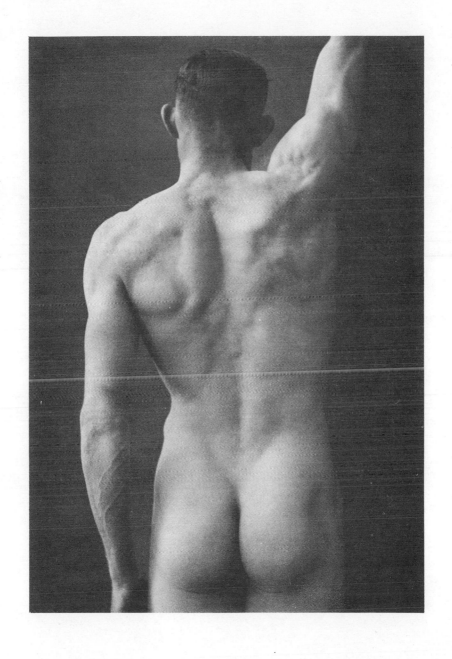

throughout. These details, though somewhat tedious, are necessary, as without a knowledge of the shape of this bone it will be difficult to understand its relation to the surrounding muscles and to the surface.

Another process of hook-like form, called the *coracoid process*, springs from the upper border of the blade-bone, close to the external angle. This is important only as affording attachment to muscles and ligaments, and is not a determinant of surface form.

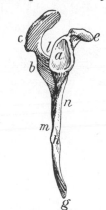

The surface of the blade-bone, opposite that to which the spine is attached, is hollowed out so as to form a shallow fossa in which fleshy muscles are lodged. This surface is directed towards the chest-wall, and lies in relation to the outer surfaces of the ribs, being separated from them by sheets of intervening muscles. As has been said, the collar bone articulates with the acromion process of the shoulder-blade. The joint itself is small and weak, but is very much strengthened by powerful ligaments which pass between the collar-bone and the coracoid process.

FIG. 60. The outer side of the shoulder-blade (scapula).

a. Glenoid fossa, for head of humerus.
b. Spine.
c. Acromion process.
e. Coracoid process.
g. Inferior angle.
h. External or axillary border.
l. Supra-spinous fossa.
m. Infra-spinous fossa.
n. Ventral or anterior surface.

By the articulation of these bones an angle is formed, which is occupied in great part by the rounded form of the upper part of the chest-wall. The interval between the girdle and the thoracic wall is occupied by the vessels, nerves, and muscles of the upper limb. By means of the above joint, the angle between the collar-bone and the plane of the blade-bone can be modified so as to adapt

it to the form of the chest-wall. When the shoulders
are drawn back the angle is opened out ; when the arms are
thrown forward the angle is diminished (Fig. 61). A slight
amount of rotation of the blade-bone on the extremity of the
collar-bone may also take place at this articulation. The
continuity of the clavicle with the acromion can easily be
demonstrated on the living; if the finger be placed on the
inner end of the collar-bone, then the outline of the bone
can readily be traced towards the shoulder to the point
of its articulation with the acromion; this is usually
recognized as a slight elevation. Passing round the summit
of the shoulder, the upper surface of the acromion can be

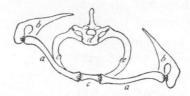

FIG. 61. On the left side of the figure the girdle is shown pulled
back, on the right side drawn forward.

a. Collar-bone (clavicle).	*c.* Breast-bone	*e.* First rib.
b. Shoulder-blade (scapula).	*d.* First dorsal vertebra.	

distinctly felt, and, if it be followed backward, the finger
will pass along the posterior border of the spine, until the
point is reached where that process blends with the in-
ternal margin of the blade-bone, a point which is still
further emphasized in the living, owing to the arrangement
of the muscles around it.

The only articulation which the blade-bone has with the
trunk is indirectly through the collar-bone, by means of
the union of the latter with the breast-bone. It is at
this joint, therefore, that many of the movements take
place which influence the position of the shoulder-blade.

The movements possible at this joint (sterno-clavicular
as it is called) when reduced to their simplest form are

those in an upward, downward, forward, and backward direction, together with a slight degree of rotation of the collar-bone on its own axis. These of course may be variously combined. As has been seen, certain movements take place at the acromio-clavicular joint, so that the movements of the blade-bone are further complicated by the addition of those which are effected at the sterno-clavicular articulation.

But, whilst the shoulder-blade is only thus slightly connected with the osseous framework of the chest, it is very efficiently supported and held in position by the many muscles with which it is connected, and these react on the surface form according as they are strongly developed or not.

In man we usually find the outer end of the collar-bone lying at a somewhat higher level than the inner end. In woman the outer end of the bone lies either about the same level as the inner end, or somewhat lower. In other words, in the male the collar-bones tend to slope outwards and upwards; in the female, outwards and downwards. This is owing to the different form of the thorax in the two sexes. The smaller and narrower chest of the female affords the girdle less support than in man, in whom the larger thorax furnishes a wider surface on which the girdle may rest. But, independently of the form of the framework of the chest, there are other factors which must be taken into account; these are the muscles. It often happens that a person with sloping shoulders is recommended to indulge in some form of gymnastic exercise to expand his chest. After the age of twenty-five, when all the bones are fully ossified and the figure set, any form of exercise will have but little influence on the form of the thorax, except that it stimulates a more healthy respiration. Yet we cannot but admit the effect which the exercise has had on the man, for he appears now with braced-up figure and square

shoulders. The increase in breadth of the chest is not due to any marked increase in the capacity or form of the chest-wall, but is due almost entirely to the increase in size of the muscles, brought about by exercise. As has been shown, some of these muscles lie between the blade-bone and the chest-wall, and one can readily understand how any increase in the thickness of these layers will tend to push upwards and outwards the blade-bone from the chest-wall, and so impart to the shoulders that squareness which is so desirable in the male figure.

In regard to the relative proportions of these bones to others, we find that the collar-bone is usually about the same length as the osseous part of the breast-bone, or about half the length of the bone of the upper arm. The length of the internal border of the shoulder-blade very nearly approximates to that of the collar-bone. These measurements are very liable to vary, and must not be taken as affecting any scientific accuracy; they are merely put forward as aids to assist the draughtsman in apportioning approximately the lengths to these different bones.

Before passing to the consideration of the muscles which move the upper limb on the trunk, it will be necessary to enter into a short explanation of the mode in which muscles act. Taking the simple case where two long bones are united by a joint which permits of a hinge-like movement, it will be apparent that any muscle attached to the upper bone and passing down over the joint, either in front of, or behind it, to be inserted into the lower bone, will, when it contracts, effect a movement of the lower bone on the upper. If the muscle passes in front of the joint, the limb will be bent or flexed; if it passes behind the joint, the limb will be straightened or extended. Such muscles are called *direct* flexors or extensors.

But it not unfrequently happens that a muscle which takes origin from the upper bone is not inserted into the

bone immediately below, but passes over that bone to be inserted into one beyond. In this case the muscle passes over more than one articulation. All the intervening joints may be influenced by the contraction of such a muscle, but as the action of this muscle is not brought to bear directly on the intermediate bone it has been described as possessing an *indirect* action.

To take the case with which we are immediately concerned. A number of muscles pass from the trunk to the bones of the shoulder-girdle. These have a direct influence on the movements of the bones of the girdle, but there are others which, arising from the trunk, are *not* attached to the bones of the girdle, but pass to be inserted into the bone of the upper arm, which is connected with the shoulder-girdle by the shoulder-joint. These muscles act primarily upon the bone of the upper arm, moving it at the shoulder-joint, but they also secondarily affect the movements of the girdle through its connexion with the bone of the upper arm. This is the indirect action of these muscles, and they are therefore described as acting indirectly on the movements of the girdle in contradistinction to those which act directly upon it.

Arranging the muscles according to their action, it will be most convenient to take up the consideration of that group which acts directly on the girdle, namely, those which arise from the trunk and are inserted into the bones of the girdle. It will not be necessary to describe them all, for some have no influence on the surface form, and may for present purposes be disregarded.

The muscles with which we are particularly concerned are the *trapezius*, the *rhomboids*, the *levator anguli scapulae*, the *serratus magnus*, and the *pectoralis minor*. Be it understood that these muscles are symmetrical on the two sides of the body. There is a pair of each, one of each pair being assigned to opposite sides of the trunk.

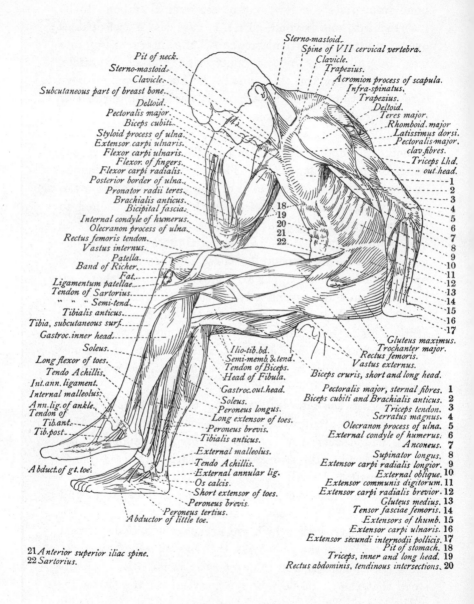

Pit of neck.
Sterno-mastoid.
Clavicle.
Subcutaneous part of breast bone.
Deltoid.
Pectoralis major.
Biceps cubiti.
Styloid process of ulna.
Extensor carpi ulnaris.
Flexor carpi ulnaris.
Flexor. of fingers.
Flexor carpi radialis.
Posterior border of ulna.
Pronator radii teres.
Brachialis anticus.
Bicipital fascia.
Internal condyle of humerus.
Olecranon process of ulna.
Rectus femoris tendon.
Vastus internus.
Patella.
Band of Richer.
Fat.
Ligamentum patellae.
Tendon of Sartorius.
" " " Semi-tend.
Tibialis anticus.
Tibia, subcutaneous surf.
Gastroc.inner head.
Soleus.
Long flexor of toes.
Tendo Achillis.
Int.ann. ligament.
Internal malleolus.
Ann.lig. of ankle.
Tendon of
Tib.ant.
Tib.post.

Abduct.of gt.toe.

Sterno-mastoid.
Spine of VII cervical vertebra.
Clavicle.
Trapezius.
Acromion process of scapula.
Infra-spinatus.
Trapezius.
Deltoid.
Teres major.
Rhomboid. major.
Latissimus dorsi.
Pectoralis major.
clav.fibres.
Triceps Lhd.
out. head.
1
2
3
4
5
6
7
8
9
10
11
12
13
14
15
16
17

18
19
20
21
22

Gluteus maximus.
Trochanter major.
Rectus femoris.
Vastus externus.
Biceps cruris, short and long head.

Ilio-tib.bd.
Semi-memb.& tend.
Tendon of Biceps.
Head of Fibula.
Gastroc.out.head.
Soleus.
Peroneus longus.
Long extensor of toes.
Peroneus brevis.
Tibialis anticus.
External malleolus.
Tendo Achillis.
External annular lig.
Os calcis.
Short extensor of toes.
Peroneus brevis.
Peroneus tertius.
Abductor of little toe.

Pectoralis major, sternal fibres. 1
Biceps cubiti and Brachialis anticus. 2
Triceps tendon. 3
Serratus magnus. 4
Olecranon process of ulna. 5
External condyle of humerus. 6
Anconeus. 7
Supinator longus. 8
Extensor carpi radialis longior. 9
External oblique. 10
Extensor communis digitorum. 11
Extensor carpi radialis brevior. 12
Gluteus medius. 13
Tensor fasciae femoris. 14
Extensors of thumb. 15
Extensor carpi ulnaris. 16
Extensor secundi internodii pollicis. 17
Pit of stomach. 18
Triceps, inner and long head. 19
Rectus abdominis, tendinous intersections. 20

21 Anterior superior iliac spine.
22 Sartorius.

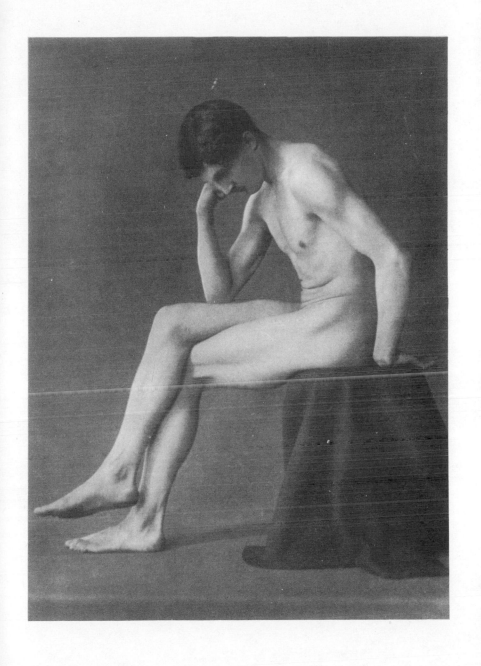

Unfortunately there is no English equivalent for these technical names, so that the student has no other alternative than to acquire a familiarity with these anatomical terms.

The *trapezius* (Fig. 62), so called from the four-sided figure which the muscles of opposite sides form, has been compared, when we consider the muscles of both sides together, to a tippet hanging over the shoulders, the tip of which reaches to about the level of the spine of the last thoracic vertebra. In order to render this description intelligible, it is necessary to supplement it by supposing that the muscles extend upwards along the back and sides of the neck to the skull, somewhat in the fashion of a high collar, the peak of which reaches the back of the head.

The two muscles take origin from the middle line, extending above as high as the back of the skull or occiput, on either side of which they are attached for a variable distance to a rough ridge which is called the superior curved line of the occipital bone ; and reaching as low down as the level of the spine of the last thoracic vertebra. In the neck the muscles arise from a medium ligament, which extends from the occiput superiorly to the spine of the seventh neck vertebra, or the vertebra prominens, inferiorly. Below this level the muscles are attached to the tip of the spine of the seventh neck vertebra, to the spines of all the thoracic vertebrae, and to the ligaments which connect these spines together.

From this wide attachment the fibres converge to be inserted into the outer third or fourth of the posterior border of the collar-bone in front, and along the entire upper border of the acromion process and spine of the shoulder-blade at the side and behind. This insertion involves a considerable alteration in the direction of the fibres of the different parts of the muscle ; thus the fibres which arise from the occiput and neck pass downwards, outwards, and forwards to the collar-bone and acromion,

whilst those which spring from the lower thoracic spines
ascend upwards and outwards to the root of the spine
of the shoulder-blade. The fibres which arise from the
intermediate attachments of the muscle pass outwards
with varying degrees of obliquity, whilst those which spring
from the upper two dorsal spines are nearly horizontal in
direction when the limb is at rest by the side of the
trunk (Pls., pp. 34, 110, 138).

The muscle is attached to these points and surfaces by
means of tendinous fibres, which are usually short; but in
some situations they are longer, and give rise to alterations
in the surface forms dependent on this muscle, for where
the tendinous fibres are long they are represented on the
surface by flattened depressions in contrast with the pro-
minences produced by the contraction of the fleshy fibres.

The tendinous fibres are long at the origin of the muscle
in the lower region of the neck and upper part of the
thorax; they reach their maximum length about the level
of the spine of the vertebra prominens (seventh neck
vertebra); a lozenge-shaped figure is thus formed by the
muscles of opposite sides, the inferior angle of which
reaches as low as the third thoracic spine, whilst above
it gradually tapers towards the occiput. On a level with
the external angles of this area is the projection formed
by the spine of the seventh cervical vertebra in the middle
line. During the powerful contraction of the muscles this
area corresponds to a surface depression, in the centre of
which the projection caused by the spine of the seventh
cervical vertebra is readily recognized (Pls., pp. 94, 98,
110, 138).

At the lowest point of origin of the muscle from the last
two or three dorsal spines the tendinous fibres form a small
triangular aponeurosis. This, combined with that of the
opposite side, forms a diamond-shaped surface which, when
the muscles are powerfully contracted, corresponds to a

depression on the surface of the back of somewhat similar shape, though less apparent than the above (Pls., pp. 50, 182). A third tendinous area is noticeable over the point where the spine of the shoulder-blade becomes blended with the internal border of that bone. As the parts of the muscle around this are thrown into relief during contraction, there is a surface depression in correspondence with it, but the position of the depression varies with the movements of the blade-bones (Pls., pp. 34, 44, 54, 94, 98, 110, 126, 138, 182).

The entire muscle is superficial; that is to say, it is merely covered by the skin and the superficial fatty layer which lies beneath the skin. According to the thickness of this fatty layer the sharpness of the surface forms dependent on the muscle will vary, being obscured in those in whom there is much fat. The surface forms also depend on the development of the muscles themselves.

These muscles overlie deeper layers of muscles, and so they themselves are influenced by the form of the structures on which they rest. On either side of the middle line the rounded form of the back is not due to the trapezii, which here constitute a comparatively thin layer, but depends on the fullness of the erectores spinae group upon which they lie (Pls., pp. 34, 38, 50, 94, 98).

Beneath the trapezius there are three muscles attached to the internal border of the blade-bone. These are the two *rhomboids* and the *elevator of the angle of the scapula.* For our purpose we may consider the two *rhomboids* as forming one muscular sheet. This is attached along the middle line, extending as high as the lower half of the median ligament of the neck, and passing downwards to be connected with the spine of the seventh neck vertebra and the spines of the first five thoracic vertebrae. The muscle lies higher at its origin than at its insertion, so that its fibres are directed downwards and outwards towards

their insertion into the inner border of the shoulder-blade, where their attachment extends from the root of the spine down to the inferior angle (Fig. 62).

These muscles, although covered by the trapezius, with the exception of a small portion below close to the inferior

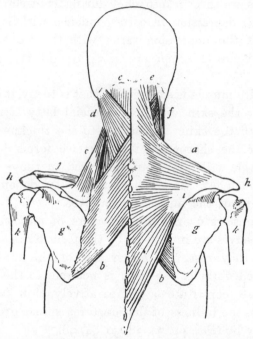

FIG. 62. View of the muscles attached to the shoulder-blade. The trapezius has been cut away on the left side of the figure.

a. Trapezius muscle.

b. Rhomboid.

c. Elevator of the angle of the scapula (levator anguli scapulae).

d. Splenius muscle.

e. Complexus muscle.

f. Sterno-mastoid muscle.

g. Infra-spinous fossa on back of scapula.

h. Acromion process of scapula.

i. Spine of scapula.

j. Collar-bone (clavicle).

k. Humerus.

angle of the blade-bone, exercise a considerable influence on the surface contours, as, in repose, as well as during contraction, they form a somewhat broad and oblique elevation which accentuates the relief of the trapezius muscles which overlie them (Pls., pp. 34, 44, 94, 98, 110). The *elevator of the*

upper angle of the scapula (levator anguli scapulae) arises from the transverse processes of the higher neck vertebrae and is inserted into the inner border of the blade-bone above the level of the spine. It is merely mentioned here as it assists in giving the rounded form to the neck and this part of the back. The greater part of the muscle is covered by the trapezius.

The action of these several muscles may now be described. As will be seen from a study of the direction of its fibres, the upper and lower portions of the *trapezius* may antagonize one another. The upper or neck part of the muscle may act in one of two ways, according to which of its extremities is fixed. If the shoulder-girdle be rendered immovable, and both muscles act at the same time, the head will be extended, that is, thrown back (Pl., p. 44). If one muscle alone be brought into play the head will be drawn to the same side, and rotated slightly away from the side on which the muscle is contracting. If, on the other hand, the head and neck be fixed, the upper fibres of the muscle will raise the shoulder-girdle, while the intermediate fibres will also assist in elevating the point of the shoulder (Pls., pp. 94, 98, 158, 162). If the lower fibres be alone called into action they will depress the shoulder-blade, and thus draw down the shoulder. The intermediate fibres also act in drawing the blade-bones closer to the middle line, as in the act of pulling back the shoulders (Pls., pp. 110, 138), and the entire muscle, acting at one and the same time, fixes the shoulder-blade, and thus furnishes a firm base of support from which the limb may act (see also Pls., pp. 38, 44, 50, 52, 54, 94, 98, 110, 126, 158, 162, 382).

It is needless to say that these movements are the result of a combination of the action of many other muscles, but for present purposes it is best to simplify the description as much as possible. The rotatory movements of the scapula will be described later.

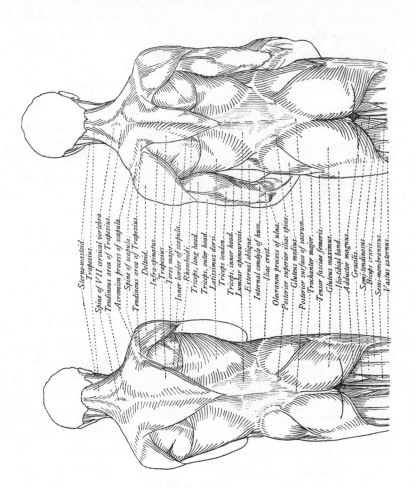

Sterno-mastoid.
Trapezius.
Spine of VII cervical vertebra.
Tendinous area of Trapezius.
Acromion process of scapula.
Spine of scapula.
Tendinous area of Trapezius.
Deltoid.
Infra-spinatus.
Trapezius.
Teres major.
Inner border of scapula.
Rhomboid.
Triceps, long head.
Triceps, outer head.
Latissimus dorsi.
External oblique.
Triceps, inner head.
Lumbar aponeurosis.
Internal condyle of hum.
Iliac crest.
Olecranon process of ulna.
Posterior superior iliac spine.
Gluteus medius.
Posterior surface of sacrum.
Trochanter major.
Tensor fasciae femoris.
Gluteus maximus.
Ilio-tibial band.
Adductor magnus.
Gracilis.
Semi-tendinosus.
Biceps cruris.
Semi-membranosus.
Vastus externus.

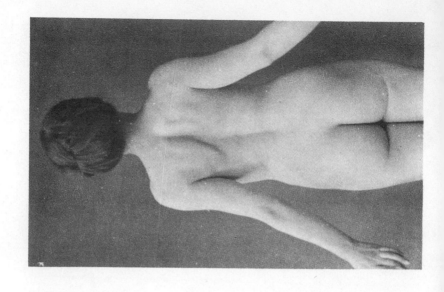

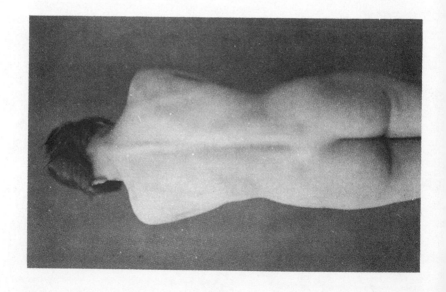

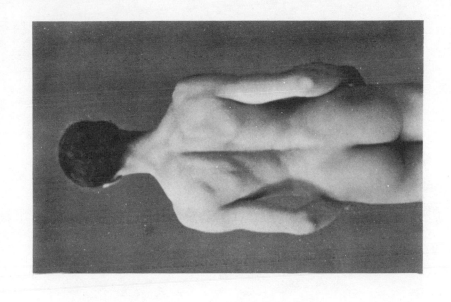

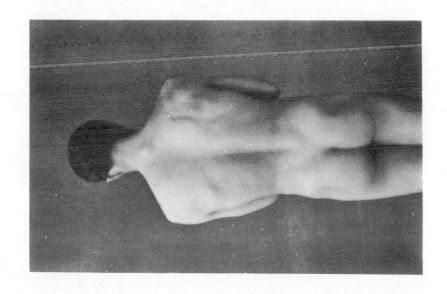

The *rhomboids* elevate the blade-bone and draw it nearer the middle line. The *levator anguli scapulae*, as its name implies, raises the upper angle of the bone.

The *serratus magnus* muscle is a broad, somewhat fan-shaped sheet of muscular fibre, and has an extensive origin from the side of the chest-wall. Passing backwards it is closely applied to the chest-wall, and lies between it and the deep surface of the blade-bone, to the inner border of which it is attached. The position of this muscle is difficult to understand : a diagram may help to explain it. Fig. 63 represents a section across the chest-cavity; the shoulder-blades are seen on either side and behind,

FIG. 63. Diagrammatic section across the chest to show the relations of the great serratus muscle.

a. Head of humerus.
b. A dorsal vertebra.
c. Ribs in section.
d. Breast-bone.
e. Shoulder-blade.
f. Serratus magnus muscle.

and the muscle is represented in section, arising from the side of the chest-wall, rather towards the front, and passing back between the chest-wall and shoulder-blade to be attached to the inner border of that bone. Only a small portion of the muscle is superficial, as it is in great part covered by other muscles and by the blade-bone; but the part which is superficial has a most important influence on the surface forms, and corresponds to that row of finger-like elevations on the side of the chest-wall with which the student is familiar in the model when the arm is raised (Pls., pp. 38, 62, 72, 86, 122, 126, 148, 152, 158); they are well shown on the figure of the Gladiator. These elevations

correspond to the points of origin of the muscle, and it will
be necessary to describe them (see Figs. 64, 65). The muscle
arises by eight or nine fleshy slips from the outer surface of
the eight upper ribs. The upper fibres may be disregarded.
The fibres from the lowest five or six slips of origin converge
in a fan-like shape to be inserted in the lower angle of
the inner border of the blade-bone, forming a well-marked
fleshy prominence which, though it is not superficial, yet

FIG. 64. View to show the
serratus magnus muscle with the
shoulder-blade in its natural
position.

FIG. 65. The same, with the
shoulder-blade turned away from
the chest-wall in order to show the
insertion of the muscle into the
anterior aspect of the inner or
vertebral border of the bone.

a. Shoulder-blade.
b. Glenoid fossa for head of humerus.

c. Coracoid process.
d. Acromion process.

influences to a marked degree the surface contour (Pls., pp.
34, 44, 122). The muscle which covers it, and which will
be presently described, forms a relatively thin layer over it.
The lower and anterior part of the serratus muscle is, however,
superficial, and it is here that its influence on the surface
contours is most readily recognized. This part of the muscle

comprises the lowest four slips which arise from the surfaces of the fifth, sixth, seventh, and eighth ribs. These slips consist of pointed, finger-like, fleshy processes, called *digitations*, and, owing to the fact that they are placed between corresponding slips of origin of the external oblique muscle of the abdomen, they are said to interdigitate with these attachments of the latter muscle, just as we can thrust the fingers of one hand between the fingers of the other.

It is this arrangement which gives rise to the zigzag furrow which is so characteristic a feature of the lower and lateral part of the chest-wall in violent action of these muscles. The general direction of the furrow so produced corresponds to a gently curved line, with the convexity directed downwards, drawn from the nipple above towards the posterior end of the crest of the haunch-bone below (Pls., pp. 86, 152, 158).

Fig. 66. A view to show the structures which underlie the deltoid and great pectoral muscles, the outlines of which are represented in dotted lines. The separation of the clavicular fibres from the sternal fibres of the great pectoral is also shown by a dotted line.

a. Collar-bone (clavicle).
b. Breast-bone (sternum).
c. Acromion process of scapula.
d. Coracoid process of scapula.
e. Pectoralis minor muscle.
f. Coraco-brachialis muscle.
g. Short head of biceps muscle.
h. Long head of biceps muscle.
k. Humerus.

The furrow is obliterated for a short distance below the nipple by the fleshy mass of the great pectoral muscle; inferiorly and posteriorly it fades away, where it joins the broad shallow furrow of the waist, and where it is overlapped by the lower fibres of the *latissimus dorsi*. The two muscles which have just been mentioned, the latis-

simus dorsi and the pectoralis major, will be described
in the next group. It has been necessary to anticipate
here in referring to them. The higher fibres of the serratus
magnus are not as a rule exposed, except when we raise
the arm over the back of the head, in which action the surface
of the chest-wall in the hollow of the armpit corresponds to
these fibres (Pls., pp. 152, 158).

The muscle assists in keeping the blade-bone closely
applied to the chest-wall, and during contraction draws it
forward as a whole (Pls., pp. 44, 110, 122, 126, 138). It is
brought into play in the act of pushing, and is the chief
muscle by which the thrusting movement in fencing is
effected. It can also bring about rotation of the shoulder-
blade, but the description of this movement is for the time
delayed.

The *pectoralis minor* muscle (Fig. 66) is not important
as a modifying influence on the surface forms, for it is
covered as a rule by the great pectoral, and it is only in ex-
ceptional positions of the limb that we can trace directly
its form on the surface. It.takes origin from the front
of the chest-wall under cover of the great pectoral ; its fibres
arise from the third, fourth, and fifth ribs, just where these
unite with their rib cartilages, and passing upwards and
outwards it is inserted by means of a pointed tendon into
the hook-like coracoid process of the shoulder-blade. Under-
lying, as it does, the great pectoral, it imparts a fullness
to the upper fleshy part of the chest, and when the arm
is raised upright a small part of its lower border becomes
superficial. This does not give rise to any distinct eleva-
tion of the surface, but helps to impart the rounded form to
the fleshy fold which bounds the hollow of the armpit in
front (Pls., pp. 152, 158). During contraction the muscle
depresses the shoulder and assists in drawing it forward.

It is by the combined action of certain of these muscles
which have just been described that the movements of

rotation of the scapula are effected. The manner of their action can best be explained by the aid of diagrams.

Fig. 67 represents in a schematic way the combined action of the trapezius behind and the serratus magnus in front. The lower fibres of the trapezius tend to pull downwards and backwards the upper angle of the blade-bone; the serratus draws downwards and forwards the inferior angle; the result is a rotation of the bone by which the lower angle is advanced and the upper angle pulled back in the directions represented by the arrows in the

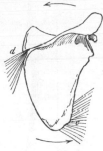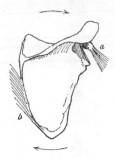

FIGS. 67 and 68. Diagrams to show how rotation of the scapula is effected.

a, Pectoralis minor muscle.
b. Rhomboideus muscle.
　The combined action of these muscles will cause rotation in the direction indicated by the arrows.
c. The fibres of serratus magnus attached to lower angle of shoulder-blade.

d　The lower fibres of trapezius passing up over root of spine.
　In combination these portions of the muscles will cause the bone to rotate in the direction of the arrows.

diagram. Fig. 68 shows rotation in the opposite direction. The rhomboids and elevator of the angle, attached to the inner border of the blade-bone, draw the lower angle upwards and nearer the middle line, whilst the pectoralis minor, inserted near the external angle, drags downwards and forwards that part of the bone, the combination of the two actions being a rotatory movement in a direction opposite to that above described. This difference is indicated by the direction in which the arrows point.

Before describing those muscles which have an indirect
influence on the movements of the shoulder-girdle through

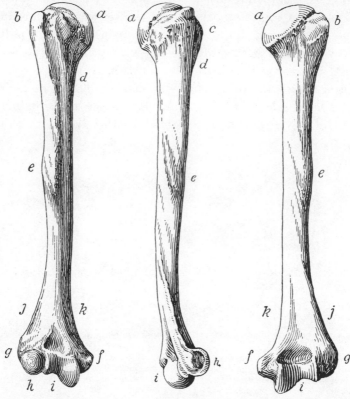

Right humerus.

FIG. 69. Front view. FIG. 70. Outer side. FIG. 71. Back view.

a. Head.
b. Greater tuberosity.
c. Lesser tuberosity.
d. Bicipital groove.
e. Deltoid impression where deltoid
 muscle is inserted.
f. Internal condyle.
g. External condyle.

h. Capitellum for articulation with head
 of radius.
i. Trochlear surface for articulation
 with ulna.
j. External condyloid ridge.
k. Internal condyloid ridge.
 These ridges afford attachment to the
 external and internal intermuscular
 septa respectively.

their attachment to the bone of the upper arm, it will be
necessary to say something about that bone, and also to

give some account of the shoulder-joint. The bone of
the upper arm is called the *humerus*. It is the first example,
as yet met with, of a long bone. As has been seen, the
long bones occur only in the limbs and serve as the levers
through which the power is transmitted. As the bones
of the upper limb are not concerned in supporting the
trunk, they are smaller and not so stout as the bones
of the lower limb which have to sustain the body weight.
The long bones have many characters in common; they
are usually described as consisting of a shaft and two
extremities. Of the latter, the upper is usually called the
head. To this rule there is an exception in the case of
the ulna, the inner bone of the fore-arm, the lower end
of which is named the head. This term, though usually
applied to the upper extremity of a long bone, is not so
employed unless that end of the bone displays a rounded
appearance—thus we speak of the head of the humerus, the
head of the femur, the head of the radius, but we do not
so describe the upper end of the tibia. Both ends of
a long bone are provided with articular surfaces, whilst
the shaft affords attachment for the muscles which cause
the movements.

The upper end of the humerus is enlarged, and is pro-
vided with a hemispherical surface. This is the *head*,
which in the recent condition is covered with cartilage,
and articulates with the shallow socket on the outer angle
of the blade-bone. To the outer side, in front, and below
the head, the bone is rough and prominent, forming two
well-marked tuberosities for the attachment of muscles;
these are called the *greater* and *lesser tuberosities*. There
is a groove between the two tuberosities, to the outer side
of which the greater tuberosity lies, whilst the lesser
tuberosity is placed on the inner side. From both these
tuberosities prominent ridges of bone descend on either
side of the groove, forming well-marked lips. The groove

is called the *bicipital groove*, from the fact that in it lies one of the tendons of origin of the biceps muscle of the arm (Fig. 66, p. 113).

The shaft of the bone, which is cylindrical above, becomes flattened below, so that its surfaces may be described as anterior and posterior. These surfaces are separated by inner and outer margins, which end inferiorly in two prominent processes, called the *condyles* of the humerus. The condyles are placed one on either side of the lower articular end of the bone, which is much broader from side to side than from before backwards. On the outer side of the shaft, about its middle, and formed by the

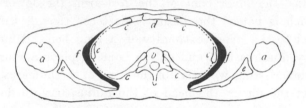

Fig. 72. Diagrammatic section across the chest to show the relations of the great serratus muscle.

a. Head of humerus	*d.* Breast-bone (sternum).
b. A dorsal vertebra.	*e.* Shoulder-blade.
c. Ribs in section.	*f.* Serratus magnus muscle.

recurved margin of the outer lip of the bicipital groove, there is a rough **V**-shaped impression, called the *deltoid impression*, which affords insertion to the muscle of that name. The fuller consideration of the lower end of the bone will be delayed until the elbow-joint is described (see p. 149).

The upper end and shaft of the humerus do not immediately come in relation to the surface, being enveloped in the fleshy mass of the shoulder and upper arm. This part of the bone, however, determines to a large extent the general form of the limb by supporting the muscles which surround it. Particularly is this the case in the

region of the shoulder, for here the large rounded head underlying the muscles of the shoulder imparts to it that roundness which is so characteristic. This is at once apparent, for, if from any cause the head of the bone is displaced, the roundness of the shoulder disappears.

In this connexion there is one other point to be noted. If we examine the humerus in an articulated skeleton, when the bones of the limb are in a position corresponding to that which they occupy in the living when the arm is hanging loosely by the side, it will be noticed that the articular head of the humerus is not turned directly inwards, but inwards and backwards. Owing to this the great tuberosity of the bone is directed somewhat forwards. The importance of this will be at once apparent if the shoulders of the living be examined. In them the most prominent part of the shoulder points towards the front, as is represented in the diagram (Fig. 72), and not towards the side, as one might naturally be led to expect (Pl., p. 382).

The *shoulder-joint* is remarkable for the wide range of its movement. The external angle of the blade-bone is provided with a shallow hollow, called the *glenoid fossa* (see Figs. 57, 58, 59). This is coated with cartilage, and slightly deepened by a ligament which surrounds its margin. The articular surface so formed is small compared with the articular area on the head of the humerus, the margin of the fossa not interfering in any way with the free movement of the head of the humerus, as would have been the case had the socket been large enough and sufficiently deep to have embraced a greater portion of the articular head.

The ligaments which surround this joint and constitute its capsule are very loose. The joint is protected above by an arch, formed by the acromion and coracoid processes of the blade-bone, which are united by a strong ligament (Fig. 73, *e*).

Movement in every direction may take place at the

shoulder-joint. These movements will be better understood
if we resolve them into their simplest forms.

There are the movements of *abduction* and *adduction*, by
which the arm is raised from or drawn down to the side.
Flexion and *extension* are movements in a forward and
backward direction; the latter is more limited in its range

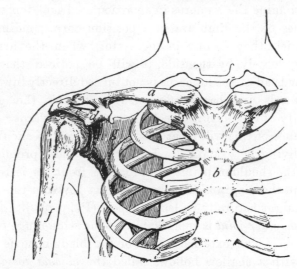

FIG. 73. View of the bones which enter into the formation of the
shoulder-joint as seen from the front.

a. Collar-bone (clavicle).
b. Breast-bone (sternum).
c. Acromion process of scapula.
d. Coracoid process of scapula.
e. Coraco-acromial ligament.
f. Shaft of humerus; the impression for
the attachment of the deltoid muscle
is just below and to the outer side
of the letter *f.*

g. Placed on the anterior surface of
the shoulder-blade (scapula). This
is the surface of the bone which is
directed towards the chest-wall.

than any of the others. There is the combination of these
four movements termed *circumduction*, and an additional
movement, that of *rotation*, by which the shaft of the
humerus is turned on its long axis. If the elbow be bent
at a right angle, and the fore-arm crossed over the front of
the trunk, we can by this rotatory movement of the humerus
carry the fore-arm away from the front of the chest, at the

same time that we keep the elbow close to the side. The range of this rotatory movement is slightly more than a quarter of a circle.

Another interesting observation may be made regarding the movements of abduction and flexion. If we raise the arm from the side, or bend it forwards, we can do so to

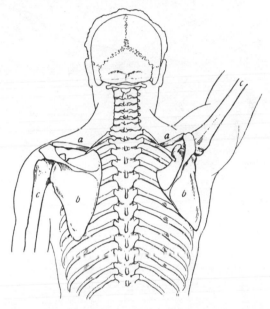

FIG. 74. Shows the change in position of the bones of the shoulder-girdle when the arm is raised; i.e. elevation of the collar-bone, and advance and rotation of the shoulder-blade.

a. Collar-bone (clavicle). b. Shoulder-blade (scapula).
c. Humerus.

a considerable extent without causing any very extensive movement of the shoulder-blade (as may be ascertained by placing the opposite hand over that bone); but when we have raised the limb from the side, so as to make a right angle with the trunk, we find, if we continue to raise the arm higher, that the movement is not now taking place at the shoulder-joint, but is being effected through

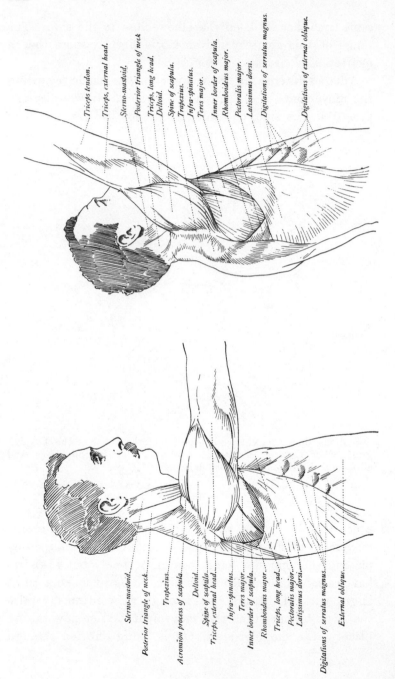

Tricps tendon.
Tricps, external head.
Sterno-mastoid.
Posterior triangle of neck
Tricps, long head.
Deltoid.
Spine of scapula.
Trapezius.
Infra-spinatus.
Teres major.
Inner border of scapula.
Rhomboideus major.
Pectoralis major.
Latissimus dorsi.
Digitations of serratus magnus.
Digitations of external oblique.

Sterno-mastoid.
Posterior triangle of neck.
Trapezius.
Acromion process of scapula.
Deltoid.
Spine of scapula.
Tricps, external head.
Infra-spinatus.
Teres major.
Inner border of scapula.
Rhomboideus major.
Tricps, long head.
Pectoralis major.
Latissimus dorsi.
Digitations of serratus magnus.
External oblique.

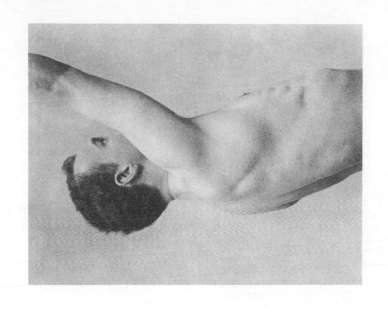

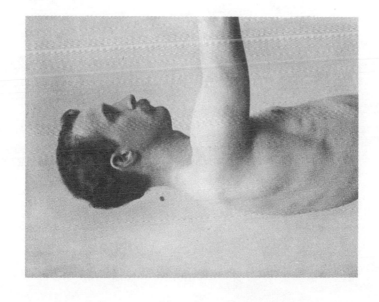

the rotation of the scapula, the lower angle of which can be readily felt advancing forwards and upwards (Fig. 74). The same holds good when we bend the arm forward. We can do so at the shoulder-joint, until we have nearly reached a right angle with the line of the trunk, after which the further movement takes place by the rotation of the scapula as before (Pls., pp. 44, 98, 122, 126).

In considering the movements of the shoulder-joint in connexion with the muscles which produce them, it will be necessary to revert to what has been already said in relation to the movements of the shoulder-girdle. The first group of muscles which we considered were those which arose from the trunk and were inserted into the bones of the girdle. The second group comprises those muscles which arise from the trunk, and which pass to be attached to the bone of the upper arm. There are two such muscles, the *latissimus dorsi*, or the broad muscle of the back, and the *pectoralis major*, or the great muscle of the breast. The one overlies the lower and back part of the trunk, the other is placed on the front and upper part of the chest.

The *latissimus dorsi* (Fig. 75) has an extensive origin from the lower six thoracic spines and the spines of the lumbar and sacral vertebra, as well as from an inch or two of the posterior end of the crest of the haunch-bone. This origin of the muscle consists of tendinous fibres, short above, but increasing in length below, and forming a fibrous layer, which constitutes the posterior layer of the *lumbar aponeurosis* (Fig. 41, p. 69). In addition to these attachments, it also arises by fleshy slips from the last three ribs, slips which interdigitate with the origin of the external oblique in a similar manner to that already described in the case of the serratus magnus. At its origin from the lower six thoracic spines the muscle is overlapped by the trapezius, and it in turn overlies the

erector spinae, which is lodged in a compartment the superficial wall of which is formed by the aponeurosis of the latissimus dorsi (Pls., pp. 34, 38, 44, 50, 52, 94, 98, 122, 126, 138, 162).

The line of attachment of the fleshy fibres of the muscle to the aponeurosis is indicated by a curved line drawn from the highest point of attachment of the muscle, near the middle line, to its inferior attachment to the iliac crest. The convexity of the curve is inwards. This arrangement of the fleshy and tendinous fibres is important, because it is readily recognized on the surface of the back of a muscular model (Pls., pp. 34, 44, 54, 126, 162, 182). From this extensive attachment the fleshy fibres converge towards the posterior fold of the armpit; here they become thick, and help to form the roundness of that fold; they then pass forward to be inserted into the front of the upper part of the shaft of the humerus, to a line corresponding to the bottom of the bicipital groove.

The upper fibres of the muscle are almost horizontal in direction, and as they pass outwards across the back they overlie the inferior angle of the blade-bone, to which they are not unfrequently attached; here they serve a useful purpose in preventing the lower angle of the blade-bone from being separated from the chest-wall in certain movements of the limb. It sometimes happens that, as a result of violent muscular effort, the lower angle of the shoulder-blade slips from under cover of the muscle. Under such circumstances it is not readily replaced beneath the latissimus dorsi, and a deformity results in the shape of an undue projection of the lower part of the scapula, thereby demonstrating the action of the muscle in keeping the blade-bone closely applied to the chest-wall. The upper border of the muscle can usually be easily seen on the model just as it overlaps the lower angle of the blade-bone (Pls., pp. 44, 122, 126, 162, 182).

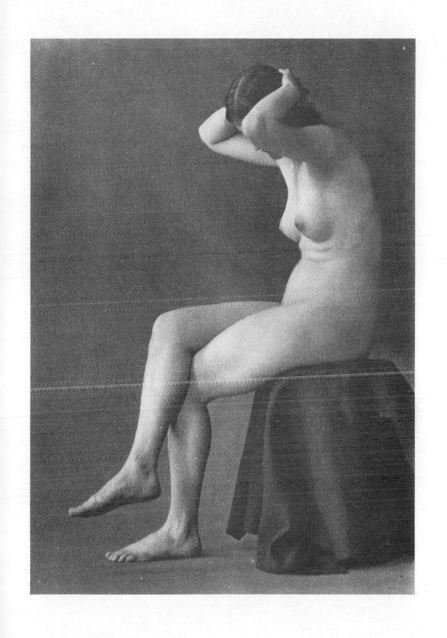

The lower fibres and those which spring from the last three ribs pass almost vertically upwards, corresponding very closely above to the outline of the front of the upper arm when the limb is hanging by the side (Pls., pp. 86, 122, 126, 158, 162).

As the fibres of the muscle are gathered together to be inserted into the bottom of the bicipital groove they are naturally brought in relation to the external border of the blade-bone which is here clothed by fleshy muscles, around which the fibres of the latissimus curve, thus forming as it were a sling in which these structures lie. The result of this arrangement is that the posterior surface of the muscle on the back of the trunk becomes the anterior surface of its tendon of insertion in front of the arm (Fig. 75).

FIG. 75. Diagram showing the attachments of the latissimus dorsi muscle. The other muscles are not represented. The fleshy fibres of the latissimus are seen crossing the lower angle of the shoulder-blade, and turning forwards to bend on themselves, so that the tendon may pass to its insertion into the bottom of the bicipital groove on the front of the humerus. This twisting of the muscle forms a groove or sling in which the fleshy part of the teres major muscle is placed.

The fibres of the muscle are comparatively thin behind, but form a thicker layer as they pass upward and outward to the arm; there, as already stated, they assist in forming the thick fleshy fold which bounds the armpit behind, and which is best seen when the limb is raised from the side (Pls., pp. 148, 152, 158).

As has been already said, the anterior border of the muscle overlaps the serratus magnus on the side of the chest-

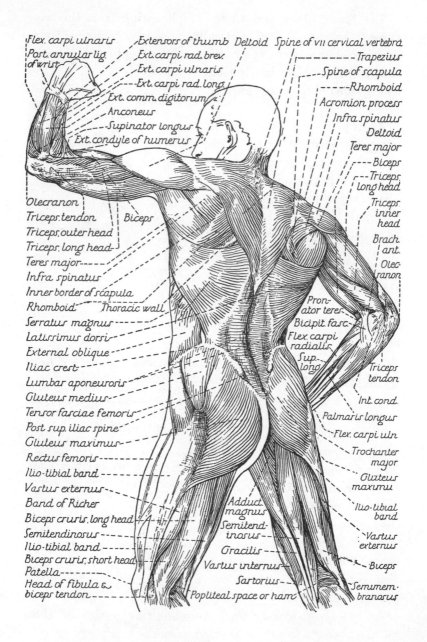

Flex. carpi ulnaris
Post. annular lig. of wrist
Extensors of thumb
Ext. carpi rad. brev.
Ext. carpi ulnaris
Ext. carpi rad. long.
Ext. comm. digitorum
Anconeus
Supinator longus
Ext. condyle of humerus
Deltoid
Spine of VII cervical vertebra
Trapezius
Spine of scapula
Rhomboid
Acromion process
Infra spinatus
Deltoid
Teres major
Biceps
Triceps, long head
Triceps inner head
Brach. ant.
Olec- ranon

Olecranon
Triceps tendon
Triceps, outer head
Triceps, long head
Teres major
Infra spinatus
Inner border of scapula
Rhomboid
Serratus magnus
Latissimus dorsi
External oblique
Iliac crest
Lumbar aponeurosis
Gluteus medius
Tensor fasciae femoris
Post sup. iliac spine
Gluteus maximus
Rectus femoris
Ilio-tibial band
Vastus externus
Band of Richer
Biceps cruris, long head
Semitendinosus
Ilio-tibial band
Biceps cruris, short head
Patella
Head of fibula & biceps tendon

Biceps
Thoracic wall

Pronator teres
Bicipit. fasc.
Flex. carpi radialis
Sup. long.
Triceps tendon
Int. cond.
Palmaris longus
Flex. carpi uln.
Trochanter major
Gluteus maximus
Ilio-tibial band
Vastus externus
Biceps
Semimembranosus

Adduct. magnus
Semitend- inosus
Gracilis
Vastus internus
Sartorius
Popliteal space or ham

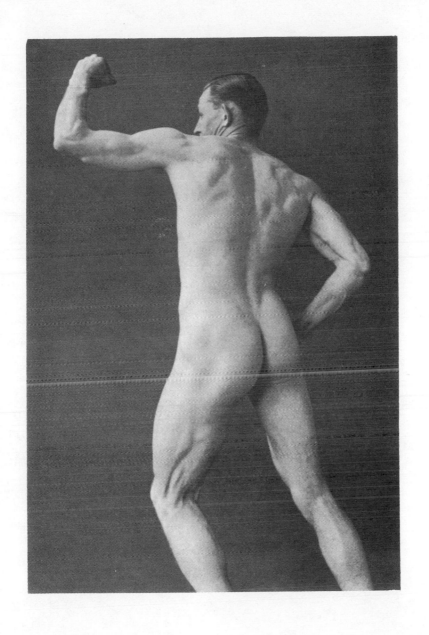

wall, and the interdigitation of the fibres which spring from
the last three ribs with the external oblique muscle forms
the continuation of the zigzag furrow, already referred to
(p. 113), between the serratus magnus and the higher slips of
origin of the external oblique.

If the arm be raised the latissimus will assist in drawing
it down again to the side. With the limb by the side the
muscle draws it downwards and backwards, and so causes
the shoulder-blade to move slightly downwards and nearer
the middle line. The muscle also assists in rotating the
upper arm inward, antagonizing the
movement of external rotation (Pl., p. 138).
Under certain conditions the action of
the muscle may be reversed, i. e. the fixed
point being the attachment of the muscle
to the humerus, the movable part corre-
sponding to its attachment to the trunk;
this happens when we pull up the weight
of the body as in the act of climbing.

FIG. 76. Diagram
to show the mode
in which the fibres
of the pectoralis
major muscle are
inserted into the
outer lip of the
bicipital groove.

The *pectoralis major muscle*, or great
muscle of the breast, has been included in
the group of muscles which spring from
the trunk and pass to the limb. This is
not strictly correct, as will presently be
seen, for the muscle also arises from one of the bones of the
shoulder-girdle; it is, however, more convenient for our
purpose to group it with latissimus dorsi.

The muscle arises by fleshy fibres from the anterior
border of the inner two-thirds or half of the collar-bone,
i. e. from that end of the collar-bone which articulates with
the breast-bone, from the anterior surface of the breast-bone
on either side of the middle line, from the cartilages of the
upper six ribs, and from the upper part of the aponeurosis
of the external oblique muscle of the abdominal wall. The
fibres of the muscle converge as they pass outwards to the

limb, the highest fibres passing downwards and outwards in front of the lowest fibres, which pass upwards and outwards. Between the two extremes they have varying degrees of obliquity. Those springing from the breast-bone at the junction of its lower and middle third (not including the cartilaginous portion) lie in a horizontal direction when the limb is hanging by the side. The tucking in of the lower fibres behind the upper as they pass from the chest-wall to the arm leads to an increase in the thickness of the fleshy fold which bounds the hollow of the armpit in front. By this convergence and infolding of the fibres of the muscle it becomes much narrowed, and is inserted by means of a flat tendon about 2½ inches in breadth into the outer lip of the bicipital groove of the humerus (Fig. 76). The muscle is superficial throughout, except at its tendinous insertion, where it is overlapped by the deltoid or great muscle of the shoulder (Pls., pp. 58, 62, 72, 86, 148, 152, 158, 382). The great pectoral muscle overlies the lesser pectoral. When the arm is raised above the head, however, the lower border of the lesser pectoral is for a short distance uncovered and imparts a roundness to the lower part of the anterior *axillary* [1] fold.

The fibres of the great pectoral which spring from the collar-bone are usually separated from the fibres which arise from the breast-bone by a shallow furrow passing obliquely downwards and outwards from the inner end of the collar-bone. The distinctness of this furrow on the surface depends on the development of the muscle and the position of the limb (Pl., p. 58). The fleshy fibres which spring from the breast-bone and ribs form a triangular mass, the apex of which overlies the front of the upper arm, while the base corresponds to the surface on either side of the middle line of the breast-bone. The prominence caused

[1] The term ' axilla ' is used by anatomists for the hollow of the armpit.

by these fibres forms the sides of the median furrow, the bottom of which corresponds to the breast-bone. The angles formed by the base and sides of the triangle above and below are rounded off. The upper side of the triangle lies contiguous with the lower border of the portion of the muscle which arises from the collar-bone. The lower side of the triangle is almost horizontal in its inner half, where it overlies the chest-wall, but, curving slightly upwards as it passes from the chest to the limb, corresponds to the lower border of the anterior fold of the armpit. From the rounding of the angles of the base of this fleshy mass it follows that the median furrow, which on the surface corresponds to the interval between the two muscles, is opened out above and below in front of the upper and lower ends of the osseous part of the breast-bone. The latter is at some little distance above the pit of the stomach, which it may be remembered corresponds to the position of the cartilaginous portion of the breast-bone (Pls., pp. 58, 62, 72, 86, 152, 158).

It occasionally happens in persons of great muscular development that bundles of tendinous fibres pass from the origin of one muscle across the middle line of the breast-bone to the opposite side, and when the muscle is powerfully contracted these may stand out as more or less prominent cords crossing and slightly interrupting the smoothness of the central breast furrow (Pl., p. 382). Oftentimes, too, the lower and internal attachment of the muscle can be recognized as a series of slight elevations corresponding to the lower fleshy slips of origin. The lower border of the muscle corresponds usually to the cartilage of the fifth rib, or to a line drawn outwards and slightly upwards from the pit of the stomach.

When well developed, the muscle completely conceals the framework of the thoracic wall, which it overlies, but in cases where the muscle is thin the ribs and rib cartilages may be recognized beneath it. Passing as it does from the

breast to the upper arm, the muscle conceals the rounded form of the chest, except in front where it is supported on the convex surface of this part of the trunk, the fullness of which it carries towards the upper part of the limb, thus imparting an appearance of width to the chest and causing it to blend externally with the general roundness of the shoulder.

The pectoralis major draws down the uplifted arm; it may also draw forward the limb, and thus counteract the influence of the latissimus dorsi, which draws the arm back; it assists that muscle, however, in effecting inward rotation of the limb. The lower fibres of the muscle assist in depressing the shoulder, whilst the upper fibres, which spring from the collar-bone, help to bend the arm forwards at the shoulder-joint. The sternal fibres also draw forward the shoulder. When the shoulders are thrust forwards the muscle is not pulled away from the chest-wall, but becomes bent upon itself so as to form a broad and shallow furrow which crosses the muscle from above, downward. It will be remembered that the principal muscle concerned in this action is the serratus magnus, which pulls forward the shoulder-blade and with it the shoulder. The hollowing of the pectoral muscle is due to the slight folding which takes place as it crosses in front of the armpit, the laxity of the tissues there permitting greater mobility.

These various actions of the muscle are reversed when the limb becomes the fixed point, as in the act of climbing; it then assists in drawing up the trunk towards the fixed limb.

The surface forms over the muscles vary very much in the two sexes; what has been already stated applies principally to the male. In the fat which overlies the muscle the breast or *mammary gland* is situated. In the male the only indication of the breast is the nipple, for the glandular part is not developed, although in some cases a slight accumulation of fat in the region of the nipple imparts

a prominence to that point. The position of the nipple is a variable one, but it usually lies opposite the interval between the fourth and fifth ribs. If a line be drawn from the navel to the joint between the collar-bone and the acromion process of the shoulder-blade it will fall over the position of the nipple on a level with the interspace between the fourth and fifth ribs.

In the female the breasts are glandular, and their development depends largely on age and other conditions. As they lie on the surface of the pectoral muscles the breasts should be widely separated from one another; this will vary according to the width of the chest-wall. In cases where that is narrow, the glands are necessarily brought closer together. The nipples should be directed forward and slightly outward so as to point away from each other. The breasts should not be unduly large, and their consistence should be such as to counteract the influence of gravity; there should be no fold or crease of the skin below them, but they should rise gently from the general surface. As Professor Brücke has pointed out, the angle formed by the apex of the cone should nearly approach a right angle, the lower part of the organ being slightly more convex and rounded (Pls., pp. 72, 80 86, 124, 132, 262, 270, 438).

In regard to the level at which the female breasts are placed, this will vary somewhat in different models, but the effect produced is always more pleasing when they are set high and combined with the general roundness of the neck and shoulders than when they are situated on a somewhat lower level.

In some models the areola, or tinted area which surrounds the nipple, is slightly elevated from the surrounding surface of the breast, a feature which is sometimes represented in modern sculpture. The breasts themselves are movable, a circumstance which accounts for the fact that in the erect posture they lie at a somewhat lower level than in the

recumbent position, when they are no longer influenced by their own weight.

What has been said regarding the form of the breasts will require modification if it be the artist's intention to represent a matronly form; in this case the changes in the gland dependent on the maternal function will have given rise to alterations in its development and consistence which materially affect its form, greater fullness and a slight folding of the tissues beneath the breasts being permissible under such conditions.

The existence of these glands in the female, and the presence of an abundant quantity of fat, naturally mask the form of the great pectoral muscle on the surface of the body. The lower border of the muscle is concealed, and the lower part of the anterior fold of the armpit is effaced by the extension of the rounded base of the gland across it (Pls., pp. 72, 80, 86, 124, 132, 262, 270, 438). Above, however, the fold of the armpit appears distinct where the muscle escapes from under cover of the breast. There is usually a considerable quantity of fat overlying the fold here, and the surface form presents a smooth, slightly convex surface extending from the collar-bone above to the somewhat thick and rounded border of the fold of the armpit below. Over this part of the great pectoral muscle there is an elevation on the surface distinct from that of the breast, the conical form of which rises gradually from this surface (Pls., pp. 72, 80, 86, 132, 438). These points may be readily recognized in a well-formed model, and may be further demonstrated by raising the limb from the side, in which position the fold of the armpit is more distinctly seen. At the same time it will be noticed that the act of raising the arm exercises a certain amount of traction on the breast, which lies higher on the side with the uplifted limb than on the opposite side if the arm is pendant (Pls., pp. 132, 434).

We have next to turn our attention to that group of

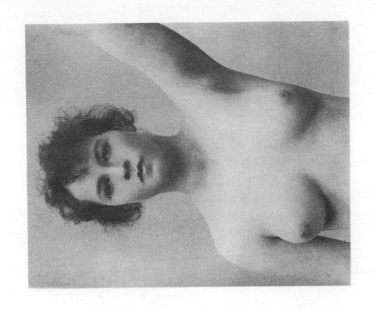

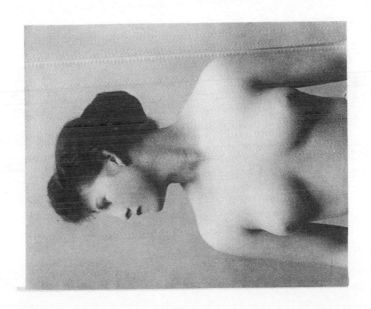

muscles which arises from the bones of the shoulder-girdle and passes to be inserted into the bone of the upper arm; the most important of this group is the *deltoid* or great muscle of the shoulder. There are others which take their origin from the surfaces of the blade-bone, but these for the most part lie deeply, and do not influence the surface forms except in so far as they constitute a padding for the more superficial muscles which overlie them. It will be necessary, however, to refer to two of them, the *infra-spinatus* and the *teres major*, because they are in part superficial. The *coraco-brachialis* muscle also arises from the blade-bone (coracoid process) and is inserted into the humerus, but its consideration had best be delayed until the surface forms of the upper arm are discussed.

The *deltoid* muscle, which is superficial throughout, forms the cap of the shoulder. As its name implies, it is trian-gular in shape, and is so called from its resemblance to the Greek letter Δ. The base of the triangle is directed upwards and is attached to the girdle-bones, the apex or pointed extremity of the muscle passes down towards the middle of the outer side of the upper arm.

The muscle arises from both bones of the shoulder-girdle, from the anterior surface of the external third of the collar-bone in front, above the shoulder from the point and outer margin of the acromion process of the shoulder-blade, and behind from the lower border of the spine of the scapula in its whole length. The origin of this muscle is thus seen to correspond to the insertion of the trapezius, indeed we may regard it as a prolongation of that muscle downward to the limb, the bones of the girdle forming an interruption to the direct continuity of the muscular fibres.

The fibres of the muscle, which arise from the bony origin just described, are arranged in fleshy bundles which con-verge inferiorly to form a strong thick tendon which is inserted into that rough **V**-shaped surface, already

described (p. 118), on the outer side of the shaft of the
humerus, about its middle. This raised **V**-shaped surface is
hence called the *deltoid eminence.* The thickest part of
the muscle corresponds to its central fibres; in front, the
anterior border of the muscle lies alongside the outer margin
of the clavicular fibres of the great pectoral, from which it
is separated by a linear depression which is wider above,
as the two muscles are slightly separated from one another
at their origins from the collar-bone. In correspondence
with this, on the surface of the shoulder in front, there is
a slight hollow below the collar-bone overlying the interval
between the muscles. From this there passes down a linear
furrow, which follows the line of separation between the
two muscles towards the external limit of the anterior fold
of the armpit where the tendon of the insertion of the
great pectoral sinks under cover of the deltoid. These
surface depressions are best seen in a muscular model with
little or no superficial fat, and are of course intensified
when the muscles are powerfully contracted. They are
absent in the female, or, if present, are very much softened
on account of the quantity of fat and the feebler muscular
development (Pls., pp. 38, 58, 62, 72, 86, 104, 148, 152, 382,
434).

The posterior border of the deltoid is much thinner.
Owing to the fact that it is intimately connected with
a strong aponeurosis which stretches across the lower part
of the blade-bone, it has much less influence on the surface
contours, though if the arm be raised over the head the
outline of this border may be traced upon the surface
(Pls., pp. 34, 38, 44, 50, 52, 54, 94, 98, 122, 126, 138, 162,
262, 270).

The roundness of the muscular mass of the deltoid is due,
as has been already stated, to the fact that it overlies the head
of the humerus and receives support from that portion of the
bone. This also explains why the most prominent point of

its general roundness is directed forwards and outwards, the
anterior part of the muscle appearing much fuller than the
posterior, which presents a somewhat flattened appearance
(Pl., p. 382).

The greatest width of the shoulders, however, does not
correspond to the points at which the deltoid muscles over-
lap the head of the humerus, but is situated at a somewhat
lower level, where the various bundles of fibres are gathered
together to pass to their insertion. This point is usually
found to correspond to the level of a line drawn outwards
across the limb in continuation with the lower border of the
anterior fold of the armpit (Pls., pp. 58, 86, 382).

The surface form does not convey a correct impression
of the extent to which the muscle descends to be attached
to the shaft of the humerus, for the insertion is obscured
both in front and behind by the fleshy muscles of the upper
arm, between which its tendinous fibres pass to a much
lower level than might at first seem likely. According to
the amount of fat present a depression more or less distinct
appears on the surface overlying the point of junction of
the fleshy fibres with the tendon of insertion. It is most
pronounced when the arm is raised and slightly drawn back
and the muscle powerfully contracted. Leading up from
this hollow on either side are the linear furrows corre-
sponding to the anterior and posterior borders of the muscle
respectively (Pls., pp. 44, 50, 52, 54, 72, 94, 98, 104, 126, 182,
382).

The origin of the deltoid is much better seen when the
limb is raised. It then corresponds to a furrow which over-
lies the outer third of the collar-bone, the upper surface of
the acromion and the spine of the scapula, over the middle
of the latter of which it gradually fades into the general
fullness of the trapezius. The depth of the furrow, which
is greatest, in the uplifted position of the limb, over the
acromion, depends on the development and state of contrac-

tion of the trapezius and deltoid muscles which lie above and
below it (Pls., pp. 38, 44, 94, 98, 122, 126, 434). This furrow,
which is seen in the female when the limb is raised, is
much softer in its contours, owing to the greater thickness
of the superficial fatty layer (Pls., pp. 262, 270). As has
been pointed out to me by my friend Mr. Pilcher, it is not
uncommon, particularly in women with plump shoulders,
to meet with a dimple overlying the angle formed by the
acromion process as it passes forwards from the spine.

The action of the deltoid varies according to the part of
the muscle brought into play. It assists in raising the arm.
That part of the muscle which arises from the acromion
draws the arm upwards and away from the side; the anterior
fibres raise the limb and bend it forwards; the posterior
fibres elevate the limb and pull it backwards. The action
of the muscle is checked by the ligaments around the
shoulder-joint, so that in the act of raising the limb from
the side further movement at the shoulder-joint ceases when
the arm forms a right angle with the trunk. Any further
movement in an upward direction is due to the rotation of
the shoulder-blade itself; this movement has been previously
described (p. 115). During powerful contraction of the
muscle the surface forms over it frequently display the details
of the arrangement of its fibres, a series of shallow furrows
indicating the lines of separation of the different bundles;
these are best seen near the bony origin (Pls., pp. 98, 182).

Of the two remaining muscles of this group little need
be said. The *infra-spinatus* arises from the posterior surface
of the blade-bone below the spine; its fibres converge
externally to end in a tendon which is inserted into the
back of the great tuberosity of the bone of the upper arm.

The muscle is triangular in shape. In close relation to
its lower border we find another muscle which is called the
teres minor. The fibres of this muscle lie parallel to those
of the infra-spinatus, and are attached along the external

border of the blade-bone. The fibres pass upwards and outwards towards the great tuberosity of the humerus, into which they are inserted immediately below the infra-spinatus. In regard to their action and their influence upon the surface forms these two muscles may be regarded as one; they both act as rotators outwards of the bone of the upper arm; they assist also in drawing the arm backwards, and

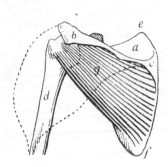 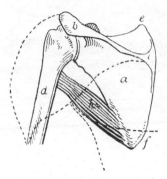

FIG. 77. Diagram showing the attachments of the infra-spinatus and teres minor. The two muscles are treated as one fleshy mass.

a. Supra-spinous fossa.
b. Acromion process.
c. Root of spine.
d. Humerus.
e. Upper angle of shoulder-blade.
f. Lower angle of shoulder-blade.
g. Infra-spinatus and teres minor. The dotted line represents the outline of the deltoid.

FIG. 78. Diagram showing the attachment of the teres major.

a. The infra-spinous fossa of the blade-bone, from which the infra-spinatus muscle and teres minor have been removed.
b. Acromion process.
c. Root of spine.
d. Humerus.
e. Upper angle of blade bone.
f. Lower angle of blade-bone. The dotted lines represent the outlines of the deltoid above and the latissimus dorsi below.
h. Teres major.

the teres minor helps to pull down the uplifted limb (Fig. 77). Both muscles are covered by a fairly strong and tough layer of fascia, a circumstance which explains why they do not produce a greater surface relief when they are in a state of contraction. The portions of these muscles which are subcutaneous correspond to a somewhat triangular area, which is mapped out by the reliefs formed by the edges of the trapezius within, the deltoid above, and the upper

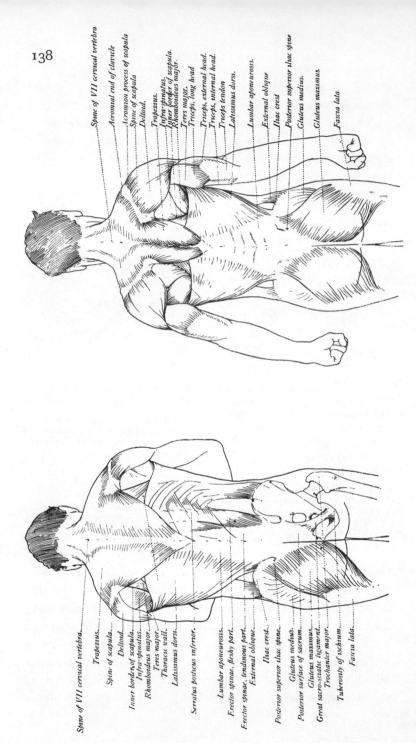

Spine of VII cervical vertebra
Acromial end of clavicle
Acromion process of scapula
Spine of scapula
Deltoid.
Trapezius.
Infra-spinatus.
Inner border of scapula.
Rhomboideus major.
Teres major.
Triceps, long head
Triceps, external head.
Triceps, internal head.
Triceps tendon
Latissimus dorsi.
Lumbar aponeurosis.
External oblique
Iliac crest
Posterior superior iliac spine
Gluteus medius.
Gluteus maximus.
Fascia lata.

Spine of VII cervical vertebra.
Trapezius.
Spine of scapula.
Deltoid.
Inner border of scapula.
Infra-spinatus.
Rhomboideus major.
Teres major.
Thoracic wall.
Latissimus dorsi.
Serratus posticus inferior.
Lumbar aponeurosis.
Erector spinae, fleshy part.
Erector spinae, tendinous part.
External oblique.
Iliac crest.
Posterior superior iliac spine.
Gluteus medius.
Posterior surface of sacrum.
Gluteus maximus.
Great sacro-sciatic ligament.
Trochanter major.
Tuberosity of ischium.
Fascia lata.

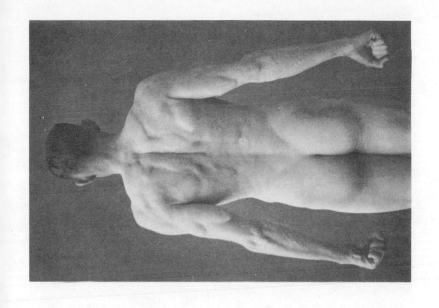

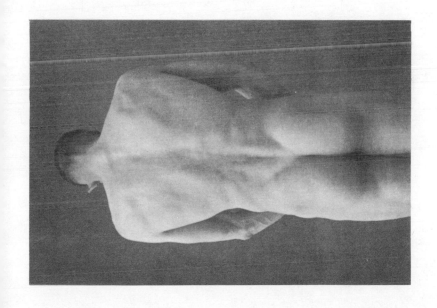

border of the latissimus dorsi below. The surface of these muscles so exposed forms a slight relief bounded by the outlines above described. These points may be seen best when the shoulders are drawn back. When the limb is raised above the head, the surface form is modified by the rotation of the blade-bone, the inferior angle of which is carried forwards and slightly upwards. In this position the inner border of that bone is rendered more apparent, and the lower part of the rhomboideus major is more fully exposed (Pls., pp. 34, 38, 44, 50, 52, 54, 94, 98, 110, 122, 126, 138, 142, 182).

The last muscle of this group which we have to consider is the *teres major*. It takes origin from the posterior surface of the lower angle of the blade-bone ; its fibres run upwards and outwards parallel to those of the teres minor, but in place of being attached to the back of the humerus the teres major runs forward to the front of the shaft of that bone and is inserted into the inner lip of the bicipital groove. The muscle, when well developed, forms a thick fleshy mass. Its relations to the latissimus dorsi and the posterior fold of the armpit are important. As has been already stated, the latissimus dorsi folds round the outer border of this muscle so as to enclose it like a sling. As the fibres of the latissimus sweep round the thick teres major muscle the latter imparts a fullness to them which accounts for the thickness of the posterior fold of the armpit. The teres major acts as a rotator inwards of the arm, thus antagonizing the action of the teres minor. Acting in conjunction with the minor it draws down the uplifted limb (Fig. 78).

The muscle imparts a fullness to the surface which overlies the outer border of the blade-bone. With the limb by the side and forcibly rotated inwards, the muscle forms a well-marked elevation between the upper border of the latissimus dorsi and the teres minor. This relief, externally, sinks under cover of the deltoid and the long head of the great

extensor muscle on the back of the upper arm, called the triceps. It is owing to the presence of this muscle that the external or axillary border of the blade-bone exercises so little direct influence on the surface forms (Pls., pp. 44, 50, 122, 126, 148, 152, 158, 162, 182).

Having now considered in detail the various superficial muscles which lie on the back of the trunk, it may be well to review briefly the main features of the superficial anatomy of this region. Arising from the middle line of the back, throughout the entire extent of the thoracic region, and extending upwards as high as the back of the skull, is the *trapezius*. The fibres of insertion are to be traced outwards to the bones of the shoulder-girdle. The higher fibres, which pass forward to be attached to the outer third of the front of the collar-bone, have a downward direction. The lower, which are inserted into a tendon overlying the root of the spine of the shoulder-blade, have an upward direction. The intermediate fibres run with varying degrees of obliquity to be inserted into the upper margin of the spine and the acromion process of the blade-bone (Pls., pp. 34, 52, 54, 94, 98, 110, 138, 182).

The origin of the *deltoid* corresponds precisely to the insertion of the trapezius, the collar-bone and the bony processes of the blade-bone alone separating the attachments of these muscles. The fibres of the deltoid are gathered together to form a pointed tendinous insertion, which is attached to the outer side of the shaft of the bone of the upper arm, about its middle. The muscle thus covers the shoulder-joint behind, in front, above, and to the outer side (Pls., pp. 34, 52, 54, 94, 98, 104, 110, 122, 138, 148, 152, 162, 182).

Arising from the middle line of the back, throughout the entire region of the loins, and also from the lower half of the thoracic region, is the *latissimus dorsi*. The latter part of its origin is overlapped by the pointed lower

fibres of attachment of the trapezius. In addition, the latissimus dorsi arises from the last three ribs as well as from the hinder end of the iliac crest for a variable distance, as has been already described. The fibres pass upwards and outwards with varying degrees of obliquity towards the hinder fold of the armpit, the contour line of which they form: here the muscle is twisted on itself to reach the front of the upper part of the shaft of the humerus into which it is inserted (Pls., pp. 34, 38, 44, 50, 52, 54, 94, 98, 122, 126, 138, 152, 158, 162).

A triangular interval between these muscles in the scapular regions is to be noted, the apex of which corresponds to the root of the spine of the blade-bone. Of its sides, the inner corresponds to the outer margin of the trapezius, the outer to the posterior border of the deltoid, while its base, somewhat curved, coincides with the upper border of the latissimus dorsi. It is within the area so defined that the blade-bone, and some of the muscles connected with it, come into direct relation to the surface. With the limbs by the side we recognize, in this triangular interval, the internal border of the blade-bone. To the inner side of this border, we note the presence of that portion of the *rhomboideus* muscle which is uncovered by the trapezius. Arising from the posterior surface of the blade-bone below the spine, we see as much of the *infra-spinatus* and *teres minor* as is uncovered by the deltoid, while, corresponding to the lower angle and external border of the blade-bone, as much of the *teres major* as is not overlapped by the latissimus dorsi is displayed (Pls., pp. 34, 94, 98, 138, 182).

The relations of the boundaries and contents of this triangular area, which, for descriptive purposes, may be called the *scapular triangle*, vary from one or other of two causes or a combination of both. These causes depend on the mobility of the blade-bone or scapula.

Firstly, the relation of this scapular triangle to the surface will alter according as the blade-bone is raised or lowered or drawn backwards or forwards, movements which take place when we raise or lower the shoulders or when we brace them back or pull them forwards (Pls., pp. 50, 110, 138).

Secondly, the outlines of the scapular triangle and its contents will be much modified by that movement of the scapula which is called rotation, and which has been already considered in detail. This is the movement which causes the inferior angle of the blade-bone to advance on the chest-wall, whilst its upper angle passes nearer the middle line, a movement which takes place to greatest extent when the arm is thrown above the back of the head or neck (Pls., pp. 38, 44, 98, 122, 126, 142, 270). Rotatory movement in an opposite direction is produced when the arm is carried across the back of the trunk towards the opposite side of the body. In this position the lower angle of the blade-bone is drawn nearer the middle line of the back, whilst the upper angle passes to lie wide of the middle line (Pl., p. 162).

As will be obvious, there may be many combinations of these movements. Two examples will be sufficient to render this clear. We may have the unlifted arm with the shoulder thrown forwards, or, on the other hand, the uplifted limb with the shoulder drawn back — in these positions the arrangement of the contents and outlines of this scapular triangle will display very characteristic differences; these the student will best appreciate for himself by a study of Pls., pp. 38, 44, 50, 98, 122, 126, 162, 182.

The only remaining superficial muscle which it is necessary to study here is a portion of the *external oblique* as it forms the flank; this is visible in a view of the superficial muscles of the back, since it lies wide of the lower attachment of the latissimus dorsi to the ribs and iliac crest.

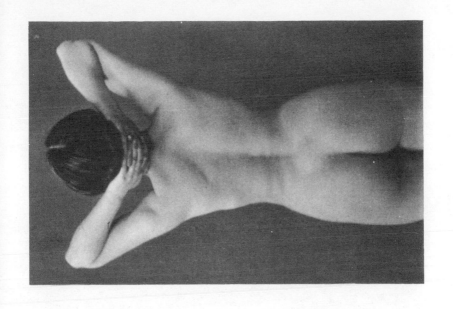

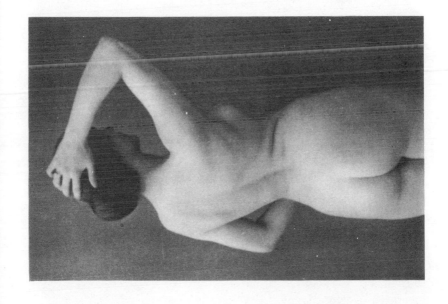

Usually, however, the superficial layer of fat in this region is so abundant that the surface contours are not much influenced by the development or contraction of this part of the external oblique (Pls., pp. 38, 44, 126, 162).

Whilst the muscles above mentioned constitute the superficial layer of the back, the student must not overlook the fact that many of the deeper muscles exercise a very marked influence on the surface forms. Most important of these are the *erectores spinae*. These control to a large extent the movements of the vertebral column, and though their action has been already fully discussed, it may be well here to remind the student that when the figure is represented in poses in which the back is bent either forwards or backwards, to the side, or twisted, these muscles undergo remarkable modification in their outline and the degree of their contraction. This will necessarily react on the surface contours, for, as has been previously stated, the muscles which overlie them are frequently so thin and tendinous that the deeper muscles exercise a much greater influence on the surface form than those which overlie them (Pls., pp. 38, 44, 50, 52, 54, 98, 162).

An examination of Pl., p. 50, will best explain this. It may be well here to emphasize the fact that when the figure is bent forward the central furrow of the back becomes shallower, and may be replaced by a ridge corresponding to the tips of the spines of the vertebrae ; the fleshy column of the erectores spinae, which lie on either side, are flattened, owing to the stretching of their fibres : whereas if the figure be bent backwards the median furrow is deepened and the erectores spinae are rendered more prominent, owing to the fact that they are now in a powerful state of contraction. The median furrow of the back in the upper thoracic region may be further deepened by the approximation of the blade-bones to the middle line, an action which is induced by the powerful contraction of the trapezii, and

the shortening and bulging of their fibres, a condition which is represented in Pls., pp. 44, 110, 138.

In concluding this *résumé* it need only be added that the difference between the sexes is in great part due to the fact that in woman the superficial fatty layer is present in such quantity as to mask, to a greater or less extent, the details above described. In the female we do not expect to find so powerful a muscular development as in the male ; the result is that, though in woman the surface contours depend on the same structures, in her the outlines are more rounded and soft, affording little if any evidence of many of the above details (Pls., pp. 36, 52, 54, 142, 270, 278).

In analysing and representing the forms of the back in action, the student should note the facts already referred to on p. 55. It is well to bear in mind that powerful muscular action is employed to overcome some resistance or to exercise considerable force in some definite direction. On the foregoing pages, when the action of a muscle is described, it is not to be assumed that the action of the muscle referred to is isolated. It is only one of a group composed of co-ordinating and opposing muscles, the combined effect of which is to produce the movement desired. The co-ordinating muscles regulate the direction of the movement generated by the most active member of the group, whilst the opposing muscles control the extent and force of the movement. It must not be assumed that when the model is on the alert, though not in active movement, his muscles are relaxed and inactive. It is only in repose, as for example when we are seated in a chair, that the muscles of the back of our thighs are flaccid and inert. Under ordinary circumstances, in our usual activities, all our muscles are 'in tone', some being in active contraction, associated with a shortening and thickening of their fibres, whilst others may be extended and stretched, not relaxed or flaccid, but regulating by their action the degree of force and movement induced by the muscle or muscles specially concerned.

CHAPTER VI

THE UPPER ARM

BEFORE passing to the consideration of the surface forms of the upper arm, it may be well to glance for a moment at the manner in which the arm springs from the trunk. When the arm is hanging by the side there is a hollow, called the *armpit*, between the upper part of the limb and the chest-wall. If the fingers be thrust into this space the anterior and posterior walls of the hollow will be found to be thick and fleshy. These have been already frequently referred to as the anterior and posterior folds of the armpit, and have been seen to be formed by the muscles passing from the trunk to the limb.

Great alterations take place in the form of this hollow when the arm is raised from the side. Its boundaries are now better seen, for the borders of the anterior and posterior folds are stretched, and more clearly defined (Pls., pp. 62, 148, 152, 434).

The most noticeable feature in connexion with them is that the posterior fold extends farther down the limb than the anterior; in consequence of this, if the figure is looked at from the front, when the arm is raised, we can see into the hollow of the armpit. In this view the anterior surface of the posterior wall is in part exposed, and we have to account for the structures which determine its form. If, on the other hand, the figure is sketched from behind when the arm is uplifted the posterior fold of the armpit, being deeper, conceals from view the hollow, and the lower margin of this fold forms the outline of the figure in this position (Pls., pp. 38, 44, 94, 162, 182). Viewed from the side,

we can of course recognize both boundaries, and get a better idea of the inner wall of the space.

For clearness of description the boundaries of the space had now better be described. In form the hollow resembles a four-sided pyramid, the sides of which are unequal. The base of the pyramid corresponds to the skin which overlies the hollow. The inner wall of the space is formed by the chest-wall overlain by the serratus magnus. The anterior wall, as has been already stated, is constituted by the pectoralis major and minor. The posterior wall is in part made up of the anterior surface and external border of the blade-bone, both of which are clothed by muscles, a muscle called the subscapularis being placed upon its anterior aspect, whilst the fleshy fibres of the teres major cover its external border. The thickness of this latter muscle is sufficient to mask the outline of the external border of the bone, which the student can easily feel by grasping firmly the posterior fold of the armpit when the limb is raised. Sweeping round the outer border of the teres major the fibres of the latissimus dorsi can readily be seen in a dissection of this region, and in certain positions of the limb their presence causes distinct alterations of the surface forms (Pls., pp. 148, 152, 158, 434). The anterior and posterior walls of the armpit are wide apart as they pass from the trunk, but as the muscles which form them—with one exception, the pectoralis minor—are all inserted into the bone of the upper arm the folds are necessarily brought much closer together at their attachments to the limb.

The outer wall of the space is necessarily much narrower than the others, and consists of the upper portion of the shaft of the humerus and certain muscles which are passing down along its inner side. These are the *biceps* muscle of the arm and the *coraco-brachialis*, which will presently be described. The hollow itself is filled with fat, in which the large vessels and nerves of this region are embedded.

It is owing to the presence of these contents, and also to the stretching of the skin and fibrous layers which form the base of the space, that the hollow is not so deep as one would expect from a mere study of the muscles alone.

The plates on pp. 62, 132, 148, 152, 158, and 434 represent the figure with the limb in different positions, and the student will be able to form a better idea of the arrangement of the muscles by a study of these plates than by any verbal description.

This is a convenient point at which to study the *coraco-brachialis* ; it arises, in conjunction with the short head of the biceps muscle of the arm, from the tip of the cora-ooid process of the blade-bone, and is inserted into the inner side of the humerus, where its attachment corresponds to the middle third of the length of the shaft. The upper part of the muscle is concealed by the anterior fold

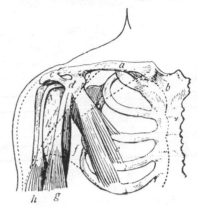

FIG. 79. A view to show the structures which underlie the deltoid and great pectoral muscles, the outlines of which are represented by dotted lines. The separation of the clavicular fibres from the sternal fibres of the great pectoral is also shown by a dotted line.

a. Collar-bone (clavicle).
b. Breast-bone (sternum).
c. Acromion process of scapula.
d. Coracoid process of scapula.
e. Pectoralis minor muscle.
f. Coraco-brachialis muscle.
g. Short head of biceps muscle.
h. Long head of biceps muscle.
k. Humerus.

of the armpit, and as it runs down along the inner side of the shaft of the humerus it is overlapped, when the limb is hanging by the side, by the fleshy fibres of the biceps. When the arm is raised and the borders of the armpit are stretched, the muscle can be readily recognized as a distinct elevation running along the inner side of the limb, between

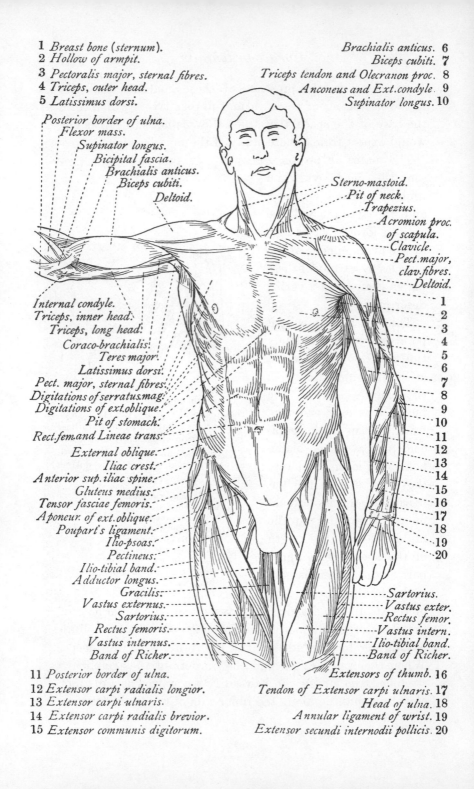

1 *Breast bone (sternum).*
2 *Hollow of armpit.*
3 *Pectoralis major, sternal fibres.*
4 *Triceps, outer head.*
5 *Latissimus dorsi.*

Brachialis anticus. 6
Biceps cubiti. 7
Triceps tendon and Olecranon proc. 8
Anconeus and Ext.condyle. 9
Supinator longus. 10

Posterior border of ulna.
Flexor mass.
Supinator longus.
Bicipital fascia.
Brachialis anticus.
Biceps cubiti.
Deltoid.

Sterno-mastoid.
Pit of neck.
Trapezius.
Acromion proc.
of scapula.
Clavicle.
Pect.major,
clav.fibres.
Deltoid.

Internal condyle.
Triceps, inner head.
Triceps, long head.
Coraco-brachialis.
Teres major.
Latissimus dorsi.
Pect. major, sternal fibres.
Digitations of serratus.mag.
Digitations of ext.oblique.
Pit of stomach.
Rect.fem.and Lineae trans.
External oblique.
Iliac crest.
Anterior sup.iliac spine.
Gluteus medius.
Tensor fasciae femoris.
Aponeur. of ext.oblique.
Poupart's ligament.
Ilio-psoas.
Pectineus.
Ilio-tibial band.
Adductor longus.
Gracilis.
Vastus externus.
Sartorius.
Rectus femoris.
Vastus internus.
Band of Richer.

1
2
3
4
5
6
7
8
9
10
11
12
13
14
15
16
17
18
19
20

Sartorius.
Vastus exter.
Rectus femor.
Vastus intern.
Ilio-tibial band.
Band of Richer.

11 *Posterior border of ulna.*
12 *Extensor carpi radialis longior.*
13 *Extensor carpi ulnaris.*
14 *Extensor carpi radialis brevior.*
15 *Extensor communis digitorum.*

Extensors of thumb. 16
Tendon of Extensor carpi ulnaris. 17
Head of ulna. 18
Annular ligament of wrist. 19
Extensor secundi internodii pollicis. 20

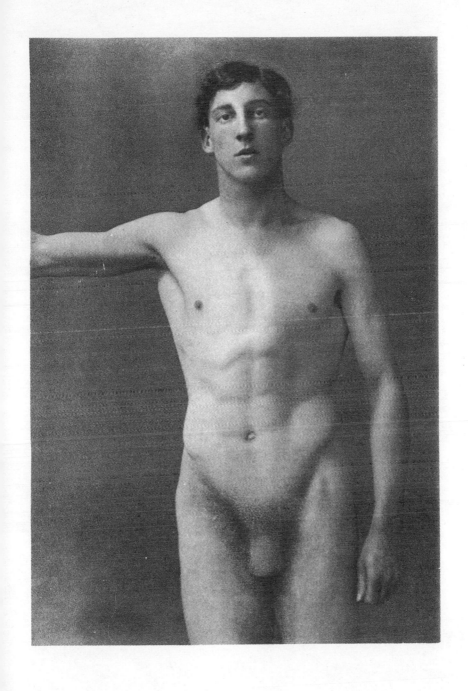

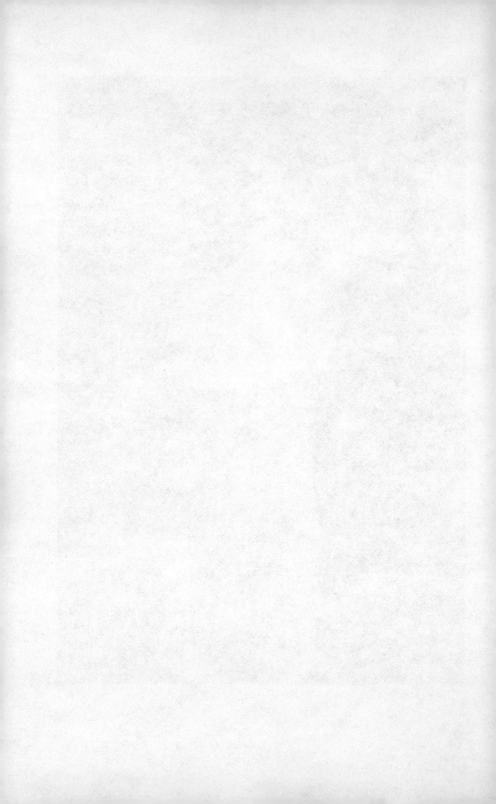

the attachments of the folds of the armpit to the limb. This elevation is distinct from, and lies behind, that formed by the upper portion of the biceps, and can be traced down along the inner side of the upper arm, gradually fading away about the middle of this portion of the limb. The muscle is most strongly marked in such positions as we see represented in pictures of the Crucifixion, but an examination of the plates on pp. 152, 158, 212, and 434 will sufficiently demonstrate the influence which it has on the surface forms. As will be seen, it is separated in front from the anterior wall of the armpit by the biceps, whilst behind it overlies the posterior fold just where the muscles which constitute that fold, viz. the latissimus dorsi and teres major, are inserted into the upper portion of the shaft of the humerus. The coraco-brachialis assists in raising the arm at the shoulder-joint; it also tends to turn the limb forwards and inwards towards the middle line of the body (Pls., pp. 148, 152, 158, 170, 176, 212).

Before passing to consider the muscles of the upper arm it will be necessary to describe the bones with which they are connected.

The *humerus*, or bone of the upper arm, has been in part described (Chapter V, p. 117), but its lower end must now be examined in greater detail.

The lower extremity of the humerus enters into the formation of the *elbow-joint*. This joint unites the bone of the upper arm with the two bones of the fore-arm. The latter lie side by side, and are called—the inner bone, the *ulna*, the outer bone, the *radius*.

The shaft of the humerus, which about its middle is more or less prismatic in section, becomes expanded inferiorly. It acquires a flattened form, and displays, as has been already stated, well-marked anterior and posterior surfaces, which are separated on the inner and outer sides by distinct margins. If traced downwards these margins will be

found to terminate in pointed processes called respectively the *inner* and *outer condyles*. Of these condyles the

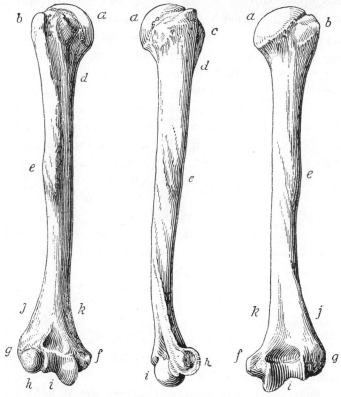

Right humerus.

FIG. 80. Front view. FIG. 81. Outer side. FIG. 82. Back view.

a. Head.
b. Greater tuberosity.
c Lesser tuberosity.
d. Bicipital groove.
e. Deltoid impression where deltoid muscle is inserted.
f. Internal condyle.
g. External condyle.

h. Capitellum for articulation with head of radius.
i. Trochlear surface for articulation with ulna.
j. External condyloid ridge.
k. Internal condyloid ridge.
These ridges afford attachment to the external and internal intermuscular septa respectively.

inner is the more prominent, whilst of the ridges leading to them (called *supra-condyloid* ridges) the outer is the

better marked. These ridges and processes are of great importance in affording attachment to numerous muscles and processes of fascia in this region. The part of the humerus which lies between the two condyloid processes is much thickened and is curved slightly forward. It is on this portion of the bone that the articular surfaces are placed by means of which it is jointed with the radius and ulna.

Just below the external condyle and to its inner side a smooth rounded surface, called the *capitellum* or little head, is noticed. This process, which lies more on the front of the lower extremity of the humerus than on its inferior aspect, is adapted to articulate with the shallow hollow on the upper end of the outer bone of the fore-arm (radius). To the inner side of this little articular head, the lower end of the humerus is grooved by a pulley-like surface which passes round it in a slightly spiral manner from back to front. This is called the *trochlea*, and is for articulation with the inner bone of the fore-arm (ulna). The trochlea is separated from the capitellum by a slight smooth ridge, whilst its inner border is defined by a well-marked and prominent edge. The latter is separated by a considerable interval from the internal condyle of the humerus, which lies above it and to its inner side. It is to this fact that the internal condyle owes its prominence.

As has been already stated, there are two bones in the fore-arm—the *radius* and the *ulna*. Now it must be borne in mind that these two bones are not immovably united, as is the case with the corresponding bones of the leg, but are freely movable on one another in certain directions. This may be best understood if we compare for a moment their relations to each other in different positions of the limb. If the arm be held with the palm of the hand directed upwards, the bones will be found to lie side by side and more or less parallel to each other, whereas if the hand be now turned so that the palm is directed downwards it will be observed

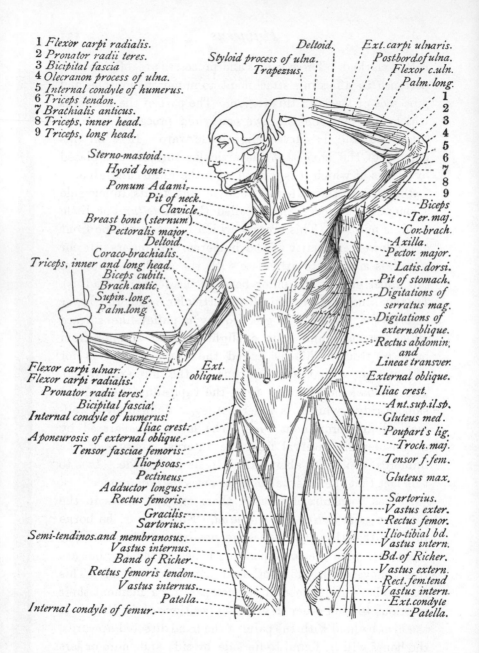

1 *Flexor carpi radialis.*
2 *Pronator radii teres.*
3 *Bicipital fascia*
4 *Olecranon process of ulna.*
5 *Internal condyle of humerus.*
6 *Triceps tendon.*
7 *Brachialis anticus.*
8 *Triceps, inner head.*
9 *Triceps, long head.*

Deltoid.
Styloid process of ulna.
Trapezius.
Ext. carpi ulnaris.
Postbord. of ulna.
Flexor c. uln.
Palm. long.

1
2
3
4
5
6
7
8
9

Sterno-mastoid.
Hyoid bone.
Pomum Adami.
Pit of neck.
Clavicle.
Breast bone (sternum).
Pectoralis major.
Deltoid.
Coraco-brachialis.
Triceps, inner and long head.
Biceps cubiti.
Brach. antic.
Supin. long.
Palm. long.

Biceps.
Ter. maj.
Cor. brach.
Axilla.
Pector. major.
Latis. dorsi.
Pit of stomach.
Digitations of serratus mag.
Digitations of extern. oblique.
Rectus abdomin. and Lineae transver.
External oblique.
Iliac crest.
Ant. sup. il. sb.
Gluteus med.
Poupart's lig.
Troch. maj.
Tensor f. fem.
Gluteus max.

Flexor carpi ulnar.
Flexor carpi radialis.
Pronator radii teres.
Bicipital fascia.
Internal condyle of humerus.
Iliac crest.
Aponeurosis of external oblique.
Tensor fasciae femoris.
Ilio-psoas.
Pectineus.
Adductor longus.
Rectus femoris.
Gracilis.
Sartorius.
Semi-tendinos. and membranosus.
Vastus internus.
Band of Richer.
Rectus femoris tendon.
Vastus internus.
Patella.
Internal condyle of femur.

Ext. oblique.

Sartorius.
Vastus exter.
Rectus femor.
Ilio-tibial bd.
Vastus intern.
Bd. of Richer.
Vastus extern.
Rect. fem. tend.
Vastus intern.
Ext. condyle.
Patella.

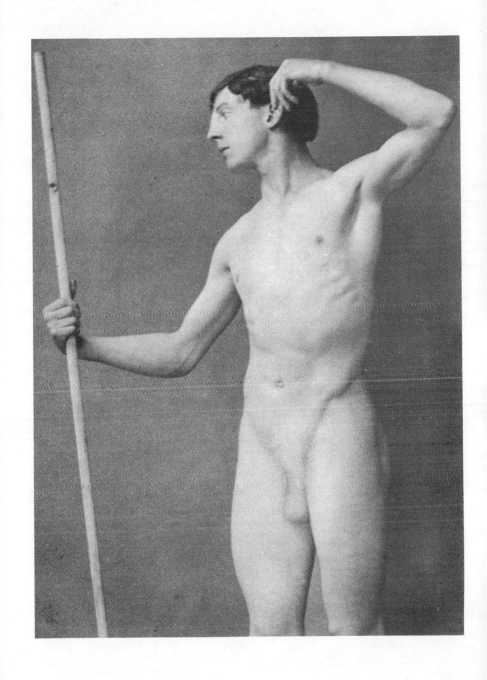

that the outer bone of the fore-arm passes to lie obliquely across the inner bone. In the former position the limb is described as being *supine*, in the latter, *prone*. The movement whereby the limb is turned from the supine to the prone position is termed *pronation*, the reverse action, viz. that which rotates the limb from the prone to the supine position, is called *supination*; these movements will require to be studied in detail later, but it is necessary that they should be referred to here, in order that the student may understand the forms of the articular surfaces of the two bones.

In comparing the two bones of the fore-arm it will be noticed that the upper extremity of the ulna is large, whilst its lower end is comparatively small. On the other hand, the upper end of the radius is small, whilst its inferior extremity is large and expanded. The student should associate with these details the fact that the ulna, or inner bone of the fore-arm, enters most largely into the formation of the elbow-joint, whilst the outer bone, or radius, plays the most important part in supporting the skeleton of the hand at the wrist-joint.

As it is with the muscles which move the fore-arm on the upper arm that we are at present concerned, it will be advisable to consider first the form of the bone of the fore-arm, which is most intimately associated with these movements.

The upper extremity of the *ulna* is large, and presents a very characteristic appearance. The most noticeable feature is a deep and well-marked notch, called the *greater sigmoid notch*, which lies between two prominent processes placed, one above, the other below it. The higher of these, called the *olecranon process*, lies in line with the upper end of the shaft. The posterior prominent angle of this process is a point of great importance, as it forms the tip of the elbow.

The lower or *coronoid process* is a wedge-shaped piece of bone which is united to the front of the upper extremity

of the shaft of the ulna, some little distance below the olecranon. The interval between the two processes corresponds to the notch already mentioned, and the surfaces of these processes, which bound the notch, are smooth and, in the living, coated with cartilage. If the ulna and the humerus are articulated, the surfaces of the greater sigmoid notch are seen to be admirably adapted to fit on the trochlear surface of the lower end of the bone of the upper arm.

A further examination of the upper end of the ulna reveals the fact that there is another articular surface to be studied in connexion with it. This is an oval hollow on the outer side of the coronoid process—called the *lesser sigmoid notch*—into which fits the thick margin of the rounded head of the upper end of the radius.

The shaft of the ulna is long and tapering; its upper part is prismatic on section, the various surfaces being separated by well-defined margins; of these, one, called the posterior border, is highly important. This border, commencing above by the fusion of two lines which enclose between them a **V**-shaped area on the back of the olecranon process, may be traced down along the posterior aspect of the shaft towards the lower extremity, where it gradually fades away, corresponding, however, in line and direction with a projection to be hereafter described as the *styloid* process. The line so formed describes a sinuous curve and corresponds to a well-marked furrow on the back of the fore-arm, which is known by the name of the *ulnar furrow*. The importance of this border of the bone is due to the circumstance that throughout its entire length it is subcutaneous, a fact which the student can easily verify for himself by running his finger firmly along the back of the fore-arm, commencing above at the tip of the elbow, and ending below at the prominence on the back and inner side of the wrist which lies in a line with the little finger.

The lower end of the ulna, curiously enough called the head, consists of a rounded thick button-like process, fused

Bones of right fore-arm.

FIG. 83. Front view. FIG. 84. Back view. FIG. 85. Outer side. FIG. 86. Inner side.

u. Ulna.
a. Olecranon process of ulna.
b. Coronoid process of ulna.
c. Greater sigmoid notch.
d. Attachment of brachialis anticus.
e. Triangular subcutaneous surface on back of olecranon process.
f. Styloid process of ulna.
g. Posterior subcutaneous border of ulna.

h. Lower end or head of ulna.
r. Radius.
i. Head of radius.
j. Bicipital tuberosity to which is attached the tendon of the biceps.
k. Placed near the insertion of the pronator radii teres.
l. Expanded lower end of radius, which articulates with the carpus.

m. Styloid process of radius.

on the extremity of the shaft. From the back and inner side of this head there projects downwards a prominent spur of bone called the *styloid process* of the ulna. The

further details of this portion of the bone will be studied in connexion with the description of the wrist.

The *radius*, or outer bone of the fore-arm, differs from the ulna or inner bone in being small above, and thick and expanded below. Moreover this bone is not as long as the ulna, which exceeds it by the length of the olecranon process.

The upper end of the radius is called the head. It too may be compared to a thick disk-shaped piece of bone fixed on the end of the shaft. The upper surface of this disk or head is slightly hollow, so as to fit on to the smooth rounded surface of the capitellum or little head of the humerus. The circumference of the disk is thick and rounded, and on its inner side is adapted for articulation with the lesser sigmoid cavity of the ulna, which we have already seen on the outer side of the coronoid process of that bone. The head of the radius can be distinctly felt beneath the skin in the dimple or depression which appears behind and towards the outer side of the elbow, when the fore-arm is straightened on the upper arm.

Below the head the shaft of the bone is constricted, but gradually expands as it passes downwards, becoming much thicker towards its lower extremity. About three-quarters of an inch below the head there is an outstanding osseous tubercle on the inner side of the shaft. This is called the *bicipital tubercle*, because the tendon of the biceps muscle is attached to it.

The shaft of the bone is so overlain by muscles that it has no direct influence on the surface contours of the fore-arm, though indirectly it reacts on the surface forms by supporting these muscles, and thus gives rise to great modifications in the general outline of the limb, according as its position is altered in the movements of pronation and supination already referred to.

The lower end of the bone is broad and expanded. It

enters largely into the formation of the wrist-joint, furnishing by its inferior articular surface a broad support for the bones of the wrist. The external border of this expanded inferior extremity is prolonged downwards in the form of a blunt-pointed projection, called the *styloid process* of the radius. This process, as well as the bone immediately around it, is subcutaneous and forms the prominence on the outer side of the wrist which lies in line with the thumb. An oval hollow, seen on the inner side of the expanded lower end of the bone, receives the thick margin of the rounded head of the ulna when the two bones are articulated.

These points will require further consideration when the movements of pronation and supination are discussed and when the anatomy of the wrist is considered.

There are few subjects which require more careful study than the elbow-joint. A knowledge of the shape and relations of the bones which enter into its formation is essential to enable the student to understand the alterations in form which depend on the movements of this joint.

The *elbow-joint* is a typical example of a hinge-joint. That is to say, movement takes place in one or other of two directions, either forwards or backwards—such movements being termed *flexion* and *extension*. In the former the forearm is bent forwards on the upper arm, in the latter the limb is straightened so that the fore-arm is brought nearly into line with the upper arm. The capsule which invests the joint is loose in front and behind, so as to allow freely of movements in those directions. At the sides of the joint, however, the capsule is strengthened by the addition of strong ligaments which prevent any lateral play.

As has been already stated, the ulna is the bone of the fore-arm which enters most largely into the formation of this joint. The sigmoid notch between the coronoid and olecranon processes is fitted on to the trochlear surface of the humerus, but as this notch is less in extent than the

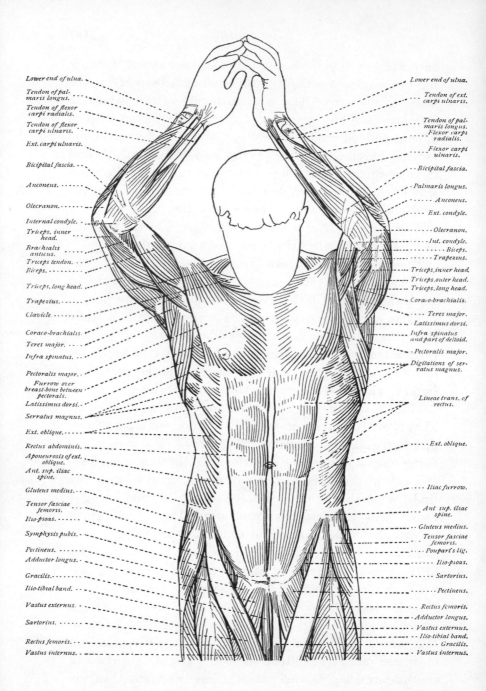

Lower end of ulna.
Tendon of palmaris longus.
Tendon of flexor carpi radialis.
Tendon of flexor carpi ulnaris.
Ext. carpi ulnaris.

Bicipital fascia.

Anconeus.

Olecranon.

Internal condyle.
Triceps, inner head.
Brachialis anticus.
Triceps tendon.
Biceps.

Triceps, long head.

Trapezius.

Clavicle.

Coraco-brachialis.
Teres major.
Infra spinatus.

Pectoralis major.
Furrow over breast-bone between pectorals.
Latissimus dorsi.
Serratus magnus.

Ext. oblique.

Rectus abdominis.
Aponeurosis of ext. oblique.
Ant. sup. iliac spine.

Gluteus medius.

Tensor fasciae femoris.
Ilio-psoas.

Symphysis pubis.

Pectineus.
Adductor longus.

Gracilis.

Ilio-tibial band.

Vastus externus.

Sartorius.

Rectus femoris.
Vastus internus.

Lower end of ulna.

Tendon of ext. carpi ulnaris.

Tendon of palmaris longus.
Flexor carpi radialis.

Flexor carpi ulnaris.

Bicipital fascia.

Palmaris longus.

Anconeus.

Ext. condyle.

Olecranon.

Int. condyle.
Biceps.
Trapezius.

Triceps, inner head.
Triceps, outer head.
Triceps, long head.

Coraco-brachialis.

Teres major.
Latissimus dorsi.

Infra spinatus and part of deltoid.

Pectoralis major.

Digitations of serratus magnus.

Lineae trans. of rectus.

Ext. oblique.

Iliac furrow.

Ant. sup. iliac spine.

Gluteus medius.

Tensor fasciae femoris.
Poupart's lig.

Ilio-psoas.

Sartorius.

Pectineus.

Rectus femoris.
Adductor longus.
Vastus externus.
Ilio-tibial band.
Gracilis.
Vastus internus.

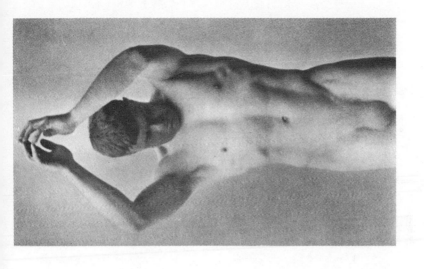

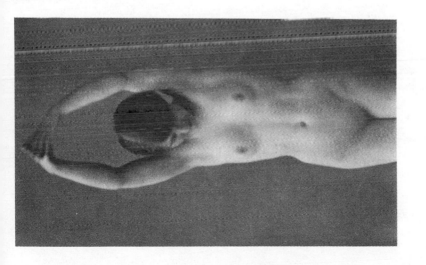

surface on which it rests, it follows that, in the movements of the joint, the notch is applied to different parts of the trochlea as the forward and backward movements are performed. Thus, when the limb is extended, i. e. straightened, the surfaces of the notch are in contact with the back and lower parts of the trochlea, whereas, when the elbow is forcibly bent, the notch is in contact with the anterior and inferior aspects of the trochlea.

The processes, which bound the notch above and below, are prominent and outstanding, and some arrangement is necessary to prevent them unduly limiting the range of movement of the joint. Above the trochlear surface of the humerus, both in front and behind, the bone is hollowed out to form two fossae. That in front is called the *coronoid fossa*; the one behind, the *olecranon fossa*. When the limb is extended the anterior and upper border of the olecranon process lies in the olecranon fossa, whilst in the bent position

FIG. 87. Front view of the elbow-joint. The head of the radius has been drawn away from the collar-like ligament (*i*) which holds it in position.

r. Radius. *u.* Ulna.
a. Trochlear surface of humerus.
b. Capitellum.
c. Head of radius.
d. Coronoid process of ulna.
e. Internal condyle of humerus.
f Coronoid fossa of humerus.
g. External condyle of humerus.
h. External lateral ligament.
i. Orbicular ligament.
j. Lesser sigmoid notch of ulna into which head of radius fits.
k. Surface for the attachment of the brachialis anticus.
l. Bicipital tuberosity of radius to which the tendon of biceps is attached.

the prominent lower border of the great sigmoid notch, formed by the coronoid process, occupies the coronoid fossa.

The movements of flexion and extension of the fore-arm are effected by the sigmoid notch being drawn over the trochlea of the humerus, but as the radius is united to the ulna by means of certain joints it follows that as the ulna moves it carries with it the radius. It has been already stated that the upper surface of the head of the radius is hollowed out to adapt it to fit the capitellum or small head of the humerus, but as this latter articular surface is placed more on the front, than on the lower aspect of the inferior extremity of the humerus, it results that the radius is but slightly in contact with this surface of the humerus when the limb is fully extended. When the elbow is bent, however, the head of the radius is more closely applied to the capitellum. The surfaces just described are so arranged as to permit not only of movements in a backward and forward direction, but also of movements of rotation of the head of the radius on the capitellum. This movement of the radius is possible in all positions of the limb, but is best controlled and most efficiently employed when the elbow is bent, for under these conditions the head of the radius fits more accurately on the capitellum and is therefore better supported.

These facts are borne out by experience. It is in the movements of pronation and supination, already incidentally referred to, that the rotation of the head of the radius takes place. When we make use of these movements, and desire to employ a considerable amount of force, we are accustomed to do so with the arm bent, as in the acts of inserting a corkscrew or using a screwdriver, for in this position of the limb the head of the radius is well supported by the capitellum. But, whilst this is the case, the student must not overlook the fact that the same movements may be performed with the limb extended, as in fencing, or when we lift and twist anything about; in the latter act, however, it will be

obvious that the joint is subjected to a tearing rather than a crushing strain.

It is necessary to consider the movements of flexion and extension of the elbow more carefully. Were the movements as simple as have been described, one would naturally expect that when the fore-arm is bent on the upper arm the anterior surfaces of the two parts of the limb would be brought into contact; that this is not the case, the student can easily demonstrate for himself. If the arms be extended by the sides of the trunk with the palms of the hands directed forwards, and the fore-arms be then bent upwards without any conscious restraint, the elbows being still kept in contact with the sides of the chest, it will be found that the hands will fall naturally in a crossed position on the front of the breast, and not, as one might reasonably expect, over the shoulders of the corresponding limbs. This will be obvious if the attempt is made to touch the shoulder with the hand of the same side, while the upper arm is still closely applied to the side of the body : the effort will prove that the action is a very constrained one.

If the arms be again extended by the side, in the manner above described, i. e. with the palms directed forwards, another point will be noticed. The fore-arms appear splayed on the upper arms; in other words, the axis of the fore-arm when viewed from the front is not in line with the axis of the upper arm, but forms with it an obtuse angle. Why this is not as a rule apparent is due to the fact that when we carry our limbs by the sides of our body we usually have the palms of the hands directed inwards towards the sides of the thighs, as in the military position of attention; in this attitude the bones of the fore-arm are in a state midway between supination and pronation, a position which so modifies the direction of the axis of the fore-arm as to bring it directly in line with the axis of the upper arm, and thus cause the disappearance of the

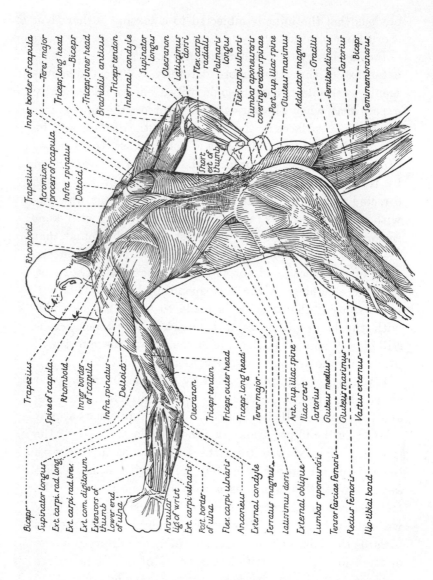

Biceps

Supinator longus

Ext. carpi. rad. long.

Ext. carpi rad. brev.

Ext. com. digitorum

Extensors of thumb

Lower end of ulna

Annular lig of wrist

Ext. carpi ulnaris

Post. border of ulna

Flex. carpi ulnaris

Anconeus

External condyle

Serratus magnus

Latissimus dorsi

External oblique

Lumbar aponeurosis

Tensor fasciae femoris

Rectus femoris

Ilio-tibial band

Trapezius

Spine of scapula

Rhomboid

Inner border of scapula

Infra-spinatus

Deltoid

Olecranon

Triceps tendon

Triceps, outer head

Triceps. long head

Teres major

Ant. sup. iliac spine

Iliac crest

Sartorius

Gluteus medius

Gluteus maximus

Vastus externus

Rhomboid

Trapezius

Acromion process of scapula

Infra-spinatus

Deltoid

Short ext of thumb

Inner border of scapula

Teres major

Triceps. long head

Biceps

Triceps, inner head

Brachialis anticus

Internal condyle

Supinator longus

Olecranon

Latissimus dorsi

Flex. carpi radialis

Palmaris longus

Flex carpi ulnaris

Lumbar aponeurosis covering erector spinae

Post. sup. iliac spine

Gluteus maximus

Adductor magnus

Gracilis

Semitendinosus

Sartorius

Biceps

Semimembranosus

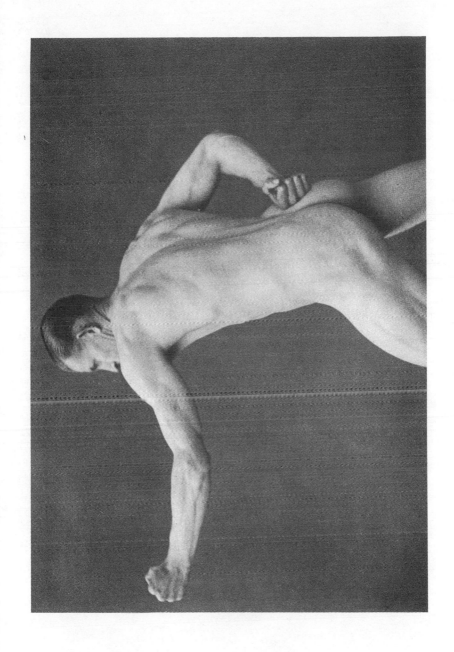

obtuse angle alluded to. To represent this angle has been regarded by many as offensive and inartistic; at the same time it must be borne in mind that the condition is a perfectly natural one, and the action in which it is most pronounced is by no means unfrequently employed by many as a gesture which is usually associated with an obsequious manner.

The explanation of the above facts is to be found in the form of the articular surfaces by which the humerus and

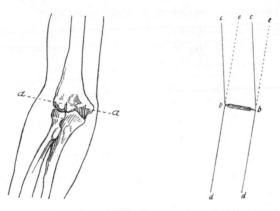

FIG. 88. Diagram to illustrate the manner in which flexion of the elbow affects the limb.

a a The axis of rotation of the joint is placed obliquely to the long axis of the humerus.
c c and *d d.* Represent two pieces of wood hinged together obliquely at *b b.* When *d d* is bent upon *c c* it occupies the position represented by the dotted lines *e e.*

ulna are united. The student will best understand this by a reference to the accompanying diagrams (Fig. 88). These do not account for all the movements which take place at the elbow, but they at least render clear the cause of the obtuse angle when the limb is extended and the crossing inwards when the fore-arm is bent. As will be seen, this is due to the fact that the axis of rotation of the hinge is not placed at right angles to the axis of the upper segment of the limb, but obliquely to it. The dotted line in the

figure represents the position which the lower segment of the two hinged pieces would occupy if it was bent on the upper.

The influence of the bones of the elbow-joint on the surface forms must now be studied. Of the two condyles of the humerus the internal is the more prominent, and can be readily felt and seen on the inner side of the elbow. The external, not nearly so pronounced on the bone, can be felt from the surface, but causes no corresponding projection, because the muscles which rise from the ridge leading to it are so fleshy as completely to mask its form (Pls., pp. 170, 200). Its position, however, is clearly indicated by an inter-muscular furrow which lies behind and to the outer side of the elbow between the muscles already spoken of and others which rise from the back of the external condyloid process. This furrow in the muscular male is clearly defined by the margin of the outstanding muscles on either side, but in the female and child, owing to the larger quantity of sub-cutaneous fat, it is replaced by a dimple (Pl., p. 262). If the finger be placed in the upper part of this furrow the back of the external condyle can be distinctly felt, whilst imme-diately below it the finger will readily recognize the head of the radius (Pls., pp. 50, 162, 200).

The olecranon process of the ulna is a feature of great importance in connexion with the surface forms of the elbow, a circumstance due, not only to its prominence, but also to its mobility. The projection of the hinder and upper part of this process forms the tip of the elbow. When the arm is fully extended this point of the bone lies on a level with a line, drawn across the back of the joint, connecting the two condyloid processes. When the arm is bent, the tip of the elbow becomes more prominent and descends to a much lower level. In the position of the limb in which the fore-arm is flexed on the upper arm at a right angle, the tip of the olecranon lies in direct line with

the axis of the humerus, and from an inch to an inch and a half, according to the size of the bones, below the level of the internal condyle. These points, if viewed from behind with the arm in this position (Fig. 91), will be seen to form a triangle, of which the base corresponds to an imaginary line connecting the two condyloid processes of the humerus, the apex being formed by the tip of the olecranon.

If flexion of the fore-arm be carried to a greater extent,

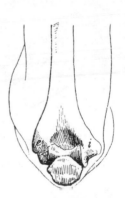

Bones of the left elbow.

Fig 89. As seen from the front when the joint is extended.

Fig. 90. As seen from behind when the joint is extended.

Fig. 91. As seen from behind when the joint is bent to a right angle.

e. External condyle. i. Internal condyle.

the tip of the olecranon will advance further, and the outline of this process will be rendered more distinct.

The back of the olecranon process forms a triangular surface which is bounded on either side by bony ridges; these gradually coalesce inferiorly to form the posterior border of the shaft of the ulna. The triangular surface of bone included between the two lines is uncovered by muscle and immediately underlies the skin; it can be

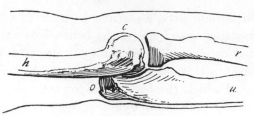

FIG. 92. View of the bones of the right elbow from the outer side
with the joint extended.

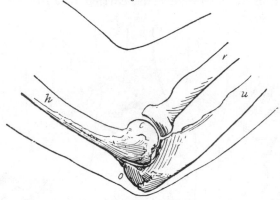

FIG. 93. View of the bones of the right elbow from the outer side
with the joint slightly bent.

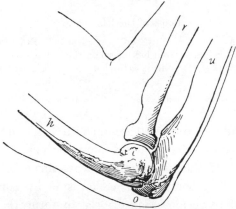

FIG. 94. View of the bones of the right elbow from the outer side
with the joint still further bent.

h. Humerus.	*r*. Radius.	*u*. Ulna.
c. Capitellum of humerus.		*o*. Olecranon process of ulna.

easily felt, and is limited above by the pointed extremity of the olecranon, whilst below it becomes continuous with the ulnar furrow which corresponds, on the surface, to the posterior border of the ulna.

The movements of which the elbow-joint is capable are those of flexion and extension. The former is effected by the contraction of the muscles of the front of the upper arm, and is checked by the opposition of the soft parts which clothe the anterior aspect of the limb. Extension is due to the contraction of the triceps, a muscle lying on the back of the upper arm, and is limited by the gradual tightening of certain ligaments which prevents any further movements of the bones, especially when the action is a violent one. The extent to which this movement may take place varies in different individuals; in some, owing to a greater laxity of the ligaments and to modifications in the form of the bones, a certain amount of hyper-extension is possible. This gives rise to an unpleasant appearance, for the fore-arm appears as if bent back on the upper arm.

The muscles which control the movements of the elbow-joint must now be described; they form the fleshy masses on the front and back of the upper arm. Beneath the skin and subcutaneous fat of the arm a sheath of fascia invests the entire limb. This *fascial sheath* may be compared to a tight-fitting sleeve. Above, it is continuous with the fascia covering the shoulder and the layer which forms the floor of the armpit; at several points corresponding to the attachment of the muscles which form the anterior and posterior folds of the armpit, it receives considerable additions by means of fibrous strands derived from the tendons of insertion of these muscles. These fibrous bands mask to some extent the borders of the tendons of insertion of these muscles, and render more flowing the outline of the axillary folds, where they become blended with the surface contours of the upper arm.

A closer inspection of this fibrous sheath reveals the fact that in the upper arm it is subdivided by partitions, which pass from it, one on either side, to become attached to the ridges of bone which have been already seen to extend upwards on each side of the shaft of the humerus from the internal and external condyloid processes.

These partitions are called the *intermuscular septa, internal* and *external*, according as they lie along the inner or outer side of the limb. The result of this arrangement is that the sleeve or sheath is divided into two compartments, in the anterior of which are lodged the muscles which bend the elbow, and which are known as the flexor group, whilst occupying the posterior compartment is the extensor mass. The intermuscular septa are structures of some importance as determinants of surface forms, but their influence in this respect will be better studied when the actions of the various muscles have been considered.

Of the flexors of the fore-arm there are two which may now be conveniently studied. There are other muscles which assist in performing these movements, but the description of them is for the time delayed. The two referred to are the *brachialis anticus* and the *biceps* of the arm.

The *brachialis anticus* is the deeper as well as the smaller ; it passes directly over the front of the elbow-joint, arising from the humerus above and passing to the ulna below. It takes origin from the front of the lower half of the shaft of the humerus, as well as from the intermuscular septa, more particularly that on the inner side ; superiorly its fibres lie on either side of the insertion of the deltoid. The fleshy fibres of the muscle diverge above, but converge below towards the insertion, which is into the front of the coronoid process of the ulna. The widest part of the muscle lies at some little distance above the elbow.

The brachialis anticus is overlain by the biceps muscle, but as the latter is narrower than the former the fibres of

the brachialis are exposed, both on the inner and outer aspects of the front of the limb. Along the outer side of the upper arm the fibres of the brachialis are seen lying in the interval between the biceps in front, the external intermuscular septum and the outer head of the triceps behind, the insertion of the deltoid above, and the origin of a muscle called the supinator longus below (Pls., pp. 38, 58, 62, 104, 126, 148, 152, 162, 170, 182, 200, 382, 434). Along the inner aspect of the upper arm the fibres are visible between the biceps in front, the internal intermuscular septum and inner head of the triceps behind, and the origin of the pronator radii teres muscle below (Pls., pp. 44, 158, 162, 170, 176, 182, 212, 434). In both these situations the muscle is superficial, and, during powerful contraction, may directly influence the surface forms. In action it will also push forward the lower part of the biceps, which lies upon it, and so indirectly exert an influence on the superficial contours.

The muscle acts as a flexor of the fore-arm; by its insertion into the coronoid process of the ulna it draws the sigmoid articular area over the trochlear surface of the humerus.

The *biceps flexor cubiti*, or biceps of the arm, belongs to that group of muscles which has been described as indirect in their action. Under normal conditions it has no attachment to the humerus whatever, but arises from the shoulder-blade. This it does by two tendons, one of which, called the *long head*, springs from the blade-bone just above the articular surface (glenoid fossa) for the head of the humerus; the other, or *short head*, arises along with the coracobrachialis (as has been already described at the beginning of this chapter) from the coracoid process of the shoulder-blade.

These tendons lie under cover of the muscles which form the cap of the shoulder, and it is just before they appear

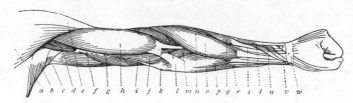

PRONE

a.	*Pectoralis major.*	*i.*	*Internal intermuscular septum.*
b.	*Latissimus dorsi.*	*j.*	*Brachialis anticus.*
c.	*Teres major.*	*k.*	*Internal condyle of humerus.*
d.	*Coraco-brachialis.*	*l.*	*Bicipital fascia.*
e.	*Deltoid.*	*m.*	*Pronator radii teres.*
f.	*Triceps, long head.*	*n.*	*Extensor carpi radialis longior.*
g.	*Triceps, inner head.*	*o.*	*Supinator longus.*
h.	*Biceps cubiti.*	*p.*	*Flexor carpi radialis.*

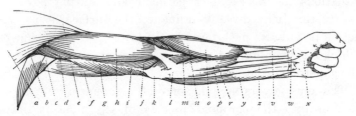

MIDWAY BETWEEN THE PRONE AND SUPINE POSITIONS

q.	*Extensor carpi radialis brevior.*	*w.*	*Annular ligament of wrist.*
r.	*Palmaris longus.*	*x.*	*Palmar fascia.*
s.	*Tendons of radial extensors.*	*y.*	*Flexor carpi ulnaris.*
t.	*Common extensor of fingers.*	*z.*	*Flexor sublimis digitorum.*
u.	{ *Extensor ossis metacarpi pollicis.*	*1.*	*Triceps tendon.*
	Extensor primi internodii pollicis.	*2.*	*Olecranon process of ulna.*
v.	*Extensor secundi internodii pollicis.*	*3.*	*Styloid process of ulna.*

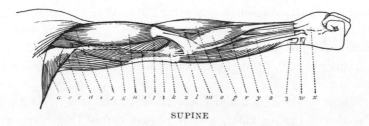

SUPINE

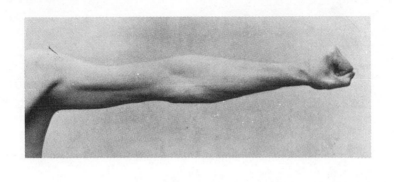

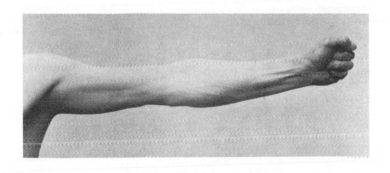

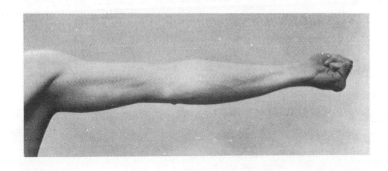

beneath the anterior fold of the armpit that they become fleshy. Each tendon is provided with a belly, hence the name of the muscle, but these bellies are so closely applied the one to the other that we may disregard their separate existence and consider only their combined fleshy mass (Fig. 79, p. 147).

At the upper part of the limb this appears as it escapes below the margin of the pectoralis major, which here forms the anterior fold of the armpit; gradually increasing in bulk, the muscle attains its maximum thickness about the middle of the upper arm. Below this point the fibres are gathered together to end in a powerful tendon, part of which passes by a ribbon-like expansion to be inserted into and blended with the fascia of the fore-arm which over-lies the muscles which spring from the inner condyle of the humerus. The remainder, by far the stronger portion, is continued downwards as a thick rounded tendon, which is inserted into the bicipital tubercle of the outer bone of the fore-arm (radius). In form the muscle may vary consider-ably in different individuals, a difference not dependent on its development from exercise or otherwise, but due to the arrangement of its component parts. Thus in some the muscular fibres are long and the tendinous portions are relatively short, whilst in others the fleshy belly of the muscle is short and the tendons are long. The influence of these varieties of the muscle on the surface form may be better understood by a reference to the condition met with in the calf of the leg. It is a matter of common knowledge that the form of the leg differs much in different persons; in many the prominence of the calf is situated high up on the back of the leg, whereas in others the swelling of the calf reaches lower down and imparts a much more clumsy appearance to the ankle. This is entirely due to differences in the length of the fleshy bellies of the muscles which are placed on the back of the leg.

In considering the relations of the biceps to the surface the student must bear in mind that the muscle is in great part superficial. It is only at its upper and lower attachments that it is concealed from view. Above, the anterior fold of the armpit covers the tendons of origin of the muscle. Below, the tendon of insertion sinks deeply between the muscles of the fore-arm (Pls., pp. 58, 62, 72, 86, 126, 148, 152, 158, 170, 176, 182, 200, 212, 382, 434).

The greater part of the fleshy belly of the muscle is therefore superficial, and it is to this that the rounded form of the front of the upper arm is due. The form of the belly of the muscle is such that its thickness is greater than its width; hence the diameter of the upper arm is greater from before backwards than from side to side. As has been already said, the width of the belly of the biceps is not sufficient to conceal entirely the brachialis anticus on which it rests, so that a portion of the latter muscle is exposed on either side of it (Pls., pp. 72, 170).

The outer and inner borders of the biceps are defined by two shallow furrows which run down one on either side of the front of the upper arm. The outer furrow corresponds superiorly to the interval between the deltoid and biceps, whilst below, where it is usually well marked, it overlies the interval between the biceps above and to the inner side, and the supinator longus below and to the outer side. The middle part of this furrow, which is less well marked, overlies the external intermuscular septum, and it is here that fibres of the brachialis anticus are brought into direct relation with the surface (see *ante*). These facts will be clearly demonstrated by a reference to Pls., pp. 58, 62, 72, 148, 170, 176, 182, 212, 216.

The surface furrow along the inner side of the upper arm corresponds to the inner border of the biceps muscle. Above, it may be traced into the hollow of the armpit, though in certain positions of the limb, viz. when the arm

is uplifted, the prominence due to the coraco-brachialis will interrupt it to some extent. The bottom of this furrow corresponds to the brachialis anticus muscle and the internal intermuscular septum, whilst the posterior margin of the furrow is due to the prominence of the triceps muscle on the back of the arm. Below, it blends with the surface in front of the elbow. The aponeurotic insertion of the biceps into the fascia of the fore-arm bridges across the interval which would otherwise exist between the biceps and the muscles of the fore-arm arising from the internal condyle of the humerus. The furrow along the inner side of the upper arm is much less marked than what we would expect from a study of the muscles alone, because the great blood-vessels and nerves which supply the arm lie along the limb in this situation (Pls., pp. 148, 152, 170, 176, 182, 212).

The biceps muscle, from its connexion with the radius, acts as a powerful flexor of the fore-arm, but it also assists in raising the arm at the shoulder-joint, as it derives its origin from the shoulder-blade. Its action as a flexor of the fore-arm is modified by the position of the radius at the commencement of the act; for if the radius, which is the bone principally concerned in the movements of pronation and supination, be crossed over the ulna or inner bone of the fore-arm, as in the prone position, the first effect of the contraction of the biceps will be to supinate the limb. The muscle is therefore a powerful supinator as well as a flexor of the fore-arm. The action of the biceps as a supinator may be easily demonstrated as follows:— Bend the elbow until the fore arm forms a right angle with the upper arm, then rotate the bones of the fore-arm in such a way as to direct the palm of the hand upwards and downwards, or backwards and forwards, as the case may be. The biceps will be most powerfully contracted when the limb is in the supine position, i. e. with the palm of the hand upwards, much less so when in the prone position.

The fleshy mass which is placed on the back of the upper arm acts as an extensor muscle of the fore-arm: it is called the *triceps*, and, as its name implies, arises by three heads, which are distinguished as the *inner*, the *outer*, and the *middle* or *long head*. The two former arise from the humerus; the latter springs from the outer margin of the blade-bone, just below the shallow socket which receives the head of the humerus (Pls., pp. 38, 44, 50, 52, 94, 98, 104, 126, 158, 162, 176, 182, 200, 212, 382). These three fleshy masses are attached inferiorly to an aponeurotic tendon, from an inch to an inch and a half wide, which reaches as high as the middle of the back of the upper arm. By means of this tendon the muscle is inserted into the hinder part and outer border of the olecranon process, a few of the fleshy fibres of the inner head of the muscle being directly connected with the olecranon without the intervention of tendinous fibres. As the fleshy mass of the muscle overlies the back of the shaft of the humerus, it is brought into relation with the inter-muscular septa which have been already described. From the posterior surface of these septa the outer and inner heads of the muscle derive fibres of origin. It will thus be seen that these septa lie between the brachialis anticus muscle in front and the triceps muscle on the back of the upper arm, one septum along the inner, the other along the outer side of the limb.

The triceps is superficial except at the upper part of the limb, where the deltoid covers a part of the long head as well as the highest attachment of the outer head.

The surface contours of the back of the upper arm depend on the arrangement of the fibres of the triceps, and the distinction between its several parts is most apparent when the muscle is in a state of powerful contraction. In this condition the contrast between the fleshy and tendinous parts of the muscle is at once apparent. The area overlying the tendinous part forms an elongated flattened surface,

passing up the centre of the back of the limb from the tip of the elbow below to a point above corresponding pretty closely to the middle of the length of the upper arm. On either side of and above this flattened area, the bulging produced by the contraction of the fleshy fibres is seen. The most noticeable contour is that caused by the attachment of the outer head of the muscle to the tendinous part; this forms a well-marked oblique furrow, which repeats at a lower level that due to the hinder border of the deltoid as it passes across the upper part of the limb (Pls., pp. 50, 104, 122, 162, 200, 212).

On the inner side of the limb, separation of the long from the inner head is indicated by a furrow which passes obliquely downwards and backwards across the hinder and inner aspect of the upper arm from a point about its middle towards the inner border of the tendinous part of the muscle (Pls., pp. 44, 162, 176, 212).

The muscle acts as a powerful extensor of the fore-arm on the upper arm. Owing to the attachment of the long head to the blade-bone, this part of the muscle also assists in drawing down the elevated limb.

Mention may now be made of a muscle called the *anconeus*, which, whilst it might well be described with the muscles of the back of the fore-arm, is better considered here, as it is intimately associated with the triceps.

The *anconeus* has a triangular outline, and fills up the interval between the back of the external condyle, the outer border of the olecranon process, and the upper part of the shaft of the ulna. It thus overlies to a slight extent the back of the head of the radius. The muscle arises from the posterior surface of the external condyle of the humerus by a pointed tendinous attachment. The fibres spread out in a fan-shaped manner; the upper, almost horizontal, cross inwards to be attached to the outer margin of the olecranon, whilst the lower pass, with varying degrees of obliquity, to

be inserted into the posterior border of the ulna along its outer margin. The extent of this attachment varies somewhat, but, generally speaking, may be said to correspond to the upper third or fourth of the length of the bone.

The muscle is held down by an expansion derived from the outer side of the tendinous insertion of the triceps. At its origin the anconeus is directly related to the muscles which arise from the front and outer side of the external condyle, and the interval between it and these muscles corresponds to the depression to which attention has already been directed in considering the surface relations of the parts about the elbow.

The general lie of the muscle may best be understood by a reference to Pls., pp. 50, 52, 162, 176, 200, 212. It acts, along with the triceps, in extending the fore-arm.

The influence of the foregoing muscles on the surface form of the limb has been already considered, but reference may now be made to the intermuscular septa which have been previously described. Of these the more important, as a determinant of surface form, is the external. When the muscles are powerfully contracted and the limb is flexed, the margin of the external septum forms a well-defined ridge, which passes up from the external condyloid process. An important group of muscles, which will be described in the next chapter, arises from the front of this septum as well as from the front of the external condyle. When the limb is straight these muscles overlie the condyle and so partially mask its form, but with the elbow bent and the muscles powerfully contracted the condyle is uncovered and the attachment of the external intermuscular septum to it is more plainly seen, as is shown in Pls., pp. 176, 182, 212. In this position the surface ridge, corresponding to the sharp edge of the septum, lies between the external head of the triceps and the muscles of the fore-arm which arise from its anterior surface.

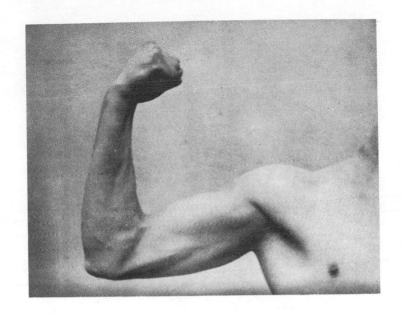

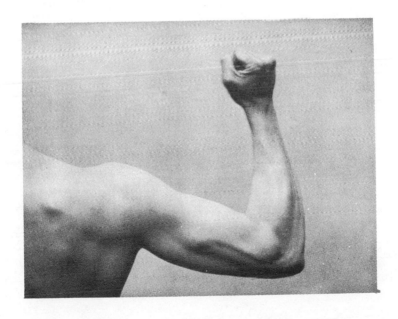

The internal intermuscular septum does not produce so pronounced a surface elevation, but its position may be readily recognized on the inner side of the upper arm when the elbow is bent and the muscles are powerfully contracted. Under these conditions it may be traced upwards from the prominent internal condyle as a rounded elevation which separates the triceps behind from the brachialis anticus in front (Pls., pp. 44, 152, 162, 176, 182, 212).

CHAPTER VII

As has been already pointed out, the two bones which form the skeleton of the fore-arm are jointed together in a manner different from that of the corresponding bones of the lower limb. In the leg, the bones are bound together in such a way that they cannot possibly move on one another, whilst in the fore-arm they are united so that one of them may rotate round the other. The importance of this arrangement cannot be overlooked when we consider how much this movement enhances the utility of the hand. By its means we are enabled to perform such acts as inserting a corkscrew or turning a screw-driver: it permits us with ease to make use of any screwing action of the hand. We employ it every time we turn the handle of a door.

These movements are termed *pronation* and *supination*.

Let us endeavour to analyse them in their simplest form. With the elbow by the side, and the fore-arm bent on the upper arm at a right angle, we can control the movement of the hand so that the palm is directed upwards. In this condition the limb is said to be *supine*. A careful examination of the limb in this position will reveal the fact that the two bones of the fore-arm are lying side by side, the radius externally, the ulna internally. The form of the fore-arm is such that it is thicker from side to side than from before backwards. Whilst still retaining the elbow by the side, the hand may be turned so that the palm is directed downwards; the limb is now placed in the *prone* position, performing at the same time the movement of

pronation. Coincident with this change in the position of the palm some remarkable alterations in the arrangement of the parts of the fore-arm are to be noted. The bones no longer lie side by side, since the outer bone or radius is now directed obliquely across the front of the ulna or inner bone. The head of the radius still retains its relation to the outer side of the upper extremity of the ulna, but the lower end of the radius is placed to the *inner* side of the lower extremity of the ulna. The shaft of the radius therefore passes obliquely across the front of the shaft of the ulna. As has been stated in the previous chapter, the lower end of the radius is large compared with that of the ulna. As a consequence of this it enters more extensively into the formation of the wrist-joint, and, playing as it does so important a part in the formation of the joint by means of which the hand is articulated with the fore-arm, it follows that when the radius moves it carries with it the hand. Now when the radius is lying parallel to and along the outer side of the ulna the palm of the hand is directed upwards and the thumb lies to the outer side, but when the radius has moved so as to lie obliquely across the front of the ulna it causes the hand to turn, so that the palm is directed downwards and the thumb inwards.

This change in the position of the radius is associated with marked alterations in the form of the fore-arm. As we have already seen, the greatest thickness of the limb with the hand in the supine position is from side to side. When however the radius lies across the front of the ulna, the flatness of the front of the fore-arm disappears, and the greatest thickness of the limb is now from front to back. This alteration in form is primarily due to the change in the relative position of the bones, but as the radius is covered by the powerful muscles which form the fleshy mass along the outer side of the fore-arm, it results that

when this bone changes its position it carries them with it, and thus brings about a further modification of the surface forms.

When the limb is in the prone position, i. e. with the palm directed downwards, we can reverse the action and bring the palm upwards again. This is the movement of *supination*.

Pronation and supination, therefore, are movements whereby we may rotate the axis of the hand through an arc of 180°, or about half a circle.

But if the student will repeat the movement already described, and, in addition, will now extend the elbow, the palm of the hand, which was in the first instance directed downwards, will, now the limb is straightened by the side of the body, be directed backwards. In the first position we had no further power of rotating the hand, but when the axis of the fore-arm is brought into line with the axis of the upper arm the hand can be turned further round, so that the palm is directed outwards. There is thus a considerable gain, for, whilst we were only able to rotate the hand through 180° with the elbow bent, now that the limb is straightened we can rotate the hand to the extent of 270°, i. e. through three-quarters of a circle. The explanation of this difference is simple. Superadded to the movements of pronation and supination, movements which are confined to the fore-arm, there is the further advantage of bringing into play the power of rotation at the shoulder-joint; this enables us to turn the humerus, and the bones of the fore-arm along with it, and so leads to a rotation of the entire limb.

These two movements must be kept quite distinct in the mind of the student, as well as the fact that they can only be associated when the limb is straight, i. e. with the elbow extended. The best example of this combination of the two actions is seen in certain of the thrusting and parrying movements in fencing.

Confining our attention strictly to the movements of pronation and supination, it is necessary to study the mechanism by which they are effected.

As will be remembered from the description given in the previous chapter, the head of the radius is like a thick disk of bone united to the upper extremity of the shaft. The margin of this disk is coated with articular cartilage, and fits into the oval hollow on the outer side of the coronoid process of the ulna, called the lesser sigmoid notch, where it is held in position by a collar or band, called the *orbicular ligament* (Fig. 95). This ligament, whilst it does not interfere with the rotation of the head of the radius within it, serves to retain the head of the bone in contact with the articular surface of the lesser sigmoid notch. Another important point to remember is that the external lateral ligament of the elbow-joint, instead of being connected with the head of the radius, is attached to the orbicular ligament, so

FIG. 95. A view of the bones of the right elbow with the head of the radius withdrawn from the lesser sigmoid notch and the orbicular ligament.

a. Trochlear surface of humerus.
b. Capitellum.
c. Head of radius.
d. Coronoid process of ulna.
e. Internal condyle of humerus.
f. Coronoid fossa of humerus.
g. External condyle of humerus.
h. External lateral ligament of elbow.
i. Orbicular ligament.
j. Lesser sigmoid notch.
k. Surface of attachment of brachialis anticus.
l. Bicipital tubercle of radius.
r. Radius.
u. Ulna.

that the rotation of the radius at this joint is in no way interfered with. These points are better shown in the

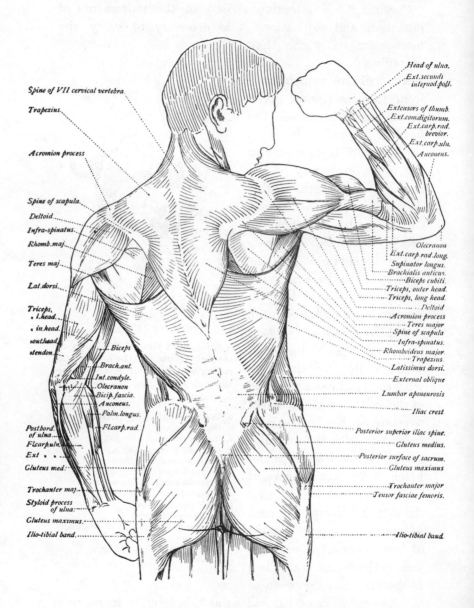

Spine of VII cervical vertebra.

Trapezius.

Acromion process.

Spine of scapula.

Deltoid.

Infra-spinatus.

Rhomb. maj.

Teres maj.

Lat. dorsi.

Triceps,
. l. head.
. in. head.
outhead.
stendon.

Biceps.

Brach. ant.

Int. condyle.

Olecranon.

Bicip. fascia.

Anconeus.

Palm. longus.

Fl. carp. rad.

Postbord.
of ulna.

Fl. carp. uln.

Ext . .

Gluteus med.

Trochanter maj.

Styloid process
of ulna.

Gluteus maximus.

Ilio-tibial band.

Head of ulna.

Ext. secundi
internod. poll.

Extensors of thumb.
Ext. com. digitorum.
Ext. carp. rad.
brevior.
Ext. carp. uln.
Anconeus.

Olecranon
Ext. carp. rad. long.
Supinator longus.
Brachialis anticus.
Biceps cubiti.
Triceps, outer head.
Triceps, long head.
Deltoid
Acromion process
Teres major
Spine of scapula
Infra-spinatus.
Rhomboideus major.
Trapezius.
Latissimus dorsi.
External oblique

Lumbar aponeurosis

Iliac crest

Posterior superior iliac spine.
Gluteus medius.
Posterior surface of sacrum.
Gluteus maximus

Trochanter major
Tensor fasciae femoris.

Ilio-tibial baud.

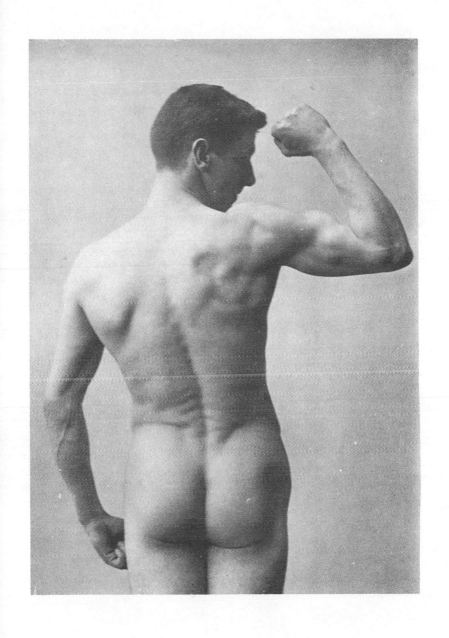

illustrations, the first of which (Fig. 95) shows the bones
of the elbow-joint, with the head of the radius withdrawn
from the orbicular ligament and lesser sigmoid notch. Fig.
96 (1.) represents a section through the upper ends of the
bones of the fore-arm, and shows how the head of the radius
is surrounded by the orbicular ligament.

Turning to the lower ends of the bones, we note first the
fact that the lower extremity of the radius is much larger
than the lower end (or head) of the ulna. On that side
of the enlarged extremity of the radius which is directed
towards the head of the ulna we observe a hollow articular
surface, called the *sigmoid cavity of the radius*, in which the
head of the ulna rests. In this respect, therefore, there
is a striking similarity between this joint and the articula-
tion between the upper extremities of the bones. In the
one case the head of the radius fits into the lesser sigmoid
hollow of the ulna, in the other the head of the ulna fits into
the sigmoid hollow of the lower end of the radius, but the
manner in which the ligaments unite the ends of the bones
is quite different. The lower end of the ulna is not bound
to the radius by an orbicular ligament, but by a triangular
fibro-cartilage, the apex of which is attached to the base of
the process of bone which springs from the inner and hinder
aspect of the head of the ulna, a process which has been
already referred to under the name of the *styloid process*.
By its base the fibro-cartilage is united to the ridge on
the lower end of the radius which separates the articular
surface for the ulna from that for the bones of the wrist.
This arrangement permits of an entirely different kind
of movement from that described in connexion with the
superior joint. The head of the ulna does not rotate within
the sigmoid hollow of the radius, as does the head of the
radius within the orbicular or collar-like ligament, but
the lower end of the radius travels over and round the
head of the ulna, so that its position may be altered from

a condition in which it lies to the outer side of the ulna to one in which it comes to be placed to the inner side of the same bone.

The accompanying diagrams (Fig. 96, II. and III.) will perhaps enable the student to understand this point. The lower ends of the two bones are represented at (II.) in the supine position: the radius here lies to the outer side of the ulna; at (III.) the same bones are represented in the

I. II. III.

FIG. 96. Diagrams to illustrate the movements of the radius and ulna during pronation and supination.

I. A section across the upper ends of the bones of the right limb, as seen from above.

a. Ulna.
b. Head of radius retained in
c. The lesser sigmoid notch by
d. The orbicular ligament. The head of the radius *b* can rotate in either direction within the collar formed by *d.*

II. and III. represent the relations of the lower ends of the bones of the right limb, as seen from above.

II. In supination.
III. In pronation.

a. Lower end of ulna (head).
b. Lower end of radius.
f. Triangular fibro-cartilage attached to
y. The styloid process of ulna. The arrows show the directions in which the radius may move on the ulna.

prone position—the arrows indicate the direction in which the radius may move from either extreme. At the same time that this movement is taking place the lower end of the ulna undergoes slight lateral displacement. But it is hardly necessary here to enter into a detailed account of the complex nature of this latter movement; the points to be emphasized are these, viz. that the upper end of the radius, whilst it undergoes a rotatory movement, still retains its relative position to the ulna and humerus, whereas the move-

ment of the lower end of the radius effects a change in its position from the outer to the inner side of the ulna. It follows, therefore, since the shaft of the radius connects the two extremities, that when these two extremities are both lying to the outer side of the ulna the shaft of the radius will also lie to the outer side of the ulnar shaft. As we have seen, the head of the radius always lies to the outer side of the superior extremity of the ulna, whilst the lower end of the same bone may be moved so as to lie to the inner side of the lower end of the ulna; under these circumstances it becomes necessary that the shaft of the radius should pass obliquely across and lie in front of the shaft of the ulna, and it is this difference in the relative position of the bones which chiefly explains the alterations in form and outline which we recognize when the limb is in the prone and supine positions respectively (see Fig. 97).

In addition to the ligaments which bind together the bones of the fore-arm at the points above described, there is a strong fibrous sheet, called the *interosseous membrane*, which unites the shafts of the bones throughout almost their entire length. We are not much concerned with this layer, except to point out that it affords extensive attachments

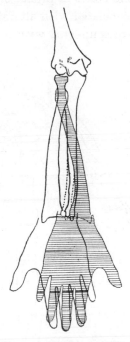

FIG. 97. Diagram to illustrate the position of the bones of the right fore-arm and the position of the hand in pronation and supination.

The simple outlines represent the position of the bones and hand in supination.

The dotted outline and shaded parts represent the position of the bones and hand in pronation. The radius now lies obliquely across the front of the ulna, and the thumb lies to the inner side with the back of the hand directed forwards.

to the deep muscles on both the front and back of the fore-arm. Its position varies according to the relation of the bones in pronation and supination, and it is necessarily associated with alterations in the forms of the muscles which are connected with it, alterations which react to a greater or less extent on the surface contours.

As many of the muscles in the fore-arm are associated with the movements of the hand, it will be necessary next to consider the anatomy of the *wrist-joint.*

The skeleton of the palm of the hand consists of five bones called *metacarpal* (Fig. 98). These are described as long bones, each possessing a shaft and two extremities. By one end they articulate with and support the *phalanges,* or *bones of the fingers* ; by the other they are united by a series of complex joints with a number of small bones, called the *wrist* or *carpal bones,* which intervene between them and the bones of the fore-arm. These carpal

FIG. 98. The bones of the right wrist and hand seen from the front.

r. Radius.
u. Ulna.
a. Styloid process of radius.
c. Styloid process of ulna.
c c. The carpal bones (8).
m m. The metacarpal bones (5).
p p. The finger-bones or phalanges (14).

bones are eight in number, and exceedingly irregular in their form, but united together they constitute a compact mass (Fig. 99) which presents for examination certain very characteristic features.

It will be well here to recall to mind certain points in regard to the structure of the lower ends of the ulna and

radius, to which reference has been already made. The lower end of the *radius* is much expanded, presenting on its inferior aspect a somewhat triangular-shaped articular surface, which is hollowed out from side to side and from before backwards. The apex of this triangle corresponds externally to the pointed projection called the *styloid process*, whilst its base is that edge which is directed towards the ulna.

This styloid process can be distinctly felt at the outer side of the wrist where it lies in line with the outstretched thumb. Its prominence is to some extent masked by the tendons which overlie it.

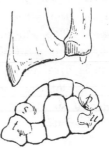

The inferior end of the *ulna* is small, and does not reach so low in the limb as the radius; for we have seen that the triangular fibro-cartilage, already described in connexion with the lower articulation between the radius and ulna, passes across its lower aspect, being attached internally to the base of the ulnar styloid process, and externally to the ridge which separates the carpal from the ulnar articular surface of the lower end

FIG. 99. In this figure the carpal bones are shown separated from the radius and ulna of the right side.

s. The tubercle of the scaphoid and

t. The ridge on the trapezium forming the prominence at the root of the ball of the thumb.

p. The pisiform and

u. The hook-like process of the unciform forming the prominence at the root of the ball of the little finger.

of the radius (see Fig. 96). From this it appears that the lower end of the ulna does not directly articulate with the bones of the wrist, but only indirectly through the medium of the triangular fibro-cartilage.

The *ulnar styloid process* projects from the inner and back part of the head of the bone, but, being overlain by tendons, is somewhat difficult to make out on the surface. It can best be felt in line with the inner border of the

palm and to the inner side of the wrist when the hand is supine. Whilst this process has little influence on the surface forms, the part of the back of the head of the ulna immediately external to it forms the well-marked rounded elevation so characteristic of the wrist. This may best be seen when the hand is pronated, i.e. palm turned down, in which position the rounded eminence caused by it is seen on the back of the limb, just above the wrist-joint, and in line with the cleft between the little and ring fingers. The student will do well to contrast its appearance, in this position of the limb, with that in which the palm is directed upwards; in the latter condition, whilst the head of the bone can be distinctly felt, its surface projection is now very much less apparent.

The radius is the only bone of the fore-arm which enters directly into the formation of the wrist-joint, the head of the ulna being, as already described, cut off from this articulation by the triangular fibro-cartilage already referred to; but whilst this is the case both bones materially assist in supporting the joint, for they furnish attachments by their styloid processes for the lateral ligaments which strengthen the articulation.

The eight bones [1] of the *carpus*, which form the complicated series of joints between the fore-arm and the skeleton of the palm, are arranged in two transverse rows of four each. The outer three bones of the first row provide a surface convex from side to side as well as from before backwards, which articulates with the lower end of the radius externally, and the under surface of the triangular fibro-cartilage internally. The bones of the second row articulate by means of an irregular joint with the bones

[1] The bones of the first row, passing from the radial to the ulnar side of the wrist, are named the scaphoid, semilunar, cuneiform, pisiform; those of the second row, the trapezium, trapezoid, os magnum, and unciform.

of the first row, and themselves provide articular sur-
faces for the bones of the palm. But these eight bones
which constitute the two rows of the carpus are not united
in such a way that the surfaces formed by their anterior and
posterior aspects are flat. Their arrangement can best be
understood by a diagram which represents a view of the
carpal bones as seen on making a section across the wrist-
joint (Fig. 100). From this it will be observed that the
bones are grouped in such a manner as to form a deep groove
anteriorly, whilst their posterior surfaces form a broad
area, rounded from side to
side. It is this surface which
we can feel on the back of
the wrist, where it is over-
lain by the tendons of the
various muscles passing down
to the back of the hand.

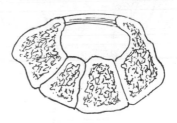

FIG. 100. A diagram to represent
on a larger scale the appearance
of the carpus when cut across at
the dotted line shown in Fig. 98.
The hollow in front of the carpus
is converted into a canal by a
ligament which stretches between
the prominent inner and outer
borders.

In regard to the anterior
aspect of the wrist-bones
they form, as has just been
stated, a deep groove, the
borders of which are out-
standing and prominent.
This groove is converted into
a tunnel by a strong band,
called the *anterior annular ligament* of the wrist, passing
across it from one prominent border to the other. In this
canal are lodged the tendons of the muscles, the fleshy
bellies of which are placed in the fore-arm. It is these
muscles which influence the movements of the thumb and
fingers by bending them forwards.

This arrangement is of advantage in retaining the flexor
tendons in position when the wrist is bent forwards, other-
wise they would be liable to be pulled out of place by the
contraction of the muscles.

If the student will but look at his own fore-arm, with the muscles strained and the wrist flexed, he will observe that all the tendons, which he can both feel and see, are firmly bound down as they cross the front of the joint.

FIG. 101. Outline of the hand, showing the arrangement of the skin folds in front of the wrist and on the palms and fingers. The shaded parts indicate the positions of the bones which form the prominent inner and outer borders of the carpus. Those at the ball of the thumb correspond from below upwards to the tubercle of the *scaphoid* and the ridge of the *trapezium*; those on the ball of the little finger to the *pisiform* and hook-like process of the *unciform*.

Returning now to the consideration of the prominent borders of this groove formed by the wrist-bones, the student will have no difficulty in recognizing the following points. If the finger be placed on the ball of the thumb close to the wrist, and in line with the cleft between the index and middle fingers, he will recognize a bony prominence; this is due to two of the bones of the wrist, called *scaphoid* and *trapezium*, which lie to the outer side of the groove. If the ball of the little finger be examined, a corresponding eminence will be noticed close to the level of the wrist and in line with the cleft between the little and ring fingers. This elevation is caused by the presence of a small rounded pea-like bone, called the *pisiform* bone. This ossicle does not enter into the formation of the joint between the radius and the first row of the wrist-bones, but articulates with the innermost bone of that row on its anterior surface. It thus helps to deepen the groove by causing a projection along the inner border of

the wrist; in front of this, but less distinctly felt, is the hook-like process of the *unciform* bone, the innermost of the bones of the second row of the carpus. It is to these prominences that the anterior annular ligament is attached, thereby converting the groove into a canal, as has been already described (see Figs. 99 and 100).

The movements of the wrist-joint are necessarily complicated by the large number of articulations involved, but for present purposes it is not necessary to consider these movements in detail.

The wrist may be bent forward, i. e. *flexed*, or bent back, i. e. *extended*. The former movement is freer than the latter. The wrist may also be moved from side to side, either to the inner or ulnar side, or to the outer or radial aspect. The former movement is frequently called *adduction*, the latter *abduction*. The range of movement towards the inner is greater than that towards the outer side. Further, these movements of flexion, extension, abduction, and adduction may be combined, constituting the movement of *circumduction*. The rotatory or twisting movement of the hand is effected, not at the wrist-joint, but by the crossing of the bones of the fore-arm, already alluded to under the terms pronation and supination (p. 178).

In studying the muscles of the fore-arm we have to deal with an exceedingly complex mass, which not only controls the movements of pronation and supination and the movements of the wrist, but also those of the fingers. Of these nineteen muscles, four are concerned with the movements of pronation and supination, nine with the movements of the thumb and fingers, and six with those of the wrist. It is a point worthy of notice that a considerable number of the muscles lodged in the forearm, whilst indirectly controlling the movements of the wrist, are in their main action directly concerned with the movements of the fingers. It will be at once apparent that had accommodation for all

these muscles, which act on the fingers, been provided in the hand itself, it would have involved a great increase in the size and bulk of that member, since the space required to lodge the fleshy fibres necessary to generate the force required would be considerable. To obviate this, nature has adopted the ingenious plan of placing the fleshy bellies of these muscles in the forearm and arranging for the transmission of the force to the moving parts by means of a series of long and slender tendons, which are easily accommodated, and take up but little room. In this way, the tapering form of the limb, which is small in the region of the wrist and of greater bulk higher up, where the fleshy bellies of these muscles are situated, is easily accounted for.

It is common knowledge that the flexor movements of the wrist and fingers are more powerful than the extensor actions. For this reason the flexor mass of muscles, viz. that disposed on the front of the limb, is larger and more strongly developed than that on the back of the forearm where lie the muscles associated with the extensor movements. In like manner it may be pointed out that the main flexor mass of the forearm arises from the internal condyle of the humerus, which is more prominent than the external condyle, from which springs the combined attachment of the extensors of the wrist and fingers, and it has been suggested that this disparity in the prominence of these condyles is directly associated with the functional activity of these two groups, since the flexors arising from the more prominent process act with greater mechanical advantage than do the extensors, which are derived from the shorter external condyle.

Happily for our purpose, a detailed description of many of these muscles is unnecessary, for a considerable number are so deeply placed that they do not directly influence the surface contours, though it should be clearly understood that *indirectly* they do modify the form of the limb, as in

a state of contraction they will cause a bulging forwards of the superficial muscles which overlie them.

It is with the superficial muscles of the fore-arm that we are most concerned, since they are the direct determinants of the surface form. Before discussing these muscles in groups, however, a word or two may be said regarding the *pronators* and *supinators*, i. e. the muscles which effect the movements of pronation and supination. These are all *inserted* into the radius, for, as we have already seen, it is that bone which moves in these acts. The pronators, of which there are two, must obviously take their origin from points internal to the radius, as they have to draw the radius inwards across the ulna, whilst the supinators, of which there are also two, must necessarily spring from points to the outer side of the radius in order to pull the radius back again to the outer side of the ulna. It follows from this that the two muscles of this group with which we are more immediately concerned, viz. the *pronator radii teres* and the *supinator longus*, will lie in relation to the inner and outer aspects of the fore-arm respectively. In this connexion the student will do well to remember the powerful action of the biceps muscle as a supinator, an action which has been already alluded to in the description of that muscle (p. 173).

The superficial muscles of the fore-arm may be subdivided into two groups, an outer and an inner, which lie along the corresponding sides of the fore-arm. Superiorly, the muscles of each group are attached to the condyles of the humerus, those of the outer group arising from the external condyle, those of the inner from the internal condyle. An inspection of the limb will enable the student to recognize that the fleshy bellies of the muscles are not confined to the sides of the fore-arm, but spread out on the front and back of the limb. Thus, the muscles which spring from the inner condyle of the humerus not only pass

down along the inner side of the fore-arm, but also clothe the anterior surface of the bones, whilst those which arise

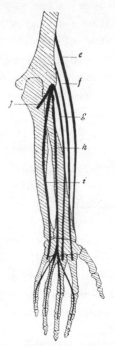

Fig. 102. Diagram to illustrate the arrangement of the pronator and superficial flexor muscles which arise from the *internal* condyle and pass down the front and inner side of the fore-arm.

a. Pronator radii teres.
b. Flexor carpi radialis (radial flexor of the wrist).
c. Flexor sublimis digitorum (superficial flexor of the fingers).
d. Flexor carpi ulnaris (ulnar flexor of the wrist).

Fig. 103. Diagram to illustrate the arrangement of the superficial muscles (extensors and supinators) which arise from the *external* condyle and the ridge above it, and which pass down the back and outer side of the fore-arm.

e. Supinator longus.
f. Extensor carpi radialis longior (long radial extensor of the wrist).
g. Extensor carpi radialis brevior (short radial extensor of the wrist).
h. Extensor communis digitorum (common extensor of the fingers).
i. Extensor carpi ulnaris (ulnar extensor of the wrist).
j. Anconeus.

from the external condyle pass down the outer side of the limb and spread backwards over its posterior aspect. The

former group comprises the flexor muscles, which lie on the front; the latter, the extensors, which lie on the back of the limb. As has been pointed out by Sir Charles Bell, owing to the fact that the internal condyle is the longer and more prominent of the two, the muscles arising from it, viz those which bend the wrist forward and close the fingers, act with great mechanical advantage, much force being required to enable us firmly to grasp an object. On the other hand, the extensors of the wrist and fingers, arising as they do from the shorter external condyle, are weaker in their action: facts which are clearly demonstrated when we compare the force which can be exerted when we close the fist as contrasted with the power we can exercise in opening it.

The greater bulk of the fore-arm above, and its tapering form below, are due to the fact that in the lower part of the limb the fleshy bellies of the muscles are replaced by their tendons, which obviously take up less room.

Examining the muscles of the inner superficial group first, they will be found to take origin from the internal condyle of the humerus by a common tendon of attachment; this group comprises the flexor muscles and one of the pronators, viz. the pronator radii teres. From this pointed superior attachment the fleshy mass spreads out below and is arranged in the following manner. The outer and most superficial part crosses the fore-arm obliquely from above downwards and outwards, and is inserted into the outer side of the shaft of the radius, about its middle; this muscle is known by the name of the *pronator radii teres* (Pls., p. 72, 170 *m*, 382).

Associated with the inner side of the origin of the pronator teres there is a well-marked fleshy belly, the muscular fibres of which are replaced by tendon about the middle of the fore-arm. This tendon may easily be recognized on the surface of the limb when the muscles are contracted;

it will be found to pass down towards the radial or outer side of the wrist to the prominence which has been already described in connexion with the base of the ball of the thumb. Here it sinks deeply into the palm of the hand, into the second metacarpal bone of which it is inserted. The muscle is a flexor of the wrist-joint, and as its tendon passes to the radial or outer side of that articulation it is called the *flexor carpi radialis* (Pls., pp. 72, 162, 170 *p*, 176, 212. 382).

If we return again to the internal condyle of the humerus, and trace the arrangement of the most internal fibres which spring from that process of bone, we find that they form a fleshy mass which lies along the inner side of the shaft of the ulna, connected therewith by a strong aponeurosis attached to the posterior or subcutaneous margin of that bone. From this extensive origin the fibres pass downwards and forwards, to end in the tendon of insertion which lies along the anterior border of the fleshy belly in its lower half. This tendon may be traced along the front and inner side of the fore-arm to its insertion into the pisiform bone, which forms, as has been already stated, the prominence on the front and inner side of the wrist in line with the cleft between the little and ring fingers. This muscle, like the last, is also a flexor of the wrist or carpus, but as it lies to the inner or ulnar side of the joint it is called the *flexor carpi ulnaris*. Its tendon is not nearly so prominent on the surface as that of the flexor carpi radialis, but its fleshy belly is of great importance in determining the surface form, as to its presence is due the flowing outline of the inner side of the fore-arm from the internal condyle above to the wrist below (Pls., pp. 38, 44, 50, 52, 94, 98, 104, 158, 162, 170 *y*, 176, 182, 200 *l*, 212).

Between the origins of the flexor carpi radialis and ulnaris from the internal condyle of the humerus there is frequently a muscle which has a slender belly and a

long thin tendon. The fleshy part of this muscle, which
is called the *palmaris longus*, is wedged in between the
bellies of the flexor carpi radialis and ulnaris, so that
it is not readily distinguishable on the surface, but helps
to form the general rounded mass which springs from the
internal condyle. Its slender tendon, which passes down
the centre of the fore-arm to cross the middle of the wrist
below and become attached to the dense fascia of the palm
of the hand, can usually be readily recognized, particularly
if the wrist be powerfully flexed. As however this muscle
is absent in about 10 per cent. of us, the student need
not be surprised if he occasionally meets with cases in
which he can obtain no evidence of its existence (Pls.,
pp. 170 *r*, 212, and those mentioned in previous paragraph).

The muscles above described comprise the superficial
part of the fleshy mass which has a common origin from
the internal condyle of the humerus, but, whilst this mass
is superficial in the sense that it is merely covered by the
skin and fascia of the limb, the student should recollect
that incorporated with the fascia, which overlies its com-
mon origin, there is the insertion of the band of fascia
derived from the biceps tendon. This insertion of the
biceps into the fascia of the inner and upper aspect
of the fore-arm has been already mentioned in connexion
with the description of that muscle, but its influence on
the surface contours may now perhaps be better understood.
If the biceps be powerfully contracted this band will be
rendered very tight, and will produce a shallow oblique
furrow overlying the fleshy bellies of the muscles which
have just been described (Pls., pp. 44, 62, 126, 152, 162, 176,
182). Another detail in connexion with the arrangement
of the muscles just mentioned is one which should not
be overlooked. In different individuals the proportion
between the lengths of the fleshy and tendinous parts of the
muscles varies, and this gives rise to individual differences

in the form of the limb. In a person in whom the fleshy part of the muscle is proportionately long the thickness of the fore-arm will be carried to a lower level, and vice versa.

Underlying these superficial muscles we have others which are placed in front of the bones of the fore-arm. These are the superficial and deep flexors of the fingers and the long flexor of the thumb, together with a muscle called the pronator quadratus, the fibres of which cross over from the lower end of the ulna to the lower end of the radius. A detailed description of these muscles is however unnecessary, as they do not directly influence the surface forms, the only exceptions being the tendons of the *superficial flexor of the fingers*, which, when powerfully contracted, appear in the intervals between the tendons already enumerated in the region of the wrist. Indirectly, however, these deep muscles do exert an influence on the contours of the limb, for they help to impart to it its characteristic roundness, and pad up, as it were, the superficial muscles which overlie them. The student may best observe this for himself by opening and closing the fist rapidly, when the slight changes in form due to the contraction of these muscles will be readily seen, particularly in the lower part of the fore-arm, where the retraction of the fascia covering the muscles renders more distinct the tendons of the superficial muscles already alluded to (Pl., p. 170 *z*).

Turning now to the consideration of the muscles which spring from the external condyle, the student will do well to remember two facts in this connexion : firstly, that the external condyle of the humerus is not so prominent as the internal ; and, secondly, that the origins of the muscles which lie along the outer side of the fore-arm are not confined to it, but extend for some very considerable distance above it, arising from the external condyloid ridge and from the external intermuscular septum attached thereto. A knowledge of these facts will do much to enable the student to

appreciate the differences between the outer and inner outlines of the limb.

The muscles which arise from this attachment consist of the supinators (two in number) and some of the extensor muscles of the wrist and fingers. Of the supinators we are concerned with one only, the *supinator longus*. This forms the highest of the fleshy fibres of the outer muscular mass, and arises from the upper two thirds of the external condyloid ridge, passing up to within an inch of the level of the lowest point of insertion of the deltoid, from which, however, it is separated by the fibres of origin of the brachialis anticus, as may be seen in the plate, p. 200. The belly of the muscle curves forward from this attachment to lie in front of the shaft of the radius, thus concealing the insertion of the pronator radii teres, and partially overlapping the belly of the flexor carpi radialis. It rests upon some of the other muscles to be presently described, and ends about the middle of the fore-arm in a strong tendon, which passes downwards with a slight outward inclination towards the lower end of the radius, to the outer side of the base of the styloid process of which it is attached. The muscle is superficial throughout, except at its lower part, where its tendon of insertion is obliquely crossed by certain tendons to be mentioned later. As the name of the muscle implies, it acts as a supinator, i. e. it draws back the radius when that bone has been carried across the front of the ulna in pronation; but from its relatively high attachment to the humerus it also acts as a flexor of the elbow, an action which is easily demonstrated when one lifts a heavy weight with the limb in a bent position. Its influence on the surface form is at once apparent, and is well seen in Pls., pp. 38, 126, 176, 182, 212; see also Pls., pp. 58, 62, 86, 148, 152, 162, 200, 212, 382.

Beneath the foregoing muscle, and partially overlain by it in front, there are two muscles, which lie along the

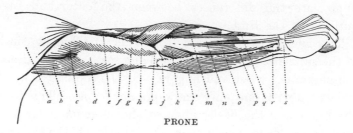

PRONE

a. *Deltoid.*
b. *Triceps, long head.*
c. *Triceps, outer head.*
d. *Triceps tendon.*
e. *Brachialis anticus.*
f. *Triceps, inner head.*

g. *Supinator longus.*
h. *External intermuscular septum.*
i. *Extensor carpi radialis longior.*
j. *Olecranon process of ulna.*
k. *Anconeus.*
l. *Flexor carpi ulnaris.*

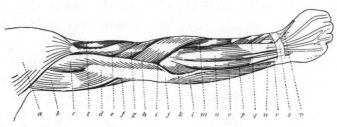

MIDWAY BETWEEN THE PRONE AND SUPINE POSITIONS

m. *Extensor carpi radialis brevior.*
n. *Common extensor of the fingers.*
o. *Extensor carpi ulnaris.*
f. *Ulna, subcutaneous posterior border.*
q. { *Extensor ossis metacarpi pollicis.*
 Extensor primi internodii pollicis.

r. *Head of ulna.*
s. *Posterior annular ligament of wrist.*
t. *Biceps cubiti.*
u. *Tendons of radial extensors.*
v. *Extensor secundi internodii pollicis.*

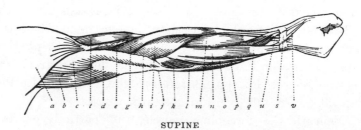

SUPINE

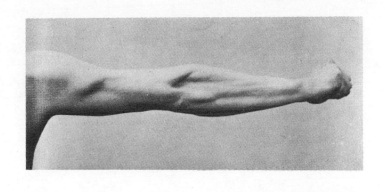

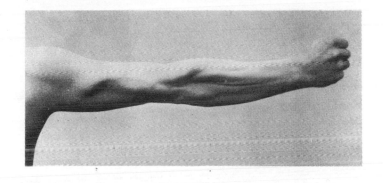

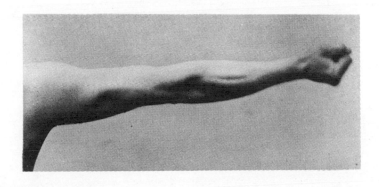

outer side of the shaft of the radius; the tendons of these muscles, however, pass to their insertion into the bones of the hand over the back of the wrist towards the outer or radial side: they are therefore extensors of the wrist and, named *extensores carpi radiales*, are distinguished from one another by being called long and short.

The *extensor carpi radialis longior* is the more superficial of the two: it takes origin above from the lower third of the external condyloid ridge, that is to say, the part of the ridge below the attachment of the supinator longus. Its fleshy belly is directed obliquely forwards and downwards, so as to lie across the outer side and front of the upper part of the shaft of the radius; in this position the muscle is in part covered by the belly of the supinator longus, only its posterior border and part of its outer surface being superficial. At a level corresponding to the junction of the middle with the upper third of the fore-arm the belly joins its tendon, which passes down in very close relation with that of the short radial extensor (Pls., pp. 200 *i*, 212; also pp. 38, 50, 126, 148, 152, 162, 170 *n*, 182).

The *extensor carpi radialis brevior* arises from the external condyle of the humerus in conjunction with the remaining members of the superficial extensor group. At its upper attachment the muscle is covered by the fleshy fibres of the extensor carpi radialis longior, but, as its fleshy fibres are directed downwards along the outer side of the shaft of the radius, they appear superficial, lying external and posterior to the belly of the preceding muscle. The fleshy belly of the short radial extensor reaches a lower level than that of the long radial extensor in the fore-arm. It joins its tendon about the level of the junction of the middle with the lower third of the fore-arm. As stated above, the tendons of these two muscles are very closely related to one another; they pass down to reach a groove on the back of the radius, just behind

the styloid process of that bone. Beyond this point they cross the back of the wrist and are inserted into the back of the bases of the metacarpal bones [1] (bones of the palm) of the index and middle fingers. These tendons are not readily recognizable from the surface, for in the lower third of the fore-arm they are covered by two muscles which pass to the thumb, and on the level of the back of the wrist another tendon, also passing to the thumb, crosses them obliquely. The action of these muscles is sufficiently indicated by their names; they extend the wrist on the radial side (Pls., pp. 200 *m*, 212; also pp 38, 50, 126, 148, 152, 182, 382).

Adopting the same method of description as has been employed in regard to the arrangement of the muscles which spring from the internal condyle, we shall next consider the most internal member of the group arising from the outer side of the external condyle. This muscle runs down in close relationship with the back of the shaft of the ulna, to the posterior border of which it is connected by means of an aponeurosis: it becomes tendinous on a level with the upper limit of the lower quarter of the fore-arm, and from this point the tendon is directed downwards across the back of the wrist to the inner or ulnar side. As it passes over the lower extremity, or head of the ulna, it lies in a groove which is placed just behind the styloid process of that bone; thence it proceeds to be inserted into the back of the base of the metacarpal bone of the little finger. This muscle is called the *extensor carpi ulnaris*, or the ulnar extensor of the wrist (Pls., pp. 200 *o*, 212; also pp. 50, 148, 152, 158, 162, 182).

In this connexion it may be as well to remind the student of certain facts which have been already referred

[1] The skeleton of the palm is made up of five bones called metacarpal bones; these articulate above with the bones of the carpus or wrist, below with the first row of the phalanges or finger-bones.

to. In the description of the ulna it was stated that the posterior border of that bone was superficial throughout its entire extent. Commencing above at the triangular subcutaneous area, which corresponds to the back of the olecranon process or tip of the elbow, this margin of the shaft may be traced along the whole of the back of the forearm to the wrist below, where it ends on the enlargement produced by the lower end of the bone. The line so traced is not straight, but takes the form of a sinuous curve. The two ulnar muscles lie, one on the inner and the other on the outer side of this border; that to the inner side is the flexor carpi ulnaris, while that which is placed along the outer or radial aspect is the extensor carpi ulnaris, just described. The bulging of these fleshy muscles on either side of this ridge of bone reacts on the surface form so as to produce a furrow between them. This surface depression is called the *ulnar furrow*, and the bottom of it corresponds to the posterior border of the bone. When the finger is run along it, one feels the ulna with the muscles above mentioned on either side. The furrow is of course best seen when the muscles are powerfully contracted, and it may be well to warn the student not to confuse it with the furrow which lies behind the back of the external condyle of the humerus and the upper end of the radius; and, further, the reader should be careful to note that the two ulnar muscles are not in close relation throughout their entire extent, but are separated above by the interposition of the fibres of the anconeus muscle in addition to the expanded upper extremity of the ulna. These points may be rendered clearer by a reference to the plate (p. 200, Figs. 1, 2 *p*; also pp. 50, 162).

Returning once more to the consideration of the superficial muscles which spring from the external condyle, and noting the fact that we have already traced the attachment and arrangement of the extensor carpi radialis

brevior and the extensor carpi ulnaris, we have now to account for the interval between these muscles as they pass down along the radial and ulnar sides of the limb. This interval is filled up by a fleshy belly of the *extensor communis digitorum*, i. e. the common extensor muscle of the fingers. There are really two muscles here, the common extensor muscle of the fingers and a special extensor muscle of the little finger, but for our purpose we may disregard the latter altogether and consider the two as one. The fleshy mass of this muscle is wedged in between the origins of the short radial extensor, on the outer side, and the ulnar extensor on the inner side, and passes down the middle of the back of the fore-arm, occupying the interval between the foregoing muscles, which are widely separated below. The common extensor of the fingers, however, does not completely fill up this interval, but is separated from the tendon of the short radial extensor by some of the deeper muscles, which here 'crop up' so as to become superficial between the short radial extensor on the outer side and the common extensor of the fingers on the inner side. In the lower third of the fore-arm the fleshy fibres of the common extensor are replaced by a broad tendon, and this subsequently breaks up into a number of slips which, after crossing the centre of the back of the wrist, spread out on the back of the hand to pass to their respective fingers. Throughout its entire length the inner border of the muscle, i. e. that portion of it which forms the special extensor of the little finger, is in contact with the outer margin of the ulnar extensor, and this, as will be subsequently noticed, is represented by an intermuscular furrow on the surface of the limb. The common extensor of the fingers acts primarily on the fingers, straightening them after they have been bent; but it also acts secondarily as an extensor of the wrist, assisting in pulling back the hand at that articulation (Pls.,

p. 200, Figs. 2 and 3 *n*; also pp. 50, 126, 148, 152, 162, 182, 212, 382).

As the tendons of these muscles, together with the tendons of others which still remain to be discussed, pass across the region of the wrist they are bound down by a ligament, called the *posterior annular ligament*. This arrangement is comparable to that already described on the front of the wrist, and prevents the displacement of the tendons in powerful extension or bending back of the wrist (Fig. 104).

Attention should next be directed to the arrangement of the foregoing muscles as they are grouped behind the external condyle of the humerus. An examination of the plate, p. 200, Figs. 1, 2, 3, and Pls., pp. 50 and 162, will show that there is a V-shaped area overlying the back and outer side of the elbow. The apex of the ∧ corresponds to the back of the external condyle ; its outer limb is formed by the hinder border of the long radial extensor, whilst its inner side corresponds to the outer border of the anconeus. The floor of this space is made up of the tendinous origins of the ulnar extensor of the wrist and the common extensor of the fingers. It results from this arrangement that when the limb is extended the borders of the muscles just enumerated become more prominent, and produce by their elevation of the surface a well-marked intermuscular depression between them, the bottom of which corresponds to the origins of the ulnar extensor and the common extensor of the fingers. In this position these latter muscles overlie the back of the head of the radius, and as they are tendinous, rather than fleshy, it follows that we can easily recognize the head of the radius beneath them when we place our fingers in the hollow, the more so if, at the same time, we pronate and supinate the fore-arm so as to cause rotation of the head of the radius. The sharpness of the surface furrow which corresponds to these structures will, of course, largely depend on the absence of fat in the

subcutaneous tissue, and on the development and state of contraction of the muscles. As has been previously stated, in the female and child there is a larger amount of subcutaneous fat, and the surface form no longer displays the characteristic appearance above described, but exhibits only a shallow depression or dimple (Pls., pp. 52, 262, 308).

As in the case of the front of the fore-arm, so on the back, we have to take into consideration the influence of the deeper muscles. Of these the most important are the extensor muscles of the thumb; the others are not directly concerned in the moulding of the surface forms.

The thumb, as we shall see hereafter, is the most important of all the digits: a fact which is further emphasized by the number of muscles connected with it. Of these, three must be studied in connexion with the back of the fore-arm. If the thumb be forcibly drawn away from the palm, one has no difficulty in recognizing two cord-like tendons running from the outer side and back of the

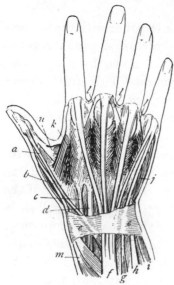

FIG. 104. View of the tendons and muscles on the back of the right hand.

 a. Tendon of secundi internodii pollicis.
 b. Tendon of primi internodii pollicis.
 c. Tendon of extensor carpi radialis longior.
 d. Tendon of extensor carpi radialis brevior.
 e e. Posterior annular ligament of wrist.
 f. Tendons of extensor communis digitorum.
 g. Tendon of extensor minimi digiti.
 h. Tendon of extensor carpi ulnaris.
 i. Tendon of flexor carpi ulnaris.
 j. Muscles of ball of little finger seen from behind.
 k. Abductor indicis or first dorsal interosseous muscle.
 l l l. Second, third, and fourth dorsal interossei muscles.
 m. Extensor ossis metacarpi pollicis.
 u. Adductor pollicis seen from behind. This muscle determines the outline of the web between the thumb and the index finger

wrist to the first joint, or knuckle, of the thumb; these are the tendons of the special extensors of this digit. The fleshy bellies of the muscles with which they are connected arise from the back of the bones of the fore-arm beneath the common extensor of the fingers and the ulnar extensor of the wrist. The two highest, called respectively the *extensor ossis metacarpi pollicis* (extensor of the metacarpal bone of the thumb) and *extensor primi internodii pollicis* (extensor of the first finger-bone or phalanx of the thumb), appear about the lower third of the fore-arm as two little fleshy bellies in the interval between the common extensor of the fingers and the short radial extensor. Having become superficial in this position, the two muscular slips end in tendons which curve downwards and outwards over the lower end of the radius to reach the outer side of its styloid process in a groove on which they are lodged. Below this point the tendons, which are indistinguishable, can be traced to the thumb, one becoming attached to the metacarpal bone of that digit, whilst the other passes along the back of that bone over the first knuckle to be inserted into the first phalanx of the thumb. The fleshy parts of these small muscles lie obliquely across the tendons of the long and short radial extensors as they pass down on the back of the lower end of the radius, and the tendons of these extensors of the thumb also overlie the tendinous insertion of the supinator longus. The student will do well to realize the importance of these small muscles as determinants of surface form. It is to their presence that the outline of the lower part of the external border of the fore-arm is to some extent due. Much will depend on their development, but the reader can easily satisfy himself as to their position by rapidly moving the thumb from and to the palm. Their tendons form a prominent ridge leading up the back and outer side of the thumb, whilst their fleshy bellies cause a distinct elevation having an oblique direction across the lower end of the radius from

behind forwards (Pls., pp. 170, Fig. 1 *u*, 200 *q* ; also pp. 38, 72, 86, 126, 162, 176, 182, 212, 216, 382).

The remaining extensor of the thumb—*extensor secundi internodii pollicis* (extensor of the second finger-bone of the thumb)—may be briefly dismissed. The fleshy part scarcely becomes superficial, and it is therefore only the tendon of this muscle which is noteworthy. If the thumb be forcibly drawn away from the palm, a prominent ridge caused by this tendon will be observed crossing the back of the wrist and hand obliquely from a point above in line with the cleft between the index and middle fingers, towards the first knuckle of the thumb below, over which it may be traced onward to reach the second or terminal phalanx of that digit. As the tendons of this muscle and those just described pass over the back and outer side of the lower end of the radius they are separated by an interval of about an inch. If the thumb be forcibly drawn away from the palm, they are rendered tense and stretch the skin over them so as to produce a little hollow, corresponding to the interval between them. This hollow has been called by the French 'la tabatière anatomique', from the circumstance that it was frequently used to measure a convenient dose of snuff (Pls., pp. 170, Fig. 1 *v*, 176, 182, 382).

Having described the arrangement of the muscles of the fore-arm so far as is necessary for our purpose, the student is now in a position to summarize many of the results obtained. Taking first the flexors and extensors of the wrist, these muscles are seen to be arranged in the following way. There is a group of ulnar flexors and extensors, and a group of radial flexors and extensors. The former lie along the ulnar or inner side of the fore-arm, the latter along the radial or outer side of the limb, but, whereas each group is further subdivided into a flexor and an extensor mass, it is seen that along the inner side of the limb there is a *flexor carpi ulnaris* running down the front of the

ulna, and an *extensor carpi ulnaris* passing along the back of the same bone. In like manner the outer side of the limb is provided with a *flexor carpi radialis* muscle, which lies more or less in front of the radius, and an extensor muscle, made up of the *extensores carpi radiales* (*longior* and *brevior*), which runs down along the posterior and outer side of the same bone. Of the pronators and supinators we are concerned only with two, viz. the *pronator radii teres*, which crosses the front of the limb obliquely from the internal condyle towards the middle of the shaft of the radius, and the *supinator longus*, which overlies the fleshy bellies of the long and short radial extensors as they pass down the outer side of the limb. The position of the remaining muscles has been sufficiently described; they occupy the intervals between the radial and ulnar flexors in front, and the radial and ulnar extensors behind, and are *flexors* or *extensors* in their action according as they lie on the front or back of the fore-arm.

Hitherto the muscles of the fore-arm have been studied with the limb in the supine position, i. e. with the radius lying parallel to and along the outer side of the ulna. Under these conditions the outline of the limb, as viewed from front or back, corresponds on the inner side with the flowing curve produced by the fleshy belly of the flexor carpi ulnaris. On the outer side the outline is made up of three curves, the prominence of which varies according to the development of the muscles on which they depend. The highest of these curves commences above in the lower third of the upper arm, and sweeps over the region of the external condyle or outer elbow, to end below at the junction of the upper with the middle third of the fore-arm. This curve depends on the origin and attachment of the long supinator and the long radial extensor of the wrist. The second curve, opposite the middle third of the fore-arm, corresponds to the fleshy belly of the short

radial extensor of the wrist. The third curve, generally
less pronounced than the others, occupies the lower third
of the limb ; it is due to the lower portion of the shaft of
the radius and the tendons and muscles which overlie it,
particularly the two extensor muscles of the thumb, viz.
the extensor of the metacarpal bone and the extensor of
the first phalanx (Pl., p. 200, Figs. 1 and 2).

When the limb is in the supine position the front of the
fore-arm is somewhat flattened, and this flattened surface
is continuous above with what is called the hollow in front
of the elbow. This hollow is due to the V-shaped interval
separating the muscles which spring respectively from the
outer and inner sides of the lower end of the humerus.
Thus, on the outer side, we find the interval bounded by
the inner border of the long supinator, whilst internally
the outer or upper border of the pronator radii teres forms
its boundary. In the interval so formed, the biceps
passes downwards to be inserted by means of its tendon
into the tubercle of the radius. This causes a projection
in the middle of the V-shaped intermuscular interval
just described, so that the surface hollow presents rather
the appearance of a Y-shaped furrow on either side of the
lower part of the biceps muscle as it lies in front of
the elbow. The two upper limbs of the Y are continuous
above with the surface furrows which lie along the inner
and outer sides of the belly of the biceps in the upper
arm. As already stated, the inner of the two upper furrows
is not so clearly seen as the outer, the reason being that
the aponeurotic insertion of the biceps into the fascia
covering the muscles which spring from the internal
condyle bridges over the interval, thus interrupting the
groove and modifying considerably the surface form (see
ante, p. 173; Pls., pp. 162, 170, Fig. 1, 72, 382). The lower
limb or stalk of the Y corresponds to the interval which
separates the long supinator from the radial flexor of the

wrist. This furrow is not noticeable to any extent when the fore-arm is in the supine position, but when the fore-arm is pronated it becomes quite distinct (Pl., p. 170, Fig. 1).

The front of the elbow is crossed by a number of fine cutaneous creases; these are due to the folding of the skin when the elbow is flexed. The most marked runs transversely across the hollow of the front of the elbow from one condyle of the humerus to the other.

In a woman's arm the furrows above described are much less marked, as the subcutaneous fat imparts a more rounded form to the limb and masks the outline of the different muscles which, in the male, exercise so important an influence on the surface contours (Pls., pp. 72, 86, 434, 438).

The influence of the change of position of the radius on the form of the limb when the fore-arm is pronated has been already dwelt upon in describing the movements of pronation and supination (p. 185). The student would do well to remember this fact, for not only does the radius move, but it carries with it the muscles which are grouped around it. Thus when, in the prone position, the shaft of the radius is thrown obliquely across the front of the ulna, so that its lower extremity comes to be placed *internal* to the head of the ulna at the wrist, the various muscles which lie along the outer and posterior surface of that bone are carried with it; the supinator and extensor mass of muscles no longer lies along the outer and posterior aspect of the limb, but takes an oblique direction, from the external condyle of the humerus and the ridge leading to it, downwards and inwards towards the inner side of the wrist, where, as has just been said, the lower end of the radius is situated. Over the lower end of this bone we have already seen that the tendons of the afore-mentioned muscles are carried in grooves in which they are retained by the posterior annular ligament of the wrist. By this arrangement the tendons are held in position, and when

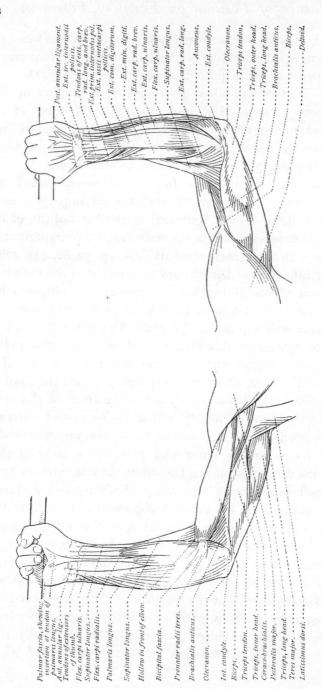

Post. annular ligament.
Ext. sec. internodii pollicis.
Tendons of exts. carp. rad. long. and brev.
Ext. prim. internodii pol.
Ext. ossis metacarpi pollicis.
Ext. com. digitorum.
Ext. min. digiti.
Ext. carp. rad. brev.
Ext. carp. ulnaris.
Flex. carp. ulnaris.
Supinator longus.
Ext. carp. rad. long.
Anconeus.
Ext. condyle.
Olecranon.
Triceps tendon.
Triceps, outer head.
Triceps, long head.
Brachialis anticus.
Biceps.
Deltoid.

Palmar fascia, shewing insertion of tendon of
Palmaris longus.
Ant. annular lig.
Tendons of extensors of thumb.
Flex. carpi ulnaris.
Supinator longus.
Flex. carpi radialis.
Palmaris longus.

Supinator longus.
Hollow in front of elbow.
Bicipital fascia.
Pronator radii teres.
Brachialis anticus.
Olecranon.
Int. condyle.
Biceps.
Triceps tendon.
Triceps, inner head.
Coraco-brachialis.
Pectoralis major.
Triceps, long head.
Teres major.
Latissimus dorsi.

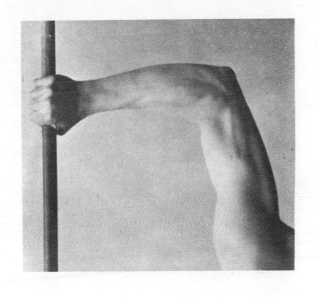

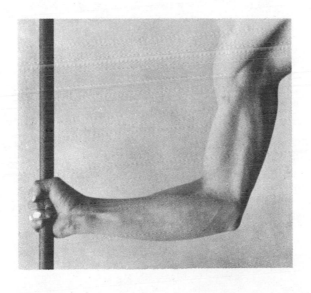

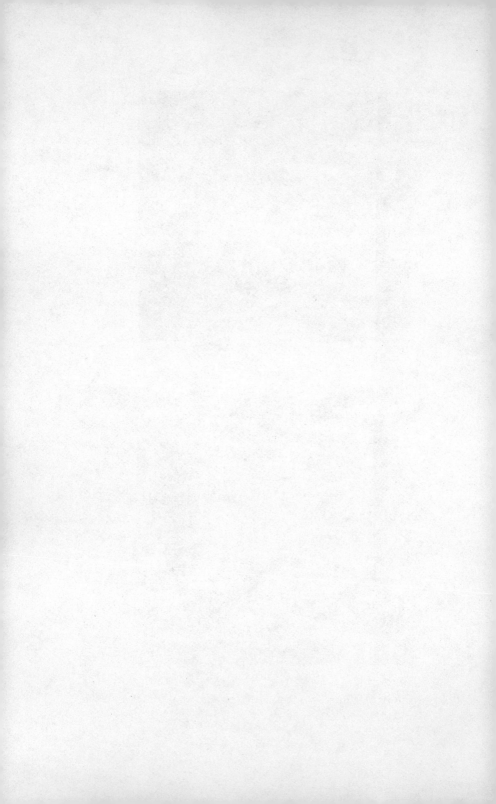

the bone (radius) moves it necessarily carries with it the tendons which are lodged in the grooves on its surface.

The modification in the form of the limb is thus explained. From being flattened from before backwards, and wide from side to side, as happens in the supine position, the fore-arm becomes rounded in the prone position, so that its thickness from before backwards exceeds slightly its width from side to side. It may here be pointed out that we usually carry our fore-arms in a position midway between extreme pronation and supination ; in other words, in walking we carry the limb with the palm of the hand directed towards the thigh, and not with the palms turned forwards, as in extreme supination, or backwards, as in extreme pronation (Pls., pp. 52, 54, 72, 86, 148, 382, 434, 438).

The modification in the arrangement and grouping of the muscles of the limb can· best be studied by an examination of the plates, pp. 170, 200, in which they are represented with the limb in different positions.

When the elbow-joint was described, the relation of its bony parts to the surface form was then discussed. Something yet remains to be said regarding the changes in form due to the muscles of the fore-arm which are grouped around it. In the extended position of the joint, i. e. when the whole limb is straight, the outer condyle of the humerus is concealed by the muscles which overlie it, and spring from it, viz the long supinator and extensors. In this connexion it is important to remember that two of these muscles, viz. the long supinator and the long radial extensor of the wrist, do not take origin from the external condyle, but from the external condyloid ridge above it. On the other hand, if we examine the inner side of the elbow there is no difficulty in recognizing the surface prominence which corresponds to the internal condyle of the humerus, for the pronator and flexor muscles,

which spring from this, do not extend upwards to any
extent to be connected with the ridge above it (the internal
condyloid ridge), but are confined in their attachment to the
condyle itself, a circumstance which explains the character-
istic prominence on the surface of this process of bone. As
a result of these arrangements we can readily explain the
marked differences which the limb presents when the elbow
is bent, according as we view it from the outer or inner

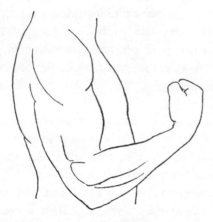

FIG. 105. Diagram to show the outline of the outer side of the arm
when the elbow is bent. The outline of the fore-arm at the elbow is
determined by the supinator longus and extensor carpi radialis longior,
which arise above the external condyle of the humerus.

aspect (Pls., pp. 38, 44, 62, 126, 152, 158, 176, 182, 212,
270).

The angle formed by the outline of the fore-arm and
the upper arm is placed much higher on the outer side
of the elbow than on the inner; this is due to the fact that
the long supinator takes origin from the external condyloid
ridge of the humerus, as high as the junction of the lower
with the middle third of the length of that bone. This may
be seen best when a heavy weight is raised with the elbow
bent; the long supinator is then powerfully contracted

and its anterior margin is rendered very tense, a condition
shown in the diagram (Fig. 105). Not only is the belly
of the supinator longus above the level of the joint, but
the long radial extensor of the wrist is also seen powerfully
contracted as it arises from the ridge on the humerus above
the external condyle, the surface point corresponding to
which is placed much below the level of the angle formed
by the outline of the limb. When viewed from the inner
side, the limb displays a marked contrast to the form just

FIG. 106. Outline of the inner side of the arm with the elbow bent.
The front of the fore-arm is in contact with the front of the upper arm,
and forms a deep fold, at the bottom of which the internal condyle is
situated.

described; a deep fold crosses the front and inner side
of the elbow. This fold is produced by the approximation
of the soft parts of the upper part of the limb with the
anterior surface of the fore-arm, and its inner extremity
passes in towards the surface prominence corresponding
to the position of the internal condyle of the humerus.
The depth of this fold will of course depend on the degree
of flexion of the joint, being most marked when the joint
is forcibly bent (Pls., pp. 38, 62, 104, 152).

In lesser degrees of flexion, say about a right angle, the

1 Rectus abdominis.
2 External oblique.
3 Anterior superior iliac spine.
4 Gluteus medius.
5 Aponeurosis of external oblique.

14 Vastus internus.
15 Band of Richer.
16 Vastus externus.
17 Rectus femoris tendon.
18 Vastus internus.
19 Patella.

28 Tibia, subcutaneous surface.
29 Tibialis anticus.
30 Soleus.
31 Peroneus longus.
32 Long extensor of toes.
33 Peroneus brevis.

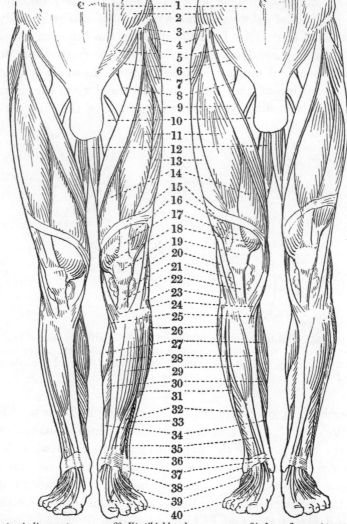

6 Poupart's ligament.
7 Tensor fasciae femoris.
8 Ilio-psoas. Pectineus.
9 Sartorius.
10 Adductor longus.
11 Rectus femoris.
12 Gracilis.
13 Vastus externus.

20 Ilio-tibial band.
21 Fat.
22 Patellar ligament.
23 Head of Fibula.
24 Tendon of Sartorius.
25 Tendon of Semi-tendinosus.
26 Soleus.
27 Gastrocnemius, inner head.

34 Long flexor of toes.
35 Long extensor of great toe.
36 Internal malleolus (tibia).
37 Annular ligament of ankle.
38 External malleolus.
39 Extensor brevis digitorum.
40 Long extensor of great toe tendon.

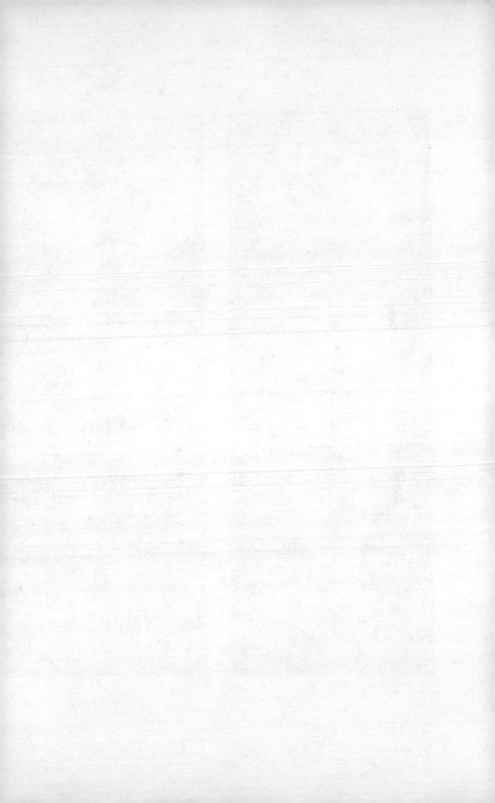

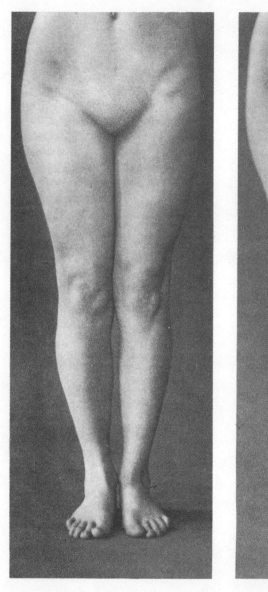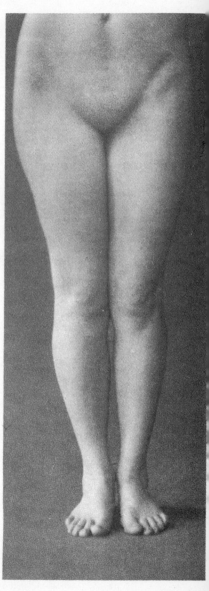

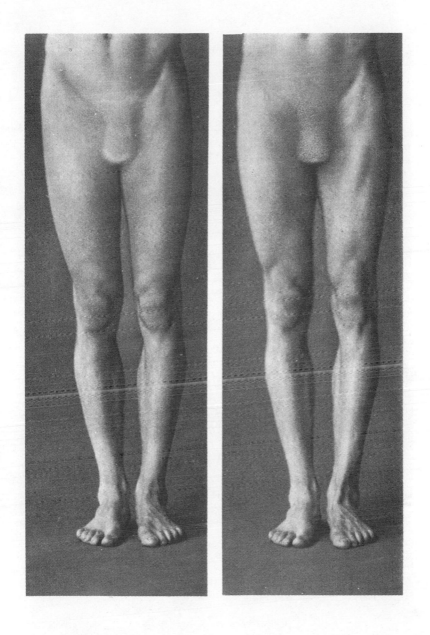

Y-shaped hollow of the front of the elbow becomes more pronounced, particularly if a powerful strain be put on the muscles, as in lifting a weight; the outer side of the hollow is rendered more prominent by the tension of its outer boundary, the long supinator. The insertions of the biceps muscle, both tendinous and aponeurotic, are now well seen as they pass into the space. Such a view of the limb is shown in the plate, p. 176, Fig. 1.

In considering these details the student will do well to contrast the influence of powerful muscular contraction on the surface forms as compared with their appearance in moderate action, a difference which he can easily demonstrate on his own person. We have here adopted the former condition as the one which enables us best to emphasize the influence of muscle in action on the contours of the limb, and it appears hardly necessary to dwell upon the fact that any pictorial representation of the parts in the condition above described would imply a vigorous use of the limb. Under ordinary circumstances, in moderate action the surface contours above mentioned would be much less definite.

Mention may here be made of the arrangement of the superficial veins of the fore and upper arm and their influence on the surface form. The distribution of these veins is liable to great individual variation, but the usual arrangement is one in which we have veins running up the outer and inner sides, as well as along the centre of the fore-arm; in front of the bend of the elbow they rearrange themselves so that there are only two superficial veins of any size in the upper arm; these lie along the inner and outer sides of the biceps and occupy the corresponding furrows. These vessels become much engorged when the limb has been subjected to any violent muscular strain or prolonged effort, and the distended veins are readily recognized by the knotted cord-like ridges which

they produce on the surface of the limb (Pls., pp. 44, 72, 182, 366). Their presence is also indicated by the bluish colour which they impart to the skin over them. In the antique the surface elevations produced by veins are frequently represented, and help to emphasize the artist's representation of the limb in violent action. A curious and not uninteresting detail may here be mentioned. This engorgement of the veins is always most marked when the limb is in such a position that the shoulder forms its highest point. If, on the other hand, the arm be uplifted, the distension rapidly disappears and the veins are no longer recognizable by their influence on the surface contours. This statement, however, requires some modification, for, if the course of a large vein be carefully examined when the blood has been suddenly drained from it, its position is in some cases, more particularly in those with thin skins and but little subcutaneous fat, indicated by a shallow furrowing of the surface, so slight, however, as almost to escape notice, and hence hardly worthy of representation in plastic art. This difference in the distension of the veins in these two positions of the limb is due to the fact that, in the first, the blood which is circulating in the veins is passing *up* towards the shoulder and has thus to counteract the influence of gravity, whereas when the arm is raised above the shoulder the blood flowing in that direction is assisted by the influence of gravity and is therefore more rapidly drained away. Consequently, if the artist wishes to be strictly accurate in his representation of the forms of the limb in action, he should not emphasize the presence of these superficial veins on the surface of the uplifted arm, unless of course he merely wishes to represent a momentary raising of the limb. On the other hand, their presence may be clearly defined if the limb be represented on a lower level than the shoulder.

The prominence of these superficial veins not only

depends on their distension, but also on the thickness of
the subcutaneous fatty layer in which they are imbedded.
They are best marked as surface elevations when that
layer is thin, as in a lean muscular model; but their
influence on the surface forms is masked when the fatty
subcutaneous layer is thick,
consequently it would be
altogether contrary to artistic
ideas to indicate them by
surface elevations in any
representation of a full and
healthy female type. Under
these circumstances their
presence is sufficiently sug-
gested by colour, and this
especially as the finer and
whiter skin of the female
enhances the contrast. Par-
ticularly is this the case in
certain regions, viz. the front
of the elbow and the front
of the wrist, where the skin
is thinner than elsewhere;
here a suggestion of this
delicacy may be conveyed by
representing the colour which
the smaller veins impart to
the surface.

The surface relations of the
various structures met with

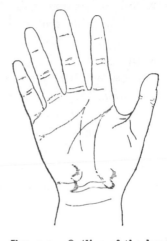

FIG. 107. Outline of the hand,
showing the arrangement of the
skin folds in front of the wrist
and on the palm and fingers. The
shaded parts indicate the positions
of the bones which form the pro-
minent inner and outer borders of
the carpus. Those at the ball of
the thumb correspond from below
upwards to the tubercle of the
scaphoid and the ridge of the
trapezium; those on the ball of
the little finger to the *pisiform*
and hook-like process of the *unci-
form.*

in the region of the wrist have been already described;
but, in addition, the existence of certain lines or creases
in the skin in front of this region must be noted. Of
these there are two which are usually well defined. The
lowest is a line with a double curve which sweeps across

the wrist, and corresponds to the bases of the elevations familiar to the reader as the ball of the thumb and the ball of the little finger. At some little distance above this, on a level with the tip of the styloid process of the radius, is a second delicate fold; this becomes at once apparent as a line of flexure when we bend the wrist forwards. Other slight folds are rendered evident, lying more or less parallel to and above this, by further bending the hand forwards.

The action of the various muscles described in the forearm is sufficiently indicated by their names. Those which flex and extend the wrist are assisted in their action by the muscles which bend and straighten the fingers.

Abduction, or the action of drawing the hand towards the radial or outer side, is effected by the muscles which lie along the outer or radial side of the limb, viz. the radial flexor and the radial extensors of the wrist.

Adduction, or the movement of the hand towards the ulnar or inner side of the limb, is caused by the combined action of the ulnar flexor and extensor of the wrist, which lie along the inner side of the fore-arm.

The movement of circumduction of course necessitates a combination of the action of flexors, abductors, extensors, and adductors, or vice versa, according as the movement takes place from within outwards or from without inwards.

This detailed description of the structures involved in shaping the limb may have proved irksome to the reader, but if he has the patience to compare, carefully, the written account of these details with the diagrammatic analysis of the surface contours furnished by the photographic plates, it is hoped that he will have acquired some general idea of the grouping and massing of the muscles involved.

CHAPTER VIII

THE hand is one of the most characteristic features of man; by means of it he is able to perform the most delicate manipulations. It may also be made use of as a means of expression. The actor's art is one of the most striking examples of this—the finger to the lips to indicate silence, the hands held up to express horror, are only instances of the more common modes of expression by this means. This may be carried further, as in pantomime, and men who could not otherwise converse are enabled to interchange ideas by means of this gesture language.

The artist will frequently have recourse to this mode of suggestion, as it enables him to assist in giving expression and action to the figures he represents.

But in other ways the hand reflects to some extent the character and mode of life of its owner. Apart altogether from the refinement associated with the female, very great variations in the form of the hand are met with in different individuals, modifications in many instances due to the uses to which the hand has been put. To represent the hand of a blacksmith as delicate and refined would be absurd from a pictorial standpoint, though it is curious to note that the hands and fingers of those employed in the most delicate manipulations are often clumsy and uncouth looking. As a rule, however, we associate delicacy of hand with refinement and with mental rather than manual labour, whilst a muscular hand is regarded as an attribute of strength and of a powerful physique. A man's hands are

often as characteristic as his face, and in portraiture the artist frequently avails himself of this feature. With women, however, this is less marked, as here we expect to see elegance and beauty rather than character, a circumstance which has often led painters in the past to supply the hands from other and better models.

The skeleton of the hand comprises the bones of the palm and fingers. The former consists of the five *metacarpal* bones already mentioned. These are long bones, long in the sense that they consist of a shaft and two extremities; the upper end or base is directed towards the wrist, the lower end, which is rounded to form a head, supports the bones of the digits. Of these five metacarpal bones, four are connected with the fingers, whilst one, the outermost of the series, supports the thumb. The bases of these five bones articulate with the second row of the wrist or carpal bones. The heads or lower ends are arranged in the following way :—The four inner bones, viz. those which support the fingers, are united together by ligaments so that they cannot be separated from each other. They may be regarded as almost immovable, for we possess little or no active control over their movements if we except the innermost member of the series, viz. that connected with

Fig. 108. The bones of the right wrist and hand as seen from the front.

r. Radius.
u. Ulna.
a. Styloid process of radius.
c. Styloid process of ulna.
c c. The carpal bones (8).
m m. The metacarpal bones (5).
p p. The finger-bones or phalanges (14).

the little finger, the slight movements of which will be after-
wards described. Whilst we cannot by the contraction of
our muscles cause any alteration in the relative position
of these bones to each other, they may, by the exercise of
pressure, be moved to a slight extent. Thus by grasping
the hand of another they may be crushed closer together, or
by pressing the palm firmly against a flat surface they may
be separated slightly from each other. In marked contrast
to this arrangement it must be observed that the lower end
or head of the metacarpal bone of the thumb is free—that
is to say, it is not connected with the heads of the other
metacarpals by means of ligaments. It is this condition
of the parts which enables us to draw the thumb away
from the palm and fingers. The student will thus observe
that it is only over the inner and outer members of this
series of bones that we have any muscular control—the
inner only to a slight degree, the outer or metacarpal of
the thumb to a very great extent.

The general form of the palm depends on its osseous
framework, but it is only on the back of the hand that
there is any distinct evidence of the arrangement and
form of its bones, for on the front of the palm their out-
line is concealed by the numerous muscles and tendons
which overlie them. On the back of the hand there are
no fleshy muscles to mask their outline, as here they
are crossed merely by the tendons of the muscles going to
the back of the fingers. The reader may satisfy himself as
to this by feeling the back of his own hand, when the
metacarpal bones of the fingers and thumb will be readily
recognized in line with the several digits. If the fist be now
closed the heads of these bones become at once apparent
as a series of well-marked rounded elevations, familiar to
all under the name of the first row of knuckles. According
to the disposition of the fatty layer on the back of the hand,
these knuckles will present a different appearance when

the hand is again opened and the fingers straightened. If the fat be absent or small in amount, the heads of the metacarpals, and the joints which they form with the first row of the bones of the fingers, will be seen to form a series of slight elevations covered with wrinkled skin, towards which the ridges formed by the several extensor tendons of the fingers may be traced ; but if, as in the ideal female hand, and also in that of the child, the fat is present in considerable quantity, the surface corresponding to the position of the knuckles is depressed and forms a series of hollows, or dimples, with but slight, if any, indication of the direction and position of the extensor tendons of the fingers.

In regard to the joints between the bases of the metacarpal bones, and the bones of the wrist, little need be said. The articulation so formed is curved from side to side, corresponding to the curve already described in connexion with the arrangement of the wrist-bones. This curve, it will be remembered, forms the sides and bottom of the tunnel, in front, through which the tendons of the flexors of the thumb and fingers pass, whilst to its posterior convexity is due the side-to-side roundness on the back of the wrist. This arched arrangement is maintained throughout by the four inner metacarpal bones, a fact which can be easily demonstrated. If we lay the back of the hand on a flat surface, it will be found that it is impossible to bring all four inner knuckles of the first row into contact with the surface at the same time, unless we employ pressure from above with the other hand. Further, this grouping of the metacarpal bones assists in forming the hollow of the palm, and imparts to the back of the hand its characteristic side-to-side convexity. It also explains the apparent separation of these bones, which has been already alluded to, when we bring great pressure to bear on the palm as it lies in contact with a flat surface, the

increase in width being due to a flattening out of this transverse arch.

A notable exception to the foregoing arrangement is the metacarpal bone of the thumb. This articulates by means of a separate joint with the outermost bone (trapezium) of the second row of wrist-bones. The surfaces of this joint are of such a kind as to permit movement of every sort except rotation, and, owing to the fact that the lower end or head of the metacarpal bone is not united by ligaments to the other metacarpal bones, the thumb can be moved across or away from the palm, brought forwards or pulled backwards, or by the combination of these movements the act of circumduction may be performed.

The first row of knuckles forms a series of rounded projections, which are due to the shape of the heads of the metacarpal bones. The bones of the first row of *phalanges*, or finger-bones, articulate with the rounded heads of the metacarpals by means of shallow hollow surfaces on their bases; for, like the metacarpal bones, these phalanges are described as long bones, though in reality some of them are very short. Each digit possesses three such phalanges, with the exception of the thumb, which has only two. Each phalanx has a shaft and two extremities, upper and lower; these extremities are articular, except in the case of the lower ends of the bones which are placed at the tips of the fingers, where each phalanx is furnished with a surface which affords attachment for the nail.

The bones of the first row are the longest, those of the third row the shortest, whilst those of the second row are intermediate in length. Both the back and the front of these bones are overlain by the tendons of the fingers in such a way as to conceal their contours. When we bend the fingers the lower ends of the bones of the first and second rows of phalanges are seen to form the projections of the second and third rows of the knuckles.

If the reader will now compare the form of these knuckles with that of the first row, previously described, he will note a difference. Whereas the surface projection of the first row of knuckles was seen to be rounded, the outline of the second and third rows is flattened from side to side. This difference depends on the shape of the lower ends of the phalanges as compared with the heads of the metacarpal bones. As previously stated, the latter are rounded and fit into the shallow hollows on the upper ends of the first row of phalanges. The surfaces permit of movements in a backward and forward direction, i. e. bending or extending the fingers; in this respect the joints are hinge joints. At the same time, another movement is here possible : the phalanges may move from side to side on the rounded end of the metacarpal bone. This is demonstrated when we spread out the fingers or draw them together, a movement which we effect at the first knuckle-joint of the four fingers. This lateral play of the phalanx on the metacarpal bone is absent in the thumb, the corresponding joint of which permits only of flexion and extension. Such movement here is unnecessary, for we possess the power of pulling the metacarpal bone of that digit away from or towards the palm, a movement which, in the other digits, is rendered impossible by the fact that the heads of their metacarpal bones are bound together by ligaments. When we separate the fingers the movement is termed *abduction* ; when we bring them close together we *adduct* them. The line of the middle finger is regarded as the axis of the hand, from and towards which these movements take place. An examination of the articular surfaces of the other knuckles explains at once their difference in form as compared with those of the first row. The lower ends of the bones of the first and second rows of phalanges are provided with two small rounded articular areas separated

by a groove; these fit into corresponding hollows on the
upper ends of the bones with which they articulate, the
two shallow hollows being separated by a slight ridge
which fits into the groove above mentioned. Such a joint
permits of movement only in one direction, viz. flexion
and extension; any lateral play is rendered impossible
by the arrangement of its articular surfaces. This is
the explanation why the surface form of the second and
third rows of knuckles is squarer in outline than that of
the first row, for the outline depends on the form of the
lower ends of the phalanges of the first and second rows
respectively; indeed, a close inspection of these joints
will show not only the squareness of the knuckle, but
also a slight hollowing in the centre, which corresponds
to the groove which separates the two small articular
surfaces. This may best be seen in the second knuckle
of the thumb.

As will be gathered from the foregoing description,
the thumb possesses a far freer range of movement than
any of the other digits, and a moment's consideration will
enable the reader to realize its great importance as a part
of the hand. The thumb can be brought into opposition
with each of the fingers; in this way we can employ it
and the finger with which it is brought into contact as
a pair of forceps enabling us to pick up the most delicate
objects. Perhaps the student will have this brought home
more forcibly to him if he considers for a moment what
the loss of the thumb entails. The fingers may, by the
power of adduction which we possess, be brought together
so as to clasp anything between them, but we have no
longer the power of opposing them, as is the case with the
thumb; this fact can easily be demonstrated if the reader
will endeavour to hold a pencil between any two fingers, and
then try to make use of it. No doubt practice will assist
us in acquiring a greater facility in holding anything in this

way, but it will be at once apparent that there is a vast
difference between the use of the instrument so held, and
the control which we can exercise over it when held by
the thumb and finger.

Accordingly, we find that the thumb is furnished with
a large number of muscles, which not only move it in
different directions, but which are sufficiently powerful
to enable us to employ very considerable force. Some
of these muscles have already been studied; they are the
long muscles of the thumb, and their fleshy bellies are placed
in the fore-arm. But there is a group of short muscles,
the fleshy parts of which lie in the hand itself.

It is this latter group which forms the rounded elevation
along the outer side of the palm and overlying the meta-
carpal bone of the thumb, which is familiarly known as
the *ball of the thumb*.

This fleshy mass consists of the following muscles: a *short
flexor*, an *abductor*, and an *opponens* of the thumb. We
need not here enter into details regarding the precise
attachment and position of these muscles; their names
have been mentioned in order that the reader may have
some idea of their action. Generally speaking, the afore-
said muscles arise from the wrist-bones which form the
external ridge of the groove in which the flexor tendons
of the fingers are lodged; this ridge has been already
referred to (*ante*, p. 190), and was seen to consist of parts
of the scaphoid and trapezium which form the elevation
at the base of the ball of the thumb on a line with the
cleft between the index and middle fingers. But as this
ridge affords attachment to the strong anterior annular
ligament which bridges over the groove and converts it
into a tunnel the muscles of the above group also derive
fibres of origin from this ligament.

From this attachment the fleshy fibres pass down to be
attached to the bones of the thumb. One is inserted into the

shaft of the metacarpal bone, and forms the *opponens pollicis,* a muscle by which we are enabled to carry the thumb across the palm and so oppose it to the other fingers. The

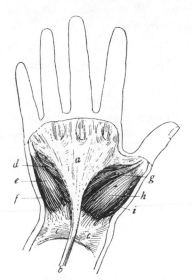

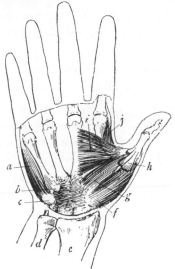

FIG. 109. Shows the arrangement of the structures in the palm.

a. Palmar fascia.
b. Tendon of the palmaris longus passing into it.
c c. The anterior annular ligament underneath which the tendons pass to the palm and fingers.
d, e, and f are the muscles of the ball of the little finger.
 d. Opponens minimi digiti.
 e. Flexor brevis minimi digiti.
 f. Abductor minimi digiti.
g, h, and i are the muscles of the ball of the thumb.
 g. Flexor brevis pollicis.
 h. Abductor pollicis.
 i. Opponens pollicis.

FIG. 110. A deeper view of some of the muscles of the hand.

a. Abductor minimi digiti.
b. Hook-like process of unciform (one of the bones of the carpus).
c. Pisiform bone.
d. Ulna.
e. Radius.
f. Opponens pollicis.
g. Deep part of flexor brevis pollicis or oblique adductor.
h. Superficial part of flexor brevis pollicis and the abductor pollicis (cut).
i. Adductor pollicis, or transverse adductor, and
j. Abductor indicis, or first dorsal interosseous muscle, both of which occupy the interval between the metacarpal bones of the thumb and index finger.

remaining fibres, which consist of the *flexor brevis pollicis* and the *abductor pollicis,* pass down to be inserted into the base of the first phalanx of the thumb in the following way.

The fibres of the short flexor are connected with a little bone, called a *sesamoid* bone, which lies to the outer side of the front of the joint between the first phalanx of the thumb and its metacarpal bone. This little nodule of bone is provided with a cartilage-covered articular surface, which glides on the rounded surface of the outer part of the head of the metacarpal bone. From this sesamoid bone, which thus acts like a pulley, tendinous fibres pass to connect it with the outer side of the base of the first phalanx. Superficial to, and to the outer side of this sesamoid bone, though not connected with it, the abductor pollicis is found as it passes to its insertion into the outer side of the base of the first phalanx along with the foregoing. The abductor action of this muscle moves the thumb as a whole, and not the phalanx on the metacarpal bone, as is the case with the other fingers (Figs. 109, 110).

A small portion of the flexor brevis is inserted into a corresponding sesamoid bone on the inner side of the joint, by means of which it is connected with the inner side of the base of the first phalanx of the thumb.

The thumb is also provided with adductor muscles, which, like the opponens, draw the thumb inwards towards the palm : of these there are two, the *oblique* and the *transverse adductors*. The former has hitherto been described as the deep part of the short flexor, but the description here given is that now generally adopted. This muscle lies deeply in the palm, and, although covered by those already described, it assists in imparting to the ball of the thumb its characteristic fullness. The oblique adductor is in greater part inserted into the inner sesamoid bone, but it also sends some fibres to the outer sesamoid as well, which unite with those of the flexor brevis. Much more important from our standpoint is the *transverse adductor*. This muscle does not assist in forming the swelling of the ball of the thumb, but lies internal to it ; it helps to form

the fleshy mass which occupies the interval between the metacarpal bone of the thumb and that of the index finger. The muscle is fan-shaped; by its pointed extremity it is united to the inner sesamoid bone along with the adductor obliquus, by its base it is attached to the front of the shaft of the metacarpal bone of the middle finger. When the thumb is outstretched the lower border of the muscle can be distinctly felt about half an inch above the fold of skin which forms the web between the thumb and forefinger. By their connexion with the inner sesamoid bone both these muscles are attached to the base of the first phalanx on its inner side. As, however, the joint of the first knuckle of the thumb allows of no lateral play, but only of flexion and extension, these muscles do not move the phalanx, but act on the metacarpal bone with which the phalanx is connected. The presence of the small sesamoid bones imparts a fullness to the front of the joint which it would not otherwise possess (Fig. 110).

The adductor transversus, as above described, is not the only muscle which occupies the interval between the metacarpal bones of the thumb and forefinger. If the reader will examine the back of his own hand with the thumb outstretched and the forefinger pulled as far apart from the middle finger as possible, he will observe a rounded elevation occupying the V-shaped interval between the metacarpal bones of the thumb and forefinger. This is due to the fleshy part of the *abductor indicis*. It is one of a series of muscles which lie between the metacarpal bones of the digits, called the *dorsal interossei*, and is hence sometimes called the *first dorsal interosseous* muscle. The former name is the better for present purposes, as it indicates the action of the muscle. It arises by fleshy fibres which are attached to the metacarpal bones of the thumb and index finger respectively, as they lie on either side of the V-shaped interval. These fibres unite to form a fleshy

belly which is placed along the radial side of the metacarpal bone of the index finger, and terminate, near its lower extremity, in a tendon which runs down the radial side of the first knuckle of the forefinger, to become attached to the base of the first phalanx of that digit along with the extensor tendons. This muscle lies behind the transverse adductor of the thumb, and when we grasp the fleshy layers between the thumb and fore-finger we compress these two muscles between our fingers.

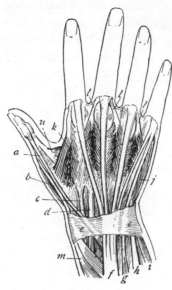

Fig. III. View of the tendons and muscles on the back of the right hand.

a. Tendon of secundi internodii pollicis.
b. Tendon of primi internodii pollicis.
c. Tendon of extensor carpi radialis longior.
d. Tendon of extensor carpi radialis brevior.
e e. Posterior annular ligament of wrist.
f. Tendons of extensor communis digitorum.
g. Tendon of extensor minimi digiti.
h. Tendon of extensor carpi ulnaris.
i. Tendon of flexor carpi ulnaris.
j. Muscles of ball of little finger seen from behind.
k. Abductor indicis or first dorsal interosseous muscle.
l. Second, third, and fourth dorsal interossei muscles.
m. Extensor ossis metacarpi pollicis.
u. Adductor pollicis seen from behind. This muscle determines the outline of the web between the thumb and the index finger.

Just as the outer digit or thumb is provided with short muscles, so the inner digit or little finger is similarly equipped, though the muscles of the latter are much smaller and less powerful than those of the former. This is at once apparent if we compare the prominence of the ball of the little finger with that of the thumb.

The *ball of the little finger* consists of the following muscles, an *abductor*, a *short flexor*, and an *opponens*. The two former are inserted into the inner side of the base

of the first phalanx of the finger, whilst the opponens is attached to the inner side of the whole length of the shaft of its metacarpal bone. These muscles arise more or less in common from the ridge on the inner side of the wrist, formed mainly, as we have already seen, by the pisiform bone, together with a process of another bone called the *unciform*. The former causes the elevation, already referred to, which may be seen and felt at the root of the ball of the little finger, on a line with the cleft between the little and ring fingers, and towards which the tendon of the flexor carpi ulnaris can be traced (*ante*, p. 190). In addition some fibres of this fleshy mass arise from the anterior annular ligament. The action of these muscles is sufficiently indicated by their name, though it may be well to note a difference in the action of the abductor of the little finger as compared with that of the thumb. This muscle draws the little finger away from the ring finger at the first knuckle-joint, a movement which is impossible in the thumb, as the corresponding joint of that digit allows of no lateral play. The action of the opponens muscle of the little finger is much more limited than that of the thumb, because the head of the metacarpal bone of the little finger is bound to that of the ring finger by ligaments. The movement is therefore limited to a slight drawing forward of the metacarpal bone which helps to deepen the hollow of the palm (Figs. 109, 110).

Between the two muscular prominences above described, the palm is hollowed out from side to side and slightly also from above downwards. If the fingers be pressed into this hollow the skin is felt to be firm and resistant. This is due to the fact that there is a dense layer of fibrous tissue, called the *palmar fascia*, immediately beneath and intimately connected with the skin in this situation. This fascia is somewhat triangular in shape; its narrow or pointed end is united to the anterior annular ligament

which bridges across the groove formed by the wrist-bones, whilst its broad end or base is directed towards the roots of the fingers, with the tendon sheaths of which it is connected. On either side this fascia thins out, furnishing fibrous expansions which cover the muscles of the balls of the thumb and little finger respectively; the middle portion is, however, by far the strongest. All the flexor tendons of the fingers, together with a number of blood-vessels and delicate nerves, pass underneath this fascia, so that ample protection is afforded to these structures, a most important detail when we remember how frequently we grasp the handle of a tool and thus subject the delicate parts within the palm to the influence of direct pressure.

The skin of the palm varies in thickness in different places; it is thick in the centre and along the inner side where it covers the ball of the little finger, thinner where it passes over the muscles of the thumb. The thickness of the skin of course depends on the occupation of the individual, 'the horny-handed son of toil' in this respect presenting a marked contrast to the appearance displayed by one who has never been required to engage in hard manual labour. The palm presents a series of small rounded elevations or pads just before the fingers spring from it. These prominences, of which there are three, lie rather in the intervals between than over the roots of the fingers. Viewed from the front, the webs between the fingers, and the skin creases which cross the roots of the fingers, form a well-defined line with a flowing curve from without inwards which limits inferiorly the region of the palm.

A number of well-marked creases or folds are seen crossing the palm in different directions. Of these, four are usually well marked, two having a somewhat transverse direction, whilst the other two pass more or less

longitudinally; their arrangement has been described as resembling the written capital *M* placed obliquely across the palm. The lower of these transverse lines may be traced from the inner border of the hand, about an inch above the level of the web between the little and ring fingers.

across the palm curving downward towards the cleft between the middle and fore fingers. The second transverse line commences about an inch above the web of the index and middle fingers, and, curving upward, crosses the palm to be gradually lost on the surface of the ball of the little finger. If the student will examine these lines with the fingers straight and the palm stretched, and then proceed to bend the fingers on the palm, he will at once recognize that they are lines of flexion and correspond to the infolding of the skin over the joints between the metacarpal bones of the fingers and the first row of phalanges.

In like manner the two longitudinal lines, one sweeping round the ball of the

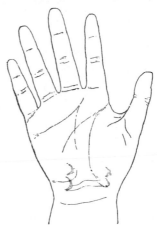

FIG. 112. Outline of the hand, showing the arrangement of the skin folds in front of the wrist and on the palm and fingers. The shaded parts indicate the positions of the bones which form the prominent inner and outer borders of the carpus. Those at the ball of the thumb correspond from below upwards to the tubercle of the *scaphoid* and the ridge of the *trapezium*; those on the ball of the little finger to the *pisiform* and hook-like process of the *unciform*.

thumb, the other running down the centre of the palm, are at once seen to be associated with the movements by which the hollow of the palm is deepened by the approximation of its inner and outer borders through the action of the opposing muscles of the thumb and little finger.

To apply any other significance to these lines is at once an imposition and a fraud.

Many persons possess the power of wrinkling the skin along the inner border of the palm overlying the ball of the little finger; this is due to the action of a small superficial muscle, called the *palmaris brevis*, the scattered fibres of which have a transverse direction across the upper and inner side of the palm, from the dense fascia of which they take origin, whilst by their inner ends they are attached to the skin.

The four fingers as they spring from the palm are united by skin folds, which form the webs of the fingers. These folds unite the fingers at a level corresponding to the middle of the first row of phalanges or finger bones, so that a considerable portion of the palm is formed by the bases of these bones and their articulation with the metacarpals. The part of the palm which lies below the level of the two transverse folds aforementioned corresponds to the roots of the fingers. As we shall see, this is one of the reasons why the fingers appear shorter when viewed from the front than from the back.

The fingers should taper regularly from base to tip, and should not display any thickening at the joints. The rounded form of the anterior surface is due to the tendons which pass down the front of the phalanges. These tendons are enclosed in a strong sheath, which, however, is much thinner where it crosses the front of the joints. The surface roundness is somewhat constricted over each joint, where delicate skin folds are seen. These are lines of flexion, and are arranged as follows: on a level with the web of the fingers, the index and little fingers are crossed by a single line, the middle and ring fingers by two lines. In front of the second joint each finger is crossed by two folds, there being only one transverse crease in front of the third joints. The tips of the fingers are provided with

well-marked ' pulps ' covering the front and ends of the third row of finger-bones, which in their turn support the nails.

The skin in front of the first joint of the thumb is crossed by an oblique fold which passes upwards and out-wards from the web between the thumb and forefinger. Two creases cross the front of the second joint.

The appearance of the back of the hand varies much, according to the amount of fat distributed in the sub-cutaneous layers. The general surface is convex from side to side, superiorly it is carried up into the roundness of the wrist. The manner in which the wrist is united to the hand varies in different individuals; in some the outline of the back of the arm is carried down as a more or less straight line on to the back of the hand. In the more refined and beautiful type, however, the flow of this line is interrupted by a rounded curve over the back of the wrist, which thus interrupts the continuity of the outline of the fore-arm and that of the back of the hand. This graceful contour is further emphasized if, at the same time, the fingers are slightly hyper-extended. These remarks apply particularly to the hands of women, in whom we expect to find suppleness and grace rather than firmness and strength.

The skin over the back of the hand is thin and trans-parent, enabling us to recognize easily the position of the superficial veins either by their colour or prominence ; the latter would be justifiable in a representation of a male hand, but would be entirely out of place if indicated in the female, unless it be the hand of an old woman in whom the wasting of the fat has led to an undue prominence of the vessels. In man these superficial veins are seen to form an irregular arch across the back of the hand from which the blood passes up by the superficial veins of the fore-arm already noticed (*ante*, p. 218).

The appearance of the first row of knuckles has been previously alluded to. In hands in which the tendons are easily seen these will be noticed, when in a state of tension, forming a series of ridges passing down from the middle of the back of the wrist to the first row of knuckles, over which they are carried on to the backs of the fingers. The tendons which form the most pronounced ridges on the surface are those associated with the thumb. These we have already described in connexion with the wrist-joint and the muscles of the fore-arm. They are the extensors of the metacarpal bone and phalanges of the thumb. That passing to the second phalanx forms the salient ridge which is plainly visible when we strongly extend the thumb; this ridge is seen to pass from a point on the back of the wrist in line with the cleft between the index and middle fingers, downwards towards the first knuckle of the thumb, after which it is carried along the back of the first phalanx to reach the base of the second, to which the tendon is attached.

The manner in which the fingers spring from the back of the hand is very different from what we have seen in front. If the fingers be spread out, the webs between them will be noticed to be attached to the sides of the fingers much lower down in front, where they form a sharp abrupt fold which stretches across the interval between the fingers on a level with the middle of the first phalanges. Above and behind this the skin between the fingers forms a broad groove when the fingers are outspread, which gradually fades away on the back of the hand in the intervals between the knuckles of the first row. When the fingers are again brought together these furrows are represented by a series of folds which carry upwards the outline of the fingers on to the back of the hand. It is for this reason that the fingers of the hand appear much longer when viewed from the back than from the front, for on

the back the whole length of the phalanges of the first row is seen to enter into the construction of the fingers, whereas on the palmar surface nearly half the length of these bones is concealed in the fore-part of the palm. The reader may at once satisfy himself as to the correctness of this explanation if he examines his two hands placed side by side, the one palm upwards, the other palm downwards (Fig. 113).

The flow of the lines which separate the fingers behind, when closely approximated, is peculiar. The lines on either side of the middle finger take different directions, that between the middle and index fingers passing outwards towards the thumb, the other between the middle and ring fingers being directed towards the inner border of the hand, a direction which is also followed by the line between the ring and little fingers. The direction of these lines is determined by the position and direction of the tendons of certain small muscles lodged between the shafts of the metacarpal bones, and called the *dorsal interossei*. The middle finger is provided with two of these muscles, one on either side, and it is the tendons of these muscles, as they pass down to be attached on either side to the first phalanx, which account for the flow of the lines in opposite directions. The corresponding muscle of the ring finger is attached to the ulnar side of the first phalanx of that digit (Fig. 111).

In the extended position of the fingers the skin is seen to be much wrinkled over the second row of knuckles, less so over the third, beyond which we find the nails.

Well-shaped nails should be long and not too broad; straight or but slightly curved in their long direction; arched from side to side. The nail of the forefinger is the least curved from side to side, that of the little finger the most curved. Short, broad, and flat nails are an unpleasant feature in the hand.

The length of the fingers varies in different individuals

but as a rule, in a well-formed hand, the relative lengths of the digits are approximately as follows. The middle finger is the longest; the tip of the index finger corresponds pretty closely to the level of the root of the nail of the middle finger. The ring finger reaches as low as the level of the middle of the nail of the middle finger, and is thus slightly longer than the index finger; the little finger reaches to the level of the third joint of the ring finger; whilst the thumb, when closely applied to the outer side of the fore-finger, should reach the level of the second joint of that digit, though it is frequently somewhat shorter. It is not unfrequent however to meet with the index finger as long as the ring finger. Seen from the front, the middle finger appears shorter than the palm, viewed from the back it appears longer than the back of the hand.

When the fingers are bent the length of their dorsal surface is increased ; this is at once apparent if we examine the condition of the skin. When the fingers are straight the skin over the knuckles is puckered and wrinkled; when bent, the skin becomes tense and stretched over the joints, thus indicating that there has been an increase in the length of the finger on its dorsal aspect. This increase is due to the fact that the thickness of the lower articular ends of the metacarpal bones and first two rows of phalanges has now to be taken into account. The accompanying diagrams will at once make this clear (Figs. 113, 114).

As a rule, extension of the fingers is limited to bringing them into a straight line with the palm, but many persons possess the power of bending back the fingers to a slight degree at the first row of knuckles, and also at the other joints. This hyper-extension at the first joints of the fingers is most easily effected when the other joints are slightly bent, and the appearance produced conveys an impression of suppleness and grace particularly pleasant in a well-modelled female hand. The movement

just described is an active movement, i. e. one controlled
by the muscles of the individual, and must not be con-
fused with passive hyper-extension which is caused by
pressing back the fingers. The extent to which this may
be carried will depend on the looseness of the joints and
the amount of pressure employed.

It may be pointed out, in connexion with the movements
of the thumb, that flexion at the first knuckle is limited
in range, whilst at the corresponding joints of the other
fingers bending may take place to form a right angle; in
the thumb we can only flex it so as to include an angle

FIG. 113. FIG. 114.

Diagrams to show how the length of the dorsal surface of the finger
is increased during flexion by the sum of the thickness of the meta-
carpal and phalangeal bones of the first and second row. In Fig. 113 the
dotted line represents the attachment of the web between the fingers,
showing how the fingers seem longer when viewed from behind than
in front.

of about one hundred and twenty or one hundred and
thirty degrees.

In summing up the facts in regard to the hand, the student
will now realize the advantages of its complex structure.
The number of bones and muscles which enter into its
formation impart to it a wide range of mobility which
adapts it for the most delicate manipulations. The
varying length of the fingers, and the manner of their
articulation, enable us to grasp with ease and firmness
objects of a spherical form. Similarly, their arrange-
ment is conducive to the ease with which we can poise

on our finger-tips and thumb any flat surface, such as a plate. The numerous bones and joints in the hand are also of much service in reducing the violence of shocks. In striking a blow with the fist the force is much broken up and diminished in intensity before it reaches the bones of the fore-arm, so that we are enabled to strike powerfully without doing injury to ourselves.

In conclusion it may be well to remind the reader that the form of the upper limb differs in the two sexes. As an artist of repute once said, 'A woman should have no anatomy'; this really is the gist of the whole matter. In the female the bones are smaller and of more delicate form; the muscles are less developed, and in addition they are covered by a thicker layer of subcutaneous fat which masks and softens the outlines of the underlying structures, imparting a roundness and fullness to the limb such as is characteristic of the sex (Pls., pp. 34, 36, 52, 54, 72, 86, 262, 270, 298, 308, 438). In both male and female the form of the limb is tapering, its greatest thickness being in the region of the shoulder, where the deltoid muscle overlies the shoulder-joint.

Another matter requiring consideration is the length of the limb. This will be more fully discussed when the question of proportion is considered; but it may be well to state here that a short arm is much more pleasing than a long one, the latter being regarded as rather an ape-like characteristic, and one which is more frequently observed in the lower races of man. As Brücke has justly observed, 'A model is not easy to find in whom the arms are too short as compared with the legs, but there is no lack of specimens in whom they are too long.'

CHAPTER IX

THE GLUTEAL REGION

BEFORE passing to the consideration of the lower limb it may be well to refer to some of the points already discussed in one of the earlier chapters. The essential difference between the upper and lower limbs of man was there described, and it was shown that the lower limb was designed to combine the functions of support and progression.

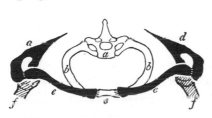

FIG. 115. Diagrammatic representation of the shoulder-girdle.

 a. First dorsal vertebra.
 b. First rib.
 c. Breast-bone (sternum).
 d. Shoulder-blade (scapula).
 e. Collar-bone (clavicle).
 f. Humerus (bone of upper arm).

FIG. 116. A diagrammatic representation of the pelvic girdle.

 a. Sacrum.
 b. Haunch-bone (os innominatum).
 c. Symphysis pubis.
 d. Upper end of thigh-bone (femur).

The attention of the student must be particularly directed to the arrangement of the bones which form the *pelvic girdle*, by means of which the lower limb is connected with the trunk. It has been already shown that the shoulder-girdle is movable on the trunk, for the upper limb is specially adapted to meet the requirements of free movement and prehension. In the case of the pelvic girdle,

however, the bones afford support to the trunk, and for this reason the girdle-bones of the lower limb are firmly united to the axial skeleton. The only movements which are comparable in the two limbs are those which take place at the shoulder and hip joints. There is no movement between the pelvic girdle and the trunk resembling that which takes place between the shoulder-girdle as a whole and the trunk, or between the component parts of that girdle, viz. the collar-bones and shoulder-blades.

On examining the skeleton, the girdle-bones of the lower limb are seen to be firmly united with that part of the vertebral column of back-bone which is specially modified by the osseous union of its component vertebrae to form the *sacrum* (*ante*, p. 7). In front they are united by an immovable joint called the *symphysis pubis*. By this means an osseous girdle, called the *pelvis*, is formed which encloses or surrounds a very considerable cavity called the *pelvic cavity*.

Leaving for the present the consideration of the pelvis, the portion of the girdle strictly associated with the limb may be examined. This consists of an irregularly shaped bone called the *innominate* or *haunch-bone*. Although in the adult this appears as a single bone, it is in reality formed by the fusion of three separate parts. The student will have no difficulty in recognizing on the outer side of the haunch-bone a well-marked cup-shaped cavity called the *acetabulum*. Into this deep hollow the head of the thigh-bone fits. The acetabulum marks the point of coalescence of the three parts of which the fully developed bone is constituted. Extending forwards and inwards from this articular cavity is the *pubis*; passing upwards, outwards, and backwards we note the expanded curved plate of bone called the *ilium*; below and slightly behind is the *ischium*. The pubis and the ischium are further united by processes called their *rami*, and thus enclose between them a wide hole,

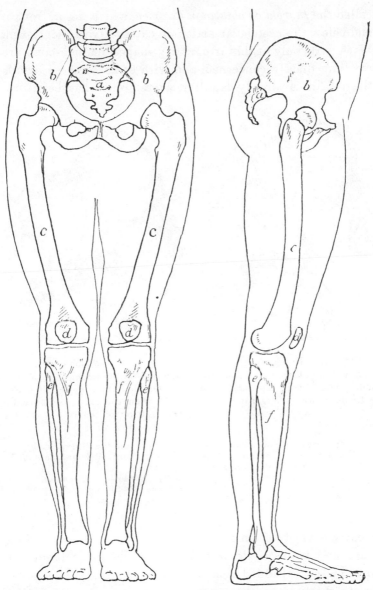

FIG. 117. The skeleton of the lower
limb as seen from the front.

FIG. 118. The skeleton of the lower
limb as seen from the outer side.

a. The sacrum.
b. The haunch-bone (os innominatum).
c. Thigh-bone (femur).

d. Knee-pan (patella).
e. Outer bone of leg (fibula)
f. Inner bone of leg (tibia).

g. Bones of foot.

called the *thyroid* or *obturator foramen,* which lies in front of and below the acetabular articular cavity above mentioned. With parts only of this irregularly-shaped haunch-bone are we immediately concerned, and with some of these details the reader is already familiar, as reference has been pre-

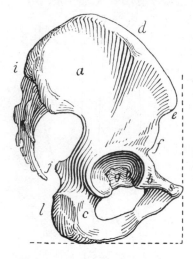

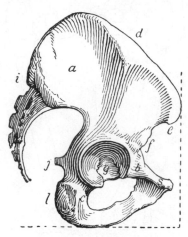

FIG. 119. Haunch-bone (os innominatum) of male seen from the outer side; it is represented as articulated with the sacrum.

FIG. 120. Haunch-bone (os innominatum) of female. Note that the female bone is more tilted forward than the male, as shown by the relation of the points *s* and *e* to the dotted vertical line.

a. Iliac portion of the innominate bone.
b. Pubic portion of the innominate bone.
c. Ischial portion of the innominate bone.
d. Iliac crest.
e. Anterior superior iliac spine.

f. Anterior inferior iliac spine.
g. Acetabulum (hollow for head of thigh-bone).
i. Posterior superior iliac spine.
j. Spine of ischium.
l. Tuberosity of ischium.

s. Spine of pubis.

viously made to them in the description of the abdominal walls and flanks (*ante,* p. 67). Thus the upper border or· *crest* of the expanded iliac bone has been already studied in its relation to the surface. This describes a sinuous curve, being towards the outer side convex in front and concave behind, whilst between its two extremities the

crest is arched in a vertical direction, the convexity of the curve being inclined upwards. The extremities of this crest, called respectively the *anterior* and *posterior superior iliac spines,* have been noted as important determinants of surface form, the anterior corresponding to the depression at the outer side of the fold of the groin (*ante*, p. 68), the posterior underlying the depression or dimple which is so characteristic a feature of the lower part of the back in both the male and female (*ante*, p. 45).

The anterior two-thirds or so of the inner surface of this plate-like bone is hollowed out to form the *iliac fossa.* This affords an expanded surface for the support of the abdominal contents and for the attachment of the iliacus muscle. The posterior third of the inner aspect of the ilium is rough and irregular, and is adapted for articulation with the side of the sacrum, to which it is firmly united. This surface corresponds to the posterior part of the crest, which curves slightly outwards. The outer surface of the ilium furnishes an extensive attachment for the muscles

FIG. 121 (after Richer). Shows the relation of the iliac furrow to the iliac crest.

of the buttock, which, in man, attain a remarkable development, and are intimately associated with the maintenance of the erect position.

Of the *pubis* we are concerned only with the anterior part or body. It is by means of this bone that the inno-

minate or haunch-bones of the two sides articulate with each other, forming a joint which is known as the *symphysis pubis*; in this way the osseous girdle is completed in front. This joint lies in the middle line in continuation with the direction of the median furrow which runs down the front of the abdominal wall. On each side of this lie the bodies of the respective pubic bones, occupying the interval between the inner extremities of the folds of the groin on either side. Owing to the thick pad of fat which overlies these bones, their outline is concealed, but they assist, however, in forming the general roundness which is so characteristic of this region. If the finger be passed along the upper border of the pubis from the symphysis outwards, one can easily recognize the presence of a well-marked process called the *spine of the pubis*. To this point attention has been already directed (*ante*, p. 68) when describing the lower limits of the anterior abdominal region. It affords attachment to an important band called *Poupart's ligament*, which stretches obliquely upwards and outwards, to be fixed to the anterior superior iliac spine (the anterior extremity of the iliac crest). It is this ligament, as has been seen, which corresponds to the position of the furrow of the groin. The upper border of the body of the pubis between the symphysis and the spine is called the *crest of the pubis*.

The *ischium* as a rule does not directly influence the surface form. The most prominent part of that bone, which lies below and slightly behind the acetabulum, or articular cup, is thick and rounded, and is called the *tuberosity*. In the standing position the tuberosity is covered by the thick fleshy fibres of one of the great muscles of the buttock, the *gluteus maximus*, but when the leg, or more properly the thigh, is bent forward at the hip-joint the muscle slips over this bony prominence, and so uncovers it. Thus, in the sitting posture, the tuberosity of the ischium underlies

the skin, and it is on these prominences that the body weight rests, so that the muscles are in no way crushed or compressed in this position. Further, provision is also made to relieve, as much as possible, the parts from pressure, for the fat overlying the ischial tuberosities is abundantly mixed with fibrous tissue which imparts to it a highly elastic quality, resembling, in this respect, the arrangement met with in the tissues underlying the heel.

It is by the fusion of these three bones, the ilium, the ischium, and the pubis, that the innominate or haunch-bone is formed, and it is, as has been said, at the point of fusion of these three bones that the *acetabulum* is placed. We need for the present only compare it with the glenoid fossa on the shoulder-blade. The latter was seen to be relatively small and shallow, thus permitting great freedom of movement and affording limited support, whereas the acetabulum is large and deep, and better adapted to furnish support, though less well fitted to allow free movement. The further details in connexion with this subject are reserved until the hip-joint is described.

It is by the union of the two haunch-bones with each other in front, and the sacrum behind, that the pelvis is formed. The *sacrum*, as has been already explained (*ante*, p. 7), is a specially modified part of the vertebral column or back-bone, which is built up by the fusion of five vertebral segments. It is, so to speak, wedged in between and behind the iliac portions of the two innominate bones, with which it is firmly united by immovable joints. In this way provision is made for the transmission of the body weight from the vertebral column downwards through the two haunch-bones, and so on to the thighs. The surface relations of the sacrum have been already studied (*ante*, p. 45), and the student may be referred to that description for further details. Meanwhile, it will be sufficient to note that it is only the posterior aspect of

this bone which is a determinant of the surface contours. The osseous girdle so formed encloses the pelvic cavity in which certain viscera are lodged. This cavity is described as consisting of two parts, the true and the false. The false pelvis corresponds to the hollow formed by the expanded iliac bones. The true pelvis is that part of the cavity which is bounded in front by the pubes, on either side by the ischia, and behind by the sacrum.

The pelvis is a most important determinant of form, not only directly, as has been already sufficiently explained, but also indirectly, since by variations in its size and shape it influences the entire modelling of the lower part of the trunk and upper part of the thighs. It is on the width of the pelvis that the narrowness or breadth of the lower part of the figure depends. These differences give rise to the characteristic figures of the two sexes. The cavity of the true pelvis in the female is, for sexual reasons, larger than that of the male, and thus necessarily reacts on the form of the bones which surround it, leading to their greater expansion. It follows therefore that the female pelvis is wider than the male. On the other hand, the male pelvis, though narrower than the female, is deeper. These two facts account for the differences in the width of the figure across the hips in the two sexes, and also for the circumstance that the flanks in the female are relatively longer than those of the male, for the iliac crests in the female do not rise to so high a level. The pelves of the male and female present many other differences, but these need not here be discussed.

Another matter of great importance in regard to the influence of the pelvis on the surface form is its position in relation to other parts of the skeleton. The student will experience considerable difficulty in acquiring a correct knowledge of its usual position in the erect position, unless he has access to a specimen which has been separated from

the rest of the skeleton, and adopts some such simple rule

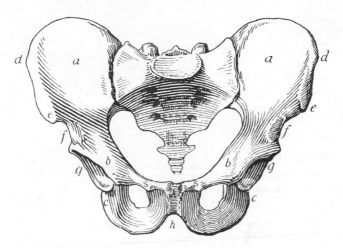

FIG. 122. The male pelvis.

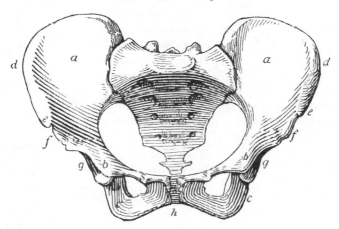

FIG. 123. The female pelvis.

a. Iliac portion of os innominatum.	*g.* Acetabulum.
b. Pubic portion of os innominatum.	*h.* Pubic arch.
c. Ischial portion of os innominatum.	*k.* Pubic symphysis.
d. Iliac crest.	*s.* Spine of pubis.
e. Anterior superior iliac spine.	The sacrum is seen wedged in between
f. Anterior inferior iliac spine.	the two innominate bones behind.

as the following:—Take the pelvis and hold it in such

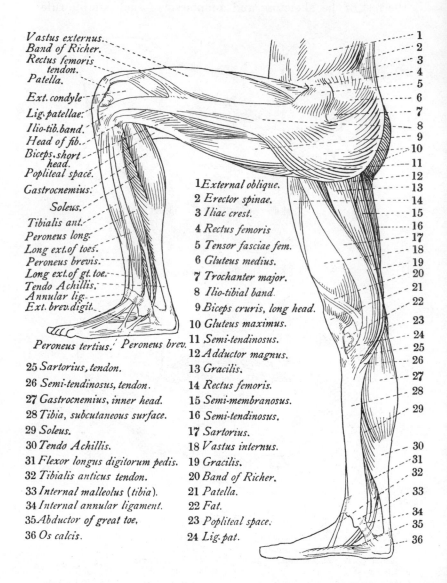

Vastus externus.
Band of Richer.
Rectus femoris
 tendon.
Patella.

Ext. condyle
Lig. patellae.
Ilio-tib. band.
Head of fib.
Biceps. short
 head.
Popliteal space.
Gastrocnemius.

Soleus.

Tibialis ant.
Peroneus long.
Long ext. of toes.
Peroneus brevis.
Long ext. of gt. toe.
Tendo Achillis.
Annular lig.
Ext. brev. digit.

Peroneus tertius. Peroneus brev.

25 Sartorius, tendon.
26 Semi-tendinosus, tendon.
27 Gastrocnemius, inner head.
28 Tibia, subcutaneous surface.
29 Soleus.
30 Tendo Achillis.
31 Flexor longus digitorum pedis.
32 Tibialis anticus tendon.
33 Internal malleolus (tibia).
34 Internal annular ligament.
35 Abductor of great toe.
36 Os calcis.

1 External oblique.
2 Erector spinae.
3 Iliac crest.
4 Rectus femoris
5 Tensor fasciae fem.
6 Gluteus medius.
7 Trochanter major.
8 Ilio-tibial band.
9 Biceps cruris, long head.
10 Gluteus maximus.
11 Semi-tendinosus.
12 Adductor magnus.
13 Gracilis.
14 Rectus femoris.
15 Semi-membranosus.
16 Semi-tendinosus.
17 Sartorius.
18 Vastus internus.
19 Gracilis.
20 Band of Richer.
21 Patella.
22 Fat.
23 Popliteal space.
24 Lig. pat.

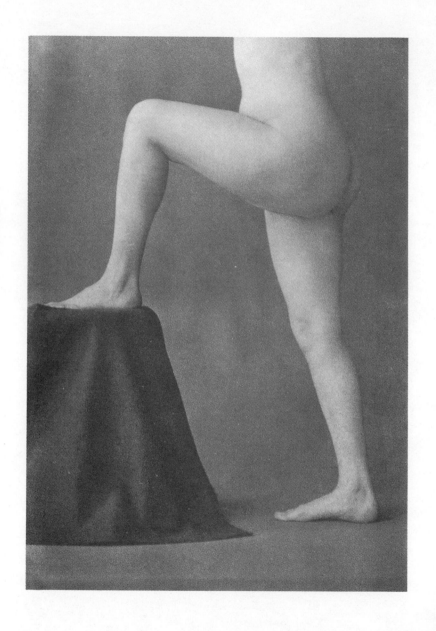

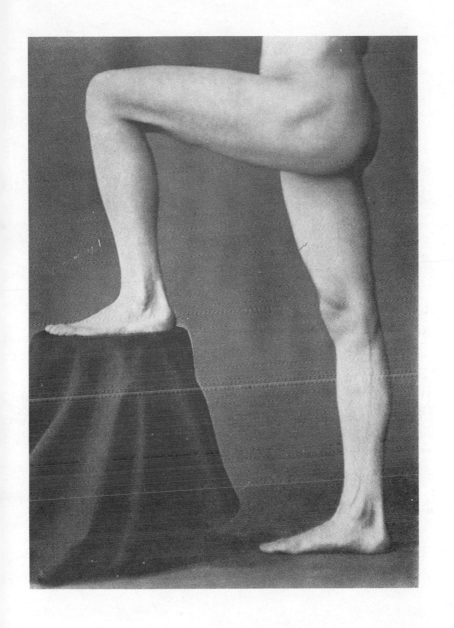

a position that the two anterior superior iliac spines (anterior extremities of the iliac crests) lie in the same horizontal line, then move the bone till the symphysis pubis lies vertically beneath the centre of the line which connects the two anterior superior iliac spines; or, draw a horizontal line on any vertical surface, a wall for instance, and place the pelvis against this vertical surface so that all three points (the two anterior superior iliac spines and the symphysis) are in contact with it at once, care having been taken to place the anterior superior iliac spines on the horizontal line already drawn. The bone will now lie approximately in the position which it occupies in the living when we stand upright. As a matter of fact its upper part is slightly tilted forwards in the female, whilst in the male this part of the bone is tilted a little backwards. This variation in the obliquity of the position of the pelvis is associated with very remarkable changes in the contours of other parts of the figure, and its further description must be delayed until the anatomy of the hip-joint has been considered; it is on the adjustment of this articulation that the alterations in position or ' obliquity ' largely depend.

The relation of the width across the hips and that across the shoulders is a point requiring some consideration. In both sexes the former is less than the latter, though in the female the difference between the two measurements is much less than in the well-proportioned male. In other words, women have broad hips and narrow shoulders, whilst men have broad shoulders and narrow hips. This difference in hip-width is largely dependent on the fact that in women the pelvic width is not only relatively, but also absolutely, greater than in man. Since this hip-width includes the upper extremities of the thigh-bones as well as the transverse diameter of the pelvis, it will be necessary to say more about it after we have described the anatomy of the thigh-bone.

The thigh-bone or *femur* (Figs. 124–126) in man is remarkable for its great length. Like other long bones, it is described as possessing a shaft and two extremities. In connexion with the upper end of the bone the *head* must be studied. This consists of a rounded knob, forming about two-thirds of a sphere, which in the living is covered with a layer of articular cartilage and fits into the deep socket of the acetabulum on the outer side of the haunch-bone. This rounded articular head is supported by means of a process called the *neck*, by which it is united to the upper extremity of the shaft, forming with it an angle of about 125°. This angle varies according to circumstances; it is more open in children, more acute as age advances, and is usually less obtuse in the female than in the male.

The length of the neck of the bone is a matter of great importance, as it permits of a freer range of movement at the hip than would otherwise be the case, considering the depth of the articular cup and the prominence of its borders; further, it acts as a lever for the muscles which control the movements of the hip-joint, and which are inserted around the neck where that part of the bone becomes fused with the shaft. At this point there are two well-marked processes developed : these are called the *trochanters*. They are distinguished by the names *great* and *small*; the *small* or *lesser trochanter* is placed on the lower side of the neck as it joins the shaft, and is of little interest from our standpoint.

The *great trochanter* is situated at the upper and outer side of the angle formed by the fusion of the neck and shaft, and overtops, as it were, the root of the neck. This process is of the greatest importance as a determinant of surface form, since its outer aspect is merely covered by skin, fat, and certain thin, though strong, tendinous layers. It can be readily felt, and its prominence assists in imparting to the hips that width to which attention has been

already directed. As a rule it corresponds in position to the greatest width of the male figure in this region; most frequently in the female the greatest breadth is at a somewhat lower level, owing to the presence of the subcutaneous fat which tends to accumulate along the upper and outer part of the thigh. It is into the trochanter major that many of the muscles concerned in the maintenance of the erect position are inserted.

The shaft of the thigh-bone is seen to be curved when viewed from the side (Fig. 125), the convexity of the curve being directed forwards. Though covered with muscles, the bone yet exercises a considerable influence on the form of the limb, and it is to this forward curve of the shaft that the rounded form of the front of the thigh is in part due.

On the hollow side of the curve, i. e. on the back of the bone, the shaft is strengthened by the addition of a rough ridge called the *linea aspera*. Besides imparting increased rigidity to the bone, this ridge affords extensive attachment to muscles.

Inferiorly the lower end of the bone is expanded, forming two processes, called the *condyles*. These are coated with articular cartilage and enter into the formation of the knee-joint. They will be more fully described when the anatomy of that joint is considered.

The position of the thigh-bone in the limb is oblique. This may be easily demonstrated. When we stand in the military position of attention, the knees are close together, whilst the upper extremities of the thigh-bones are separated by the pelvic width between the two acetabular hollows. According as the interval between the heads of the thigh-bones is increased or diminished, so the obliquity of the shaft is rendered greater or less. This explains how it is that the thigh-bones of women are usually more oblique in their position than those of men, because superiorly they are separated by a pelvis of greater width, whilst inferiorly

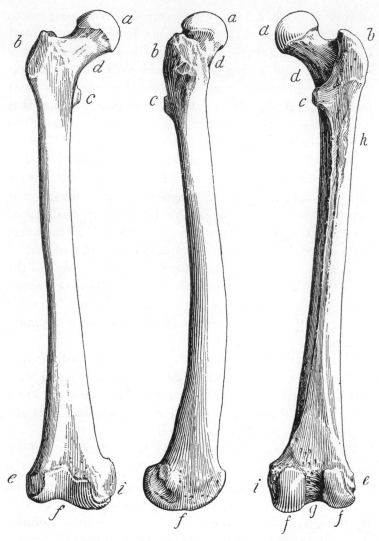

Right thigh-bone (femur).

FIG. 124. Front view FIG. 125. Outer side. FIG. 126. Back view.

a. Head.
b. Trochanter major.
c. Trochanter minor.
d. Neck.
e. External condyle.

f. Articular surface of condyles.
g. Intercondyloid notch.
h. Surface for attachment of gluteus
 maximus.
i. Internal condyle

they touch each other at the knees. It is this greater obliquity of the femur in women which gives rise to the knock-kneed appearance which is really a characteristic of the sex. When, from shortness of the thigh, this appearance is unduly pronounced, it becomes exceedingly offensive and unpleasant, but in its gentler form it often conveys a sense of delicacy and refinement. It is seldom, indeed, that the artist would be called upon to represent the female nude,

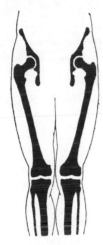 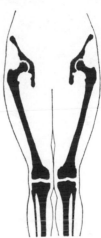

FIG. 127. FIG. 128.

Diagrams showing the greater degree of obliquity of the thigh-bones dependent on the greater pelvic width in woman, Fig. 128, as compared with man, Fig. 127.

with the limbs placed as has just been described, i. e. the position in which the knock-kneed appearance is most pronounced : more usually one or other knee would be advanced and slightly bent, an action sufficient to impart to the figure a sense of grace and modesty. As a result of the greater obliquity of the thigh-bone in women it follows that the angle formed by the neck of the femur with the shaft is more acute than in the male.

The *hip-joint* lies so deeply embedded on all sides in

fleshy muscles that it has but slight influence on the surface form. It is only when the limb is thrown as far back as possible that the head of the femur pushes forward the soft parts which overlie it, and thus leads to the obliteration of that depression on the upper and anterior aspect of the limb called the hollow of the thigh.

The surfaces of the joint fit so accurately that atmospheric pressure is alone sufficient to keep the smooth rounded articular head of the femur in contact with the hollow of the acetabulum. This has been demonstrated experimentally, after death, by cutting away all the muscles and ligaments; under these circumstances the articular surfaces of the bones still remained in contact instead of falling away, as one might expect.

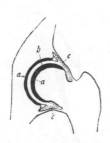

FIG. 129. Diagrammatic section through the hip-joint.

a. The thick black lines represent the cartilage-covered articular surfaces.
b. The joint cavity.
c. The ligaments around, forming the capsule, the interior of which is lined by synovial membrane represented by dotted lines.

The socket of the acetabulum, further deepened by a ligament which surrounds its edge, affords ample support to the head of the femur, through which the weight of the trunk is transmitted. The joint is a very strong one. This is partly due, as above stated, to the form of its articular surfaces, but is also dependent on the strength of the ligaments which bind the bones together. One frequently hears of dislocations of the shoulder-joint, but displacements of the hip-joint are of rarer occurrence and are generally the result of much greater violence.

The capsule of the hip-joint is formed of dense fibrous tissue. In certain situations it is much thickened and forms well-marked fibrous bands, which are described as the ligaments of the joint and have received special names. The most important of these is one which passes

down in front of the articulation; it is called the *ilio-femoral ligament*, or, from its resemblance to an inverted λ (Y), the *Y-shaped ligament*. This is attached to a part of the ilium immediately above the acetabulum, called the *anterior inferior iliac spine*, and spreading out inferiorly in a fan-shaped manner, it is united to the thigh-bone below along a rough line, called the *spiral* line, which marks the point of fusion anteriorly of the neck of the bone with the shaft; superiorly this line is carried up along the inner and anterior border of the great trochanter.

Great importance attaches to this ligament, because it prevents excessive extension backwards of the thigh on the trunk; it has been already pointed out that one of the characteristics of man is the fact that he alone of all four-footed animals can place the thigh-bone in such a position that the axis of the limb falls in line with the axis of the trunk. Any further range of movement beyond this is checked, however, by the tightening of this ligament.

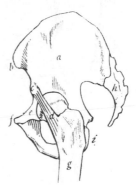

FIG. 130. Diagram showing the attachment of the ilio-femoral ligament.

a. Ilium.
b. Anterior superior iliac spine.
c. Anterior inferior iliac spine.
d. Ilio-femoral ligament.
e. Pubis.
f. Symphysis pubis.
g. Femur.
h. Sacrum.
i. Tuberosity of ischium.

It is mainly owing to the presence of this ligament that man can stand erect for prolonged periods without experiencing much muscular fatigue. When we stand upright, the line of gravity passes behind the axis of the hip-joint and the points of attachment of this ligament; thus, that force in this position is constantly acting so as to keep the ligament tense and stretched, thereby mechanically locking the joint; no special muscular effort is required to effect this purpose,

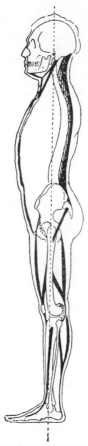

FIG. 131. Diagram to show how the figure is held erect.

The thick black lines indicate the principal muscles therein concerned. The vertical dotted line indicates the direction exercised by the force of gravity. Note that this falls behind the axis of rotation of the hip and in front of that of the knee, thus rendering tense the ligaments of these joints, which are represented on the figure by dotted lines passing in front of the hip (ilio-femoral) and behind the knee (posterior ligament).

hence we do not suffer from the fatigue which would be involved by a constant and prolonged muscular strain.

The student may satisfy himself as to the correctness of these observations by making a little experiment. He will find that he can stand in the military position of attention for a long time with little discomfort and fatigue. If, in this position, the hands be placed on the buttocks and back of the thighs, the muscles of these regions will be found flaccid, or but slightly contracted, but if the body be now bent forward at the hips, or swayed forward at the ankle with the knees straight, so as to throw the line of gravity in front of these joints, he will find it impossible to maintain this position for long without becoming tired. On passing the hand along the back of the thighs and over the buttocks he will now recognize that the muscles are powerfully contracted, particularly in the former situation. The movement of the hip is no longer mechanically checked by the action of the ligaments, but is controlled by the contraction of the muscles situated in the aforesaid regions, which is the explanation why this position cannot be maintained for any length of time without a sense of muscular fatigue.

Slight variations in the length of this ilio-femoral liga-
ment occur in different individuals. These variations are
attended with very remarkable differences in the contours
of the figure. A slightly longer ligament will naturally
allow of a greater range of extension of the thigh on the
pelvis; on the other hand, when the ligament is short, the
range of movement in a backward direction will be less.

Interpreted in another way, this means that when we
stand erect with the thigh-bones in a more or less vertical
position it follows that the pelvis, which they support on
their upper extremities, will be tilted forwards or back-
wards according as the ligament is short or long; this
variation in the position of the pelvis consequently leads to
alterations in its obliquity. Under ordinary circumstances,
the plane formed by the *inlet* of the true pelvis, represented
by a line passing across from the upper part of the symphysis
pubis to the point where the lowest lumbar vertebra unites
with the upper part of the sacrum, usually forms with the
horizon an angle of from 60° to 64°. If the pelvis be tilted
further forwards, as is the case when the ilio-femoral ligament
is short, the *obliquity of the pelvis* is thereby increased, whereas
if the ligament be long the pelvis will lie in such a position
that the plane of its inlet more nearly approaches the hori-
zontal: in the latter case, therefore, the obliquity of the
pelvis is diminished. In using the expression 'obliquity
of the pelvis' we refer to the obliquity of the plane of its
inlet; the position of the entire pelvic girdle is, however,
necessarily involved, as its component parts are immovably
united, and variations in this obliquity will obviously be
associated with alterations in the relative position of the
pelvic girdle to other parts of the skeleton.

A little consideration will enable the reader to realize the
importance of the changes in form which are secondarily
dependent on these alterations in the position of the pelvis.
The back of the pelvic girdle is formed by the sacrum.

and the position of this bone accordingly alters as the entire
pelvis is tilted forwards or backwards; thus, if tilted back-
wards, the posterior surface of the sacrum (that part of it
with which we are most concerned as a determinant of sur-
face form) will more nearly approach the vertical, whereas
a forward tilt of the pelvis will cause this surface to incline
more obliquely, the axis of the bone being directed more
backwards. But the sacrum, formed, as the reader is aware,
by the fusion of several segments of the back-bone, is con-
nected above with the movable part of the vertebral column.
If now the sacrum, and with it the pelvis, be tilted forwards,
so that the upper extremity of the sacrum is thrown further
in front, it follows that the bones of the vertebral column.
with which it is connected, must be inclined forward too.
As it is however necessary, for the maintenance of the erect
position without muscular fatigue, that the line of gravity
should pass through the column at certain points, and
fall in definite relation to certain joints, it also follows
that this forward thrust of the entire column must be com-
pensated for by the development of more strongly marked
curves in order that the tilted column may recover its
generally upright position. This is what takes place, for
in persons where the pelvic obliquity is great, i. e. where the
pelvis is much tilted forwards, a condition which, as has
been said, is largely dependent on the existence of a short
ilio-femoral ligament, the curves of the back, particularly
the lumbar curve, are more strongly marked, and the
projection of the buttocks is more pronounced ; whereas in
individuals in whom the pelvic obliquity is slight, i. e. in
persons who possess a long ilio-femoral ligament, the curves
of the back are but slightly emphasized, as here the
necessity for strongly marked compensatory curves does not
arise. These facts may perhaps be better understood by
reference to the accompanying diagrams: Fig. 132 repre-
sents a female figure with well-marked pelvic obliquity

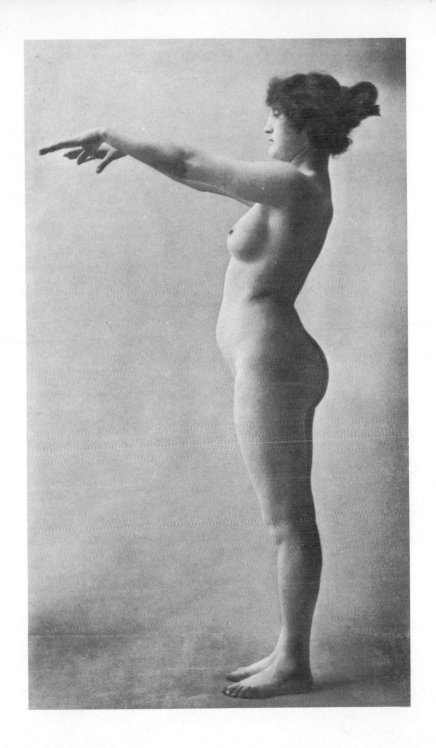

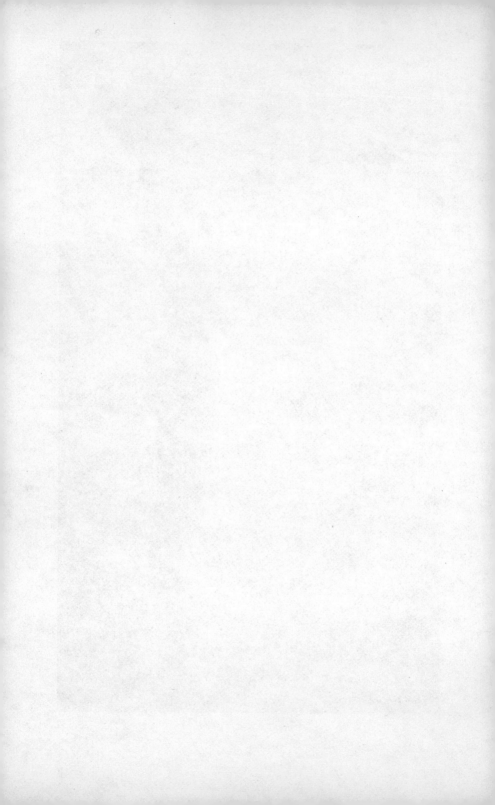

and pronounced curves in the back, Fig. 133 is that of
a male in whom the obliquity of the pelvis is less, and

<div align="center">FIG. 132. FIG. 133.</div>

Figs. 132, 133, show the influence of the pelvic obliquity on the
figure of the male and female. In Fig. 132 the female pelvis is tilted
further forward than in the male, Fig. 133, as will be seen by noting the
position of the anterior extremity of the iliac crest (anterior superior iliac
spine). As a result of this the lumbar curve is more pronounced in
Fig. 132 than in Fig. 133. This reacts on the outline of the figure, the
curves being more pronounced in the female than in the male.

as a consequence the back appears much flatter than in
Fig. 132 (see also Figs. 119, 120, p. 246; also Pl., p. 54,
262, 278, 438).

This difference in the pelvic obliquity reacts on the form of the thigh as well as on the trunk, for if the obliquity of the pelvis be increased the anterior superior iliac spines (the anterior ends of the iliac crests) will be thrust forward, so as to lie on a plane anterior to the plane occupied by the symphysis pubis. Under these circumstances, the most prominent border of the thigh above will correspond to the anterior superior iliac spine, and the anterior surface of the limb will slope slightly inwards and backwards towards the symphysis pubis ; whereas, when these several bony points lie in the same vertical plane, or when the anterior superior iliac spines lie in a plane behind that of the pubic symphysis, the surface of the thigh between these two points will be directed forwards, instead of forwards and inwards as in the former case. The same thing may be expressed differently by saying that, in the former condition, the pubic symphysis is withdrawn between the thighs, and overhung by a more prominent abdominal curve, whereas, under the latter conditions, the symphysis lies on the same plane with the fronts of the thighs, and is less overhung by the abdominal curve (Pls., pp. 72, 86, 216, 298, 434, 438).

The artist will of course be guided in his selection of models by a reference to these points, avoiding, as far as possible, extreme conditions, and recognizing that the most pleasing results are obtained when the average is represented, though he will not fail to observe that in the female one meets with degrees of obliquity which, if represented in the male, would be altogether out of character with the type. He may note, as a more or less definite rule, that in the female the anterior superior iliac spines lie slightly in advance of the symphysis pubis in the erect position, and that in the male they lie either on the same plane or slightly behind the symphysis (Figs. 119, 120, p. 246).

The movements of the hip-joint must next be considered. *Flexion* is the movement whereby the thigh is

bent forward on the trunk; this movement is limited by the approximation of the anterior surface of the thigh to the front of the abdomen. It is worth noting that the range of this movement is affected by the position of the knee. When that joint is bent, we can flex the thigh on the trunk until their surfaces come into contact; when the knee is straight or extended, flexion at the hip is much more limited in its range, and is arrested by the stretching of the muscles called the hamstrings on the back of the thigh. This is at once apparent when we touch, or attempt to touch, the toes without bending the knees (see p. 306).

Extension, as has been said, is remarkably free in man, but a word or two is necessary to prevent any misconception regarding the range of this movement. When the thigh is brought into line with the axis of the trunk the movement is checked by the ilio-femoral ligament, and no further movement is possible in this direction; how comes it then that we can touch the ground behind us with the foot? In order to understand how this takes place, we must consider the movement which takes place at the hip-joint of the opposite limb to that which touches the ground behind us. The reader may best recognize the movements which take place by studying them in his own person. If he stands with the toe of the right foot touching the ground about a couple of feet behind the heel of the left foot, upon which he is resting the weight of the body, he will note that the trunk is thrown forward, and the right leg is directed backward in line with the axis of the trunk, i. e. in the condition of full extension. Under these conditions no change in the relative position of these two parts of the body has taken place; but if now he examines the condition of the left hip he will observe that the joint is in a state of flexion, and it is the combination of flexion of the left hip-joint with extension of the right thigh that

enables him to pass the right leg behind the point through which the line of gravity of the body falls.

Fig. 134 will at once make this clear.

The other movements which take place at the hip-joint are movements of *adduction*, or crossing the legs, and *abduction* or separating the legs. *Rotation* of the entire limb also takes place at this joint: it is the movement whereby we turn the point of the foot in or out. *Circumduction* is the combination in sequence of the foregoing movements, either from within outwards or from without inwards. The several movements are checked in most instances by the action of ligaments, or else by the contact of the neck of the thighbone with the margin of the acetabulum.

FIG. 134.

In considering the muscles which effect these movements the reader must bear in mind one important difference between the girdles of the upper and lower limbs. In connexion with the former we studied a number of muscles which passed from the trunk and were inserted into the bones of the shoulder-girdle; by the action of these muscles the shoulder-girdle was moved upon the trunk. In considering the musculature of the pelvic girdle we have no such group to examine, as, for reasons which have (*ante*, p. 243) been elsewhere fully stated, the pelvic girdle is immovably united with the axial skeleton of the trunk; hence the examination of the muscles which control the movements of the hip may be at once proceeded with.

The *gluteus maximus*, or great muscle of the buttock, has

an extensive origin from the posterior fourth of the iliac crest of the haunch-bone, from the aponeurosis covering the erector spinae muscle, from the side of the lower part of the sacrum, from the side of the coccyx, and from the surface of a ligament which stretches from the sacrum to the ischium, called the *great sacro-sciatic ligament*. A consideration of these attachments will enable the reader to realize that the origin of the muscle corresponds pretty accurately to the side of the V-shaped interval, at the root of the back, which separates the prominences of the buttocks behind, the upper and outer limits of which are marked by the presence of little hollows or dimples overlying the position of the posterior superior iliac spines (the posterior extremities of the iliac crest), whilst the lower angle corresponds to the cleft between the buttocks.

From this attachment the fibres pass outwards, forwards, and downwards, forming a thick fleshy sheet of muscle, which is inserted in front into a broad tendinous aponeurosis. All the fibres of the upper half of the muscle, together with the superficial fibres of the lower half, are inserted by means of this strong aponeurosis into the dense fascia which runs down along the outer side of the thigh. The bulk of the fibres of the lower half of the muscle, except the superficial ones above mentioned, are attached by means of a flattened tendon to a rough ridge, called the *gluteal ridge*, on the back of the upper third or fourth of the shaft of the thigh-bone; the latter insertion is entirely concealed by the former. It is the attachment of this muscle to the fascia of the thigh which gives rise to the most marked changes in the surface form (Pls., pp. 34, 38, 52, 54, 94, 98, 126, 162, 182, 252, 268, 278, 318, 338, 366).

In the erect position the fleshy fibres are seen becoming tendinous behind the line of the great trochanter and shaft of the thigh-bone, so that the outer surface of the great trochanter is merely covered by the aponeurotic insertion of

the muscle, and not by its fleshy fibres. This fact is easily ascertained by placing the hand over the trochanter when in the upright position ; under these conditions the outline and form of the trochanter can be readily recognized; further, if the muscle be thrown into a powerful state of contraction, the prominence of the trochanter will be still more emphasized by the tension of the aponeurotic layers over it, and the consequent hollowing out of the surface form behind it caused by the retraction of the fleshy fibres of the muscle (Pls., pp. 44, 50, 52, 54, 86, 318, 338).

The upper border of the muscle describes a curved outline, the convexity of which is upwards. Its general direction is indicated by a line drawn from a point a little in advance of the posterior superior iliac spine downwards, outwards, and forwards to the tip of the great trochanter. The outline of the lower border of the muscle is also curved, with the bend directed downwards across the back of the thigh. The highest point of this border corresponds to the cleft between the buttocks, whilst its lowest extremity reaches a level corresponding pretty closely to the middle of the outer side of the thigh (i. e. the distance from the iliac crest to the knee) (Pls., pp. 50, 52, 54, 86, 126, 318, 338).

The oblique direction of the lower border of the muscle is a matter of some importance, as there has been a tendency to ascribe the direction of the *transverse furrow of the buttock*, or the *gluteal fold* as it is sometimes called, to the influence of this border of the muscle. It will be evident that this cannot be so, as the direction of the former is transverse, whilst the latter is oblique. As a matter of fact, the gluteal furrow is a skin fold the depth of which depends on the degree of extension of the thigh on the trunk, and the quantity of fat present over the inner and lower aspect of the gluteus maximus muscle (Pls., pp. 34, 36, 52, 110, 142, 182, 262, 268).

The gluteus maximus muscle is entirely superficial, but

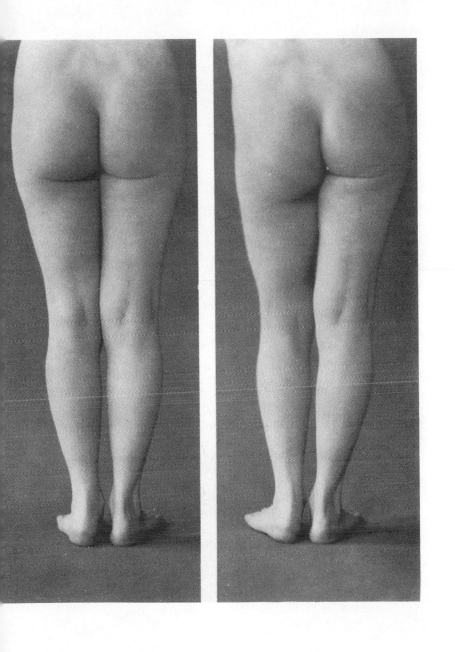

as it is always overlain by a fatty layer of considerable thickness the outline of the muscle is much masked thereby, and the surface form therefore more rounded. The fat is most abundant on the back of this region, being much reduced in quantity as it passes forward over the side of the thigh. In the female the layer of fat is much thicker than in the male, so that we have less evidence of the form of the subjacent structures. For the same reason, the gluteal fold in women is more strongly marked, and of greater length transversely than in the male, whilst the overhang of the gluteal projection is in them more pronounced (Pls., pp. 36, 52, 54, 142, 262, 268, 318, 338).

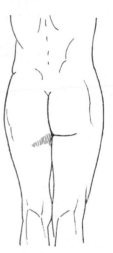

FIG. 135.

It may here be noted that the sharpness of this fold varies according to the position of the limb; it is always best marked when the limb is fully extended, i. e. straightened on the trunk, whilst it undergoes gradual obliteration with the bending of the thigh. Coincident with this movement, and the disappearance of the sharp transverse furrow, we note the tendency to an increase in the obliquity of its direction, so that it overlies, and more directly corresponds with, the oblique lower margin of the gluteus maximus. This difference is clearly seen in Fig. 135, and is readily apparent when we view the figure in profile in the erect and stooping positions; in the former attitude the back of the thigh is abruptly separated from the buttock by a well-defined furrow, caused by the overhang of the gluteal region (Fig. 136), whilst in the latter position the flow of the line of the back of the thigh is continued into the contour of the buttock by a very open angle, or put in another way, this means, that the furrow which separated the two regions has

now all but disappeared (Fig. 137, and Pls., pp. 34, 44, 252, 268, 270).

It sometimes happens that, in the male, the gluteal fold,

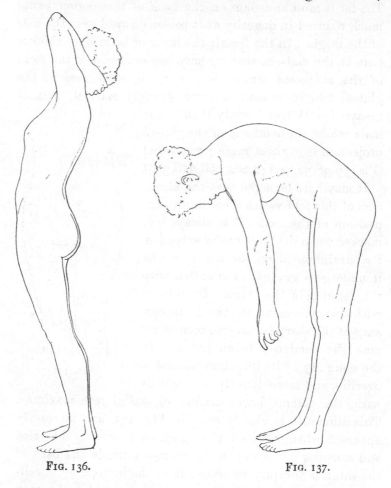

FIG. 136. FIG. 137.

in place of being single, is double. As such it is only seen when the limb is fully extended (Pls., pp. 52, 94, 98).

Superiorly, the disposition of the fatty layer over the gluteus maximus is different in the two sexes. In women the fat forms a thick pad, which passes over the iliac

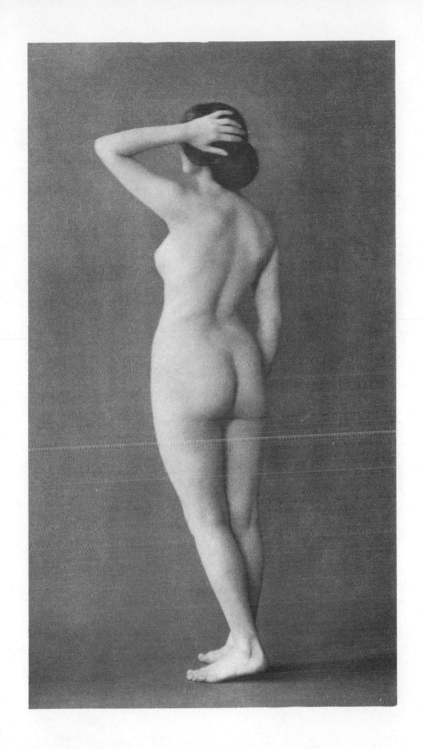

crest in front of the posterior superior iliac spine (i. e. the posterior extremity of the iliac crest), and thus becomes continuous with the fatty layer which covers the back and side of the flank. In this way the surface forms of the flank and buttocks are blended in one uniform contour ; we have no such definition of these regions as we see in the male, in whom the iliac crest is more or less apparent throughout its entire extent as a surface furrow (see Pls., pp. 34, 36, 52, 54, 86, 110, 142, 268).

The female back is much less ' cut up ', by the indications of bony and muscular structure, than is the male, and displays a much simpler and more rounded contour, owing to this peculiar disposition of the superficial fat (Pls., pp. 34, 36, 52, 54, 142, 270, 278).

Anteriorly, the fat of the buttock is distributed in a very characteristic way in the female. It tends to accumulate in considerable quantity on the outer side of the thigh, just below the trochanter. This circumstance accounts for the less marked prominence of the trochanter in the female, and also explains why the width of the figure, in the female, is usually greater at some little distance below the level of the trochanters than at the trochanters themselves. When in the female fat is present here in undue amount it imparts a clumsy and ungainly appearance to the limb, particularly in certain positions, and models which display this tendency to any marked extent should be avoided. A slight fullness, however, below the trochanters is not unpleasant, as it conduces to a more rounded form of the limb and gives a better outline to the outer side of the thigh. The student should be warned against the ungainly forms which are dependent on the undue accumulation of fat in the region overlying the iliac crest. This is particularly liable to occur in female models past their prime, and imparts a grossness to the form at variance with the delicacy and refinement displayed in earlier life (Pls., pp. 34, 36, 52, 72, 278, 298, 434).

The gluteus maximus muscle is a powerful extensor of the hip-joint. It straightens the thigh on the trunk when the hip-joint is bent. It acts in one or other of two ways or by a combination of both. Thus if the thigh be flexed on the trunk this muscle extends the thigh-bone at the hip-joint, or if the trunk be bent forward on the thighs, as in the stooping position, it assists in straightening the figure.

The muscle is thrown into a powerful state of contraction in such actions as springing, leaping, rising from a chair, or running upstairs or up an incline. It also comes into play in some of the movements of abduction and adduction, and likewise assists in external rotation of the thigh.

The gluteus maximus muscle in man has attained a very remarkable development, and is, as has been just shown, largely concerned in straightening the body. The figure, when once erect, can be held in that position for lengthened periods by the mechanical locking of the hip-joint, without any marked voluntary effort, though a certain amount of muscular contraction is necessary to steady the joint.

The importance of the insertion of the gluteus maximus muscle into the fascia of the outer side of the thigh must not be overlooked. As will be described hereafter, this fascia forms a thickened band which passes down to be attached to the bones of the leg below the knee. Through this process of fascia the gluteus maximus exercises an influence in supporting and steadying the knee when that joint is extended ; and its action, in the male at least, is demonstrated by its influence on the surface forms along the outer aspect of the thigh (Pls., pp. 54, 86, 318, 338).

The relation of certain bony parts of the pelvis and thigh-bone to the muscle varies according to the position of the limb. Of these the most important, from the present standpoint, is the relation of the *trochanter major* to the fleshy and tendinous parts of the muscle. In the erect position, the trochanter is covered merely by the tendinous aponeurosis

of the muscle, but if the thigh be flexed upon the trunk the trochanter glides backwards under cover of the fleshy fibres. The reader can easily prove this by placing the hand over the trochanter whilst standing up; under these conditions the bone is felt to be quite subcutaneous, being covered only by skin and the dense aponeurosis; if, however, the trochanter be felt when sitting down, the student will recognize that it is separated from the fingers by a greater thickness of tissue, a circumstance which is due to the fact that the process is now overlain by some of the fleshy fibres of the muscle (Pls., pp. 104, 252, 274).

In like manner the *tuberosity of the ischium* (the hinder and lower part of the haunch-bone) is at times covered and at other times uncovered by the muscle. In the erect position the lower border of the gluteus maximus overhangs the tuberosity of the ischium, but when the thigh is bent it slips over that process of bone and so uncovers it, causing it to lie directly beneath the skin and subcutaneous fat. As already stated, it is upon this part of the skeleton that we rest the weight of the body in the seated position, and thus avoid any pressure on the fleshy part of the muscle. It is only in such views as that of a kneeling figure seen from behind, or from the side, that the artist would have any reason to concern himself with the surface forms dependent on these processes of bone. Under the conditions just mentioned, the rounded angle which marks the limit of the gluteal region, within and below, is dependent on the surface projection caused by these outstanding processes of bone.

The *tensor fasciae femoris* is the name given to a muscle which separates the region of the buttock from the anterior aspect of the thigh; it arises by tendinous fibres from the anterior extremity of the iliac crest, close to the anterior superior iliac spine. The fleshy belly of the muscle is short and of considerable thickness.

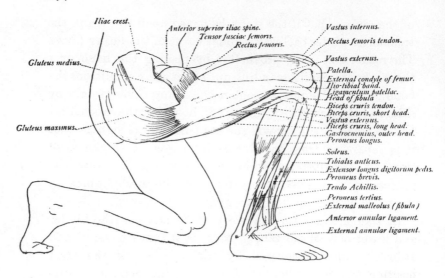

Iliac crest.
Anterior superior iliac spine.
Tensor fasciae femoris.
Rectus femoris.
Vastus internus.
Rectus femoris tendon.
Gluteus medius.
Vastus externus.
Patella.
External condyle of femur.
Ilio-tibial band.
Ligamentum patellae.
Head of fibula
Biceps cruris tendon.
Biceps cruris, short head.
Vastus externus.
Biceps cruris, long head.
Gastrocnemius, outer head.
Peroneus longus.
Gluteus maximus.
Soleus.
Tibialis anticus.
Extensor longus digitorum pedis.
Peroneus brevis.
Tendo Achillis.
Peroneus tertius.
External malleolus (fibula)
Anterior annular ligament.
External annular ligament.

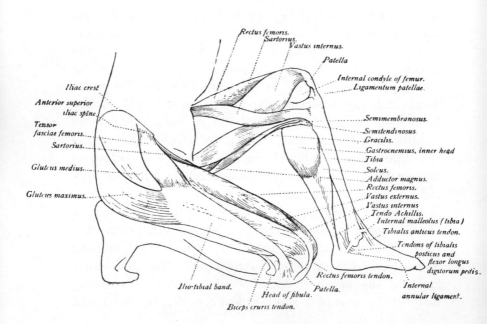

Rectus femoris.
Sartorius.
Vastus internus.
Patella
Internal condyle of femur.
Ligamentum patellae.
Iliac crest
Anterior superior iliac spine.
Tensor fasciae femoris.
Sartorius.
Semimembranosus.
Semitendinosus.
Gracilis.
Gastrocnemius, inner head
Tibia
Gluteus medius.
Soleus.
Adductor magnus.
Rectus femoris.
Vastus externus.
Vastus internus.
Tendo Achillis.
Gluteus maximus.
Internal malleolus (tibia)
Tibialis anticus tendon.
Tendons of tibialis posticus and flexor longus digitorum pedis.
Ilio-tibial band.
Head of fibula.
Patella.
Rectus femoris tendon.
Internal annular ligament.
Biceps cruris tendon.

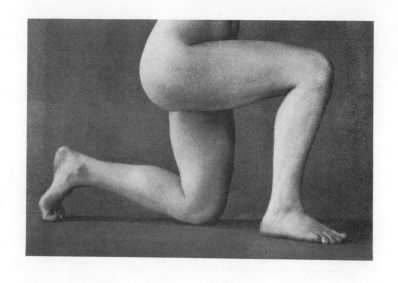

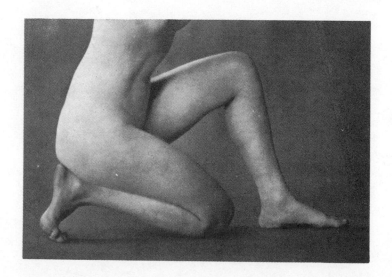

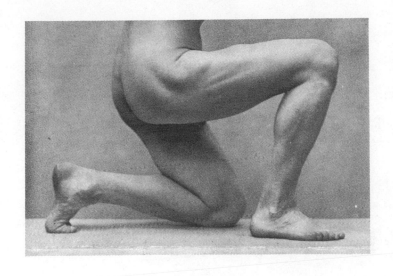

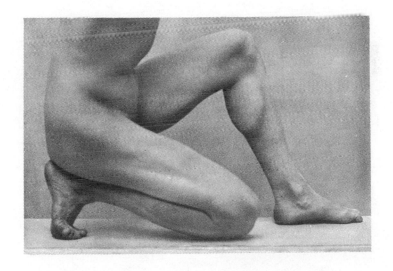

The fibres follow a direction downwards, and slightly backwards towards the front of the great trochanter of the thigh-bone, and reach about three inches below it. At this point the muscle becomes blended with the strong fascia, which forms a band along the outer side of the thigh (Pls., pp. 54, 58, 86, 104, 126, 162, 252, 274, 318, 338, 366).

The reader will remember that the gluteus maximus has an extensive insertion into this process of fascia. The muscles of the thigh are invested by a sheath of fibrous membrane much in the same way as the limb is covered by a tightly fitting stocking. This covering is much thicker along the outer side of the limb, and it is this thickening of the fascia which forms the band called the *ilio-tibial band.* This may be regarded as the conjoined flattened tendon of the gluteus maximus and tensor fasciae femoris. The former is inserted into it above and behind, whilst the latter is attached to it above and in front. Inferiorly the ilio-tibial band passes over the outer side of the knee-joint and is inserted into the external tuberosity of the tibia (one of the bones of the leg). In this way the two muscles above described exercise an important influence in supporting the knee-joint in the extended position (Pls., pp. 54, 86, 318, 338).

From the fact that the upper end of this band is connected with muscles both in front and behind, it follows that the traction exercised by the combined action of these muscles keeps the ilio-tibial band in the direct line of the thigh.

Superiorly, the gluteus maximus and the tensor fasciae femoris are separated by a V-shaped interval, the angle of which corresponds to a point two or three inches below the summit of the great trochanter. The sides of the V correspond to the posterior border of the tensor fasciae femoris in front, and the upper border of the gluteus maximus behind. Superiorly, this triangular area is limited by the curved margin of the iliac crest. This surface is overlain by

a fascia which stretches over it, from the gluteus maximus behind, to the tensor fasciae in front. Under cover of this fascia, and occupying the whole of the interval described, is another of the gluteal group of muscles called the *gluteus medius* (Pls., pp. 44, 54, 86, 126, 162, 318, 338, 366).

The gluteus medius is a fan-shaped muscle. Its superior attachment is spread over the outer surface of the iliac expansion of the haunch-bone, extending from near the posterior superior iliac spine behind to the anterior superior iliac spine in front. Inferiorly, the fibres are gathered into a flattened tendon which is inserted into an oblique line running downwards and forwards across the outer surface of the great trochanter. As this attachment lies below and between the anterior and posterior origins of the muscle, it follows that the anterior fibres pass downwards and backwards, whilst the posterior pass downwards and forwards, to this insertion.

The muscle, as has been said, occupies a superficial position in the interval between the tensor fasciae femoris and the gluteus maximus, but it is partly overlain both in front and behind by these muscles.

The gluteus medius is a powerful abductor of the thigh, i. e. it draws the limb away from the middle line of the body, causing the separation of the legs as in standing stride-legs. The action of the muscle is still better seen if the leg be raised from the ground; again, we bring it into play if we stand on one leg and incline the trunk to the side over the supporting limb. The muscle varies in its action according to the part used. If the anterior fibres contract, they will act as rotators inwards of the thigh, whilst the posterior fibres will assist in turning the thigh outwards. It plays an important part in the act of walking, as it supports the trunk on the limb which is in contact with the ground during the time that the opposite foot is uplifted.

The surface forms of the buttock vary much, according to the position of the limb. As has been already stated, the gluteal fold or line which separates the region of the buttock from the back of the thigh undergoes gradual obliteration as the limb is carried from the fully extended condition to one of marked flexion. Coincident with this, there is a pronounced infolding of the furrow of the groin, together with a deepening of the fold immediately beneath it which crosses the upper and inner aspect of the thigh, which lies slightly above and towards the outer side. Externally, the angle formed by the profile of the

FIG. 138. FIG. 139.

front of the limb with the side of the trunk corresponds to the position of the anterior superior iliac spine; according to the amount of flexion so the direction of the lines meeting at this angle varies. A reference to Figs. 138, 139, will make this clear. The fold of the thigh passes outwards across the front of the limb so as to fall below the level of the anterior superior iliac spine, whilst the furrow of the groin corresponds externally to that process. When the limb is only partially flexed the profile outline of the front of the thigh, at the angle formed with the side of the trunk, alters its direction a little and passes with a slightly more pronounced

upward curve over the anterior superior spinous pro-
cess, but if the limb be more fully flexed the fold on the
front of the thigh tends to curve outwards over the outer
side of the limb, and the outline of the front of the thigh
breaks up into two lines, one of which curves downwards
whilst the other is continued upwards. The angle formed
by these two lines overlies the prominence of the anterior
superior iliac spine (see Pls., pp. 252, 274). In the fully
extended position of the limbs, with the muscles in a
powerful state of contraction, a well-marked hollow lies
behind the trochanter major. This is caused by the tight-
ening of the fascia, due to the contraction of the gluteus
maximus. In front, this hollow is bounded by a rounded
elevation which passes from the anterior extremity of the
iliac crest, downwards and slightly backwards, to the front
of the trochanter; this depends upon the presence of. the
fleshy fibres of the tensor fasciae femoris (Pls., pp. 44, 54, 86,
318, 338). The deepest part of the hollow corresponds to the
angle formed by the tensor fasciae femoris and the gluteus
maximus; it is rounded off above by the surface elevation
produced by the fleshy part of the gluteus medius, which
lies superficially in the interval between the tensor and
the gluteus maximus. When the thigh is flexed this
hollow appears as a well-marked furrow, the lower part
of which runs down along the outer side of the limb
behind the trochanter and upper part of the shaft of the
thigh-bone, whilst the upper end curves upwards round
the end of the trochanter, following the direction of a line
towards the middle of the iliac crest, midway between
which and the trochanter it gradually fades away. The
anterior border of this furrow is the more pronounced, and
depends on the contraction of the tensor fasciae and the
anterior fibres of the gluteus medius, which together
form a well-marked elevation on the anterior half of the
outer side of the limb : in forced contraction of these

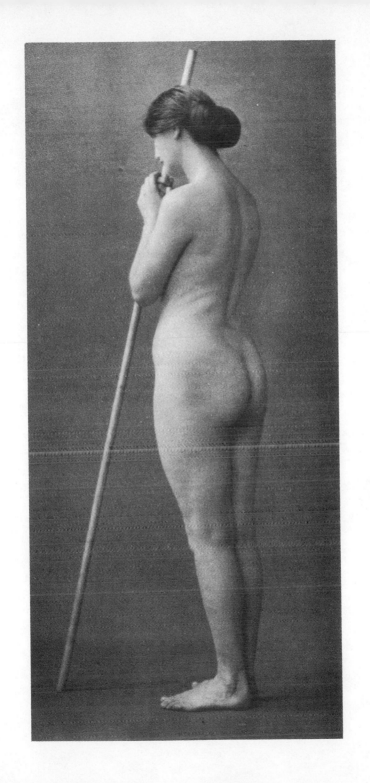

muscles their outlines are still further defined by a furrow which lies between them (Pls., pp. 44, 104, 252, 274, 382).

In dealing with these details the student must not overlook the fact that great muscular development, and a greater or less abundance of subcutaneous fat, modify very much the character of the surface forms, a fact which he will specially note in connexion with the representation of the female figure. In well-selected female models, owing to the existence of a thick fatty subcutaneous layer, the influence of the muscles and bones on the surface is much reduced; the forms are more rounded, and the depressions, when they exist, are less sharply defined and much shallower than in a male of athletic build. These facts are sufficiently emphasized in the plates given for reference (Pls., pp. 34, 36, 52, 54, 80, 86, 124, 252, 262, 270, 274, 278, 308, 318, 338, 366, 438).

Needless to say the earnest student should take every opportunity of verifying these details on the living model. To rest content with a knowledge derived from written descriptions and illustrations is a poor substitute for the information obtained by studying the appearance of the model with the limbs in different positions, for in this way, only, will the student realize how the relation of the various structures involved is modified by different postures.

CHAPTER X

BEFORE passing to the consideration of the thigh, the knee-joint requires description. The lower end of the thigh-bone is expanded and forms two broad recurved processes called the *internal* and *external condyles*. Posteriorly the ends of these processes, which project backwards behind the lower end of the shaft, are separated by a deep notch about a finger's breadth in width. When the femur is held so that the shaft is vertical, the inner of these processes projects beyond the level of the external; when the condyles of the femur are placed on some flat, horizontal surface, such as a table, so that both condyles are in contact with it at the same time, the shaft of the bone assumes an oblique direction as seen from the front or back. If, in place of one femur, the two thigh-bones be taken and placed side by side in this way on a table, with their lower ends close together, the upper extremities, with the inturned heads and necks, will be separated by a considerable space, an interval which corresponds to the pelvic width between the two acetabular hollows. This is a fairly accurate way of estimating the position of the femur in the thigh, since, in the living, the plane of the knee-joint is very nearly horizontal, and as the knees should just touch each other in the erect position it follows that the line of the thigh-bone very nearly corresponds to that displayed in the above experiment.

The anterior, inferior, and posterior aspects of the condyles are smooth, and in the recent condition coated with articular cartilage. The inner surface of the inner condyle

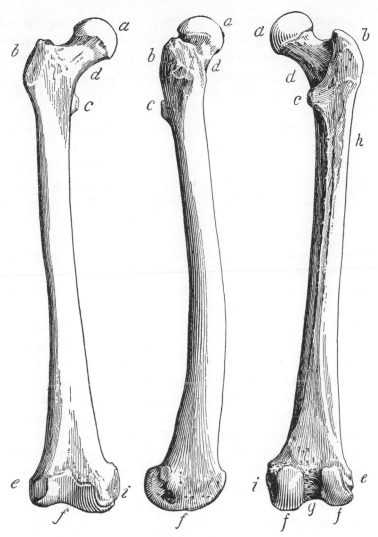

Right thigh-bone (femur).

FIG. 140. Front view. FIG. 141. Outer side. FIG. 142. Back view.

a. Head.
b. Trochanter major.
c. Trochanter minor.
d. Neck.
e. External condyle.

f. Articular surface of condyles.
g. Inter-condyloid notch.
h. Surface for attachment of gluteus
 maximus.
i. Internal condyle.

is rounded and prominent, and projects from the line of
the shaft more than does the outer, the external surface
of which is somewhat flattened and less prominent.
Towards the hinder part of the outer surface of the external
condyle there is a well-marked groove in which the tendon
of a muscle is lodged.

The condyles of the thigh-bone are important deter-
minants of surface form. The size of the knee depends
upon their development, and to their disposition is also due
the rounded projecting form of the joint on the inner
side as compared with the flatter appearance along its
outer aspect.

The bones of the leg are two in number; they are
placed side by side, and so firmly united to each other
by ligaments that any movement between them is ren-
dered impossible. They differ very much in size; the
inner, called the *tibia* or *shin-bone*, is by far the stouter
and stronger of the two. It alone enters into the forma-
tion of the knee-joint, and supports the entire weight
of the trunk and thigh above. The *fibula*, which is a long
slender bone, lies along the outer side of the tibia, to which
it is immovably united by joints and ligaments. The
fibula bears no share in the articulation of the knee, but
along with the tibia enters into the formation of the ankle-
joint. The fibula is of small service as a means of support,
but furnishes a bony attachment for many of the muscles
of the leg. As regards the form of these bones, the *tibia*
(or inner bone) displays a shaft with two expanded ex-
tremities; the upper end, which supports the condyles of the
femur, equals them in width, and forms two *tuberosities*,
an *inner* and an *outer*. The latter more overhangs the
shaft and is slightly more projecting than the former.
Both tuberosities project backwards from the line of
the shaft to a slight extent; their upper surfaces form
two somewhat rounded or oval areas, separated in the

283

middle line by a well-marked process called the *spine*, which projects upwards and occupies the notch between

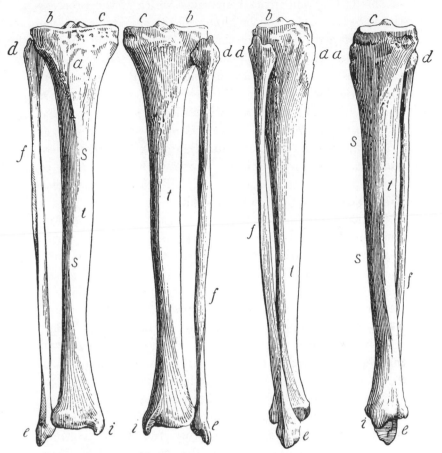

Right tibia and fibula articulated.

FIG. 143. Front view. FIG. 144. Back view. FIG. 145. Outer view. FIG. 146. Inner view.

t. Tibia, inner bone of leg.
a. Tubercle of tibia, to which ligament of patella is attached.
b. External tuberosity.
c. Internal tuberosity.

d. Head of fibula.
e. External malleolus (fibula).
f. Fibula.
i. Internal malleolus (tibia).
s s. Crest or shin.

the condyles of the femur when that bone is in position;

it is upon the upper surfaces of these tuberosities that
the condyles of the femur rest in the various positions
of the limb. Whilst the transverse width of the tuberosi-
ties of the tibia equals that of the condyles of the
femur, it will be noted that the measurement of the
tuberosities from before backwards is much less than
the corresponding diameter of the femoral condyles. At
some little distance below and in front of the tuberosities
of the tibia the student will notice a projection called
the *tubercle of the tibia*. This process is of importance, as
to it is attached the powerful ligament, the *ligamentum
patellae*, which is connected above with the *patella* or
knee-pan, the latter a flattened bone of nearly circular form
which lies in front of the knee-joint.

The shaft of the tibia is somewhat triangular in section,
and thus has three margins. Of these the anterior forms
a prominent sharp border, which can be traced from
the tubercle of the tibia downwards, with a gentle
sinuous curve, towards the anterior surface of the pro-
jection on the inferior extremity of the bone which
forms the prominence of the inner ankle. This ridge,
with which every one is familiar under the name of
the *shin*, is superficial throughout its entire length, i. e.
it is merely covered by skin and superficial fascia. The
surface of the shaft of the bone immediately to the inner
side of the shin is smooth and rounded from side to side,
and may be traced from the inner tuberosity above to
the inner ankle below. It is widest superiorly, narrowest
towards the middle of the shaft, and expands again slightly
near the ankle. Throughout almost its entire extent
this surface is covered merely by skin and subcutaneous
fascia; it is only above, close to the inner tuberosity of
the bone, that it is crossed and overlain by the tendons
of certain muscles which pass down along the inner side
of the knee. The hinder border of the shaft limits this

surface posteriorly, and can be traced downwards in front of the muscles of the calf, along the inner side of the leg. The other surfaces and remaining border of the bone are covered and concealed by fleshy muscles, and have no direct influence on the surface forms.

If the under surface of the most projecting part of the external tuberosity be examined, a small smooth circular surface will be noticed. This is for articulation with the upper end of the fibula.

The lower end of the shaft is expanded and enters into the formation of the ankle-joint. From its inner side there projects downwards a process called the *internal malleolus* which corresponds to the prominence of the inner ankle. The further consideration of this part of the bone is reserved until the ankle-joint is described.

Little need be said regarding the *fibula* or *splint-bone*. It is about the same length as the tibia, but is placed at a somewhat lower level in the leg, so that its upper end does not reach as high, whilst its lower extremity projects beyond the tibia ; the shaft of the bone is extremely slender : its thickness is not usually greater than that of the little finger. The form and curvature of the shaft are liable to very great individual variation, but as this part of the bone is surrounded on all sides by fleshy muscles, except at its lower end, it matters little what its precise shape may be, as it has little direct influence on the surface forms. The fibula lies along the outer side of the shin-bone, but the direction of the axis of its shaft is not parallel to that of the tibia ; in the upper part of the leg it lies somewhat behind the tibia, whilst, below, its inferior extremity is placed directly to the outer side of the expanded end of the shin-bone. The ends of the bone are enlarged, the upper is the *head*, the lower the *external malleolus*, a process which forms the prominence of the outer ankle.

The head of the fibula is an irregular rounded process of bone, from which passes a short upward projection called the *styloid process*, to the front of which the strong external lateral ligament of the knee-joint is attached. On the inner surface of the expanded head is a small, smooth, circular surface, adapted for articulation with the corresponding area already described on the under surface of the overhanging external tuberosity of the tibia. This joint permits of no perceptible movement, the bones being firmly united by surrounding ligaments. Situated as this articulation is, below the level of the knee-joint, it follows that the upper end of the fibula does not share in the formation of that joint and is in no wise concerned in supporting the condyles of the femur. The student will do well to determine in his own person the precise position of the head of the fibula. If he follows the direction of the outer hamstring, when the knee is bent, this will lead him to the head of the fibula, which he will recognize as a rounded knob of bone lying just below the level of and behind the knee-joint on the outer side. This warning is necessary, as most students, when asked to place the finger on the head of the fibula, make the mistake of pointing to a spot in advance of that really occupied by the bone. This part of the bone is subcutaneous on its outer and anterior aspect, where it is uncovered by muscle; superiorly it has attached to it the external lateral ligament of the knee-joint, whilst the outer hamstring, viz. the tendon of the biceps muscle of the thigh, passes down to be inserted into it. The lower part of the shaft and the inferior extremity of the bone will be further referred to in connexion with the description of the leg and ankle.

The *knee-joint* is the largest joint in the body. By its great size it affords adequate support for the weight of the trunk which is transmitted through it. Three bones

enter into its formation, the femur, the tibia, and a bone not hitherto described, called the *patella*. When we straighten the knee, and no longer contract the muscles of the front of the thigh, this last may be felt as a movable disk lying in the loose tissues in front of the joint. If, however, we contract the muscles of the front of the thigh or bend the knee, the patella can no longer be freely moved, but is felt lying in close contact with the lower end of the thigh-bone, and practically fixed in position.

The patella consists of a disk of bone the anterior surface of which is rounded from side to side and slightly from above downwards; the deep surface of the bone is adapted for articulation with the condyles of the femur, on which it glides as on a pulley. The margin of the disk varies in thickness; inferiorly it is somewhat pointed, and has connected with it a strong ligament, called the *ligament of the patella*, by means of which the bone is connected inferiorly with the tubercle of the tibia. The patellar ligament consists of a thick broad band of non-elastic fibrous tissue, so that, whatever the position of the limb may be, if the ligament is drawn tight by the contraction of the muscles which are attached to the patella, the distance between the lowest point of that bone and the tubercle of the tibia never varies. In the extended position of the joint, when the muscles are in action, the lower border of the patella lies about one inch above the articular surface of the tibia; when the muscles are relaxed the bone slips to a somewhat lower level, and, the strain being taken off, the patellar ligament becomes lax. The reader may demonstrate these facts for himself by standing erect and alternately contracting and relaxing the muscles of the thigh, when the knee-pan will be seen to move accordingly. The upper border of the bone is thick, and here, as well as at the sides, are attached the

powerful fleshy muscles which form the extensor group of the front of the thigh.

The patella plays an important part in the modelling of the anterior aspect of the knee. Applied as it is to the lower end of the femur, it masks the form of the condyles in front, and fills up the shallow groove which separates them anteriorly and inferiorly, so that, even when the joint is flexed, it gives a rounded appearance to the front of the knee.

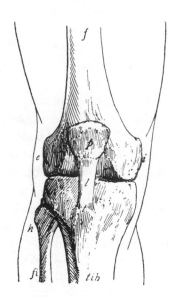

FIG. 147. The bones of the extended right knee, front view.

f. Femur.
fi. Fibula.
tib. Tibia.
e. External condyle of femur.
i. Internal condyle of femur.
h. Head of fibula.
p. Patella, or knee-pan.
l. Ligament of the patella.
t. Tubercle of tibia.

The knee-joint is exceedingly complicated in the arrangement of its articular surfaces and the ligaments which strengthen it. It is not necessary for present purposes to enter into a detailed account of this articulation, except to mention that the condyles of the femur, as they rest on the upper surface of the tuberosities of the tibia, are supported by pads of cartilage of a semilunar form, which are placed in relation to the circumference of each rounded facet on the articular surface of the tibia. Passing from the sides of the deep notch, which separates the femoral condyles posteriorly, to the surface of the tibia in front of and behind the spine, are two powerful ligaments which from their crossed arrangement are called the *crucial ligaments*. On either side, the articulation is

strengthened by strong *lateral ligaments*; the internal
stretches from the inner surface of the internal condyle
of the femur down over the inner tuberosity of the tibia,
and is attached to the shaft of the bone just below that
process. The external lateral ligament, which is of a

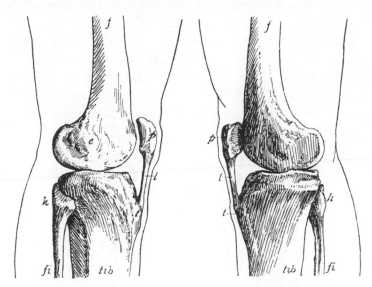

FIG. 148. The bones of the ex-
tended right knee, outer side.

 f. Femur.
 fi. Fibula.
 tib. Tibia.
 e. External condyle of femur.
 h. Head of fibula.
 p. Patella, or knee-pan.
 l. Ligament of the patella.
 t. Tubercle of tibia.

FIG. 149. The bones of the ex-
tended right knee, inner side.

 f. Femur.
 fi. Fibula.
 tib. Tibia.
 i. Internal condyle of femur.
 h. Head of fibula.
 p. Patella, or knee-pan.
 l. Ligament of the patella.
 t. Tubercle of tibia.

rounded cord-like form, is connected above with the outer
surface of the external condyle of the femur, and is attached
below to the head of the fibula.

The capsule posteriorly is formed by a broad mem-
braneous band, called the *posterior ligament*, which is
united above to the femur along the upper edge of the

notch between the condyles, and is attached below to the posterior margin of the upper extremity of the tibia.

In front, the joint is enclosed by a thin capsule with which the ligament of the patella is incorporated, whilst additional support is afforded by tendinous expansions from the muscles, which are inserted into the sides of the patella.

A glance at the bones will enable the reader to understand that there is one part of the articular surface of the femoral condyles which never comes into contact with the tibia or

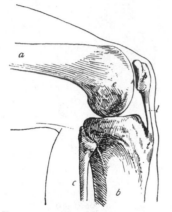 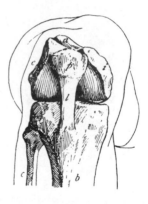

FIG. 150. The bones of the bent right knee, outer side.

 a. Femur.
 b. Tibia.
 c. Fibula.
 e. External condyle of femur.

FIG. 151. The bones of the bent right knee, front view.

 i. Internal condyle of femur.
 p. Patella.
 l. Ligament of the patella.
 t. Tubercle of tibia.

semilunar cartilages, for if the bones be placed one on the top of the other, as in the extended position of the limb, a considerable articular surface is displayed on the front of the condyles, which lies above the level of the tibia. It is on this that the patella rests in extension. When the joint is bent the femoral condyles hinge and roll on the upper surface of the tibia and on the semilunar cartilaginous pads afore-described in such a manner that in extreme flexion

their hinder surfaces rest on the upper surface of the tibia, whilst the surfaces of the condyles, which were previously in contact with the tibia in the extended position, are now turned forwards; they are thus brought into contact with the deep surface of the patella, which cannot shift its position, owing to its connexion with the tubercle of the tibia by the patellar ligament. Thus, whilst in extension the patella rests on a part of the femoral condyles peculiar to itself, it passes, in flexion, to rest on portions of the condylar articular surfaces, which were previously in contact with the tibia and semilunar pads.

The chief movements of the knee are those of *flexion* and *extension*. Flexion is limited by the back of the calf coming into contact with the back of the thigh. Extension is checked, when the leg is brought in line with the thigh, by the action of certain ligaments. In this extended or straight position of the knee it may be said that all the ligaments of the joint are in a state of tension, except one of the crucial ligaments and the part of the capsule in front of the joint, the principal ligament of which, the ligamentum patellae, may or may not be tense according to the state of contraction of the muscles on the front of the thigh. By this means the joint is mechanically locked, so that little or no muscular effort is necessary to enable us to stand erect with the knees straight. The explanation of this is that under these conditions the line of gravity falls in front of the axis of rotation of the joint, and this force keeps the ligaments tense, thereby mechanically locking the joint and preventing any further movement of extension (Fig. 131). The reader may convince himself of this in one or other of two ways. If, when standing erect, he sways the body backwards, so that the line of gravity falls behind the axis of the joint, he will only be able to prevent himself from falling by the exercise of very violent muscular effort, and he will realize that the muscles of the front of the thigh

are thrown into a state of powerful contraction ; but if the body be again swayed forward, so as to bring into action the ligaments aforementioned, no muscular effort is necessary to maintain the joint in its extended position, and the fleshy mass on the front of the thigh may now be felt soft and relaxed. Or again, an admirable demonstration of the mechanical principles involved is afforded by the schoolboy trick of knocking the knees from under one. The victim, unconscious at the time of any such attack upon his stability, is standing upright with his muscles in a state of relaxation when the blow is struck behind the knee. The joint is then held in the extended position by the tension of the ligaments only ; the force of the blow, however, knocks the knee suddenly forwards, and thus causes the line of gravity to fall behind the axis of the joint, with the usual result, that, before the subject of the experiment has time to recover himself by bringing into play the powerful muscles which control the joint, he falls to the ground.

The degree of extension of the joint depends, like that of the hip, on the length of its ligaments. Under ordinary conditions these are sufficiently long to permit of the leg and thigh being brought into the same straight line; exceptionally, when these ligaments are longer, the joint may be more fully extended, so that the front of the leg forms with the front of the thigh an open angle, with a corresponding curve along the back of the limb. As Brücke has pointed out, this is more or less characteristic of the type so commonly represented in the period of the German renaissance, and, though minor degrees of this condition are tolerable, it should be discarded when unduly emphasized in the male, or when present in the female.

When the knee is straight we have no power of rotating the leg on the thigh ; if we wish to turn the point of the toes inwards or outwards we do so by rotating the whole

limb, the movement taking place at the hip-joint. When the knee is bent, however, any one, who tries it, may satisfy himself that a limited amount of rotation of the leg on the thigh is possible, as the ligaments of the joint are relaxed. The range of this movement is not great, and is checked by the tightening of the ligaments of the knee.

In considering the arrangement of the fleshy muscles which form the bulk of the thigh it is necessary to study several groups, two of which, viz. that in front of and that behind the shaft of the thigh-bone, are immediately concerned in the movements of the knee-joint. The third group, that which lies along the inner side of the thigh, is mainly associated with the movements of the thigh at the hip, and particularly with that action, called adduction, whereby the outspread limbs are brought together. It is therefore called the *adductor group* of muscles.

All the muscles of the thigh are encased in a sheath of fascia, which invests the limb like a tight-fitting stocking. We have already seen how this sheath is thickened along the outer aspect of the thigh to form the strong ilio-tibial band, which is connected above with the insertions of the gluteus maximus and tensor fasciae femoris muscles, and is attached below to the external tuberosity of the tibia (*ante*, p. 275). The fascial sheath is subdivided into three compartments by means of fibrous partitions, which pass from its deep surface to become attached to the thigh-bone. The compartments thus formed are for the lodgement of the groups of muscles just mentioned; that in front contains the *extensor group*, that behind the *flexor muscles*, whilst the internal compartment is occupied by the *adductors*.

The muscles of the *extensor group*, or those which lie along the front of the thigh, are four in number, viz. the *crureus*, on either side of which are the *vasti*, named *internal* and *external* according to their position, whilst,

superficial to all, is the *rectus femoris*. All these muscles
are inserted into the patella, and are oftentimes referred
to as the *quadriceps extensor*, on account of the four-headed
arrangement of their fleshy mass. For present purposes
it will be most convenient to describe the muscle as con-
sisting of two parts, a superficial and a deep; the latter
includes the *crureus* with the *vasti*, one on either side
of it. It is unnecessary to consider the details of the
attachment of the several parts of this fleshy mass; it
is sufficient to point out that it clothes the front and
sides of the thigh-bone, extending as high as the base
of the outer side of the great trochanter, and following
inwards and downwards from that point the spiral
line which sweeps across the upper part of the thigh-
bone, from the root of the great trochanter externally to
the linea aspera or rough ridge which passes along the
posterior aspect of the shaft of the bone. Inferiorly these
muscles are inserted into the sides and upper border of the
patella. The arrangement of the fleshy fibres is such that
the whole length of the outer side of the shaft of the thigh-
bone, reaching as far back as the linea aspera, is covered
with a thick fleshy layer which imparts to the outer side
of the thigh its rounded contour and flowing outline, whilst
internally the shaft is clothed by the vastus internus, which
sweeps round the inner side of the bone to the rough
ridge on its posterior aspect. This part of the muscle
attains its greatest thickness in the lowest quarter of
the thigh, where its rounded surface not only imparts
a fullness to the front of the thigh in this situation,
but also influences the outline of the inner side of
the limb, where it is overlain by a strap-like muscle
called the *sartorius*, which here passes down along its
inner side (Fig. 152).

There is a characteristic difference in the way in which
the lateral portions of this fleshy mass are connected with

the patella. The outer part, or *vastus externus*, passes down to be attached to the outer side of the *upper* border of the patella, from which it sends a general expansion over the anterior part of the capsule of the knee. The *vastus internus*, on the other hand, reaches a much lower level on the inner side of the thigh, and is inserted into the upper half of the *inner* border of the patella. The lowest fibres of the vastus internus are very oblique in their direction, and overlie the upper part of the internal condyle of the thigh-bone, whereas those of the external vastus are much more vertical in their direction and in the erect position do not cover the outer side of the external condyle at all, but pass down to the patella above it; here the posterior border of this

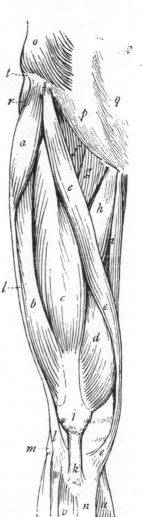

FIG. 152. Front view of the muscles of the right thigh.

a. Tensor fasciae femoris.
b. Vastus externus.
c. Rectus femoris.
d. Vastus internus.
e. Sartorius.
f. Psoas and iliacus.
g. Pectineus.
h. Adductor longus.
i. Gracilis.
j. Patella.
k. Tubercle of tibia with ligamentum patellae attached.
l. Ilio-tibial band.
m. Head of fibula.
n. Subcutaneous surface of tibia.
o. External oblique.
p. Aponeurosis of external oblique.
q. Placed over sheath of rectus.
r. Gluteus medius.
s. Anterior superior iliac spine.
t. Iliac crest.
u. Inner head of gastrocnemius.
v Tibialis anticus

part of the muscle is defined by a tendinous edge which is emphasized during contraction. Behind this a few fleshy fibres of the crureus become superficial, but as they are overlain by the lower part of the ilio-tibial band they do not exercise much influence as determinants of surface form (Fig. 152, and Pls., pp. 54, 72, 86, 216, 318, 328, 338, 382).

Resting on this deeper stratum of muscle, and occupying a position corresponding to a line leading from the anterior superior iliac spine to the patella, there is a superficial muscle called the *rectus femoris.* This muscle has a fusiform belly, with upper and lower tendons of attachment. It arises by two tendons, the details of which need not be described, from the iliac part of the haunch-bone, just above the acetabulum or cup for the reception of the head of the thigh-bone. At this point the muscle lies deeply, having to its outer side the tensor fasciae femoris, whilst in front of and along its inner side for a short distance is the above-mentioned *sartorius,* a muscle to be presently described. The fleshy belly of the rectus crops up in the angle formed by these two muscles, and passes downwards towards the patella, into the upper border of which it is inserted by a broad flat tendon about three inches in length. As the fleshy belly overlies the deeper stratum, it only partially covers it, so that the vasti appear on either side of it. The fleshy part of the muscle imparts a fullness to the front of the thigh which is not only due to the development of its fibres and the thickness of the subjacent muscular stratum, but is also dependent on the forward curve of the shaft of the thigh-bone, to which reference has been already made (p. 255; Pls., pp. 54, 72, 86, 216, 274, 318, 338, 366, 382).

The above muscles act as powerful extensors of the knee—that is to say, they straighten the leg. This takes place in one or other of two ways. Suppose we are seated on a chair with the knees bent at a right angle, we can straighten

the legs in one or other of two ways, either by raising the feet from the ground, in which action the upper is the fixed attachment of the muscle; or by rising from the chair and standing on our feet, in which case the leg and foot are the fixed points, and it is the thighs which move, carrying with them the trunk. These different actions of the extensor muscles are of common occurrence, and depend, as has been said, on which is the fixed end of the limb, the thigh or foot; but, as has been already noticed (p. 291), their action is not necessary to enable us to stand erect, for in this position, when the foot is resting on the ground, the patella may be felt lying loose in front of the knee. It becomes fixed, however, if these muscles be contracted, or if the extended limb be raised from the ground. The reader will have noticed a difference in the origin of these various parts of the quadriceps extensor. The deeper stratum arises from the thigh-bone, whilst the superficial part or rectus arises from the haunch-bone; the latter therefore crosses the front of the hip-joint and may also act as a flexor of that joint (Fig. 152).

There is a muscle which occupies a position in front of the upper part of the thigh, and which subsequently runs down along the inner side of the limb; this is the *sartorius*, already alluded to. It cannot be grouped with either the extensor muscles above described or with the adductor mass which lies along the inner side of the thigh-bone, but may now be conveniently studied, as it forms a sort of natural boundary between these two groups. The muscle, which is of elongated form, in fact the longest in the body, takes origin above from the anterior superior iliac spine (anterior extremity of the iliac crest) and from the bone immediately below it; it passes obliquely across the front of the upper part of the thigh so as to reach its inner side about the middle, and, coursing down along this aspect of the limb, it passes behind the most prominent part of the internal

condyle of the thigh-bone and along the inner side of the knee. Below this point it forms a thin expanded tendon, which turns forward beneath the level of the inner tuberosity of the tibia and is inserted into the subcutaneous surface of the upper part of the shaft of that bone, close to the tubercle in front. The muscle resembles a strap which has been twisted round the front of the limb in a spiral fashion. It thus helps to divide the front of the thigh into two regions: an outer and lower, occupied by the extensor muscles which have just been described, and an upper and inner, which contains the adductor group. The sartorius overlies the rectus femoris at its origin, as well as the hinder portion of the vastus internus along the lower and inner aspect of the thigh. It also lies in front of the insertions of the adductors (Fig. 152; Pls., pp. 72, 86, 216, 318, 366, 382).

The action of this muscle is to flex the knee and hip-joints: when the knee is bent it acts as an internal rotator of the leg on the thigh; it also assists in everting the entire limb. The relation of the muscle is best understood by a reference to the Plates, pp. 274, 318. It will be noticed that its influence on the surface forms is not great. It helps to define the upper limit of the fullness of the vastus internus and rectus from the hollow of the thigh which lies above the sartorius and between it and the furrow of the groin. In violent action, when the thigh is flexed upon the trunk, the superior attachment of the muscle to the anterior superior iliac spine may form an outstanding ridge on the surface of the limb (Pl., p. 216). In many models the angular interval between the origins of the sartorius in front, and the tensor fasciae femoris to the outer side, is represented on the surface by a furrow or dimple. It is here that the rectus femoris, concealed at its origin, becomes superficial (Pls, pp. 58, 148, 158, 298).

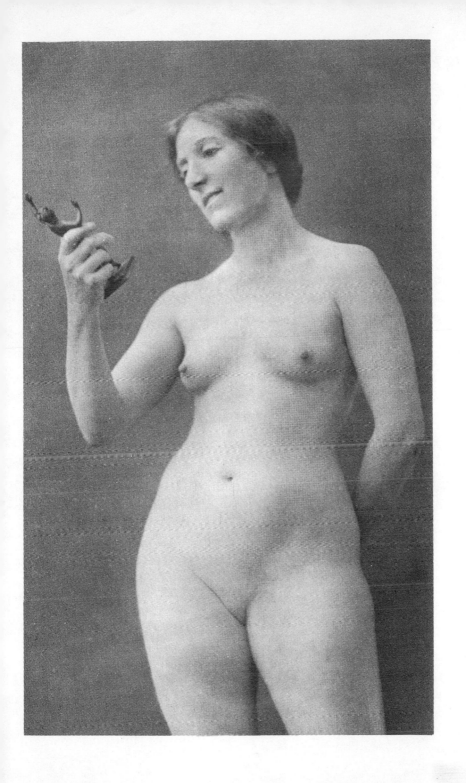

Owing to the oblique position of the thigh-bone, there is a triangular interval between the inner side of the shaft of the bone, the inner border of the limb, and the pelvis above. This interval is occupied by the *adductor muscles*. They form a fleshy mass of triangular shape, attached above to that part of the pelvis in front of the acetabulum which is formed by the pubis, and that portion of the ischium which lies in front of the ischial tuberosity. Externally and inferiorly these muscles pass to be inserted into nearly the whole length of the back of the shaft of the thigh-bone, reaching as low as a prominent spur on the upper surface of the internal condyle, whilst internally they assist in forming the outline of the inner side of the thigh. This fleshy mass is broken up into several muscles, named the *adductor longus, adductor brevis, adductor magnus, pectineus,* and *gracilis,* but it is unnecessary to enter into a detailed account of them all, as they influence the surface forms rather by their bulk than by their details. As has been already stated, they lie above and to the inner side of the sartorius muscle; here, as they stretch across from the front of the pelvis to the upper part of the thigh-bone, they assist in forming the floor of the depression which lies immediately below the groin, and which is called the *hollow of the thigh*. This corresponds to a triangular interval between the sartorius on the outer side and the inner border of the adductor longus on the inner side. The base of the triangle, which is directed upwards, corresponds to Poupart's ligament. The floor of this space is deepest in the centre, and corresponds on the inner side to the anterior surfaces of the pectineus and adductor longus, whilst externally two muscles, called the *psoas* and *iliacus*, which pass down from within the pelvis, under cover of Poupart's ligament, form the outer half of the floor of the space. The influence of

these structures on the surface form is very much modified by the presence of an abundance of fat and other tissues, and depends also on the position of the limb. It is here that the large blood-vessels and nerves which enter the thigh are placed, and, lying as they do in a considerable quantity of fat, they serve to mask and obscure the outlines of the structures above enumerated ; the hollow as such only exists, in a well-nourished model, when the thigh is flexed upon the trunk (Pls., pp. 38, 274). In this position the boundaries of the space become more distinct, and the surface contours flattened, whereas when the thigh is fully extended the front of the limb assumes a fullness which is largely dependent on the fact that the head and neck of the thigh-bone, which underlie some of the structures enumerated, are thrust forward and so cause a bulging of the tissues which overlie them (Pls., pp. 72, 148, 152, 216).

Of the adductor group the most important as a determinant of surface form is the *gracilis*. This muscle arises by a thin tendon about 2 or 2½ inches broad from the bone, close to and parallel with the symphysis pubis. The attachment extends somewhat behind this joint. It differs from the other members of the group in not being attached to the thigh-bone. Its fleshy fibres, which form a broad strap-like muscle, pass vertically downwards along the inner side of the limb, thus coinciding with the outline of the upper and inner aspect of the thigh when viewed from the front. A little below the level of the middle of the thigh it comes in contact with the posterior border of the sartorius, which has crossed over the front of the thigh to reach the inner side, and here the gracilis usually becomes tendinous. Its tendon is closely applied to the posterior border of the sartorius, and passes down in company with it along the inner side of the knee. Below the internal tuberosity of the tibia the tendon curves

forwards, and is inserted under cover of the expansion of the sartorius into the inner aspect of the upper part of the shaft of the tibia (Pls., pp. 216, 252, 274, 318, 338, 382).

As their names imply, these muscles adduct the thigh ; in other words, they enable us to draw together the outspread limbs. They are usually well developed in those who indulge in much riding exercise, though of course the reader must bear in mind that this remark applies only to those who ride cross-saddle. Individual members of the group are associated with other actions ; thus the pectineus and adductors longus and brevis assist in flexing the thigh, whilst the gracilis helps to bend the knee and at the same time causes inward rotation of the bent leg. The adductors as a whole may also assist

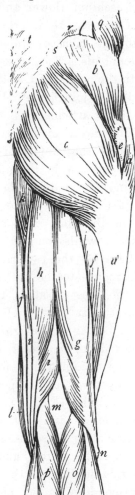

FIG. 153. View of the muscles of the back of the right thigh.

a. Tensor fasciae femoris.
b. Gluteus medius.
c. Gluteus maximus.
d. Ilio-tibial band.
e. Trochanter major of femur (thigh-bone).
f. Vastus externus.
g. Biceps of thigh.
h. Semitendinosus.
i i. Semimembranosus.
j. Gracilis.
k. Adductor magnus.
l. Sartorius.
m. Popliteal space or ham.
n. Head of fibula (outer bone of leg).
o o. Outer head of gastrocnemius.
p p. Inner head of gastrocnemius.
q. External oblique muscle of abdominal wall.
r. Origin of latissimus dorsi.
s. Posterior superior iliac spine.
t. Posterior layer of lumbar aponeurosis.

in turning the limb outwards by reason of their insertion into the back of the shaft of the thigh-bone.

The *hamstring muscles* form the *flexor group*, which is placed on the back of the thigh. They consist of the *biceps of the thigh*, the *semitendinosus*, and the *semimembranosus*. They all take origin from the tuberosity of the ischium (lower and hinder part of the haunch-bone), and pass to be inserted into the bones of the leg: two into the tibia or inner bone, one into the fibula or outer bone. They thus connect the bones of the leg with the pelvis, and, as they cross over the back of the hip and knee-joints, they therefore control the movements of these two articulations.

This flexor mass forms a thick fleshy column which occupies the middle of the back of the thigh. It is not sufficiently wide to influence either the inner or outer outline of the limb when viewed from behind, for external to it the fleshy fibres of the vastus externus, overlain by the ilio-tibial band, are the determinant of the surface outline, whilst on its inner side the adductor group, covered by the sartorius below and the gracilis above, corresponds to the outline of the inner aspect of the thigh. In the erect position the origin of these flexor muscles from the tuberosity of the ischium is concealed by the lower border of the gluteus maximus. When the thigh is flexed on the trunk, however, the lower border of the gluteus maximus slips forward over the ischial tuberosity, thereby more fully exposing the superior attachment of these muscles (Fig. 153; Pls., pp. 44, 52, 54, 252, 274, 318).

The *biceps* and *semitendinosus* lie side by side and superficial to the semimembranosus; the line of separation between the biceps and semitendinosus corresponds to the middle line of the back of the thigh. At a point corresponding pretty closely with the junction of the lower with the middle third of the thigh these two

muscles separate from one another. The outer one, or *biceps*, passes towards the outer side of the knee, below which it is inserted into the head of the fibula, whilst the *semitendinosus* is directed downwards towards the inner side of the knee, and is inserted into the inner aspect of the upper part of the shaft of the tibia, just below the inner tuberosity of that bone and under cover of the tendinous expansion of the sartorius. The biceps differs from the other members of this group in possessing a second head of origin from the thigh-bone, hence its name. This *femoral* origin is called its *short* head, in contradistinction to the *long* head, which arises along with the other hamstrings from the ischial tuberosity. The short head of the biceps arises from the rough line on the back of the thigh-bone, below the bony insertion of the fibres of the gluteus maximus, extending down to near the external condyle (Pls., pp. 52, 54, 274, 318, 338, 366).

There is a marked difference between the forms of the biceps and semitendinosus. The latter ends in a long and slender tendon (to which circumstance it owes its name), about the level at which the two muscles separate from one another, viz. at the junction of the lower with the middle third of the thigh, whereas the biceps remains fleshy until it has reached the level of the knee (Pls., pp. 252, 318, 338, 366).

The *semimembranosus*, so called on account of the peculiar arrangement of its tendinous parts, lies at its origin under cover of the preceding muscles. The bulk of the fleshy part of the muscle is placed on the inner side of the middle line of the back of the thigh. In this situation the fleshy belly of the semitendinosus rests upon it above, whilst, below, the tendon of that muscle may be traced downwards on the surface of the fleshy part of the semimembranosus, which reaches as low as the upper border of the internal condyle of the thigh-bone. Inter-

nally the semimembranosus is in relation above to a portion of the adductor magnus, whilst in the lower two-thirds of the thigh it lies close to the hinder border of the fleshy belly and tendon of the gracilis muscle. Curving round the hinder end of the internal condyle of the thigh-bone, the muscle passes to be inserted by a strong tendon into the back of the inner tuberosity of the tibia (Pls., pp. 52, 252, 274, 318, 338, 366).

It is to the presence of these muscles that the roundness of the back of the thigh is due. We have already seen that they exert no influence on the outer and inner outlines of the limb, but if the thigh be viewed from the side they determine its shape as we trace it from the fold of the buttock to the back of the knee, the surface outline being due to the fleshy bellies of the biceps and semitendinosus, though the semimembranosus not unfrequently has a direct influence on the surface form a little above and behind the knee. The reader may, however, better satisfy himself as to these details by a reference to the Plates, pp. 54, 252, 274, 318, 338, 366).

It is particularly in the region of the *ham* or the *hollow behind the knee* that these muscles are most readily distinguished. When the knee is bent their rounded cord-like tendons may be felt with ease on both the inner and outer aspects of the hinder surface of the joint. These tendons are hence called the hamstrings, a term which is also applied to the muscles with which they are connected. The *outer hamstring,* or tendon of the biceps, can be readily traced to its insertion into the head of the fibula, whilst the *inner hamstrings,* of which the more superficial is the tendon of the semitendinosus, can also be easily recognized. That of the semitendinosus passes to the inner side of the upper end of the shaft of the tibia, whilst the tendon of the semimembranosus can be traced with more difficulty

to the back of the internal tuberosity of the tibia (Pls., pp. 252, 274, 318, 328, 338, 366).

As regards the action of these muscles, the student must bear in mind the fact already referred to, viz. that they pass over both the hip and the knee-joints; but note that in the case of the hip the muscles lie in relation to its extensor aspect, whilst in the case of the knee they are placed in relation to its flexor surface. They may thus act as extensors of the hip as well as flexors of the knee. They combine with their flexor action on the knee a certain power of rotating the bent leg. The biceps helps to rotate the leg outwards, whilst the semimembranosus and semitendinosus will counteract this by turning the leg inwards at the knee.

Their action as extensors of the hip may best be understood by reference to a very simple experiment. When we endeavour to touch the toes without bending the knees a great strain is put on the hamstring muscles; they are stretched to their full extent, and our ability to perform this feat depends on the extent to which they have been exercised in this particular way. It is when we recover ourselves and again assume the erect position by straightening the trunk on the limbs at the hip-joints that we bring into play the extensor action of these muscles. As has been stated, the extent to which we can bend forward without flexing the knees depends on the length of those muscles. This controlling action of the hamstrings is illustrated in another way; we can only raise the limb, or in other words bend the thigh, to a limited extent, barely to a right angle with the trunk, when the knee is extended, but if on the other hand the knee be flexed the tension on the hamstrings is at once relieved, and the thigh can be bent to such a degree that we can bring its anterior surface in contact with the front of the trunk. Similarly there is no difficulty in touching the toes if we slightly bend the

knees. The accompanying diagrams serve to illustrate these facts (Figs. 154, 155).

The form of the thigh tapers from the hip to the knee. Its roundness depends largely on the quantity of fat present beneath the skin. In a muscular model but sparingly covered with fat the grouping of the muscles into an internal and upper group (adductors), an external and lower group (extensors), and a posterior group (flexors) is at once apparent, as these several regions resolve themselves into surfaces which

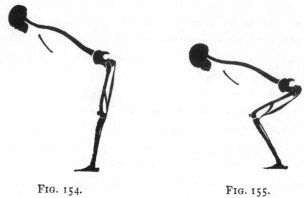

FIG. 154.　　　　　　　　　　FIG. 155.

Diagrams to illustrate how flexion at the hip-joint is controlled by the hamstring muscles. In Fig. 154 the hamstrings are represented tightly stretched when the knee is straight. In Fig. 155 the muscles are shown relaxed when the knee is bent. A greater amount of flexion is thereby permitted at the hip-joint.

are more or less distinctly defined from one another—the two former by the furrow corresponding to the sartorius, the two latter by the furrow which passes down the outer side of the thigh and corresponds to the posterior border of the vastus externus. The fullness on the inner side of the thigh passes insensibly into the roundness caused by the hamstring group (Pls., pp. 52, 54, 72, 86, 216, 318, 366, 382).

In the female the separation of the thigh into regions, corresponding to the grouping of the muscles, is obliterated to a very great extent by the presence of a thick sub-

cutaneous fatty layer (Pls., pp. 52, 54, 72, 80, 86, 216, 252, 262, 268, 270, 278, 298, 308, 318, 338, 366, 434, 438).

Owing to the greater pelvic width in woman, and the consequent greater obliquity of the thigh-bone, the limb is relatively wider above compared with its length than in the male : this conveys the impression that in the female the thigh is shorter than it really is. As a fact, the thigh is relatively somewhat shorter than in the male,

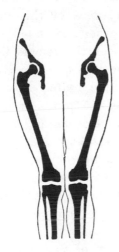 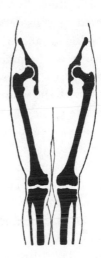

FIG. 156. FIG. 157.

Diagrams showing the greater degree of obliquity of the thigh-bones dependent on the greater pelvic width in woman, Fig. 156, as compared with man, Fig. 157.

but in well-proportioned females the shortness is more apparent than real, and is dependent on the causes afore-mentioned. It may be noted, however, as a matter of experience, that it is by no means easy to obtain female models with the requisite limb proportions, for in no respect do they vary so much.

The greater breadth of the upper part of the thigh and the greater obliquity of the thigh-bone give rise in

women to a knock-kneed appearance. This is further em-
phasized by the outline of the outer side of the thigh
forming a more pronounced angle with the outline of the
outer side of the leg than in the male (Pls.,pp.216,298). When
from great width of the upper segment of the limb this ap-
pearance is unduly pronounced it gives rise to an unpleasant
impression, and models which display this feature should
be discarded, though much may be done to remedy these
unpleasant lines by placing the limbs in such a position
as to modify considerably the appearance of this defect.
The condition above referred to, when not unduly em-
phasized, is a characteristic feature of the female figure,
and imparts to it a sense of refinement and modesty in
harmony with the whole sentiment of the figure. In women
there is a tendency to the massing of fat on the outer side
of the thigh below the level of the trochanter. This, as
has been already explained (p. 271), causes the width of this
part of the figure to fall lower than in the male, in whom
it is generally situated on a level with the trochanters,
but in cases where this fat is present in too great quantity
it destroys the symmetry of the thigh and produces an
unpleasant outline along the upper and outer aspect of
the limb. This difference in the form of the limb in the
two sexes may best be observed if we view the figure from
behind. In women the greatest width across the thighs
is seen to lie as a rule on a level with the folds of the
buttocks, whereas in the male the greatest width is con-
siderably above this level. These differences are apparent
in the plates, pp. 34, 52, 110, 142, 216, 434).

The outlines of the thigh, when viewed from front or
back, depend on the vastus externus on the outer side, and
on the gracilis above and the sartorius below, on the inner
side. The student should remember that the ilio-tibial
band overlies the fleshy fibres of the vastus externus, and
when tight leads to a compression of the muscle, thus

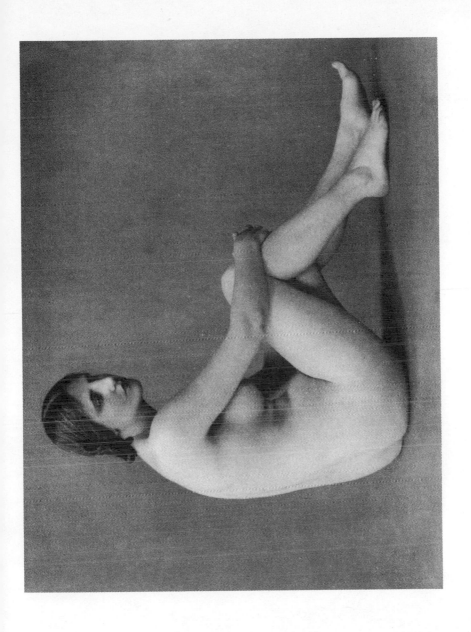

giving rise to a flattening of the form along the outer side of the limb. This is best seen when the model stands on one leg, or when the weight of the trunk is mainly supported on one leg, with the knee extended, whilst the other leg is bent and slightly advanced (Pl., p. 298). In this position the bent leg carries little weight, but merely acts as a support to steady the limb upon which the bulk of the weight rests. In profile the outline of the front of the thigh depends upon the sartorius, rectus femoris, and the vastus externus. If the limb be slightly rotated outwards, a small part of the vastus internus, as it crosses over the internal condyle of the thigh-bone, comes into direct relation with the outline just above the knee. In this view of the limb, the surface outline, due to the fleshy bellies of the vastus externus and rectus, is frequently interrupted towards its lower part by a shallow hollow, corresponding to the position of an arching band of fibres which cross the general investing fascia of the limb ; these fibres are connected with the ilio-tibial band behind, and curve downwards and forwards over the front of the thigh on the upper part of the lower third of the limb. Richer[1] calls them the *arched band* of the fascia of the thigh (Pls., pp. 72, 86, 366).

Posteriorly the outline depends on the hamstrings, the biceps, or semitendinosus chiefly, whilst, below, the semimembranosus directly influences the surface contours for a short distance above the knee (Pls., pp. 54, 80, 86, 252, 274, 318, 338, 366).

When the limbs are straight with the knees together there should be but a slight interval between the thighs, and that only where the sartorius muscles curve back to lie along the inner side of the limb. In women the thighs may be in contact all the way down. This difference is due to the greater quantity of subcutaneous fat, and

[1] *Anatomie Artistique,* Paul Richer. Paris, 1890.

when an interval exists between the limbs in this position it should be much less than in the male. In either sex the space between the thighs when the knees are in contact should never be carried up as high as the fork, as such a condition is indicative of a meagre development of the lower limbs and produces a most unpleasant impression. (Pls., pp. 216, 268.)

In men of athletic build one not unfrequently meets with a certain amount of outward curve in the limbs. This bow-legged appearance, in minor degrees, is quite consistent with a normal growth and an athletic development, and must not be confused with those cases in which the curves of the limb are the result of disease. Brücke [1] has laid down a rule which enables the student to determine when this outward curve of the limb has exceeded the limits consistent with a well-shaped leg. He takes two straight lines, the inner from the middle line of the trunk at the level of the pubis, the outer from the outer side of the thigh, just where the trochanter lies beneath the surface. Both lines are carried down so as to meet at a point corresponding to the most elevated part of the instep of the foot. As these two lines cross the front of the knee, the patella should lie between them ; in cases where the patella lies outside these limits the curve of the limb is unduly great, and the form inelegant. It follows from this that, in men in whom this form of limb is met with, the inner sides of the knee may not be in contact when they stand erect with the heels together, but may be separated by an interval the width of which is limited by the rule already referred to. Such a condition is inconsistent with the form characteristic of the female, and models displaying such a tendency should be avoided.

The variations in the form of the thigh, due to alterations

[1] *The Human Figure*, Professor Ernest Brücke. London : Greval & Co., 1891.

in its position, are best understood by a reference to the plates, pp. 274, 318. In flexion of the thigh on the trunk it is always well to recognize the position of the anterior superior spine of the iliac crest, as this gives us the key to the drawing of the tensor fasciae femoris, a muscle which exercises an important influence on the surface forms of the upper and outer part of the limb. In slight degrees of flexion the fold of the groin is deepened, and the outer limit of that furrow corresponds to the bony point in question. When flexion is carried farther, the line of flexion which crosses the front of the upper part of the thigh, just below the furrow of the groin, becomes

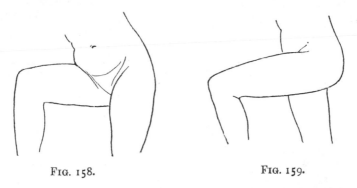

FIG. 158. FIG. 159.

emphasized, and these two folds as they reach the outer side of the limb form a V or Y-shaped fold between the sides of which the anterior superior iliac spine can be distinctly felt. This is well shown in the plates, pp. 80, 104, 124, 252, 274, 318.

The consideration of the surface forms of the knee is extremely difficult. In the first instance it is very important that the student should have an accurate knowledge of the shape of the bones which enter into the formation of this joint. The most common defect met with in the knee is its size; this tends as a rule to be too big, a circumstance which is principally owing to the large-

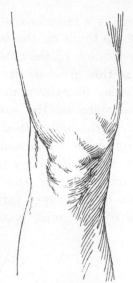

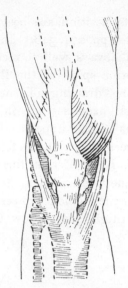

FIG. 160. The right knee with the muscles relaxed.

FIG. 161. Diagram of the right knee with the muscles relaxed, showing the arrangement of the parts on which the surface form depends.

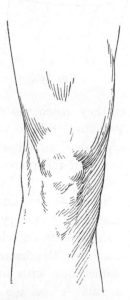

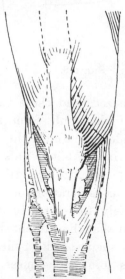

FIG. 162. The right knee with the muscles contracted.

FIG. 163. Diagram of the right knee with the muscles contracted, showing the arrangement of parts.

ness of the articular ends of the bones, though the presence
of a superabundance of fat in this region may assist in
emphasizing the defect. The joint should be small, though
not unduly so, as this may tend to impart a weak appear-
ance to the limb. It should form a summit to the taper
of the thighs, and link the thigh and leg together in
such a way as to carry the flow of the lines from one
portion of the limb to the other without any abrupt
interruption of their curves.

Along the inner side of the joint the outline of the thigh,
determined by the sartorius muscle, should flow evenly and
continuously over the prominence of the internal condyle
to the upper part of the shaft of the tibia below. The outer
side of the joint, less prominent and somewhat flattened,
corresponds to the bottom of the curve formed by the
outline of the outer side of the thigh above and the swelling
of the calf below. In front the form of the patella should
be distinct in the male, though in the female it may be less
noticeable. It should be small and not unduly prominent,
else the knee may have a pointed appearance, which is
objectionable (Pls., pp. 62, 72, 216, 328, 434).

The patella is connected above with the muscles of the
front of the thigh, and below, by means of its ligament,
with the tubercle of the tibia ; these details are not recog-
nizable when the muscles are relaxed, but are plainly seen
in action. In repose the patella drops to a slightly lower level
and lies loosely in the tissues in front of the joint, being
supported below by two considerable pads of fat, which
occupy the intervals between the ligament of the patella
and the front of the joint on either side. By the contrac-
tion of the muscles of the front of the thigh the patella is
drawn up so that its lower border lies about an inch above
the level of the articular surface of the tibia. The ligament
which connects it with the tubercle of the tibia is thus
put on the stretch, and becomes conspicuous as a surface

elevation, which is usually marked off above by a shallow furrow corresponding to its line of attachment with the patella. On either side the fullness of the ligament is maintained by the pads of fat already mentioned, which help to soften its outline. Superiorly a flattened triangular depression, leading up into a furrow, corresponds to the tendinous insertion of the muscles into the upper border of the knee-pan. The fullness on either side of this depression corresponds, on the inner side, to the fleshy fibres of the vastus internus, which curve obliquely across the internal condyle of the thigh-bone to reach the upper half of the inner border of the knee-pan, whilst at a higher level the fibres of the vastus externus, as they sweep down to be inserted by tendinous fibres into the outer part of the superior border of the patella, limit the surface depression externally. The arching fibres of Richer, as they pass across the vastus internus, tend to emphasize the bulge of the lower part of this muscle (Pl., p. 72). These details are ordinarily absent in the knee of the female, in whom we have a less strong muscular development and a greater abundance of subcutaneous fat. In the antique there is little suggestion of detail, the forms being kept simple and rounded. In females great variety of modelling is met with, depending on the disposition of the fat; but as a rule the existence of the patella is oftenest indicated by a slight hollowing and flattening of the surface along its outer side, thus emphasizing its presence. It is by no means uncommon, when the joint is forcibly extended, to meet with a triradiate furrow in front of the joint, one limb of the furrow overlying the ligament of the patella, whilst the two upper limbs serve to define the lower and outer borders of the bone itself, the fullness between these being due to the shape of the patella, whilst the rounded forms on either side of the descending furrow are caused by the disposition of the fat on each side of

the ligament (Pls., pp. 72, 216, 298, 434, and Figs. 160 and 162).

As viewed from the outer side, the outline of the front of the knee is due to the form of the femoral condyles and the patella. The position of the latter depends on whether the muscles of the front of the thigh are contracted or not. It is more prominent when the knee is forcibly extended than when it is bent, as in the latter condition the patella slips into the groove between the femoral condyles. But be it noted that, the ligament of the patella having once been put on the stretch, the distance between the tubercle of the tibia and the lower border of the patella can never vary, whatever be the position of the joint. In this view of the limb the relation of the femoral condyles to the upper end of the tibia is well seen. They should appear as if well supported on the head of the tibia, and should not display a forward thrust, as if there was a risk of their slipping over the front of the tibia. This appearance is by no means uncommon in models, and imparts to the limb an extremely ugly outline, the line of the front of the leg appearing to lie behind the line of the front of the thigh, instead of being continuous with it over the surface prominences of the knee. In flexion of the joint, as the patella sinks into the groove between the two condyles, the rounded form of the front of the joint becomes more and more due to the condyles, the inner of which, being the more prominent of the two, helps to determine the outline, even though viewed from the outer side. The roundness caused by this condyle is further emphasized by the fibres of the vastus internus, which are curving obliquely across it to join the inner border of the patella (Pls., pp. 54, 80, 86, 216, 252, 262, 270, 274, 318, 338, 366, 438).

The outer side of the joint is overlain by the ilio-tibial band, which is here passing down to be attached to the outer tuberosity of the tibia, in front of the head of the fibula.

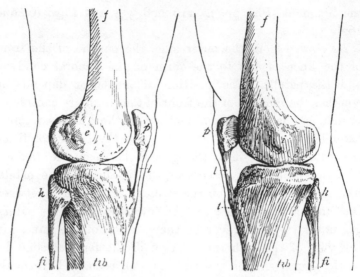

The bones of the extended knee (right side).

Fig. 164. Outer side.	Fig. 165. Inner side.
f. Femur. *fi.* Fibula.	*h.* Head of fibula.
tib. Tibia.	*p.* Patella or knee-pan.
e. External condyle of femur.	*l.* Ligament of the patella.
i. Internal condyle of femur.	*t.* Tubercle of tibia.

The bones of the bent knee (right side).

Fig. 166. Front view.	Fig. 167. Outer side.
a. Femur.	*i.* Internal condyle of femur.
b. Tibia.	*p.* Patella.
c. Fibula.	*l.* Ligament of the patella.
e. External condyle of femur.	*t.* Tubercle of tibia.

In such actions as put a strain on this band it forms a sur-
face relief distinct from that caused by the vastus externus,
which lies in front. Behind the ilio-tibial band the tendon
of the biceps muscle may be traced to the head of the
fibula; in passing down, it causes a surface elevation
corresponding to its form and direction. In flexion this
relief is at once emphasized. The relations of the other
structures in different positions of the joint are best
understood by a reference to the plates, pp. 252, 275, 318, 338.

The roundness of the inner side of the knee is due to the
projection of the internal condyle and the internal tuberosity
of the tibia. The lowest fibres of the vastus internus partly
overlie the former, whilst curving down over the posterior
half of the inner side of the joint are the fibres of the
sartorius (here fleshy), behind which there lie in the fol-
lowing order, from before backwards, the tendons of the
gracilis, semimembranosus, and semitendinosus. The semi-
membranosus tendon passes away from the surface opposite
the level of the internal tuberosity of the tibia, into the
posterior border of which it is inserted. The tendons of all
the other muscles here enumerated pass down to be attached
to the upper part of the inner surface of the shaft of the
tibia below the internal tuberosity, the sartorius forming
a broad expansion underneath which the other two tendons
are united to the bone, that of the gracilis lying on
a higher level than that of the semitendinosus. These
details are not indicated on the surface forms by separate
reliefs; together they combine to form a rounded elevation
which curves over the inner side of the joint. In flexion
the two inner hamstrings, viz. the tendons of the semi-
membranosus and semitendinosus, become very prominent,
particularly the latter, and serve to carry the line of the
back of the thigh across the inner and posterior aspect of
the flexed joint. On either side the spring of the muscles
of the calf, from the back and upper parts of the femoral

318

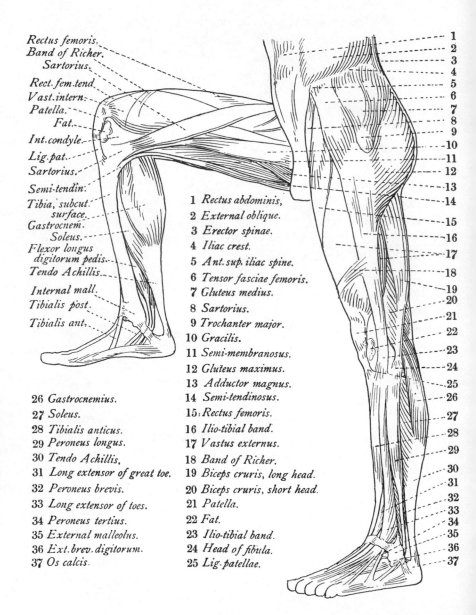

Rectus femoris.
Band of Richer.
Sartorius.

Rect. fem. tend.
Vast. intern.
Patella.
Fat.
Int. condyle.
Lig. pat.
Sartorius.

Semi-tendin.
Tibia, subcut.
surface.
Gastrocnem.
Soleus.
Flexor longus
digitorum pedis.
Tendo Achillis.

Internal mall.
Tibialis post.

Tibialis ant.

1 Rectus abdominis,
2 External oblique.
3 Erector spinae.
4 Iliac crest.
5 Ant. sup. iliac spine.
6 Tensor fasciae femoris.
7 Gluteus medius.
8 Sartorius.
9 Trochanter major.
10 Gracilis.
11 Semi-membranosus.
12 Gluteus maximus.
13 Adductor magnus.
14 Semi-tendinosus.
15 Rectus femoris.
16 Ilio-tibial band.
17 Vastus externus.
18 Band of Richer.
19 Biceps cruris, long head.
20 Biceps cruris, short head.
21 Patella.
22 Fat.
23 Ilio-tibial band.
24 Head of fibula.
25 Lig. patellae.

26 Gastrocnemius.
27 Soleus.
28 Tibialis anticus.
29 Peroneus longus.
30 Tendo Achillis,
31 Long extensor of great toe.
32 Peroneus brevis.
33 Long extensor of toes.
34 Peroneus tertius.
35 External malleolus.
36 Ext. brev. digitorum.
37 Os calcis.

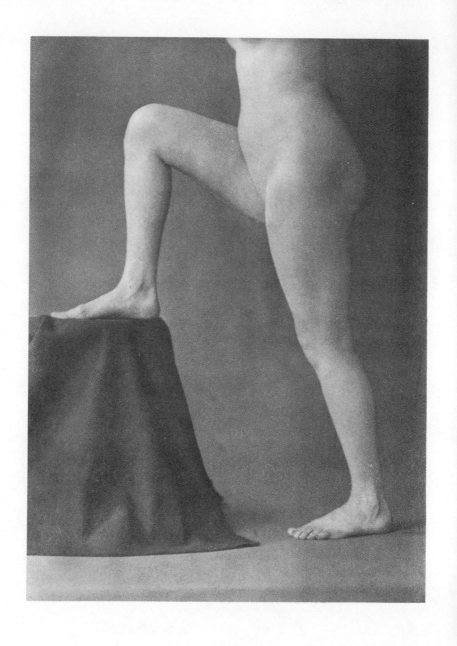

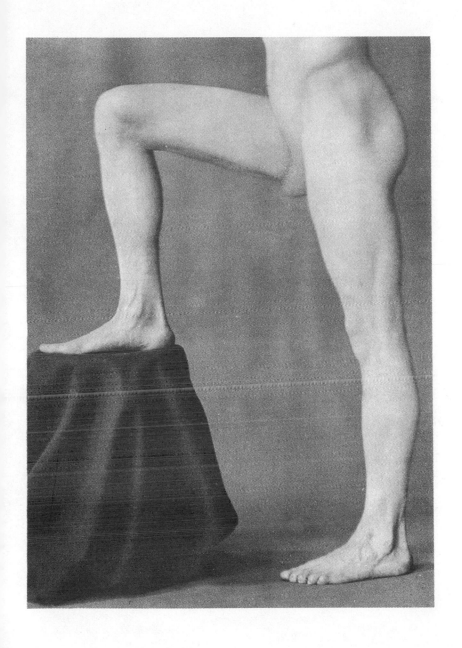

condyles, imparts a fullness to the back of the limb, behind and below the joint (Pls., pp. 252, 274, 318, 338, 366).

The consideration of the surface forms on the back of the knee must be postponed until the muscles of the calf have been described. (See p. 342.)

CHAPTER XI

THE muscles of the leg [1] are concerned in the movements of the foot and toes. Before considering them, something must therefore be said about the bones of the foot and the ankle-joint.

The bones of the leg have been already described in the previous chapter, but a more detailed account of their lower extremities is necessary before the reader can fully appreciate the structure and movements of the ankle-joint. Unlike the knee, both bones of the leg enter into the formation of the ankle, though the *tibia* or inner bone plays a much more important part in its construction than the *fibula* or outer bone.

The lower end of the tibia is expanded, and on its inferior surface displays a quadrilateral articular area, hollow from before backwards and very slightly convex from side to side. On the inner side of this the bone is prolonged downwards to form a broad and more or less pointed process called the *internal malleolus*. The inner aspect of this process is subcutaneous, and corresponds to the surface projection of the inner ankle. The outer surface of the internal malleolus is provided with an articular facet, which is continuous with that already described on the under surface of the expanded lower end of the tibia.

The lower end of the *fibula* is also enlarged, and forms a process called the *external malleolus*. This is narrower

[1] The term leg is here applied to that part of the limb which lies below the knee.

and more pointed than the internal malleolus. The outer
surface of the external malleolus is subcutaneous and forms

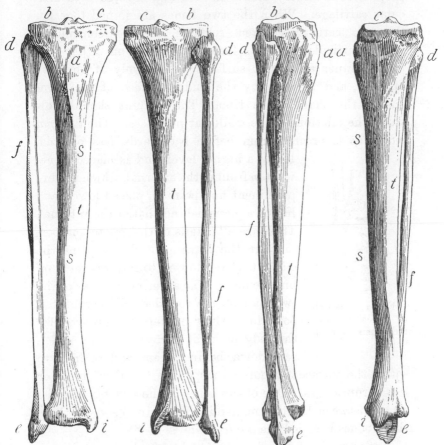

Right tibia and fibula articulated.

FIG. 168. Front
view.

FIG. 169. Back
view.

FIG. 170. Outer
view.

FIG. 171. Inner
view.

t. Tibia, inner bone of leg.
a. Tubercle of tibia, to which ligament
of patella is attached.
b. External tuberosity.
c. Internal tuberosity.

d. Head of fibula.
e. External malleolus (fibula).
f. Fibula.
i. Internal malleolus (tibia).
s s. Crest or shin.

the elevation of the outer ankle. The inner side of the
lower end of the fibula is firmly united to the outer side

of the inferior extremity of the tibia, beyond which it projects considerably, and is smooth and covered with articular cartilage. When the two bones are joined together the two cartilage-covered surfaces become continuous, and an articular recess is formed, bounded on either side by the inner and outer surfaces respectively of the two malleoli, and between by the under surface of the lower end of the shaft of the tibia. The student should now study the relations of the malleolar processes. The *internal malleolus* is broader from before backwards, less pointed,

FIG. 172. Sketch of bones of right ankle as seen from behind.

lies at a higher level, and is placed somewhat in front of the external, which is more prominent and pointed, placed lower, and lies on a plane behind that of the internal. These are all details of the greatest importance in the drawing of the foot, and the student would do well to impress them on his memory. The anterior margins of the two malleoli are rounded off in front, but posteriorly their borders are grooved for the lodgement of certain tendons which pass down behind them and so help to soften the surface contours corresponding to these more or less abrupt edges. One of the bones of the foot fits into the recess between the two malleoli. The joint between these three bones is called the *ankle-joint*.

Just as we have carpal, metacarpal, and phalangeal bones in the hand, so we have *tarsal, metatarsal*, and *phalangeal* bones in the foot. The *tarsal* bones correspond in the foot to the carpal or wrist-bones of the hand. They are seven in number, in place of eight as in the carpus : this is due to the fact that the representative in the foot, of the pisiform bone of the hand, has become fused to another of the tarsal bones, thus leading to a reduction in the number of these bones by one.

The tarsal bones form a striking contrast to the bones of the wrist; they are much larger and stouter, and constitute a far larger proportion of the foot than do the corresponding bones of the hand. If the length of the inner border of the foot be taken from the heel to the tip of the great toe, the skeleton of the hinder half of the foot is made up of these tarsal bones, the half in front being formed of the *metatarsals* and greatly reduced *phalanges* or *toe-bones*. The advantage of this arrangement is at once obvious. It is on the feet that we habitually stand and rest the weight of the body, and for this purpose strength and solidity are necessary. The foot is not a prehensile organ like the hand, in which great freedom of movement is obviously an advantage.

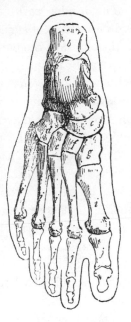

FIG. 173. The bones of the right foot as seen from above. The tibia and fibula have been removed so as to expose

a. Astragalus
b. Os calcis or heel-bone
c. Navicular or scaphoid
d. Cuboid
e. External cuneiform
f. Middle cuneiform
g. Internal cuneiform
} Tarsus.

i i i i i. Metatarsus.
j j j j j. Phalanges or toe-bones.

The tarsal bones, of which a diagram is here given (Fig. 173), are named the *astragalus, os calcis, navicular, internal, middle* and *external cuneiforms*, and the *cuboia*.

Of these the two most important are the *astragalus* and the *os calcis* or *heel-bone*; the rest help to form the rounded surface on the back of the foot called the *instep*.

The *astragalus* consists of a hinder or larger part, the body, the upper side of which is provided with a saddle-shaped articular surface. The fore part of the bone is called the head. This rounded surface, which is moulded

on an ill-defined neck, articulates with the navicular bone, and thus supports the skeleton of the inner border of the foot.

The hinder part of the bone is of little importance as a determinant of surface form, but is noteworthy because it links together the bones of the foot with the bones of the leg. Superiorly it fits into the recess between the two malleoli, which thus prevent its lateral displacement and also check excessive movement from side to side. Inferiorly it rests on the upper surface of the heel-bone, whilst in front it articulates, as has been said, with the navicular.

The *os calcis* or *heel-bone* is not placed directly beneath the astragalus, but lies under the outer half or so of that bone. It supports the astragalus in part on its upper surface, and in part by means of a bracket-like process called the *sustentaculum tali*, talus being another name applied to the astragalus. The inner side of the os calcis forms a wide hollow which is overhung by the sustentaculum. The broad groove which lies behind the inner ankle, and between it and the prominence of the heel, allows the passage of the numerous structures (tendons, vessels, &c.) which run from the back of the leg downwards into the sole of the foot. The most marked feature of the os calcis is its large posterior extremity, which forms the prominence of the heel. The length of this process varies in different individuals; it is more prominent in a thin, narrow, and long foot than in a short and broad foot. The powerful tendon of the muscles of the calf, called the *tendo Achillis*, is inserted into this process. The outer side of the os calcis is subcutaneous except where crossed by two tendons which pass down behind the external malleolus: these tendons help to carry the relief of the external malleolus on to the surface form corresponding to the outer side of the heel-bone. In front the os calcis articulates with the cuboid, and thus supports the bones which lie along the outer border of the foot.

Such further description of the remaining tarsal bones as may be necessary is for the present delayed until the foot as a whole is considered.

The *ankle-joint* is the articulation between the tibia and fibula above, and the astragalus below. The fibula shares but little in the transmission of the weight through the leg to the foot; by its external malleolar process, however, it affords support to the outer side of the joint, and thus prevents lateral displacement of the astragalus. It is through the under surface of the lower extremity of the shaft of the tibia, which rests on the saddle-shaped surface of the upper aspect of the astragalus, that the bulk of the weight passes. The projection of the internal malleolus on the inner side assists in strengthening the joint internally. The ankle is further supported on either side by very strong lateral ligaments which are attached above to the malleolar processes and pass downwards as radiating bands which are connected with the surfaces of the adjacent bones in front, below, and behind. Anteriorly and posteriorly the capsule of the joint is completed by thin and weak ligaments.

The movements of the ankle-joint are mainly those of flexion and extension. Under ordinary conditions the axis of the foot is placed at right angles to the axis of the leg. The term flexion is applied to that movement in which the joint is bent so as to bring the back of the foot nearer the front of the leg. Extension is the reverse action; in it the axis of the foot is drawn more directly into line with the axis of the leg, the heel is raised, and the toes are pointed. The reader may easily satisfy himself that in the extremes of flexion and extension the degree of lateral play of the joint varies very considerably. When the joint is strongly flexed the articular surfaces are forced together very firmly, owing to the fact that the wider part of the upper articular surface of the astragalus is driven home between the two malleoli and acts like a wedge, thus

tightening the joint. In extension the narrower portion of the articular surface of the astragalus occupies the interval between the two malleoli, the whole joint is

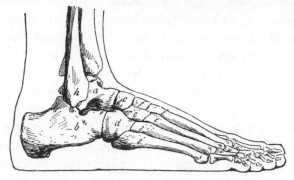

FIG. 174. Bones of right foot, outer view.

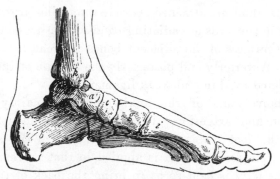

FIG. 175. Bones of left foot, inner view.

a. Astragalus.	*g.* Internal cuneiform.
b. Os calcis (heel-bone).	*h.* External malleolus (fibula).
c. Navicular. *d.* Cuboid.	*i i i i.* Metatarsus.
e. External cuneiform.	*j.* Phalanges.
f. Middle cuneiform.	*k.* Internal malleolus (tibia).

much looser, and a slight amount of lateral play is now possible.

The foot may also be turned so that the sole is directed inwards or outwards as desired, the latter movement only to a very limited extent. These movements take place at

the joints between the tarsal bones and not at the ankle, though the slight lateral play of the latter joint may assist a little in imparting more freedom to the movement.

The *muscles of the leg* are subdivided into three groups : those lying in front of the bones, those behind, and those which run along the outer side of the fibula. The leg, similarly to the thigh, is invested with a sheath of fascia like a stocking : along the inner side of the limb this sheath is blended with the antero-internal subcutaneous surface of the shaft of the tibia, so that it ceases to exist as a distinct layer as it lies over the bone. From the deep surface of the sheath along the outer side there pass in partitions which connect it with the fibula. These *inter-muscular septa*, as they are called, separate the muscles which lie along the outer side of the fibula from those in front and behind. In the region of the ankle the fascia of the leg becomes thickened and forms more or less distinct bands, one of which passes across the front of the ankle, another over its inner, and a third over its outer side ; these are called *annular ligaments*, and serve to retain in position the numerous tendons which pass over the different aspects of the joint, preventing them from being drawn away from the surface of the bones in whatever direction the foot is moved (Pls., pp. 216, 252, 318, 328, 338, 366).

The muscles which lie along the front of the leg are the following—the *tibialis anticus*, the *extensor proprius hallucis* (special extensor of the great toe), the *extensor longus digitorum* (long extensor of the toes), and the *peroneus tertius*. These muscles arise partly from the tibia, partly from the fibula, and also from the interosseous membrane which connects the two bones throughout nearly their whole length, and which, in the interval between the two bones, separates the muscle of the front of the leg from those which lie deeply on the back. The tendons of these four muscles pass down in front of the ankle-joint

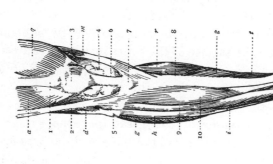

MALE LEG AND FOOT, FRONT VIEW

MALE LEG AND FOOT, BACK VIEW

a. Vastus externus.
b. Biceps cruris, long head.
c. Biceps cruris, short head.
d. Biceps cruris tendon.
e. Popliteal space.
f. Gastrocnemius, outer head.
g. Soleus.
h. Peroneus longus.
i. Peroneus brevis.
j. Long flexor of great toe.
k. External malleolus (fibula).
l. External annular ligament.
m. Sartorius.
n. Gracilis.
o. Semimembranosus.
p. Semitendinosus.
q. Vastus internus.
r. Gastrocnemius, inner head.

t. Long flexor of the toes.
u. Tendo Achillis.
v. Internal malleolus (tibia).
w. Tibialis posticus tendon.
x. Os calcis.
y. Anterior annular ligament.
z. Short extensor of the toes.
1. Rectus femoris band.
2. Ilio-tibial band.
3. Patella.
4. Fat.
5. Head of fibula.
6. Ligamentum patellae.
7. Tubercle of tibia.
8. Tibia, subcutaneous surface.
9. Long extensor of the toes.
10. Tibialis anticus.
11. Special extensor of great toe.

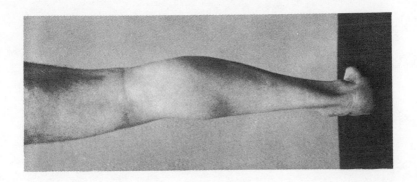

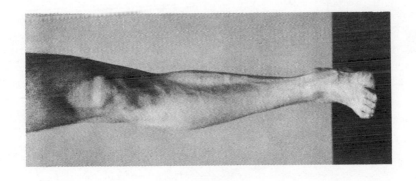

under cover of the anterior annular ligament; they are therefore flexor muscles of the ankle, though the reader will notice that some of them are named extensors. This is an illustration of how the action of a muscle varies according to the joints over which it passes; thus the extensor muscles of the toes pass along the dorsal or extensor surface of the toes, and in action will straighten or extend them, but as they pass down to reach the toes they cross over the front or flexor aspect of the ankle and thus become flexors of that joint.

Of these muscles the innermost is the *tibialis anticus.* It lies along the outer side of the shaft of the tibia, from the upper two-thirds of which it arises, as well as from the external tuberosity of the same bone : deeply it takes origin from the interosseous membrane. The muscle becomes tendinous about the middle of the leg, and, following the line of the shin for some distance, passes over the middle of the front of the lower end of the tibia, across the ankle-joint beneath the anterior annular ligament, and reaches the middle of the inner border of the foot, round which it turns to be inserted into the inner and under surface of the internal cuneiform bone and the base of the meta-tarsal bone of the great toe (Pls., pp. 216, 318, 328, 338, 366).

Above, where the muscle is thick and fleshy, it serves to conceal the outline of the sharp anterior border of the tibia; it carries the roundness of the inner surface of the leg on to the front, imparting a fullness to it, and concealing the shank-like appearance which is obvious when this muscle is wasted. The tibialis anticus is a flexor of the ankle, and also assists in raising the inner border of the foot from the ground and turning the sole inwards.

Lying to the outer side of the tibialis anticus is the *long extensor of the toes.* This muscle arises from the external tuberosity of the tibia in front of the point of its articulation with the head of the fibula, from the head

of the fibula, from the anterior surface of the shaft of that bone, and from the adjacent surface of the interosseous membrane. The bulk of the fibres which arise from the front of the shaft of the fibula, viz. those which spring from the upper three-quarters, unite in front to form a tendon which passes down along the anterior edge of the muscle in the lower half of the leg. Under cover of the anterior annular ligament this tendon divides into four separate slips, which spread out below the level of the ligament and pass to the upper or dorsal surface of the four outer toes, where they form expansions which are inserted into the bases of the second and third phalanges of these digits (Pls., pp. 216, 252, 318, 328, 338, 366).

The fleshy fibres which arise from the lower quarter of the anterior surface of the fibula have a different insertion from the fibres which arise above. This small slip is called the *peroneus tertius,* and its tendon passes to be inserted into the dorsal or upper surface of the base of the metatarsal bone of the little toe (Pls., pp. 216, 252, 318, 338, 366).

The peroneus tertius is of little importance from the present point of view, and may for all practical purposes be disregarded.

The fleshy bellies of the tibialis anticus and the long extensor of the toes lie close together in the upper half of the leg. At the point where these muscles become tendinous they separate, and in the interval between them another muscle appears; this is the special extensor of the great toe.

The *special extensor of the great toe* arises from the middle three-fifths of the anterior surface of the shaft of the fibula, and also from the adjacent surface of the interosseous membrane. At its origin it is in part concealed by the long extensor of the toes and the anterior tibial muscle, but becomes superficial as it occupies the interval between the tendons of these two muscles. The tendon of the

special extensor of the great toe therefore occupies an intermediate position between the tendons of the foregoing muscles, and, entering a distinct compartment of the anterior annular ligament of the ankle-joint, passes along the inner and upper aspect of the instep to reach the dorsal surface of the great toe, into the base of the terminal phalanx of which it is inserted. In front of the ankle this tendon lies immediately to the outer side of that of the tibialis anticus, but when the latter has passed to the middle of the inner border of the foot, that to the great toe becomes the most internal of the tendons passing along the upper surface of the foot. The special extensor of the great toe and the long extensor of the toes, as their names imply, serve as straighteners or extensors of the toes, but they also act as flexors of the foot on the leg (Pls. pp. 216, 328, 338).

Lying to the outer side of the long extensor of the toes is the group of muscles which arise from the external surface of the shaft of the fibula. This comprises the *peroneal muscles*, of which there are two; the longer of these muscles is the more superficial and overlies the shorter one (Pls., pp. 216, 252, 318, 328, 338, 366).

The *peroneus brevis* arises from the lower two-thirds of the external surface of the shaft of the fibula and from the intermuscular septa on either side of it. It ends in a tendon which winds round the back of the external malleolus and is inserted, on the outer side of the foot, into the projection at the base of the metatarsal bone of the little toe. The *peroneus longus* arises from the head of the fibula and the upper two-thirds of the external surface of the shaft; its fleshy part overlies the origin of the peroneus brevis, and its tendon courses down over the outer surface of the same muscle to reach the back of the prominence of the external malleolus, behind and beneath which it passes in company with the tendon of

the brevis to reach the outer border of the foot. At a point just behind the prominent base of the metatarsal bone of the little toe the tendon enters a groove on the under surface of the cuboid (one of the two tarsal bones of the outer border of the foot), and courses deeply across the sole of the foot to be inserted into the internal cuneiform and base of the metatarsal bone of the great toe. The tendon as it crosses the under surface of the foot lies deeply, and has no influence whatever on the surface forms. These two muscles, as they cover the outer surface of the fibula, conceal the form of the shaft of that bone. Above, the head of the fibula is readily recognized. Below, the external malleolar process and the bone immediately above it are subcutaneous, occupying the interval between the peronei, which pass behind, and the lowest fibres of the long extensor of the toes and the fibres of the peroneus tertius, which lie in front. In the upper three-fourths of the leg the anterior borders of the peroneus longus and brevis are in contact with the posterior border of the long extensor of the toes, which lies in front ; behind, the peronei run alongside the anterior external border of one of the calf muscles, called the soleus, which here takes origin from the posterior surface of the head and shaft of the fibula. In the lower fourth of the leg these muscles separate from one another, the tendons of the peronei passing behind the external malleolus, whilst that of the soleus is continued down to the prominence of the heel. An interval is thus formed, which in the living is filled with fat and bridged over by certain layers of fascia ; this corresponds to the surface hollow between the external malleolus and the tendo Achillis, or tendon of the calf muscles ; the depth of this hollow varies according to the quantity of fat present. Occasionally one of the deeper muscles of the back of the leg, called the *long flexor of the great toe*, becomes uncovered in the interval above described, though

lying at some considerable distance from the surface ; this muscle exercises but a slight influence on the surface forms.

The tendons of the two peronei as they pass down behind the outer ankle lie obliquely across the outer surface of the os calcis or heel-bone : in this position they are held down by a ligament, called the external annular ligament. By this means the prominence of the outer ankle is rendered less abrupt, and the surface contours become more rounded. The peroneus longus and brevis act as extensors of the foot, i. e. they assist in pointing the toes. Along with the peroneus tertius they also raise the outer border of the foot and turn the sole outwards : the range of this movement is limited. Their principal action is to antagonize the muscles which turn the sole of the foot inwards ; accordingly, when the foot is inverted they will draw the foot back again to its normal position.

The muscles on the back of the leg which constitute the prominence of *the calf* are subdivided into a superficial and a deep group. The latter comprises the long flexors of the toes and the tibialis posticus, which are placed so deeply, however, that they have little direct influence on the modelling of the surface, though by their presence they impart a fullness to the limb. The tendons of these muscles all pass down into the sole of the foot in a series of grooves, which lie behind the prominence of the inner ankle and between it and the projection of the heel. It is here that, to a slight extent, their fleshy bellies crop up between the tendo Achillis and the posterior border of the tibia, as will be noticed hereafter (Pls., pp. 252, 318, 328, 338, 366).

The superficial muscles of the posterior group are the *soleus* and the *gastrocnemius*. The *soleus* is the deeper of the two. It arises from the back of the head and upper third of the shaft of the fibula, and from the back of the shaft of the tibia along a line which leads from the surface on the external tuberosity, where the head of the fibula articulates,

obliquely downwards and inwards, to blend with the posterior border of the bone, i. e. that border which limits posteriorly the subcutaneous internal surface of the shaft. The muscle is attached to this border as low down as the junction of the middle with the lower third of the length of the tibia. The student will observe that the soleus takes origin from the posterior borders of both bones of the leg, from the tibia on the inner side, and from the fibula on the outer side : the importance of this will be hereafter referred to.

Between the two bones the muscle arises from a tendinous arch, which crosses over the deeper structures. The fleshy fibres, which are short, are inserted into a broad tendon, which gradually narrows as it passes downwards. The lateral fibres of origin as they spring from the tibia and fibula pass obliquely towards the middle line of the muscle. The tendon, which also receives the insertion of the gastrocnemius muscle, is called the *tendo Achillis*, and is attached below to the back part of the tuberosity of the heel-bone (Pls., pp. 104, 252, 274, 318, 328, 338, 366).

The *gastrocnemius*, which rests upon and lies superficial to the soleus, has no attachment to the bones of the leg. It arises by two heads from the back of the lower end of the thigh-bones, immediately above the condyles. At its origin it is partly tendinous and partly fleshy. The two bellies lie side by side behind the knee, with the hamstring tendons to their inner and outer sides ; below, where they have escaped from the confining influence of these structures, the bellies of the gastrocnemius become much enlarged and bulge out laterally (Pls., pp. 52, 54, 252, 318, 328, 338, 366).

The inner head is more prominent than the outer, and somewhat longer. Both bellies are inserted into the superficial aspect of the *tendo Achillis*, about the level of the middle of the leg, the inner head, as has been said, reaching a somewhat lower level than the outer. Above, where the two heads of the muscle lie behind the knee and between

the hamstring tendons, they are separated by a V-shaped interval which bounds inferiorly the hollow called the ham. Below this the angle of the V is continued downwards as a linear depression, which serves to indicate the separation of the two halves of the muscle: this may be traced right down to the insertion, where it opens out to correspond with an interval overlying the tendon and placed between the rounded and somewhat pointed inferior extremities of the fleshy bellies.

As will be seen by a reference to the plates, pp. 52, 72, 216, 318, 328, the inner belly of the gastrocnemius overlaps the upper part of the inner or tibial attachment of the soleus, and here determines the outline of the limb as seen from either front or back. The outer belly, being narrower, does not overlap the outer or fibular attachment of the soleus, so that the gastrocnemius plays no part in determining the surface outline of the outer side of the leg as viewed from the back or front; here the outline depends on the soleus above and the peronei below (Pls., pp. 52, 72, 216, 328).

The *tendo Achillis*, which is the combined tendon of the soleus and gastrocnemius, occupies the lower half of the back of the leg. Its size and strength vary with the muscular development of the model; superiorly it may attain a width of three inches. At this point it receives the insertions of the fleshy bellies of the gastrocnemius: gradually diminishing in width as it passes downwards, it receives on either side the fleshy fibres of the soleus as they run towards the middle line of the calf—from the fibula on the outer side and the tibia on the inner side.

At a point about three or four inches above its lower attachment the tendon runs down clear of muscular fibres, and, gradually tapering, at a point about an inch above the tuberosity of the heel it again expands before it is actually inserted into the os calcis. At its narrowest part the tendon measures about three-quarters of an inch in width, but this,

as has been said, largely depends on the muscular development of the model: it is inserted into the middle third of the tuberosity of the heel-bone. The upper part of the tuberosity is separated from the deep surface of the tendon by a little sac called a bursa, containing oily fluid, which serves to lubricate the opposed surfaces of the bone and tendon as they move on one another. Not unfrequently the bone below the insertion of the tendon projects somewhat; this, when covered by the dense tissue of the heel, forms a rounded contour distinct from, and below, the insertion of the *tendo Achillis*, which is often represented in the antique, and is well seen in the outstretched left leg of the Fighting Gladiator. This form of heel is by no means universal, and the student need not be disappointed if he fails to meet with it in the majority of models he examines.

The gastrocnemius and soleus are powerful extensors of the ankle. If the foot be raised from the ground and the toes pointed, the foot acts like a lever of the first class ; the ankle is the fulcrum, the part of the foot in front of the ankle is the long arm of the lever which in this instance represents the weight, the part of the foot behind the ankle is the short arm to which the force exercised by the muscles is applied. It is by the contraction of the same muscles that we are enabled to raise ourselves on tiptoe ; in this position the foot is now converted into a lever of the second class, the fulcrum being represented by the part of the foot in contact with the ground, the weight corresponding to the ankle, through which the pressure exercised by the bulk of the body is transmitted to the foot, the force, as before, being applied to the extremity of the heel.

But the reader will note that the gastrocnemius muscle differs from the soleus in not being attached to the bones of the leg. It arises from the lower end of the thigh-bone, it therefore passes behind the knee, and will accordingly

under certain conditions, act as a flexor of that joint. These conditions are the fixation of the ankle-joint by the extensor muscles on the front of the leg, and the relaxation of the extensor muscles of the knee on the front of the thigh.

In regard to the development of the muscles of the calf a point of some practical importance arises. It has been shown how the foot is to be regarded as a lever; the force necessary to effect the same results will vary inversely as the length of the lever; thus a short lever will require the application of a greater force to produce the same result than when a long lever is employed. It follows from this that the development of the muscles of the calf which supply the power will stand in some relation to the foot. Experience proves that this is the case. We find the most marked muscular development of the calf associated with a short foot and a short heel, while a long foot and a long heel are the usual concomitants of a poorly developed calf. Yet it by no means follows that the latter type is less capable of performing feats of endurance and fatigue than the former; indeed, an examination of the legs of some of the best running men of the day goes far to prove that their success does not at all depend on an excess in the bulk of the calf, for many of them display, what an uneducated spectator might regard as, but a feeble development of these muscles.

During powerful contraction of these muscles, as in the act of standing on tiptoe, the fleshy bellies of the gastrocnemius become outstanding elevations, their lower ends where they are inserted into the tendo Achillis forming abrupt margins of a more or less pointed form. At the same time the fibres of the soleus which lie uncovered on either side of the limb form elongated surface elevations, which blend inferiorly with the margins of the tendo Achillis, the broad expanded upper surface of which corresponds to a more or less triangular flattened area, which

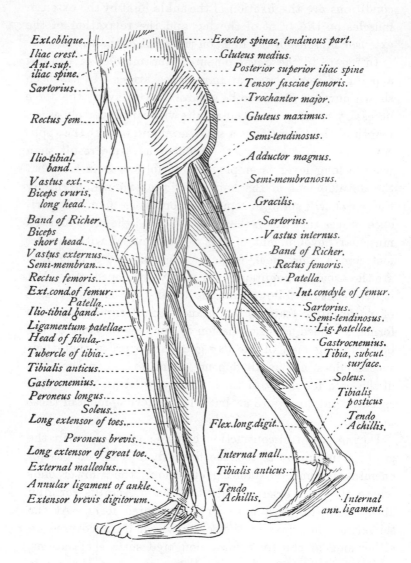

Ext.oblique.

Iliac crest.

Ant.sup. iliac spine.

Sartorius.

Rectus fem.

Ilio-tibial. band.

Vastus ext.

Biceps cruris, long head.

Band of Richer.

Biceps short head.

Vastus externus.

Semi-membran.

Rectus femoris.

Ext.cond.of femur.

Patella.

Ilio-tibial band.

Ligamentum patellae.

Head of fibula.

Tubercle of tibia.

Tibialis anticus.

Gastrocnemius.

Peroneus longus.

Soleus.

Long extensor of toes.

Peroneus brevis.

Long extensor of great toe.

External malleolus.

Annular ligament of ankle.

Extensor brevis digitorum.

Erector spinae, tendinous part.

Gluteus medius.

Posterior superior iliac spine

Tensor fasciae femoris.

Trochanter major.

Gluteus maximus.

Semi-tendinosus.

Adductor magnus.

Semi-membranosus.

Gracilis.

Sartorius.

Vastus internus.

Band of Richer.

Rectus femoris.

Patella.

Int.condyle of femur.

Sartorius.

Semi-tendinosus.

Lig.patellae.

Gastrocnemius.

Tibia, subcut. surface.

Soleus.

Tibialis posticus

Tendo Achillis.

Flex.long.digit.

Internal mall.

Tibialis anticus.

Tendo Achillis.

Internal ann.ligament.

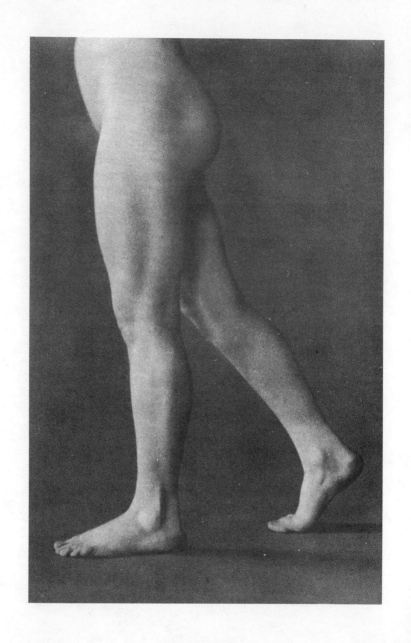

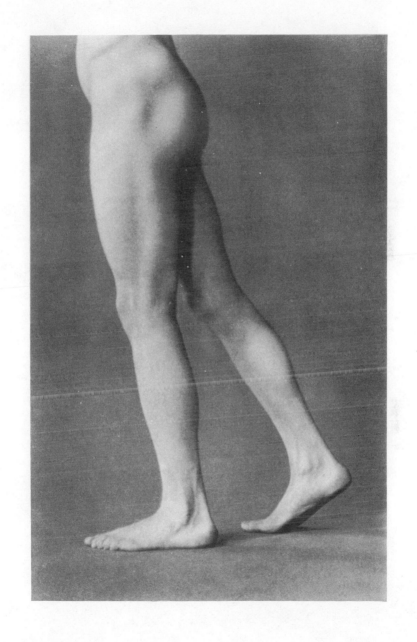

gradually narrows and merges inferiorly with the ridge
which leads below to the prominence of the heel, and which
corresponds to that part of the tendon which is free from
muscular fibres (Pls., pp. 268, 274, 328).

In the profile view of the back of the limb the outline of
the upper half or so of the leg depends on the form of the
fleshy bellies of the gastrocnemius, and will vary according
to their state of contraction ; below, the outline depends on
the tendo Achillis. This outline is gently curved—convex
backwards above and slightly hollow below, where it passes
to the heel : the latter curve should not be unduly empha-
sized, as it leads to an unpleasant projection of the heel
(Pls., pp. 252, 274, 318, 338, 366).

In front and on the outer side of the limb the anterior
border of the soleus is defined by a straight linear de-
pression, which passes from the back of the head of the
fibula to the outer border of the tendo Achillis ; this line
serves to separate the calf muscles behind from the peronei
(long and short) in front (Pls., pp. 274, 338).

On the inner side of the limb the muscles of the calf
are very clearly mapped out by the posterior border of the
tibia. This border, the reader will remember, corresponds to
that margin of the bone which defines posteriorly the sub-
cutaneous surface of the shaft, the surface which lies between
the flexors of the ankle in front and the extensor muscles
posteriorly. Behind the upper fourth or so of this margin
lies the inner prominent head of the gastrocnemius, where
it escapes from under cover of the inner hamstrings as they
pass to the inner tuberosity of the tibia. The middle third
of this margin lies in front of the fibres of the soleus which
arise from the tibia, and which are passing obliquely down-
wards and backwards to be inserted into the inner border
of the tendo Achillis. Below that point the posterior border
of the tibia is separated from the tendo Achillis by an
elongated triangular interval, the apex of which is directed

upwards. It is here that the fleshy bellies of some of the deeper muscles, particularly the long flexor of the toes, become superficial and exercise a direct influence on the surface, helping to fill up the gap that would otherwise exist between the tibia and the tendo Achillis (Pls., pp. 252, 274, 318, 338, 366).

The hollow behind the inner ankle is of crescentic form. Its greatest width is between the internal malleolus and the prominence of the heel; superiorly it fades away on the surface corresponding to the triangular interval above referred to; whilst inferiorly it curves behind and below the inner ankle to pass under the inner border of the foot and thus reach the hollow of the sole. The margins of this hollow are less abrupt than might be expected from an inspection of the skeleton; this is due to the arrangement of the fascia, which here forms the *internal annular ligament* and serves to bridge over the interval. It is beneath this structure that the tendons of the deep muscles of the back of the leg pass to the sole of the foot. The muscles which spring from the under surface of the heel-bone, and which run along the inner border of the sole of the foot, have also a considerable influence in modifying the surface forms; and the distribution of the subcutaneous tissue which here forms the pad of the heel should not be overlooked.

In studying the outline of the leg, as seen from the front, the student's attention must be directed to the fact that the outlines of the inner and outer side of the limb do not depend on any of the structures which lie on the front of the leg, but are chiefly due to the projection on either side of the muscles of the calf. Along the outer side the fibular attachment of the soleus determines the outline of about the upper third of the limb; below, the outline is carried down to the external ankle by the two peroneal muscles (long and short). If the outline of the inner side of the leg be divided into thirds, the upper third is due to the projection

of the inner belly of the gastrocnemius, the middle third
to the fibres of the soleus arising from the tibia, whilst the
lower third, which includes the projection of the inner
ankle below, depends for its fullness above on the fleshy
fibres of the long flexor of the toes, which here become
superficial between the tibia in front and the tendo Achillis
behind (Pls., pp. 216, 328).

The hollow behind the knee, the *ham*, so called, was not
described in the last chapter, because the reader was not
then familiar with all the structures necessary to enable him
fully to understand the relations of this space.

The hollow corresponds to a diamond-shaped intermus-
cular space which lies behind the knee-joint. Above, it is
formed by the separation of the hamstring muscles as they
pass outward and inward on either side of the knee, the
biceps to the outer side, the semitendinosus and semimem-
branosus to the inner side. Below, the space corresponds to
the V-shaped interval between the heads of the gastro-
cnemius as they arise from the back and upper surface of each
femoral condyle. The interval is occupied by a large quantity
of soft fat in which lie the vessels and nerves passing down
to the leg. Stretching across from the sides of the space is
a layer of fascia, which is particularly strong in this region;
it is really only a specialized part of the general fascial
investment of the limb which overlies the hollow, imme-
diately beneath the skin and superficial fat, and serves to
retain the contents of the space in position. The tenseness
of this fascia varies with the position of the limb: when the
knee is bent it becomes relaxed, as any one may satisfy
himself by feeling the back of the knee when the joint
is flexed. The sharp skin-folds on either side depend
on the position of the inner and outer hamstrings, within
which the two heads of the gastrocnemius may be felt
passing from the back of the condyles of the thigh-bone
(Pls., pp. 52, 268, 328).

With the limb in the extended condition the fascia is rendered tense, and the student will experience difficulty in recognizing the afore-mentioned details unless he is familiar with the anatomy of this region. In this position the hamstring tendons are best recognized further up the back of the limb ; in place of there being a hollow between them, there is a distinct fullness over the back of the joint, due to the contents of the space being pushed up against the tightly stretched fascia, as well as the femoral condyles, which, together with the heads of the gastro-cnemius, are now forced back as far as possible. The positions of the hamstring tendons on either side of this central elevation are now indicated by shallow longi-tudinal furrows, which pass down towards the inner and outer tuberosity of the tibia, the external reaching the head of the fibula. In women the inner of these furrows is often especially well marked. The appearance may perhaps be better described by saying that in the extended position of the limb the surface elevation overlying the calf is prolonged upwards on the back of the thigh, occupying like a wedge the Λ-shaped interval between the outer and inner hamstrings, the positions of which are indicated by the shallow furrows above described. Crossing this eleva-tion at a level corresponding to the joint is a cutaneous fold or line of flexure. This fold is either slightly curved with the convexity directed upwards, or it may display a slight obliquity, being a little higher on the outer than on the inner side. Its depth varies considerably in different individuals: in a spare model it is but faintly marked, but in one in whom there is much superficial fat, or in women, it is readily recognized. The fold is of course stretched during extension of the joint, but becomes at once emphasized when the knee is bent (Pls. pp. 52, 54, 252, 268, 270, 308, 318).

Little need be said beyond what has been already stated

in regard to the influence of the structures already described on the form of the limb; in powerful contraction the lines of separation of the muscles on the front of the leg are indicated by a series of shallow longitudinal furrows all more or less parallel, and best seen in the upper or fleshy part of the leg. Passing from within outwards, we can recognize the furrows separating the anterior tibial muscle from the long extensor of the toes, the long extensor of the toes from the peronei (long and short), and the peronei (long and short) from the fibular origin of the soleus. The surface markings on the back and inner side of the leg have been sufficiently explained (Pls., pp. 54, 72, 86, 216, 252, 318, 328, 338, 366).

We have taken as our type the spare athletic male. The influence of the muscles on the surface forms is much reduced whenever the subcutaneous fat becomes abundant: this is exemplified in the female, in whom the limb presents a uniformly smooth appearance with little or no indication of subjacent structures except under the most exceptional circumstances; the outlines are more flowing, and the curves more uniform. In this connexion it may be noted that in the female the fullness of the calf descends to a lower level than in the male. In women, owing to their more delicately modelled bones, the surface forms of the inner and outer ankle are less prominent and more rounded than in the male. The shortness of the female foot is no doubt associated with the greater relative development of the muscles of the calf (Pls., pp. 52, 72, 80, 216, 252, 268, 274, 308, 338).

As has been already stated in the earlier part of this chapter, the skeleton of the foot consists of tarsal, metatarsal, and phalangeal bones. The part of the foot formed by the tarsal bones exceeds in length that formed by the metatarsal, and similarly that formed by the series of metatarsals exceeds in length that formed by the phalanges or bones of the toes. This arrangement of the bones of the foot is in

striking contrast with what one sees in the hand; the combined length of the phalanges or finger-bones is greater than the length of the palm or meta-carpal bones, and these in turn exceed the length of the part of the hand formed by the wrist or carpal bones. It is obvious that these differences are correlated with the functions the foot is called upon to discharge, for the toes, which correspond to the most freely movable part of the hand—the fingers—are much reduced in their relative proportions, whilst that part which corresponds to the supporting part of the hand, the wrist, is greatly increased. As has been already pointed out, this increase in the size of the tarsal elements imparts greater strength and solidity to the foot, requirements of which it stands much in need from the nature of the duties it has to perform.

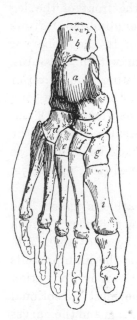

FIG. 176. The bones of the right foot as seen from above. The tibia and fibula have been removed so as to expose

a. Astragalus
b. Os calcis or heel-bone
c. Navicular or sca-phoid
d. Cuboid
e. External cunei-form
f. Middle cuneiform
g. Internal cunei-form
} Tarsus.

i i i i i. Metatarsus.
j j j j j. Phalanges or toe-bones.

The astragalus and os calcis have been sufficiently described (*ante,* p. 323). The astragalus supports the inner column of the foot, which consists, in order from behind forwards, of the *navicular,* the *three cunei-forms,* and the *three metatarsal bones* which support the three inner toes.

The os calcis, or heel-bone, supports the skeleton of the outer column of the foot, which includes from behind forwards the *cuboid* and the *metatarsal bones* of the two outer toes. The outer border of the foot, as we proceed from

the heel forward, is formed by the os calcis or heel-bone, the cuboid, the metatarsal bone, and the phalanges of the little toe. The metatarsal bone of the little toe is characterized by an enlarged base; this forms a marked projection which can be readily felt at the middle of the outer border of the foot. Tracing the outline of the inner border of the foot, the os calcis can be recognized on the inner side of the heel: below and in front of the inner ankle the sustentaculum tali of the os calcis and the astragalus can be felt; in front of the latter the projecting inner border of the navicular bone, called the tuberosity, can be easily distinguished; lying in front of this is the internal cuneiform articulating anteriorly with the base of the metatarsal bone of the great toe : this joint corresponds pretty closely to the middle of the inner border of the foot, reckoning the distance from the heel to the tip of the great toe. In front, the head of the metatarsal bone articulates with the first phalanx of the great toe, which in turn supports the terminal phalanx of that digit, there being only two phalanges in the great toe in place of three as in the others, an arrangement which corresponds with what we have seen in the case of the thumb. The joint between the metatarsal bone and the first phalanx of the great toe is supported beneath by two small nodules of bone; these are called *sesamoid* bones, and the whole joint so formed corresponds to what is known as the ball of the great toe. The bones which form the outer and inner columns of the foot, above referred to, are themselves united together by joints and ligaments, with the exception, of course, of the bones of the toes, which are not laterally united to each other (Fig. 176).

Just as the bones of the hand were arranged so as to form the hollow of the palm, so the bones of the foot are united together to form a series of longitudinal and transverse arches, which curve the sole in such a manner that the whole of its surface is never in contact with the

ground. The best way by which to demonstrate this is to wet the foot by dipping it in water and then step on a dry floor; the wet imprint left when the foot is lifted represents accurately the surface of the sole which has touched the ground. From this it appears that the heel, the outer border of the foot, the fore part of the foot corresponding to the ball of the great toe, and the pads which cover the under surface of the other metatarso-phalangeal joints have all been in contact with the floor, whilst the part corresponding to the interval between the heel and ball of the great toe, lying along the inner border of the foot, has not touched the ground, as is evidenced by the fact that the floor corresponding to this part of the sole is dry.

FIG. 177. Outlines of the imprint of the sole of the foot. The dotted line shows the outline of the sole of the foot when it merely rests without pressure on a plane surface. The thick black line represents the same when the weight of the body rests on the foot. The latter outline is longer and broader than the former, which shows how the foot expands in all its diameters when it is subjected to pressure.

Again, it must have been the experience of every one when trying on a new boot that the fit was apparently comfortable and perfect so long as the foot was raised, but on placing the foot to the ground and throwing the weight of the body on it, the boot, which otherwise appeared to fit the wearer, then felt cramped and tight; this at once brings home the fact that under these different conditions the shape and size of the foot alter considerably; in other words, the foot spreads out when the weight of the body is thrown upon it: it lengthens, the toes being pushed further into the point of the boot, and it becomes wider, as is proved by the tightness across the instep (see Fig. 177).

It is important that the reader should be familiar with the mechanism by which these changes are effected. As has been stated, the bones of the foot, apart from those of the toes, are arranged in a series of transverse and longitudinal arches; the former are apparent, as they form the rounded contour, from side to side, of the upper surface of the foot. The concavity of these transverse arches assists in forming the hollow of the sole.

The experiment with the wetted foot has demonstrated the existence of a longitudinal arch, of which the posterior pillar is the prominence of the heel, the anterior pillar

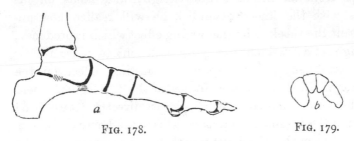

FIG. 178. FIG. 179.

Diagrams to illustrate the arches of the foot.

a. The longitudinal arch.
b. The transverse arch through the cuneiforms and cuboid.

corresponding to the ball of the great toe and the pad of the fore part of the foot immediately external to it: the arch between these two points coincides with the inner border of the foot, which is raised from the ground. The existence of these arches imparts a certain amount of elasticity to the foot; they are like curved springs the extremities of which are in contact with the ground: if over the most elevated part of the spring pressure be applied, the result will be that the spring will spread out, its extremities will be more widely separated, and the distance between the highest point of the curve of the spring and the ground will be reduced. The arches of the foot act very much

in the same way; they spread out when the weight of the body is thrown on the foot, but they recover themselves at once when the pressure is removed. The elasticity thus imparted to the foot is of the greatest service in enabling it to withstand the violent shocks to which it is so frequently subjected. A little experiment will bring this home to the reader. In jumping from a height one lands ordinarily on the ball of the foot, the heel being the last part to touch the ground; the shock is thus much reduced before the force is transmitted up through the leg: but if in place of landing on the fore part of the foot the reader jumps from an inconsiderable height and lands on his heels, with the knees extended, he will realize how unpleasant the shock is by the jarring effect which it produces; a height of a few inches is quite sufficient to cause results unpleasant enough to produce a lasting effect on the memory. In this case the arches of the foot cannot yield to the force, and so the shock is directly transmitted through the heel-bone and astragalus to the bones of the leg.

Apart from the elasticity which is thus imparted to the foot, these arches also serve a useful purpose in protecting the nerves and vessels of the sole from the baneful effects of pressure. The reader will now realize how these structures, as they lie in the hollow behind the inner ankle, pass down into the sole under cover of the arch which raises the inner border of the foot from the ground.

The lesson to be learnt from these observations is that the foot when it supports the weight of the body on the ground is longer, broader, and flatter than when raised, in which position, the strain being taken off the arches, the foot becomes more curved and the elevation of the instep more pronounced.

As man only exceptionally makes use of the foot as a prehensile organ, the reader will note that that part of the foot (i. e. the toes) which corresponds to the most movable segment

of the hand—the fingers—is much reduced in size : moreover, owing to the fact that in the foot the further extremity of the metatarsal bone of the great toe is united to the other metatarsal bones, we have no such power of opposition of the great toe with the other toes as we possess in the thumb and fingers, for in the hand the distal end of the metacarpal bone of the thumb is free and unconnected with the other metacarpals.

The dorsal surface of the foot owes its form in great part to the arrangement of the bones. Overlying these are the tendons which are passing down from the anterior surface of the leg in front of the ankle. As previously described, the tendon of the anterior tibial muscle may be traced from the inner side of the front of the ankle down to the middle of the inner border of the foot; in like manner the tendon of the peroneus tertius, the muscle which is intimately associated with the lower fibres of origin of the long extensor of the toes, may be traced from the ankle immediately in front of the lower end of the fibula to the middle of the outer border of the foot, where it is attached to the base of the metatarsal bone of the little toe on its upper surface : this tendon is small and thin, and only exceptionally gives any indication of its presence by a corresponding surface elevation. Between the foregoing muscles as they lie on either side of the front of the ankle are placed the tendons of the long extensor of the toes and the special extensor of the great toe. The former, which are four in number, pass to the dorsal surfaces of the four outer toes, whilst the latter, which is single, passes down to the dorsum of the great toe. Above, at the front of the ankle, the tendons are confined within narrow limits; below, on the dorsum of the foot, they spread out as they pass forwards to reach the toes (Pls., pp. 216, 328).

If the reader will place his finger on the dorsum of his own foot, in front of the outer ankle, he will recognize that

something soft and of considerable thickness here overlies the tarsal bones and prevents him from recognizing as easily as elsewhere their details. This is a muscle, called the *short extensor of the toes*: it arises from the fore part of the os calcis or heel-bone and the hollow between it and the astragalus, from the outer side of the os calcis in front of the groove in which the peroneus brevis is lodged, and also from the anterior annular ligament: the muscle at its origin therefore lies immediately in front of, and below, the prominence of the outer ankle. The fleshy part of the muscle is placed obliquely across the dorsum of the foot from without inwards, ending in four small tendons which pass to the four inner toes. The tendon to the great toe is inserted into the base of the first phalanx, the other tendons blend with those of the long extensor muscle which pass to the second, third, and fourth toes. As the muscle crosses obliquely over the dorsum of the foot it is overlain by the tendons already enumerated, with the exception of the special extensor of the great toe and the tibialis anticus, which lie altogether to its inner side.

It is to the presence of this muscle that the fullness of the dorsum of the foot in front of the external malleolus is due. The tendons which cross it, particularly the tendon of the peroneus tertius, help to restrict its influence on the surface contours; but in the interval between the peroneus tertius in front, the external malleolus behind, and the tendon of the peroneus brevis below as it passes to the spur of the metatarsal bone of the little toe, the fleshy part of the muscle forms an oval elevation, which is considerably intensified when the toes are forcibly extended (Pls., pp. 216, 318, 328, 338, 366).

The appearance of the back of the foot will vary according to the amount of subcutaneous fat present; if that is considerable in quantity, the outlines of the various

tendons are masked, and only become apparent when
the muscles are strongly contracted. Similarly with the
veins which usually form a feature of some prominence
on the back of the foot; they are best seen in a model
of spare habit, where their presence is indicated by their
surface projection; when embedded in a layer of sub-
cutaneous fat their outline is displayed rather by colour
than by relief. As the arrangement of the veins of
the lower limb will be described hereafter, it is not neces-
sary at present to refer further to them.

As in the hand, so in the foot, the intervals between the
metatarsal bones are occupied by muscles called *interossei*;
these serve to maintain the uniformity of the surface con-
tours and prevent an undue definition of these bones of
the foot.

The under surface of the bones of the foot is provided
with many muscles; these are arranged for the purpose
of anatomical description into layers, but a knowledge of
their details is happily unnecessary. The muscles which
have most influence on the surface form are naturally those
which are immediately covered by the skin and fascia
of the sole. The three most important arise posteriorly
from the under surface of the prominence of the heel. Of
these, one passes forward along either border of the foot,
whilst the third occupies an intermediate position.

The *abductor hallucis*, or *abductor of the great toe*, arises
behind from the inner side of the under surface of the
bony prominence of the heel. Its fibres pass forwards
along the inner border of the arch of the foot, forming
a fleshy longitudinal prominence. Anteriorly the muscle is
inserted into the inner of the two sesamoid bones, which
are placed one on either side of the under surface of the joint
between the metatarsal bone and first phalanx of the great
toe helping to form the ball of the great toe (Pls., pp. 318, 388).

The *abductor minimi digiti*, or *abductor of the little toe*,

arises behind from the outer side of the under surface of the bony prominence of the heel. As its fleshy fibres pass along the outer border of the foot they are attached to the prominent tubercle of the base of the fifth metatarsal bone. Anteriorly the muscle is inserted into the base of the first phalanx of the little toe along with the short flexor of that digit. The fleshy part of the muscle forms the surface elevation along the under surface of the outer border of the foot, between the heel-bone behind and the prominent spur of the fifth metatarsal bone in front, as well as along the outer and under surface of that bone. In standing on the foot this border is in contact with the ground, and is compressed and flattened by the weight thrown on it (Pls., pp. 318, 338).

The action of these two muscles is indicated by their name. Only here it is necessary to warn the reader that the terms adduction and abduction of the toes apply to movements whereby the toes are drawn to, or away from, a line passing along the axis of the *second* toe, and have no relation whatever to the middle line of the body.

Occupying the interval between these two muscles, and lying along the middle of the sole of the foot, is the *flexor brevis digitorum*, or *short flexor of the toes*. This arises behind from the under surface of the pro- minence of the heel-bone, between the two muscles just described. In front, it ends in four tendons, which pass to the four outer toes, there to be attached to the bases of the second phalanges on their under surfaces. The fleshy part of the muscle occupies the central part of the sole ; in the intervals on either side of it, and in front, some of the short muscles of the great and little toe come in relation to the surface. It is not necessary to dwell on these details further than to point out that to the sesamoid bones at the base of the great toe there are attached the short flexor and adductors of that digit, whilst on the

outer side of the sole, the short flexor of the little toe unites with the abductor of that digit to be inserted into the base and outer border of the first phalanx of the little toe. The action of the short flexor of the toes is sufficiently indicated by its name; it assists the long flexor in bending the toes towards the sole of the foot.

The influence of these muscles on the surface forms of the sole is less than what one might expect, owing to the fact that the skin in this region is very thick and tough, and also because there is a considerable quantity of fat and a layer of dense fascia overlying them.

The *plantar fascia* very much resembles the fascia which has been already described in the hand. It consists of a very strong and thick central portion which covers the short flexor of the toes, and two thinner lateral expansions which spread over the abductors of the great and little toes respectively. The strong central part, which is connected with the under surface of the heel behind, and with the anterior extremities of the metatarsal bones in front, is a structure of no little importance, as it assists in maintaining the longitudinal arch of the foot by tying together its two extremities. The subcutaneous fat of the sole of the foot is specially modified to enable it to serve the purpose of an elastic pad. The fatty lobules, which are of small size, are abundantly mixed with fibrous tissue, which imparts to the layer so formed a remarkable toughness and resiliency. This layer is especially thick over those parts of the sole on which the bulk of the weight rests, particularly over the heel and the ball of the great toe. The skin which forms the superficial covering is likewise modified. In no part of the body is it so thick as over the heel, and an inspection of the sole of the foot will reveal the fact that over all the parts of the sole which touch the ground the skin is thick and horny, whereas where the foot is not in contact with

the ground the skin is thinner and more delicate, as is indicated by its colour and wrinkling.

The hollow of the sole, which is continuous with the hollow behind the inner ankle round the inner border of the foot, occupies the interval between the surface of the heel which is in contact with the ground behind and the ball of the great toe in front. The latter projection corresponds to the metatarso-phalangeal joint of that digit, a joint which is greatly enlarged owing to the presence of the two sesamoid bones already referred to. This forms a well-marked oval elevation, around which the hollow of the sole curves slightly before it is interrupted in front by the pad of the fore part of the foot which corresponds to the metatarso-phalangeal joints of the remaining toes. Externally the hollow of the sole is bounded by the outer border of the foot which is in contact with the ground when standing.

The toes, with the exception of the great toe, are much bent, so that when viewed from the under surface little can be seen of their shafts except the enlarged extremities by which they rest on the ground, see Fig. 177; the pad of the fore part of the foot is therefore separated by a deep groove from the enlarged ends of the toes. In correspondence with this, the dorsal surfaces of the toes are more or less curved in an antero-posterior direction.

Models with good feet are exceedingly difficult to find. The habit of wearing boots is so universal amongst civilized races, that it is difficult to meet with a person whose feet have not been tortured and disfigured by this means, and in the peasantry of our own islands who habitually go barefooted the exposure and injury to which the feet are subjected do much to destroy their natural beauty: we are largely dependent therefore for our ideal on our knowledge of the antique. In regard to the length of the toes, there is much diversity of opinion. The type most frequently represented in the

antique is that in which the second toe projects beyond the great toe. As a matter of fact, this condition is more frequently met with in dwellers of the south, for observations made on our Highland peasantry, some of whom have gone about barefooted from childhood, appear to indicate that the great toe is almost universally the longest of the series: this is a detail, however, of little moment, and the choice may well be left to the individual taste of the artist. The third toe is shorter than the second by the length of the nail, the fourth hardly reaches the level of the nail of the third, and the fifth presents many variations in length; there is anatomical evidence that this toe is gradually undergoing a reduction in size.

In regard to the direction of the different toes a certain misconception appears to exist. The 'Anatomical bootmaker' would have us believe that the inner borders of the foot and great toe are in line when the foot is at rest. An examination of the best models appears to upset this view, for normally the great toe has a slight outward inclination, though undoubtedly this is oftentimes unduly exaggerated by the wearing of pointed boots. The student, however, should clearly understand that we possess a limited power of abducting and adducting the great toe at the metatarsophalangeal joint. The second and third toes as a rule should follow this outward inclination, whilst the fifth should be slightly inturned, the direction of the fourth being more or less straight, or directed slightly inwards or outwards, as the case may be.

The cleft between the great and second toes is oftentimes a little deeper than that between the second and third. As a rule, the clefts between the four outer toes are linear, whilst that between the great and second toe is wide: this may be well seen in an infant's foot, particularly when the toes are outspread. Advantage was taken of this wider interval between the great and second toes

to pass the thong by which the sandal was held in position. The toes appear longer when viewed from above than when seen from below; this is due to the web between the toes sloping downwards and forwards towards the sole.

As the bones of the leg are firmly fixed together, there is no movement in the lower limb comparable to the movements of pronation and supination which occur in the fore-arm. This necessarily limits the range of the movements of the foot as compared with those of the hand. Apart from the movements which have been described as taking place at the ankle-joint, the foot may be turned inwards or outwards; in the one case the sole is *inverted*, in the other *everted*; the range of motion in the latter direction is the more limited. These movements take place at the joints between the tarsal bones. The toes may be flexed or extended as well as moved apart and drawn together; this latter movement is freest between the great and second toe.

The foot of the female is absolutely smaller than that of the male. If we take into consideration its proportion to the height, we find that it is relatively slightly shorter in women. A foot unduly small, if represented in the nude, at once imparts a feeling of instability to the figure. In no respect do artists concede more to fashion than in the representation of the female foot: one has only to imagine what the same foot would look like if divested of its coverings to realize to what absurdities this sacrifice of truth may lead. Another point on which the lay mind is apt to be misled is the height of the instep. The foot as it rests within the boot is really supported on an incline, the slope of which depends on the height of the heel: this tends of course to emphasize the arch on the dorsum of the foot, as the toes are necessarily somewhat bent upwards at the metatarso-phalangeal joint. The reader need only notice the appearance of a foot in a high-

heeled shoe to realize this fact. Naturally when the same foot is bared and placed flat upon the ground the curvature of the instep is much reduced; so marked is the change that I have frequently been struck with the criticism passed on photographs of fairly well-formed feet, to the effect that they were unduly flat.

True flatness of the foot must of course be avoided, but the student will readily recognize this condition, as he will notice that the sole of the foot not only touches the ground at the surfaces already described, but is in contact with it at the parts corresponding to the inner border and hollow of the sole. Whilst undue flatness of the foot is ugly, the other extreme, excessive arching of the instep, should be avoided, as it imparts a cramped appearance to the foot.

Great variation will be met with in the length and breadth of the foot. As a rule, the width of the foot is about one-third of its length. Excessive prominence of the heel, which is associated with marked curving of the tendo Achillis as it passes down to it, should also be avoided, as it gives rise to an unpleasant outline.

The smaller bones, the greater abundance of fat, and the less marked muscular development impart to the female foot a softer outline and a plumper form.

Much that has been already stated in regard to cutaneous veins in general might be repeated here, but the reader is referred to p. 217, where the matter has been previously discussed. The blood in the veins of the leg flows contrary to the direction of the force exercised by gravity; in consequence there is a much greater tendency for the blood to accumulate in these vessels than in the upper limb, where the flow of the blood through the veins is frequently accelerated by the raising of the arms. In the lower limb we meet with the longest vein in the body; it extends from the inner ankle up the inner side of

the leg and thigh, and terminates above a little below the inner extremity of the fold of the groin. It is superficial throughout its entire length, and when distended with blood it forms a well-marked surface elevation, as may be seen in the thighs of the Fighting Gladiator. Over the dorsum of the foot a more or less arched arrangement of the veins is readily recognizable, whilst running up the outer side of the ankle and back of the leg to reach the hollow behind the knee is another vein, which is pretty definite in its position. These veins are called respectively the *inner or long saphenous* and the *outer or short saphenous veins*. They will be seen best as surface elevations when the model is of spare habit and when the limbs are in action, as under these conditions they are distended. The student is warned that these veins are often unduly prominent and tortuous, an appearance which depends on their abnormal distension or varicose condition; hence care must be exercised to avoid a too realistic representation of them. In the antique they are employed to emphasize powerful muscular action, and the student cannot do better than follow the example set before him in these masterpieces of plastic art.

When the type is less athletic and the subcutaneous fat more abundant, the veins are indicated by colour rather than contour, a condition which particularly obtains in the female, in whom their representation as surface elevations would be altogether out of keeping with the character of the figure.

CHAPTER XII

In considering the anatomy of the neck it will be necessary in the first instance to examine the skeleton of this part of the body, and note how it is united with the head above. As was stated in a previous chapter (see *ante*, p. 36), there are seven cervical or neck vertebrae in that part of the 'back-bone' which passes through and supports the soft tissues of the neck. One of the characteristic features of these neck vertebrae is the shortness of their spines: to this there is one exception, the last or seventh cervical vertebra. The reader's attention has been already directed to the importance of the spine of this vertebra as a surface prominence on the back of the root of the neck (see *ante*, p. 106), and the name, *vertebra prominens*, often given to it,

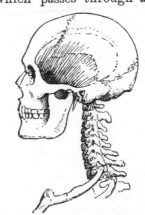

Fig. 180. Skull and cervical vertebrae of man, showing small face bones, large brain case, and short cervical spines.

refers to this peculiarity in the length of its spine. In regard to the other neck vertebrae, the shortness of their spines is a distinct advantage, as it enables the vertebral column to be more fully extended, i.e. bent back, in this situation than in any other region. The two highest of the neck vertebrae are modified in a peculiar way to adapt

them for articulation with the skull. It is not necessary that the student should be familiar with the details of structure of these two vertebrae, as they have no influence whatever on the surface forms, but some account of the nature and range of motion possible at these joints is of service in enabling the reader to understand the subsequent account of the movements of the head and neck.

The highest of the cervical vertebrae is called the *atlas*, owing to the circumstance that it supports the globe of the head : it is provided with a pair of peculiar articular surfaces on which rest the condyles of the occipital bone, one of the bones forming the base or under surface of the skull. These condyles may be compared to the rockers on a cradle, and as they move in the hollows on the upper surface of the atlas they produce a rocking or nodding movement of the head. Associated with this there may be slight degrees of oblique or lateral movement.

The atlas fits on the vertebra beneath it—the *axis*, so called—very much as a ring fits over a peg, for the latter vertebra is provided with an upstanding process called the *odontoid* or tooth-like process, which is enclosed above in a ring formed by the bony arch of the atlas together with a ligament. The joint is a pivot joint, and here take place the movements of rotation whereby the head, and with it the atlas, are turned from side to side. The range of these movements is checked by ligaments, but as a rule the head may be rotated to one or other side of the middle plane of the body to the extent of 30°. The reader will thus realize the importance of these two joints, as at the upper the nodding movements alone take place, whilst at the lower the movements of rotation only occur.

In the remainder of the cervical portion of the vertebral column the principal movements are effected in a backward and forward direction; *extension* or bending backwards is more free than *flexion* or bending forwards, for the reason

explained at the commencement of this chapter, and also
because the forward movement is checked when the chin
comes into contact with the front of the chest. The other
movement of which this part of the
column is capable is a combination of
rotation and *lateral flexion*, a movement
whereby we bend the neck to the side.

The neck vertebrae are so surrounded
on all sides by muscles and other tissues
that under ordinary conditions they
have no direct influence on the surface
forms, with the single exception of the
spine of the vertebra prominens. Be-
hind and on either side it is principally
muscle which we have to deal with,
whilst in front the gullet, windpipe,
and larynx all conceal the form of the
bony structures. The fleshy mass met
with behind is a continuation upwards
of that great group of muscles which
has been already described under the
name of the erectores spinae (see *ante*,
p. 41): the latter was seen to occupy
the furrows on either side of the spines
of the lumbar and dorsal vertebrae, but
became much reduced in bulk in the
mid-dorsal region : above that point,
however, the muscular column is rein-
forced by additional slips, all more
or less intimately associated with the
movements of the head and neck.
See Fig. 181. These form two cylin-

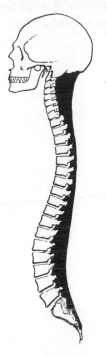

FIG. 181. A diagram
to show the arrange-
ment of the muscles
which support the
back-bone. The mus-
cles, which are repre-
sented in solid black,
are seen to be thick
in the regions of the
loins and neck, and
comparatively thin in
the mid-dorsal region.

drical masses which pass up to reach the under surface of
the back of the skull on either side of the short spines of
the cervical vertebrae which, in consequence, have no direct

influence on the surface contours. The fleshy columns on either side are separated from one another by a fibrous partition called the *ligamentum nuchae*, a feeble representative in man of the stout elastic ligament so often met with in many of the lower animals. As was stated in an earlier

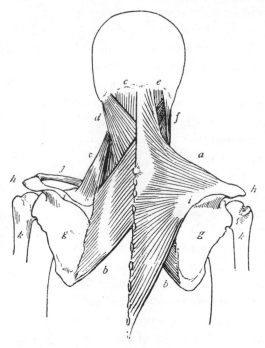

FIG. 182. View of the muscles attached to the shoulder-blade. The trapezius has been cut away on the left side of the figure.

a. Trapezius muscle.
b. Rhomboid.
c. Elevator of the angle of the scapula (levator anguli scapulae).
d. Splenius muscle.
e. Complexus muscle.

f. Sterno-mastoid muscle.
g. Infra-spinous fossa on back of scapula.
h. Acromion process of scapula.
i. Spine of scapula.
j. Collar-bone (clavicle).
k. Humerus.

chapter (Chapter I, p. 21), the poor development of this ligament in man is associated with the assumption of the erect posture, a position in which the head is almost balanced on the summit of a vertical column, whereas in the

lower animals the ligament is of necessity strong in order to support the head at the extremity of a more or less horizontal column.

It is needless to enter into any detailed account of these fleshy masses on the back of the neck, as they are in great part overlain by the trapezius, which has been already described (p. 105), as well as by other superficial muscles, to be hereafter discussed; but their indirect influence on the surface contours of the back of the neck should not be overlooked, as it is to their presence that this region owes its full and rounded appearance.

The form of the front of the neck is partly due to muscle and partly to other structures which are associated with the alimentary tract and the respiratory system. In front of

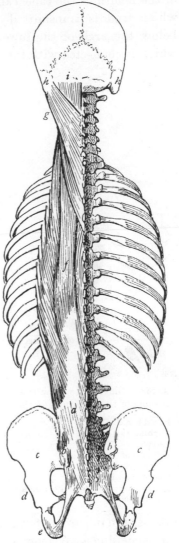

a. Placed over tendinous part of erector spinae.
b. Posterior superior iliac spine.
c. Haunch-bone (os innominatum).
d. Socket for head of thigh-bone (acetabulum).
e. Tuberosity of the ischium.
f. Placed over fleshy part of erector spinae.
g. Splenius muscle.
h. Mastoid process of temporal bone.
i. Complexus muscle and superior curved line of occipital bone.

FIG. 183. Shows the great erector mass of muscles. The muscles are shown only on one side; the groove in which they are lodged is seen on the right side of the figure.

the vertebral column, and commencing above at the back of the mouth, is the tube, called the *gullet* or *oesophagus*, by which food is transmitted to the stomach. Within and below the arch of the lower jaw there is the *hyoid bone*, which is connected with the root of the tongue. Below the hyoid bone, and lying in front of the gullet, is the *trachea* or *windpipe.* The upper extremity of this respiratory tube is peculiarly modified to form an organ immediately concerned in voice-production — the *larynx.* In front of the windpipe, and below the level of the larynx, there is a gland of considerable size called the *thyroid body.* Connecting the hyoid bone and larynx with surrounding parts, such as the lower jaw-bone, the breast-bone, and collar-bones, there are a number of small muscles which, whilst they do not as a rule influence the surface forms in detail, yet in

Fig. 184. Diagram to show the position of some of the structures in the neck.

a. Hyoid bone.
b. Thyroid cartilage of the larynx (Adam's apple).
c. Left lobe of thyroid gland.
d. Upper end of breast-bone.
e. Trachea or windpipe.
f. Spine of seventh cervical vertebra (vertebra prominens).

bulk assist in imparting to the front of the neck its characteristic modelling. A more detailed description of some of these structures is necessary.

The *hyoid bone*, or bone of the tongue, which is a small slender bone formed like a ∪, is situated at the angle formed

by the outline of the soft parts below the chin and the line of the front of the neck. The position of the bone varies according to the position of the head. When the eyes are directed straight forwards the hyoid bone lies nearly on a level with the angle of the lower jaw. The reader may satisfy himself as to the position of the bone by grasping the tissues of the neck in this region firmly between the thumb and fingers. When the head is extended or thrown back, the angle formed by the line below the chin and the line of the front of the neck is opened out, and the position of the bone is more easily recognized; it always corresponds to the line of flexure or angle where the head bends forward on the neck. When the head is thrown back the first point of resistance met with, in passing the finger from the chin downwards along the middle line of the neck, is the hyoid bone.

About half an inch below the level of the hyoid bone a well-marked elevation will be easily recognized: this projection is due to one of the cartilages of the larynx or voice-box. It is called the *pomum Adami*, or *Adam's apple*, and is usually more prominent in the male than in the female. In the adult it is large as compared with that in the child. If the neck of a child be examined there is little or no evidence of its presence, but at that period of life when youth gradually merges into manhood, changes take place in the growth of the larynx which are associated with marked increase in the size of its cartilages, and their surface outlines become factors of importance in the modelling of the throat. This alteration in the size of the larynx is intimately associated with the changes which are taking place at the same time in the character of the voice, changes which are popularly referred to as the 'breaking of the voice'. In the female there is no such marked difference between the forms displayed in the child and the adult, so that in woman the rounded contours of the front

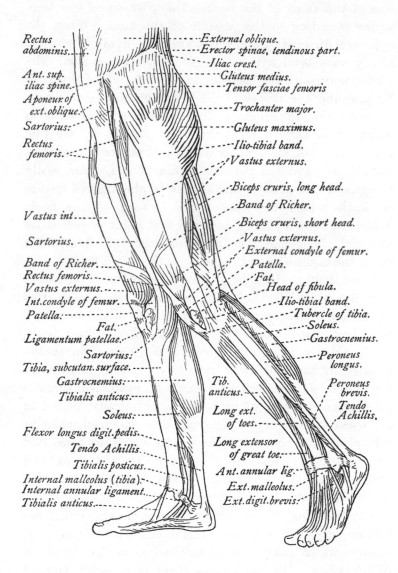

Rectus abdominis.

External oblique.

Erector spinae, tendinous part.

Iliac crest.

Ant. sup. iliac spine.

Gluteus medius.

Tensor fasciae femoris

Aponeur. of ext. oblique.

Trochanter major.

Sartorius.

Gluteus maximus.

Rectus femoris.

Ilio-tibial band.

Vastus externus.

Biceps cruris, long head.

Band of Richer.

Vastus int.

Biceps cruris, short head.

Sartorius.

Vastus externus.

External condyle of femur.

Band of Richer.

Patella.

Rectus femoris.

Fat.

Vastus externus.

Head of fibula.

Int. condyle of femur.

Ilio-tibial band.

Patella.

Tubercle of tibia.

Fat.

Soleus.

Ligamentum patellae.

Gastrocnemius.

Sartorius.

Peroneus longus.

Tibia, subcutan. surface.

Gastrocnemius.

Tib. anticus.

Peroneus brevis.

Tibialis anticus.

Tendo Achillis.

Soleus.

Long ext. of toes.

Flexor longus digit. pedis.

Tendo Achillis.

Long extensor of great toe.

Tibialis posticus.

Ant. annular lig.

Internal malleolus (tibia).

Ext. malleolus.

Internal annular ligament.

Ext. digit. brevis.

Tibialis anticus.

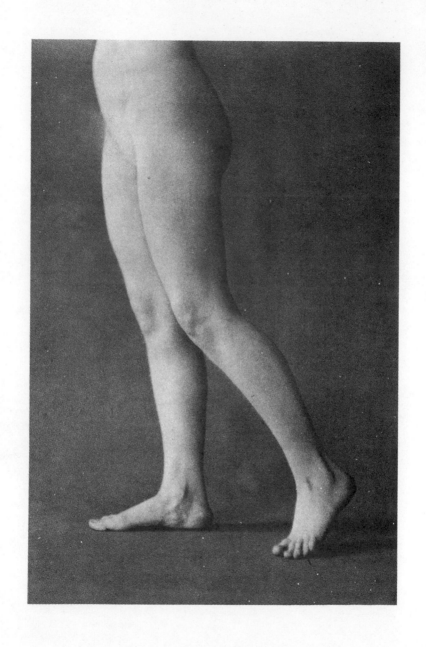

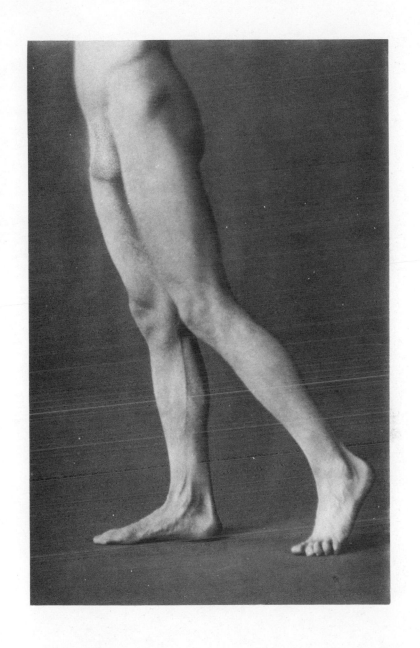

of the neck are not as a rule disturbed by any undue pro-
jection of these laryngeal cartilages.

Below the larynx, the *windpipe*, which is composed of a
number of cartilaginous rings united together by membrane,
passes down behind the upper end of the breast-bone to
enter the thorax. On either side of this tube, which, owing
to its structure, always remains open or distended, there
are the lobes of a structure called the *thyroid body*. These
consist of masses of gland tissue of oval flattened form which
lie on either side of the trachea, and which are connected
with each other anteriorly by a bridge of gland substance
called the *isthmus*, which passes across the front of the
windpipe just below the larynx. These structures lie under
the layer of thin muscles which pass up from the breast and
collar-bones to be attached to the hyoid bone and larynx
above, and serve to increase the fullness of the neck in this
region. As the thyroid gland is usually larger in the
female than in the male, it assists in imparting that round-
ness and fullness to the lower part of the neck in the female
which is regarded as so charming a feature in its modelling.
The reader is warned that undue emphasis of this feature
may give rise to an unnatural form, a form which is by
no means uncommon and is associated with the diseased
enlargement of the gland called goître.

These structures, as has been stated, are some of them
overlain by thin muscles, whilst others are supported and
fixed by the same means. A detailed description of these
appears unnecessary, as it is only under exceptional circum-
stances that they can have any direct influence on the
surface forms : thus it is only in the emaciated, or in such
extremes of muscular effort as are associated with the
struggles of an unfortunate creature gasping for breath, that
their details are at all apparent.

The muscle which plays the most important part as
a determinant of the surface form of the neck is the *sterno-*

mastoid. Inferiorly this muscle is attached to the anterior surface of the upper end of the breast-bone by a thick rounded tendon; it also derives fleshy and tendinous fibres from the inner third or so of the collar-bone; these two origins are separated by an interval of variable width. The fleshy belly formed by the union of these two attachments passes upwards and backwards towards the part of the skull immediately behind the ear. If the finger be placed on the bone in this situation, a thick rounded blunt process can be distinctly felt : this is called the *mastoid process* of the *temporal bone,* and it is into this and the rough ridge passing back from it, called the *superior curved line* of the *occipital bone,* that the muscle is inserted. The extent of the attachment of the muscle to this ridge varies considerably in different individuals (Fig. 185, and Pls., pp. 58, 72, 86, 152, 382, 410).

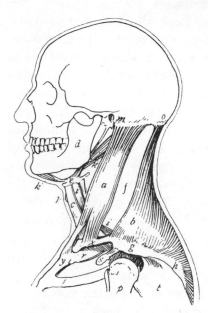

FIG. 185. Diagram showing the arrangement of some of the principal structures of the neck.

a. Sterno-mastoid muscle.
b. Trapezius muscle.
c. Sterno-hyoid muscle.
d. Lower jaw.
e. Hyoid bone.
f. Posterior triangle.
g. Acromion process of scapula.
h. Spine of scapula.
i i. The two bellies of the omo-hyoid muscle.
j. Thyroid cartilage of larynx (Adam's apple).
k k. The two bellies of the digastric muscle.
m. Mastoid process of temporal bone.
o. Superior curved line of occipital bone.
p. Humerus.
r. First rib.
s. Coracoid process of scapula.
t. Placed on infra-spinous fossa of scapula.
x. Collar-bone.
y. Breast-bone.

The sterno-mastoid as it passes obliquely across the side

of the neck divides that region into two triangles : the one,
in front and above it, is called the anterior triangle, that
behind and below it the posterior triangle. The conver-
gence of the muscles of either side below, where they are
attached to the upper end of the breast-bone, has a most
important effect on the moulding of the surface forms : here
their tendons of origin from the breast-bone lie just within
the expanded inner extremities of the collar-bones as they
rest upon the upper border of the sternum on either side.
Thus a V -shaped recess is produced, the sides of which are
formed by the tendons of the
two sterno-mastoid muscles,
whilst the angle of the V cor-
responds to the upper border
of the breast-bone. The depth
of the recess is further em-
phasized by the projection
caused by the inner end of
the collar-bone on either side.
This depression corresponds
to the surface hollow familiar
to the reader under the name
pit of the neck. In the male
its borders are sharply de-
fined, especially during vio-
lent muscular effort; in the

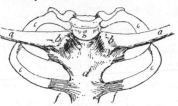

FIG. 186. Showing articulation
of the collar-bones (clavicles) with
the breast-bone (sternum).

a. Collar-bones (clavicles).
b. Sternal ends of collar-bones.
c. Placed on the first and second ribs.
d. The upper piece of the breast-bone
(manubrium sterni).
f. Rib cartilages.
g. Placed over the body of the first dorsal
vertebra; lies in the interval between
the sternal ends of the collar-bones,
a space which corresponds to the
surface depression at the root of the
neck, called the pit of the neck.

female, owing to the presence of an abundant layer of fat
beneath the skin, the outlines are smoother and more rounded,
and the surface depression is altogether softer, and forms
a feature of great beauty in the modelling of the throat as
it rises from the general fullness of the breast (Pls., pp.
58, 62, 132, 148, 152, 298, 434).
 It is in the interval between the two sterno-mastoids that
the structures already enumerated lie, viz. the windpipe,
larynx, and hyoid bone. These, as we have seen, are

covered by a layer of small muscles on either side. The interval between the sterno-mastoids above, which is bounded superiorly by the border of the lower jaw and inferiorly by the hyoid bone, is filled up in part by the muscles of the tongue and floor of the mouth, in part by blood-vessels, and in part by the salivary glands; one of the latter occupies the interval between the ear and the angle of the jaw. Under cover of the angle of the jaw there is another of these glands, which imparts a fullness to the surface as it sweeps inwards and downwards towards the hyoid bone (Plate, p. 410).

In regard to the region behind and below the sterno-mastoid, the student should recollect the arrangement of the superior fibres of the trapezius—that muscle arises above from the back of the base of the skull close to the middle line behind, and passing downwards, outwards, and forwards, is inserted into the outer third of the upper border of the collar-bone. There is thus an interval between the anterior border of the trapezius and the posterior border of the sterno-mastoid, and this space constitutes the posterior triangle of the neck, the base of which corresponds to the middle third of the collar-bone, the summit to the interval between the attachment of the muscles to the superior curved line above, whilst the floor is formed by the deeper muscles, which are here superficial and are thus brought in direct relationship to the surface. So dense and tough, however, is the fascia which covers them, and so thick the layer of fat, that their details are hardly, if at all, apparent on the surface. The boundaries of this space, constituted as they are by the posterior border of the sterno-mastoid anteriorly, and behind by the anterior edge of the trapezius, form in muscular males and thin-necked females outstanding surface contours which map out very clearly the triangular interval referred to. Especially is this the case towards the lower part of the neck, where the

clavicle forms a prominent ridge, the hollow above which corresponds to the interval between the two muscles : this depression is in marked contrast to the fullness below caused by the origin of the great pectoral and the deltoid muscle of the shoulder, though the interval between these is often-times indicated by a shallow furrow. These details, as has been said, are best seen in a spare athletic male ; in the female such evidence of structure is contrary to the usually accepted type, in which the general roundness of the neck is largely due to the abundance of fat; but in women of a spare habit and with slender necks these details, if not unduly emphasized, may be in harmony with the type represented (Pls , pp. 58, 62, 72, 132, 148, 152, 158, 382).

The position of the shoulder-girdle has a marked influence on the production of this hollow ; in models in whom there is no evidence of this depression when the arms are hanging by the side we get clearer indications of its presence when the arms are raised and carried forwards (Pls., pp. 158, 382). In this position the collar-bone is not only elevated, but carried forwards from the chest wall ; it is rendered more prominent, and the space is thus more clearly defined, though even under those conditions, especially in well-formed women in whom the subcutaneous fat is uniformly distributed, the surface contours are rounded and less abrupt than in the male. If the muscles be strongly developed and the action violent, one of the deeper muscles crossing the floor of the space not unfrequently forms an oblique surface elevation, which can be distinctly recognized passing across the interval between the sterno-mastoid and trapezius just above the collar-bone. This muscle is called the *omo-hyoid* : it has two bellies. The portion with which we are more immediately concerned arises from the superior border of the shoulder-blade, just internal to the root of the coracoid process. The anterior belly is attached to the outer part of

the lower border of the hyoid bone. These two small fleshy bellies are connected by an intermediate tendon which lies beneath the sterno-mastoid muscle (see Fig. 185). It is the posterior belly which forms the surface projection above referred to, and it passes obliquely upwards and forwards from under cover of the collar-bone, where the fibres of the trapezius are attached, in a direction corresponding to a line drawn from that point upwards and forwards towards the

hyoid bone when the neck is outstretched. The student will recognize the surface form produced by this muscle on the right side of the neck of the Fighting Gladiator. An absence of fat in this region contributes to the clearness with which these details are seen.

Not unfrequently in models of spare habit the lower attachments of the sterno - mastoid are very distinct. As has

FIG. 187. Shows form of neck with shoulder depressed.

been stated, there is an interval of variable width between its origins from the breast-bone and collar-bone, and this is often represented on the surface by a triangular depression (Pls., pp. 58, 62, 72, 148, 152, and Figs. 187, 188, 189). An undue emphasis of these details is likely, however, to detract from the massive feeling which should be aimed at in representing the rise of a powerful neck from a well-developed thorax.

In regard to the action of the sterno-mastoid muscles—when one muscle contracts, the head is inclined to the same side, whilst the face is directed towards the opposite side. Concerning the combined action of the two muscles, there is much contradiction in the various textbooks : some assert that the muscles bend forward the head and neck, whilst others state that the muscles act as extensors of the head ; the truth appears to lie between the two statements. Their united action seems to be the bending forward of the neck on the thorax combined with the extension of the head upon the bent neck. In other words, they are in action when the neck is thrust forwards and the face upturned.

FIG. 188. Shows form of neck with shoulder raised.

Overlying the structures of the neck which have just been described is a dense layer of fascia called the *deep cervical fascia.* This invests not only the entire neck in a fibrous sheath, but also furnishes prolongations from its deep surface which form compartments for the lodgement of these various structures. A detailed account of this fascia is needless, but the student would do well to remember the restraining influence which it exercises on the structures which lie beneath it. It is between this fibrous investment and the skin of the neck that the superficial fat which constitutes what is called the *superficial cervical fascia* lies. Here we have to study a muscle called the *platysma myoides,* which is a survival in man of a muscle

which commonly occurs in many animals. Any one who has watched a fly settle on a horse's back has seen that the latter has the power of rippling or wrinkling its skin in a remarkable manner. The muscle which we are now describing belongs to the same class. Its development varies very much in different individuals. Some people, too, appear to have much more control over its contraction than others.

The *platysma*, which forms a thin muscular sheet, arises below from the fascia covering the great pectoral, the deltoid, and the trapezius: its fibres are directed obliquely upwards and forwards to pass over the lower jaw-bone from the chin as far back as the angle: some of its fibres are attached to this bone, but others pass up to blend with the muscles which are connected with the lower lip and angle of the mouth (see Pl., p. 410, *b*). Under ordinary conditions there are no indications of the presence of this muscle, though in old people in whom the fat has disappeared it may be often recognized, as it forms the dewlap-like folds which hang beneath the chin. The action of the muscle is best displayed in the expressions of fright and terror, wherein it draws down the angle of the mouth and wrinkles the skin of the neck transversely; at the same time it appears to increase the transverse diameter of the root of the neck in front by flattening the surface forms over and above the collar-bone.

Of other structures which lie in the superficial fascia we are concerned only with the veins. To avoid repetition the student is referred to the remarks already made on this subject at the end of last chapter (p. 357). The vein which is most apparent is the *external jugular*. This is well seen in the lower part of the right side of the neck of the Fighting Gladiator. It runs down the side of the neck, from the region behind the angle of the jaw to a point above the collar-bone and just external to the origin of the sterno-mastoid. Usually the vein of one side of the neck is

much larger than that of the opposite. The superficial veins become distended with blood when the contraction of the muscles of the head and neck is prolonged and violent. They also become prominent under the influence of excitement. In the expression of rage and passion they are more or less engorged. Under all circumstances due care and restraint must be exercised in their representation. As indicated by colour, they are of service in imparting a feeling of delicacy to the skin.

Having described in some detail the structures which determine the contours of the neck, we may pass on to consider the form of the neck as a whole.

The neck is rounder in front than behind. The flattened surface of the back of the trunk is carried up on to the back of the neck without any interruption in the surface contours. In front, the rounded form of the root of the neck appears implanted on the breast between the shoulders, the modelling of which is distinct and separate from that of the neck. The spring of the neck from the shoulders on either side is very much higher than its root in the middle line in front, where the pit of the neck corresponds to the upper edge of the breast-bone. If the figure be viewed in profile, the pit of the neck is seen to lie on a very much lower level than the surface projection formed by the spine of the seventh cervical vertebra, which marks the inferior limit of the neck posteriorly. This is due to the oblique position of the first pair of ribs, which, with the breast-bone, form the boundaries of the inlet or superior aperture of the thorax. The effect of this obliquity is that the upper end of the breast-bone lies on a level with the second or third dorsal vertebra, hence it follows that the root of the neck appears to spring obliquely from the upper end of the thorax. This circumstance explains why in profile the front of the neck appears longer than the back.

There is considerable variation in the length of the neck

in different individuals. This is more apparent than real, and is not due to any marked difference in the length of the cervical portion of the back-bone, for observations prove that the back-bone is of all other parts of the skeleton the least liable to variations in its length. The length of the neck depends largely on the elevation of the shoulders. A long neck is associated with sloping shoulders, while broad and square shoulders are the concomitants of a short neck. The position of the shoulder-girdle depends to some extent on the development of the muscles which are connected with it, as well as on the form of the thorax, as has been already explained (p. 101). The sloping shoulder coincides with a collar-bone which slants outwards and downwards, whilst in the square-shouldered the outer end of the clavicle lies on a higher level than the sternal end. The muscular development of a person with sloping shoulders is usually poor ; hence the muscles of the neck are not so bulky: this reduces the width of the neck and tends to exaggerate the appearance of length. The broad and square-shouldered are commonly persons of powerful physique ; their muscles are usually strongly developed, and increase thereby the width of the neck. This increase in the width of the neck detracts from its appearance of length.

Much depends, as has been said, upon the quantity of subcutaneous fat which is here distributed. In women of a robust and healthy type the modelling of the neck is full and round, and only in exceptional actions are there indications of the superficial muscles. The fat, which is often present in considerable quantity, imparts a width to the neck which does away with any appearance of undue length. In such the neck is often crossed in front by one or two delicate cutaneous folds. This type is associated with a full and well-developed bust and shoulders.

Another type is that in which we meet with the long and swan-like neck. This form occurs in women of a sparer habit

with narrower chests and more sloping shoulders. The
forms themselves may be very beautiful, but hardly convey
that feeling of rude health which is so characteristic of
the former type. Here the slightness of the forms conveys
a feeling of delicacy associated rather with a highly sensitive
and nervous temperament. Owing to the less abundant
layer of superficial fat we are in them more liable to have
surface indications of the superficial structures.

FIG. 189. Shows the hollow above the collar-bone when the shoulders
are raised and the head bent forward.

The neck undergoes very considerable modifications in
its form according to its position. The movements of the
head on the neck have been already referred to at the
beginning of this chapter. As a matter of fact these move-
ments are usually associated with corresponding movements
of the neck. Thus when the head is bent forward the neck
moves forward with it. A backward movement of the head
is usually accompanied by extension of the neck. In like

manner, the movements of lateral inclination and rotation of the head and neck are usually combined. The reader must not suppose that these movements may not be dis-associated. We can extend the head when the neck is bent, and we can flex the head on the extended neck, but these actions are unusual and constrained.

In *flexion* of the head and neck the hollow curve of the back of the neck disappears and is replaced by a convex outline, which is an upward and forward continuation of the curve of the dorsal region of the back. The spine of the seventh cervical vertebra becomes more prominent, and the spines of the upper two or three dorsal vertebrae can usually be recognized. The outline of the front of the neck is concealed by the fact that the chin comes into contact with the upper end of the

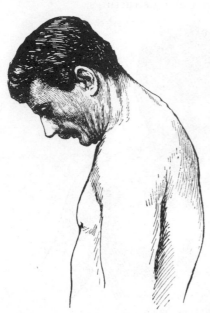

FIG. 190. Shows the form of the neck in flexion.

breast-bone. A series of transverse folds cross the neck in front, the most

pronounced corresponding to the surface of the skin immediately beneath the border of the lower jaw. The inner end of the collar-bone is emphasized, and the slight hollow which lies between the angle of the jaw and the anterior border of the sterno-mastoid is obliterated by the approximation of these two structures. The anterior border of the trapezius can usually be recognized passing from the occiput to the outer third of the collar-bone (Fig. 190).

When the head and neck are thrown back or *extended*, the angle formed by the structures underlying the lower jaw and the outline of the front of the neck is opened out. The hyoid bone, as we have seen, corresponds almost precisely to this angle. The interval between the hyoid bone and the upper end of the breast-bone is increased, so that the outline between these two points is lengthened and the skin stretched over the sub-jacent structures. In the male the outline of the cartilages of the larynx is rendered distinct; in the female, owing to the greater quantity of fat and the slighter development of these structures, the outline describes a uniform forward curve from the pit of the neck to the angle where it sweeps forward to the chin (Fig. 191). In correspondence with this the back of the head or occiput is brought nearer to the prominence caused by the seventh cervical spine. The outline of the back of the neck is shortened and rendered

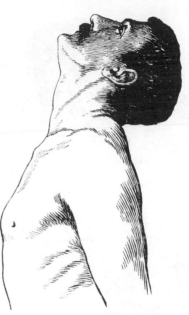

FIG. 191. Shows the form of the neck in extension.

more concave, and the skin is thrown into thick transverse folds, the skin of the back of the neck being much thicker and tougher than that of the front. The neck is somewhat increased in its transverse diameter by the outward thrust of the muscles, and, owing to the stretching of the skin over the lower jaw, the outline of that bone becomes more distinct, and the hollow between its angle and the anterior border of the sterno-mastoid is more pronounced. The lower attach-

ments of the sterno-mastoids are rendered tense, and the pit of the neck becomes sharply defined (Fig. 191).

Whilst the collar-bone is easily recognized by the stretching of the skin over it, the hollow above it corresponding to the interval between the sterno-mastoid and trapezius becomes obliterated. A fullness appears over the back and upper part of the shoulder, owing to the relaxed fibres of the anterior part of the trapezius.

When the head is turned towards the shoulder the skin of the side of the neck from which the head is turned is tense and stretched, whilst that on the side towards which the head is directed is obliquely wrinkled. The surface form of the side of the neck from which the head is turned is full and round; the anterior border of the sterno-mastoid muscle is outstanding, though its clavicular attachment is less marked.

Fig. 192. Shows the relation of the sterno-mastoid to the surface when the head is turned towards the shoulder.

The skin as it is stretched over the collar-bone emphasizes that structure, and the hollow above it is effaced to a great extent, though the border of the trapezius may be frequently recognized. The posterior belly of the omo-hyoid as it crosses the lower part of the interval between the trapezius and sterno-mastoid is stretched, and often forms a surface elevation when there is little subcutaneous

fat. On the side towards which the head is turned the hollow above the collar-bone is deepened, but the outline of the superficial muscles is concealed by the wrinkled skin. A deep cutaneous fold defines the angle of the jaw and runs up behind the ear, marking the interval between the jaw-bone and the anterior border of the upper part of the sterno-mastoid (Pls., pp. 72, 86, 132, 152).

By the rotation of the head and neck the structures which lie in the middle line of the neck are dragged obliquely towards the side to which the head is turned, and in the male, as also to a slight extent in the female, the form of the laryngeal cartilages is apparent (Pls., pp. 86, 132, 308).

In the lateral movements, in which the head is inclined towards the shoulder,

FIG. 193. Shows the relation of the sterno-mastoid to the surface when the head is bent to the side.

the skin over the neck on the side towards which it is bent is wrinkled: the best marked of these folds corresponds to the spring of the neck, and curves round the root of the neck from the inner end of the collar-bone upwards and backwards across the middle of the anterior border of the trapezius, whilst another follows more or less accurately the anterior border of the sterno-mastoid, passing up between it and the angle of the lower jaw to reach the

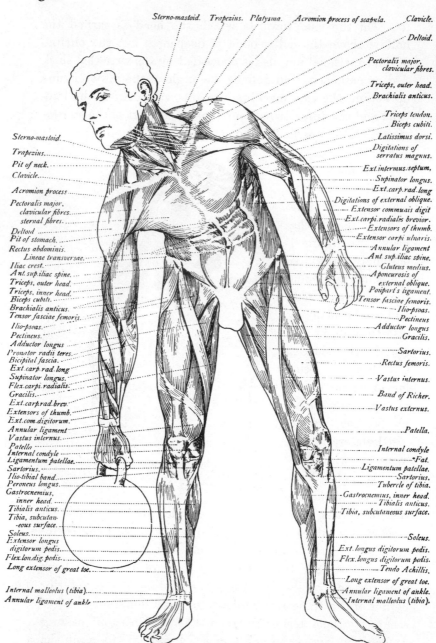

Sterno-mastoid. Trapezius. Platysma. Acromion process of scapula. Clavicle.

Deltoid.

Pectoralis major,
clavicular fibres.

Triceps, outer head.
Brachialis anticus.

Triceps tendon.
Biceps cubiti.

Latissimus dorsi.

Digitations of
serratus magnus.

Ext. internus. septum.

Supinator longus.

Ext. carp. rad. long

Digitations of external oblique.

Extensor communis digit

Ext. carpi. radialis brevior.

Extensors of thumb.

Extensor carpi ulnaris.

Annular ligament

Ant. sup. iliac spine.

Gluteus medius.

Aponeurosis of
external oblique.

Poupart's ligament.

Tensor fasciae femoris.

Ilio-psoas.

Pectineus

Adductor longus

Gracilis.

Sartorius.

Rectus femoris.

Vastus internus.

Band of Richer.

Vastus externus.

Patella.

Internal condyle

*Fat.

Ligamentum patellae.

Sartorius.

Tubercle of tibia.

Gastrocnemius, inner head.

Tibialis anticus.

Tibia, subcutaneous surface.

Soleus.

Ext. longus digitorum pedis.

Flex. longus digitorum pedis.

Tendo Achillis.

Long extensor of great toe.

Annular ligament of ankle.

Internal malleolus (tibia).

Sterno-mastoid.

Trapezius.

Pit of neck.

Clavicle.

Acromion process

Pectoralis major,
clavicular fibres.
sternal fibres.

Deltoid

Pit of stomach.

Rectus abdominis.

Lineae transversae.

Iliac crest.

Ant. sup. iliac spine.

Triceps, outer head.

Triceps, inner head.

Biceps cubiti.

Brachialis anticus.

Tensor fasciae femoris.

Ilio-psoas.

Pectineus.

Adductor longus

Pronator radii teres.

Bicipital fascia.

Ext. carp. rad. long

Supinator longus.

Flex. carpi. radialis.

Gracilis.

Ext. carp. rad. brev.

Extensors of thumb.

Ext. com. digitorum.

Annular ligament

Vastus internus.

Patella

Internal condyle

Ligamentum patellae.

Sartorius.

Ilio-tibial band.

Peroneus longus.

Gastrocnemius,
inner head.

Tibialis anticus.

Tibia, subcutan-
eous surface.

Soleus.

Extensor longus
digitorum pedis.

Flex. lon. dig. pedis.

Long extensor of great toe.

Internal malleolus (tibia).

Annular ligament of ankle.

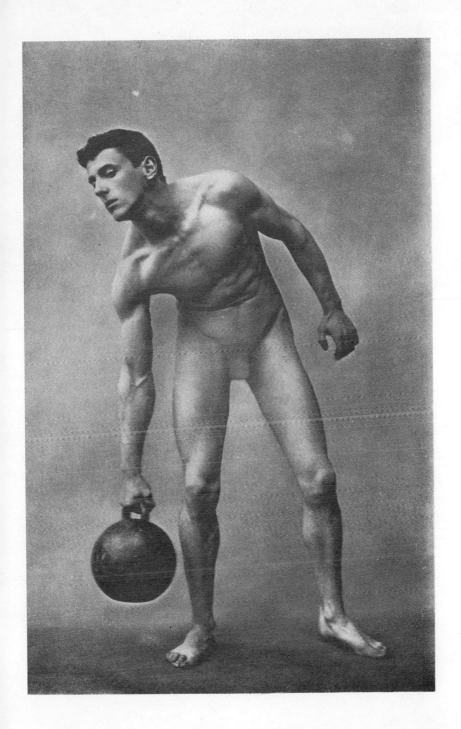

back of the ear. On the side from which the head is inclined the sterno-mastoid is distinctly seen, its origin from the collar-bone being especially evident. Here too the collar-bone is brought more or less into prominence by the stretching of the skin over it, and the attachment of the trapezius to that bone is usually easily recognized. A surface elevation dependent on the posterior belly of the omo-hyoid may also be noticed. These forms will of course be very much modified if the shoulder from which the head is inclined is elevated at the same time (Fig. 193, and Pl., p. 72).

It only remains to be said in this connexion that the sweep of the fibres of the trapezius, as they pass from the occiput and the middle line of the back of the neck downwards and outwards towards the outer end of the collar-bone and upper border of the acromion process of the shoulder-blade, plays an important part in linking together the shoulder with the neck. Their presence determines the outline which passes from the side of the root of the neck to the shoulders. The direction of this outline will vary with the position of the shoulder-girdle. It has a downward slope when the shoulder is depressed, but when the limb is elevated or the girdle raised it becomes more nearly horizontal (Pl., p. 152).

The influence of the fibres of the *platysma* must not be overlooked, but it is only exceptionally and in strained action that the contraction of this muscle masks the details of the underlying structures.

CHAPTER XIII

THE *skull* is the bony framework of the head. It is conveniently divided into two parts, one of which envelops and protects the great nervous centre, the brain, while the other forms a series of chambers for the lodgement of some of the organs of special sense, viz. the globe of the eye, the nose, and the tongue. The former is called the *cranial box* or *calvaria* ; the latter is known as the *skeleton of the face*. All the bones forming these several parts are immovably united to one another, with the exception of the *mandible* or *lower jaw*, which articulates by means of a movable joint with a hollow fossa in front of the ear on the under surface of the *temporal bone*.

As the brain in man is larger in proportion to the rest of his body than in any other mammal, the bony case which surrounds it necessarily attains a great size. On the other hand, as was pointed out in Chapter I, a corresponding reduction has taken place in the size and projection of the facial part of the skull; the jaws are no longer necessary for offensive or defensive purposes, nor are they so powerful, for man almost without exception prepares and softens his food by cooking. The sense of smell is not nearly so keen in man as in many animals, in whom it serves to protect them from their enemies and assists them in obtaining their food. This has led to a corresponding reduction in the size of the nose in man. In animals the nose and jaws form a muzzle or snout, which projects in front of that part of the skull

which contains the brain, whilst in man the large cranial box overtops the greatly reduced facial skeleton in place of lying only behind it, as in the lower animals.

These two parts of the skull can be conveniently defined in the living by drawing a line from the root of the nose

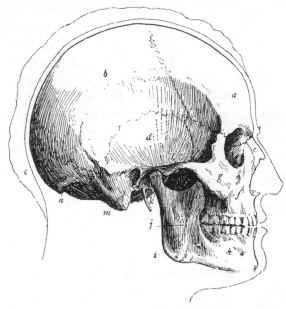

FIG. 194. Male skull. Side view.

a. Frontal bone. b. Parietal bone.
c. Occipital bone.
d. Temporal bone.
e. Nasal bone.
f. Upper jaw-bone (superior maxilla).
g. Cheek or malar bone.
h. Mandible or lower jaw (inferior maxilla).

i. Angle of lower jaw.
j. Ramus of lower jaw.
k. Condyle of jaw.
l. Zygomatic arch.
m. Mastoid process of temporal bone.
n. External occipital protuberance.
o. Coronoid process of lower jaw.

to the orifice of the ear, and thence backwards to the point where the neck unites with the posterior part of the head in the middle line. There, a rounded knob of bone can usually be felt: it is called the *external protuberance* of the *occipital bone*.

The part of the skull above this line is for the lodgement

of the brain, that below and in front of the line which stretches between the root of the nose and the ear belongs to the face.

The *cranial box* is built up of expanded plates of bone : these present a smooth and rounded appearance where they form the dome-like roof and sides of the head, and impart to it its characteristic shape. The form and size of the head vary very much in different individuals, a circumstance which usually enables us with certainty to recognize our own hats.

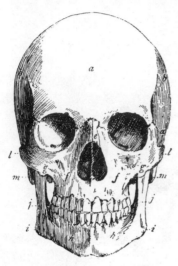

FIG. 195. Male skull. Front view.

a. Frontal bone.
b. Parietal bones.
d. Temporal bones.
e. Nasal bones.
f Upper jaw-bones.
g. Malar or cheek-bones.
h. Mandible or lower jaw.
i. Angles of lower jaw.
j. Rami of lower jaw.
l. Zygomatic arches.
m. Mastoid processes of temporal bones.

The under surface of this bony box is called the *base of the skull.* In front, it is united with the bones of the face. Behind, it is rough and irregular and pierced by many holes. Here it affords attachment to a great many muscles, which control the movements of the head. By a large hole, called the *foramen magnum,* placed immediately over the canal in the vertebral column for the lodgement of the spinal cord, it allows that nervous structure to pass upwards and become connected with the brain.

We are in no wise concerned with these details, nor is it necessary that we should further discuss the manner in which the head articulates with the top of the vertebral column. This was described in the last chapter (p. 360).

The bones of the cranial vault, as we pass from before backwards, are named the *frontal*, which forms the forehead ; the two *parietals*, one on either side, which constitute the top and part of the sides ; and the *occipital* bone, which forms the back of the head. The side of the cranium in front, above, and behind the ear is made up of the *temporal* bone. In addition a portion of the *sphenoid* fills up the interval between the temporal bone posteriorly and the frontal anteriorly on either side.

It is unnecessary to describe these in detail, for it is by their union with each other that they mould the form of the head. There are but slight indications of their lines of union in the living, and the hairy scalp further conceals any evidence of their outlines.

They are united by a series of interlocking teeth-like projections, and the joints so formed are called *sutures*. In Chapter II the advantage of this arrangement was pointed out. The bones are by this means immovably united, at the same time that growth by expansion is rendered possible. In the aged, after all growth has ceased, these sutures frequently disappear, and the bones can no longer be separated from one another, as they have become fused together by osseous union.

The structure of these bones requires some explanation. They are composed of a dense inner and outer layer, the interval between which is formed of softer and more spongy osseous tissue, called the *diploë*. In some situations this diploë is liable to disappear at certain periods of life. Spaces are thus formed between the inner and outer hard layers. Through their connexion with the respiratory passages these spaces contain air, and are hence called *air sinuses*. The growth of these air sinuses takes place in the earlier periods of life, but some of them are strikingly developed at that age when youth merges into manhood. One of these sinuses has a special interest

for us, as it leads to very considerable modifications in
the surface form of the bone. The frontal bone, as it
moulds the forehead, can be felt underneath the eyebrows,
forming the arches over the cavities in which the eyes
are lodged. In this situation it is hollow, and contains
an air sinus called the *frontal sinus.* This space is not
developed in childhood, and only to a slight extent in
youth. In man it attains its maximum development
and imparts to the bone underlying the eyebrows a marked
fullness and prominence. In this respect man differs from
woman, for in the latter the sinus is much smaller, resem-
bling rather the condition met with in childhood. This
explains why a woman's forehead is flatter and smoother
than a man's, and accounts for the persistence in her of
the juvenile type.

The bones of the vault of the cranium ossify in a peculiar
way: they are what are termed membrane-bones. In the
early stages of growth the bone appears in the form of
a localized earthy deposit in the membrane which is subse-
quently to become ossified: from this centre the ossifying
particles spread until the membrane has become converted
into a plate of bone. These 'centres of ossification' are
readily recognized in the child ; they constitute the 'bumps'
which are so easily seen and felt in certain situations.
The most noticeable of these are the *frontal* and the *parietal
eminences*; the former cause the projection of the upper
part of the forehead on either side, whilst the latter can
be readily felt at some little distance above the ears.
The fullness imparted to the child's forehead by those
frontal centres of ossification is maintained through-
out life, though not in such a pronounced form, for in man,
owing to the development of the frontal sinuses, the brows
become more projecting, thus causing the forehead to slope
more, and so reducing the appearance of prominence in the
region of the frontal eminences. In women, owing to

the feebler projection of the brow ridges, the forehead retains its vertical appearance and the frontal bosses seem more pronounced. In this respect again the female resembles the child.

The relative proportion of the brain-case to the face varies much at different periods of growth. Apart altogether from the proportions of the head in relation to the rest of the body, the most casual observer must have noticed that in the child the part of the skull which contains the brain is relatively much larger as compared with the face than

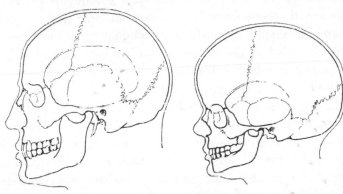

FIG. 196. Skull of adult showing proportion of face to brain-case.

FIG. 197. Skull of child showing proportion of face to brain-case.

what we see in the adult. Growth takes place in both these parts concurrently, though to a greater extent in the structures of the face than in the cranial box, else the relative proportions met with in the adult could not be attained.

The size of the cranial box is some index of the development of the brain, since a large brain necessarily requires a large covering. The size of the brain may, with certain reservations, be regarded as an indication of the development of the intellectual faculties. Though it by no means follows that a man with a big head is

a philosopher, yet, speaking generally, it may be stated that the more civilized the race the larger the brain, and consequently the bigger the head.

Since women as a rule are smaller than men, so we find that their brains are smaller than men's; not only are they absolutely less, but also relatively so in proportion to the bulk of the body. Curiously enough, this disproportion between the sexes is less marked in savage than in civilized races; in the latter perhaps the difference has been emphasized by the greater facilities afforded for the education of the intellectual faculties in the male. Correlated with these facts is the size of the head, which in woman should be small and shapely, though this is often concealed by the luxuriance of the hair. The fashion of wearing the hair naturally modifies the appearance of the head: travellers have frequently been misled thereby, describing races as big-headed in which in reality the skulls were of small size.

Whilst willing to admit that a well-shaped head is some guarantee of high mental and moral attainments, it must be pointed out that the detailed mapping out of the faculties on the surface of the skull is not based on, or supported by, any scientific facts.

As has been said, the face is proportionately small in the young child. As yet the air sinuses in the bones have not been fully developed. These air sinuses are all accessory to the respiratory tract, with which they communicate. They act apparently as resonators, and influence thereby the character of the voice. Many of them are connected with the nose, and the reader will at once appreciate their effect on the voice if he notes the changes which take place in its quality when one is suffering from a severe cold in the head.

The most important of these sinuses in connexion with the face is that found within the upper jaw, a bone, which

though apparently solid, displays on section a large cavity in its interior. Besides the function above ascribed to these sinuses, it will be evident that by substituting hollow bones for solid ones the weight of this part of the skull is very much diminished.

Among the most important of the bones of the face as determinants of form are the *cheek* or *malar* bones. These impart the width to the upper part of the face. If the finger be placed upon the brows, and the outline of the orbits be traced beneath the skin, these bones may be felt as they form the margin of these hollows to the outer and lower side, lying in this position between the outer parts of the frontal bone above and the upper jaw-bones below. Wide of the orbit the malar bones form the prominence of the cheeks. Posteriorly they can be felt to be supported by an arch of bone which can be readily traced back to the region in front of the ear. This is called the *zygomatic arch*, and is in part made up of a backward process of the cheek-bone and a forward projection of the temporal bone. Beneath this arch, when the skull is stripped of its fleshy parts, there is a hollow extending up on either side of the head. This is called the *temporal fossa*, and in it is lodged a large muscle called the *temporal muscle*. The reader may satisfy himself as to the presence of this muscle by placing his fingers above the zygomatic arch and then opening and closing the mouth alternately. The fibres of the muscle will then be felt contracting, for they are inserted into the lower jaw and help to move that bone (Figs. 194, 195, 200).

The zygomatic arches therefore act as buttresses to the cheek-bones, at the same time that they allow the fibres of the temporal muscle to pass beneath them to be inserted into the lower jaw.

The character of the face largely depends on the cheek-bones. It is to these that the Mongolian and Tartar races owe their characteristic flatness of face ; whilst they impart to the

Australian aborigines their remarkable breadth of features. The prominence of the cheek-bones, apart from these racial characteristics, depends largely upon the fullness of the tissues of the cheek. When, from absence of fat or wasting of the tissues, the cheek loses its roundness, the form of the malar bones becomes more easily recognized. Under these circumstances we describe a person as having high cheek-bones. This prominence is more apparent than real, and depends, as has been said, on the wasting of the surrounding tissues rather than on any undue projection of the bone itself. In old age they become prominent by the sinking of the cheeks beneath them.

As has been said, one of the characteristic features of man's skull is the absence of a muzzle: though this is the case, it is true that minor degrees of projection of the upper together with the lower jaw are met with. These variations in the position of the bones lead to very characteristic differences in the appearance of the features. The student may best realize this by contrasting the two extremes: viz. the ideal type represented in the antique, and that characteristic of the negro races. In the one the outline of the face is more or less vertical; in the other it slopes forward.

A Dutch anatomist named Camper was the first to draw attention to this difference and record it by a scientific method. The projection of the face can be expressed by what is termed the *facial angle*. A base line is taken which passes across the face, cutting the orifice of the ear posteriorly, and lying on a level with the border of the septum of the nose in front; on this another straight line is drawn which touches the most prominent part of the forehead above, and the anterior surface of the upper incisor teeth or the front of the upper lip below; the angle formed by the intersection of the two lines, marked in the accompanying diagrams, is the facial angle (Figs. 198, 199, *c e b*).

In order to measure this angle on the living, different forms of apparatus are used, but the method described above, if applied to a profile outline of the head, will enable the student to recognize the variations met with.

The angle ranges from 62° to 85°. These are the extremes. The former figure indicates a very marked projection, the latter a more vertical outline. Commonly the angle measures from 70° to 80°; the white races being characterized by a facial angle of from 75° to 80°, the yellow by an angle which ranges from 70° to 75°, whilst the negroid

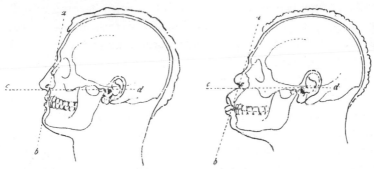

FIG. 198. Head of a European. FIG. 199. Head of a Negro.

The facial angle *c e b* is formed by the two lines *a b* and *c d*. In the negro the angle *c e b* is smaller than in the European, owing to the greater projection of the jaws.

races display a projection of the lower part of the face which often causes the facial angle to fall below 70°. In other words, the European races have more or less straight faces; the yellow, slightly sloping faces; and the black, markedly projecting faces. In the latter this appearance is further emphasized by the presence of a broad and flattened nose, and thick and everted lips.

In the more highly civilized races, as we have seen, the face is much straighter, and this may account for the ideal forms represented in the antique, in which no doubt a sense of dignity is imparted to the features by the

undue emphasis of this condition. In some of these the facial angle exceeds a right angle, a condition not met with in man under normal circumstances. Subjected to these tests many of the types represented in the antique are impossible, yet in spite of all such criticism they still remain the embodiment of all that is great and noble in art.

Another bone of much importance in the modelling of the face is the *lower jaw*. This is divided into two lateral halves, united together in the middle line in front, each half consisting of a *body*, an *angle*, and a *ramus*. The *body* of the jaw is that part which forms the arch which supports the lower teeth; in front it determines the projection of the chin, and its lower border can easily be traced beneath the skin backwards to a point a little in front of the ear. Here its lower border turns suddenly upwards, forming the *angle,* and becomes continuous with the posterior border of the *ramus*. The upper end of the rami, for there is one on each side, supports two processes. The hinder of these, which is called the *condyle* of the jaw, is furnished with a surface by means of which it articulates with the temporal bone in front of the ear, in a way which will be described below. Separated from this by a notch called the *coronoid* notch, and lying in front of it, is a pointed process called the *coronoid process*. This process, when the jaws are closed, passes up beneath the zygomatic arch, and into it the fibres of the temporal muscle, previously referred to, are inserted (Figs. 194, 195, 200).

The temporo-maxillary articulation is a joint of peculiar construction. In place of the cartilage-covered condyle of the lower jaw, coming in contact with the articular hollow on the under surface of the temporal bone, a pad of cartilage, called a meniscus, intervenes between them; the upper surface of this is adapted to fit on to the articular surface of the temporal bone, whilst its lower aspect is moulded

to receive the rounded condyle. These two joints are distinct and permit of different though associated movements. Thus a gliding movement takes place between the meniscus and the temporal bone, whilst a hinge-like movement occurs between the meniscus and the condyle. As already stated, the two movements mentioned above are intimately associated, as may be demonstrated by placing the finger over the joint and opening the mouth, when not only will the jaw be felt to swing, but the prominence caused by the condyle will be observed to advance forwards towards the cheek. Besides the movements of opening and closing the jaws, we can also move the lower jaw from side to side as in grinding the food. Further, we have the power of protruding or retracting the lower jaw, all of which movements occur at this articulation.

Connecting the lower border of the zygomatic arch with the outer surface of the jaw-bone, corresponding to the angle, is a powerful muscle called the *masseter*. Of quadrilateral form, it overlies the ramus of the jaw, and so conceals its outline, except behind, where the posterior border of the ramus can readily be felt as it passes up in front of the ear. The masseter thus corresponds to the hinder and lower part of the cheek, the fullness of which in this situation is due to the presence of this muscle. The reader may satisfy himself as to the correctness of this statement by placing his fingers on his cheeks a little in front of and above the angle of the jaw; then on firmly closing the jaws he will feel the hardening caused by the contraction of the muscles. These two muscles, the temporal and the masseter, as they arise from fixed attachments on the side of the skull, elevate the inferior maxilla and so close the jaws. They are much concerned in the movements of chewing, and are hence classed among the muscles of mastication.

The size of the lower jaw varies much, being small in

infancy, large in adult life, and again reduced in old age. But coincident with these changes in size there are also alterations in shape. If the jaw of a child be examined, the angle formed by the ramus with the body is seen to be much more open than that displayed by the adult, in whom it more nearly approaches a right angle. With advancing years the angle again alters, and becomes more like that seen in infancy. The growth and eruption of the teeth

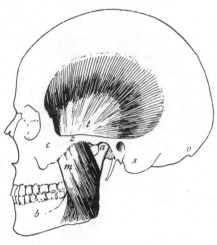

FIG. 200. Side of the skull, showing the position of the temporal and masseter muscles.

a. Condyle of lower jaw.	*o.* External occipital protuberance.
b. Body of lower jaw.	*t.* Temporal muscle.
c. Malar or cheek bone.	*x.* Mastoid process of temporal bone.
m. Masseter muscle	*z.* Zygomatic arch.

have much to do with the form of the jaw. Whilst the child derives its nourishment from the mother the body of the jaw remains small; but when nature provides it with teeth to chew its own food the jaw alters its shape. It is only after the permanent teeth have succeeded the milk-teeth that the lower jaw attains its full development. In later life, when the natural process of decay, or it may be disease, leads to the loss of the teeth, a shrinkage and

atrophy of the bone take place, which bring about the alterations in form characteristic of old age.

These variations in the shape and size of the jaw are associated with alterations in the surface forms, and account for the nut-cracker appearance imparted to the faces of old people in whom the jaws are toothless. The lips and cheeks, no longer supported by the teeth, are thin and wasted and form loose and wrinkled hollows.

The size of the teeth varies in different individuals. The lower races of man as a rule have larger teeth than the more highly civilized. This is no doubt accounted for by the fact that the higher races pay more attention to the preparation of their food by cooking, &c. Large teeth necessarily require large jaws, and we can thus account for the massive lower jaws met with in many savages. Too big a jaw imparts a brutal appearance to the face, a feature which draughtsmen have often emphasized in representing the criminal type.

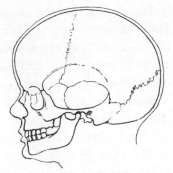

FIG. 201. Infant.

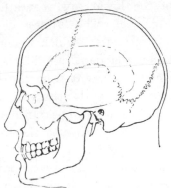

FIG. 202. Adult.

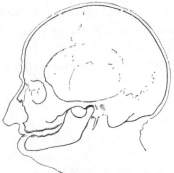

FIG. 203. Old Age.

Show the shape of the lower jaw and its influence on the surface form in infancy (Fig. 201), in the adult (Fig 202), in old age (Fig. 203).

The chin is a very characteristic feature of man's face; it depends on the forward projection of the central point of the lower jaw. It presents a variety of forms: it should be full, prominent, and somewhat square in the male, in contrast with the more pointed form which is so pleasant a feature in women. Not unfrequently a depression or dimple overlies its centre, due to a muscle which is here attached to the skin and which helps to raise the tissues of the chin in certain expressions. This muscle is called the *levator menti*; it takes its origin from the front of the lower jaw, beneath the lower lip (Pl., p. 410, Fig. 2, *c*). The fullness of the chin is increased by the quantity of fat which underlies the skin. In cases where this is abundant the chin is circumscribed by a fold below which defines it from the fullness beneath the jaw. Not unfrequently the tissues here are so loaded with fat as to give rise to the appearance of double-chin.

In some, owing to the feeble development of the lower jaw, the chin, instead of being prominent, recedes. This imparts a feeling of weakness to the whole face, in striking contrast to the look of strength and determination associated with a square jaw.

The other parts of the skeleton of the face do not require much description, as their form is masked by the overlying tissues.

The shape of the *orbits* or hollows in which the eyes are lodged varies considerably in different races. The most pronounced feature, and one which alters considerably the appearance of the face, is the overhang and projection of the brows. This, as has been said, depends on the presence of large frontal sinuses and corresponding brow ridges—a condition which leads to modifications in form of the lower part of the forehead in the male as contrasted with the female.

The form of the nose depends on the shape and size of the *nasal bones* and the arrangement and form of the *nasal*

cartilages. In a skull in which the nasal cartilages have been destroyed, in the process of preparation, the form of the nasal aperture is like an inverted ace of hearts; but on looking at a number of skulls of different races it will be seen that this opening varies considerably in appearance. In the negroid races it is broad and short, whilst in the European it is long and narrow. This corresponds with the form of the nose in the living. The negro has a broad flat nose, whilst in the white man the nose is long and thin.

Differences in the form and projection of the nasal bones are associated with characteristic variations in the shape of the nose in the living. So also the moulding of the nasal cartilages plays an important part in this the most prominent feature of the face. The disposition of the nostrils and the form of the end of the nose depend on these structures. The persistence of type in the arrangement of those parts is often remarkable, as exemplified in the characteristic nose of the Jewish race.

The root of the nose is very variable. Formed as it is by the nasal bones, its outline depends on the shape and disposition of these bones. In some the root of the nose is depressed and clearly marked by a hollow from the ridge of the brows; in others it is more projecting and carries down the outline of the forehead.

Further description of this feature is unnecessary. A great variety of shapes are met with, but the student can now realize on what structures these modifications in form depend.

The *external auditory meatus* marks the position of the ear on the skull. It is a canal leading into the interior of the temporal bone, placed between the articular hollow for the lower jaw-bone, in front, and the projecting process behind, called the *mastoid process*, to which the anterior fibres of the sterno-mastoid are attached.

In front of this aperture the temporal portion of the zygomatic arch springs.

Implanted in and surrounding this orifice is a convoluted leaf of cartilage, which when covered by skin forms the shell-like ear. Connected with the cartilage below is a quantity of fatty tissue which forms the lobe of the ear. Great differences are seen in the shape and size of the ear. In women it should be small and not projecting, its delicacy being enhanced by its colour and the light and shade which its contours impart. In men it should not be unduly large, and should lie close to the side of the head. Unpleasant forms are due to irregularities in the folding of the cartilage and a spreading out of its edge. The lobe too varies, in many being absent, whilst in others it is not free in front, but is tied down to the tissues of the cheek. Attempts have been made to identify these conditions with racial characteristics, but sufficient has been said to enable the student to judge for himself as to the forms most suitable for representation. Below and behind the ear, the hollow, which lies between the jaw in front and the anterior border of the sterno-mastoid behind, ends abruptly.

We have hitherto confined our description to the bones, cartilages, and some of the muscles of mastication which influence the surface form of the face; but covering the front of these, and serving as a mask, is an investment of skin and fat and superficial muscles. It is to this that our attention must next be directed.

It will be well, in the first instance, to study the various openings on the face. Of these there are five—the mouth, the nostrils, and the openings between the eyelids. The orifice of the ear is not included, as it lies on the side of the head and has already been sufficiently described. All these openings are liable to modification in their form by the action of the muscles which surround them. It

is largely to these alterations in shape that the expression
of the emotions is due.

The mouth, the largest and most important of these
apertures from the point of view of expression, is the cleft
between the lips; it varies much in size and in the form
of its boundaries. The lips should be full and rounded, the
red parts being clearly defined from the rest by a more or
less prominent margin. The upper lip should project some-
what, so as to throw part of the under lip in shadow. The
form of the upper lip is often a feature of great beauty.
From the angles of the mouth the red part of the upper lip
should curve over so as to form an arch, the centre of which,
however, is interrupted by a gentle groove which passes
across its middle from the septum of the nose. As this
groove joins the red edge of the lip it breaks the continuity
of the curve and imparts to it that characteristic appearance
which has been named 'Cupid's bow'. It is just where this
groove breaks the outline that the lip is most prominent.
The upper lip varies considerably in length in different
individuals, a short lip being regarded as one of the
attributes of ideal beauty. The lower lip, though full,
should not project as far forwards as the upper. Beneath
its red part it should be recurved and separated by a broad
depression from the prominence of the chin, thus tending to
cast a shadow beneath, which helps to accentuate its curved
outline. At the angles of the mouth the red parts of the
lips are narrowed down to a line and tend to be inturned.
The fullness of the tissues of the cheek here forms an angular
depression which, thrown in shadow, breaks the otherwise
abrupt union of the upper and lower edges. The modelling
of these parts displays great subtilty of form and imparts
a delicacy and finish to the curves of the lips. It is hardly
necessary here to remind the reader of the many defects
displayed in this feature.

An undue length of the upper lip, as well as thinness or

excessive fullness of the red parts of the lip, are characters which should be avoided in ideal conceptions, though doubtless they have their value in the representation of more realistic types. The most remarkable feature about the mouth is its extreme mobility; this we will see hereafter is of the greatest value as a modifying influence in expression.

The structures which determine the form of the nose have been already described. The form of the nostrils displays many varieties, according to the shape of the nose. These openings are separated by the septum, which joins the upper lip at a point corresponding to its median furrow; on either side, the cartilages which form the *alae* of the nose overhang the nostrils. These cartilages are separated posteriorly from the fullness of the cheek by a curvilinear furrow. Their lower borders are more elevated than the lower border of the septum, so that in profile the septum determines the outline, and the aperture of the nostril is seen. The shadow thrown across the nostril by the overhanging ala is warm in tone, owing to the exposure of the highly vascular membrane which lines the interior of the opening. It is worth noting at present that the alae of the nose are slightly movable, and are to a certain extent under the control of the will.

The size of the eyes depends on the extent of the surface of the globe exposed between the eyelids. This naturally varies with the length of the fissure between the lids, which on the statement of expert authority should form one-fifth of the width of the head. The two apertures should be separated by a width equal to the length of one.

With the eyes open, the angles formed by the union of the upper and lower lids should lie on the same horizontal line. Deviations from this are not uncommon, the most remarkable being that in which the outer angles are raised, thus giving the eye an oblique appearance. It is partly due

to this obliquity that the eyes of the Chinese and Japanese owe their distinctive appearance. Another characteristic of these races is the condition known as *epicanthus*; in this the inner angle of the eye is overhung by a fold of skin which passes downwards from the upper eyelid. This appearance is not unfrequently met with in European infants, though in them it usually disappears as the child grows up.

The globe of the eye rests on a pad of fat within the orbit. Its movements are controlled by the action of six muscles which are attached to it. If the fat within the orbit be scant in amount, the eyes appear deep-set and sunken. When prominent the condition depends on the increase in the bulk of these supporting pads.

The setting of the eyes is further affected by the prominence of the brows. When these overhang, the eyes appear deep-set. The orbital margin is only recognized as a surface form along the brows and towards the outer side. Below, the skin passes from the lower lid to the cheek without any indication being given on the surface of the lower margin of the orbit.

Of the two eyelids, the upper is the longer and the more movable. The closing of the eye is effected by the descent of the upper eyelid, and not by the raising of the lower lid. The margin of the upper lid is more curved than that of the lower. Both margins are furnished with eyelashes, of which the upper are the longer. The margin of the upper lid is sufficiently thick to throw a shadow on the eyeball beneath it. Viewed from the front or side, the surface of this margin is not visible. The margin of the lower lid, thinner than that of the upper, is upturned, and, viewed from the front in ordinary positions, is clearly seen. From its colour and from the fact that, being a moist surface, it more readily catches the light it forms an element of much importance in the drawing of the eye.

The inner and outer angles between the eyelids differ. The outer angle, or *external canthus* as it is called, is formed by the upward curve of the lower eyelid beneath a fold which is continuous with the margin of the upper lid. Internally the two eyelids do not directly unite with one another, but are separated by a small ⊃-shaped recess. Here are found the ducts which carry away the tears, and here also a small triangular-shaped vascular fold, which stretches across the angle between the lids, supplies the painter with opportunities of applying local colour. The red tint of this fold is carried inwards into the recess aforementioned. Passing inwards towards the root of the nose from the *inner canthus*, for about one-eighth of an inch, a prominent surface ridge can often be seen which is due to the presence of a little ligament called the *tendo oculi*, which unites the eyelids with the inner wall of the orbit.

When the eyes are closed, as in sleep, the form of the upper lid depends on the shape of the eyeball. This is not a simple sphere, but consists of part of a sphere of smaller diameter placed on the front of a larger one. It might be compared to a well-curved watch-glass placed on the surface of a cricket-ball. This more prominent part of the eyeball is called the *cornea* ; it corresponds to the coloured part of the eye as distinct from the white of the eye. The white of the eye is due to the white glistening fibrous coat of the eyeball, called the *sclerotic*. This serves as a protection for the delicate contents within the globe. The corneal part of the eyeball is transparent, and allows of the transmission of the colour of the parts which lie within. The colour of the eye is due to the pigment in the *iris*, a curtain which serves to control the amount of light which enters the interior of the eye. It corresponds to the diaphragm of a photographic lens, varying the size of the aperture or *pupil* through which the light passes.

Both the cornea and sclerotic, so far as they are exposed

between the eyelids, are covered by a delicate membrane, called the *conjunctiva*, which is always kept moist by the secretion of the tears and thus reflects the light which falls upon it. In this way the 'high light', which is so important a detail in the drawing of the eye, is accounted for. The presence or absence of this high light and its position will vary with the direction of the light falling on the eye of the model. An abuse of this high light is frequently seen in productions of ' artist ' photographers.

When the eye is open the upper eyelid is withdrawn within a deep fold, which repeats more or less accurately the curve described by its free margin. Above this fold the tissues form a fullness which is continuous above with the projecting brows. Variations in the outline of these details are of course numerous, and alter with the expression and the modelling of the parts.

Expression is in great part due to the modifications which take place in the form and outline of the features which have just been described, but the study of the subject is beset with many difficulties, and is by no means so easy as at first appears. To take a case in point, the differences between the expression of terror and horror are but slight, yet so marked that there is no mistaking them. Horror is not necessarily associated with fear, nor terror with disgust, yet both are remarkable for the general similarity in the mode of their representation. The analysis of these differences requires careful study, and many subtilties are apt to escape the casual observer. The artist may rely on his models for their outward shape, but it is only exceptionally that he can trust to those means for the inspiration which quickens his forms and gives life and directness to their actions.

In the study of expression, the broader effects are easily attained by what one may almost term conventional methods. It is only when the more delicate shades of difference are

treated that we recognize the master hand. This comes home to us in our experience of the stage. We acknowledge success and condemn failure almost intuitively. When the mimicry of the actor falls short of our standard of experience we do not hesitate to criticize his performance adversely, yet how often are we unable to explain the reasons of his lack of success! He has failed to appeal to us because he has not seemed natural, for though he has employed all the conventionalities of his art he has omitted the niceties which infuse truth and realism into his conception.

It is the recognition of these details and shades of difference that enable us at once to place our finger on the weak spot, and it is only by prolonged study and careful observation that we can hope to attain to anything like excellence in this respect. Fortunately we are able to avail ourselves of the experience of a great teacher. Darwin, whose book on the *Expression of the Emotions* is a masterpiece of thoughtful inquiry, has given us a striking exposition of the manner in which these problems should be attacked. The student will be well repaid if he reads this book, for not only will his interest be aroused, but his spirit of inquiry and observation will be stimulated.

It is outside the scope of this work to attempt anything like a full consideration of this subject, and in the following pages only a few of the more striking facts are referred to.

As has been said, expression largely depends on the alteration in the form of the features by muscular means, but the student may be reminded that action is not confined to the facial muscles alone. Attitude and posture largely assist us in the expression of the emotions; the pose of the body, the turn of the head, the position of the hands, all bear a part.

There are changes due to other factors, as for instance the blood-vessels and their contents. In certain conditions of excitement, the heart beats faster, the blood-vessels are

filled with more blood, and the countenance becomes suffused. On the other hand there are emotions associated with a great diminution in the quantity of blood in the cutaneous vessels, attended by a death-like pallor of the surface of the body. These changes in the circulation react, too, on other organs and systems; thus the eye becomes more brilliant in certain forms of excitement, due to an increase in the tension of its contents, whereas in other conditions, as in extreme prostration through fear, &c., it lacks much of its natural lustre. Again, perspiration is a result of similar influences, and curiously enough, this transudation through the pores of the skin is associated either with increase or decrease in the amount of blood in the cutaneous capillaries. Reference need only be made to the occurrence of a cold and clammy sweat in states of terror to verify this fact. Blushing is also due to vascular changes dependent on nervous influence, but as the quality of a blush, as contrasted with a general heightening of the colour, depends upon its transient nature it is outside the range of pictorial representation. A moment's consideration will enable the reader to realise that, whilst the contraction of the facial muscles is under the influence of our will, the vascular and nervous phenomena above referred to are beyond our control, and hence beyond our powers of mimicry, so that in representing the various emotions the artist must rely on his own experience and observations rather than on the conventional efforts of his model.

It is with the first group of phenomena, viz. those due to the contraction of the facial muscles, that we are mainly concerned. In discussing these we must bear in mind that the openings on the face are each associated with a particular sense: the eye with sight, the nose with smell, and the mouth with taste; moreover the nose and the mouth are also concerned with the admission of air to

the lungs. The bearing of these facts will be seen here-
after, when we come to realize that certain emotions are
associated more or less intimately with certain of these
senses. Thus the turning away of the eyes in shame, the
sniffing associated with a disdainful look, and the move-
ments of the lips frequently observed in the expression of
disgust, are proof of the association of these emotions with
particular sense organs. One ashamed does not look the
accuser in the face; the sniffing in disdain implies that
a person by his very odour has rendered himself offensive;
and in disgust the same meaning is conveyed as if by the
movement of the lips on an unsavoury morsel.

The muscles of expression may be grouped as follows,
viz. those which influence the movement of the scalp, and
particularly that part of it which forms the covering of the
forehead, and those which control the form of the various
apertures of the face, i. e. the eyes, nose, and mouth.

The scalp consists of the tissues overlying the skull, from
the brows in front, to the external occipital protuberance
behind. The part which covers the forehead is free from
hair, that behind forms the hairy scalp. It is loosely
connected with the underlying bones, so that it can be
moved backwards and forwards on them. The freedom
of this movement varies very considerably in different
individuals. Many possess this power to a remarkable
degree, whilst in others it is almost absent.

These movements are effected by the action of certain
muscles—most important of which is the *occipito-frontalis*.
This muscle consists of two thin fleshy portions with an
intermediate fibrous sheet, called the *epicranial aponeurosis*.
The occipital part of the muscle covers the back of the
head and is attached to the ridge on the occipital bone
called the *superior curved line*. This corresponds to the
junction of the tissues of the neck with the back of
the head. Superiorly the fleshy fibres are connected

with the hinder part of the epicranial aponeurosis. The frontal part of the muscle overlies the forehead : it has no bony attachment. Superiorly it arises from the fore part of the epicranial aponeurosis, and inferiorly is inserted into the skin of the brows and the root of the nose (Pl., p. 410, Figs. 1, 2, *n. q. 15*).

When this muscle contracts, as in the expression of surprise, it *raises the skin* of the forehead, and throws it into a series of folds, which repeat fairly accurately the curves of the eyebrows. Descending from the frontalis, on either side of the middle line and over the root of the nose, are two little muscular slips called the *pyramidales nasi*. These have their fixed points below, and are attached in part to the outer surface of the nasal bones, and in part to the aponeurosis which overlies the cartilages of the nose. When these muscles act they therefore *draw down* the skin of the forehead towards the centre, thus causing a depression of the inner ends of the eyebrows and a wrinkling of the skin over the root of the nose. Such movements are associated with expressions of displeasure, as in frowning (Pl., p. 410, *m*).

The *corrugatores supercilii* muscles occupy an oblique position above the inner half of the brows, one on either side. They lie under cover of the frontalis, and arise from the bony arch of the orbit on either side of and slightly above the root of the nose ; spreading outwards and upwards they become attached to the skin over the middle of the eyebrows. When these muscles contract, the skin over the outer part of the forehead is drawn inwards, and a series of central longitudinal folds is produced. The muscle is usually combined in its action with the foregoing, that is to say either with elevation or depression of the skin of the forehead. In this way the transverse folds produced by the frontalis and pyramidales are modified in the middle line. In combination with the central part of

MUSCLES OF THE NECK AND FACE.

a. Trapezius.
b. Platysma myoides.
c. Levator menti.
d. Depressor labii inferioris.
e. Depressor anguli oris.
f. Risorius.
g. Orbicularis oris.
h. Zygomatici.
i. Depressor alae nasi.
j. Compressor naris.
k. Levator labii superioris alaeque nasi.
l. Orbicularis palpebrarum.
m. Pyramidalis nasi.
n. Frontalis (cut on left side).
o. Corrugator supercilii.
p. Surface of skull exposed by removal of epicranial aponeurosis.
q. Epicranial aponeurosis.
r. Temporal fascia covering temporal muscle.
s. Levator labii superioris.
t. Levator anguli oris.
u. Buccinator.
v. Masseter.
w. Hyoid bone.

x. Thyroid cartilage of larynx (Adam's apple).
y. Anterior belly of omo-hyoid.
z. Sterno-hyoid.
1. Placed on structures which form lower part of floor of posterior triangle (levator anguli scapulae, scalenus posticus, and scalenus medius).
2. Posterior belly of omo-hyoid.
3. Acromial end of collar-bone.
4. Upper end of breast-bone.
5. First rib with costo-clavicular ligament.
6. Acromion process of scapula.
7. Sterno-mastoid.
8. Origin of sterno-mastoid from breast-bone.
9. Acromion process and spine of scapula.
10. Parotid gland.
11. Zygomatic arch.
12. Anterior auricular muscle.
13. Superior auricular muscle.
14. Posterior auricular muscle.
15. Occipitalis.
16. Complexus.
17. Splenius capitis.
18. Levator anguli scapulae.

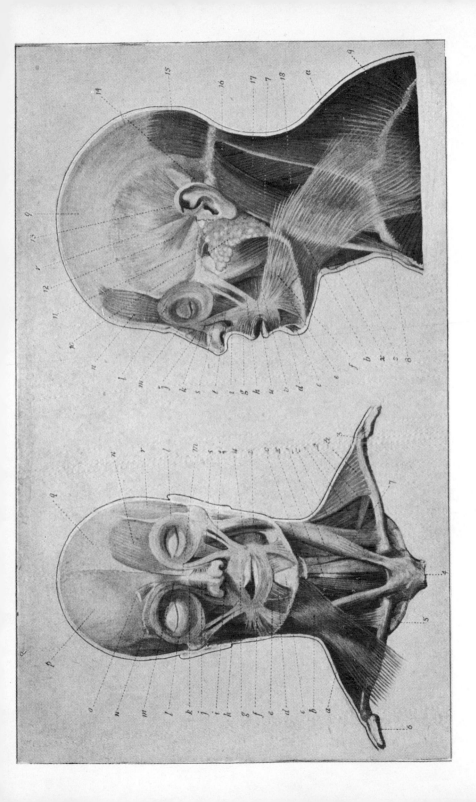

the frontalis the corrugatores supercilii cause the eyebrows to become oblique, and pucker the skin in the centre of the forehead, as in the expression of grief. In associated action with the pyramidales muscles they help to emphasize the wrinkling over the root of the nose and lower part of the forehead as in frowning. If the reader will consider for a moment the results produced by the contraction of these muscles he will realize that the wrinkling of the skin caused by them is always transverse to the direction of the fibres of the muscles (Pl., p. 410, Fig. 1, *o*).

In passing to the consideration of the muscles of the face proper we recognize that they are grouped around the various orifices, each of which is provided with opening and closing muscles, in addition to others which modify their shape.

Surrounding the fissure of the eyelids and overlying the lids themselves is a thin sheet of muscle called the *orbicularis palpebrarum*. The fibres are arranged in a series of concentric loops which are attached internally to the inner bony margin of the orbit. Elsewhere the muscle spreads over the margin of the orbital hollow and is connected with the skin superficial to it. Above, it blends with the frontalis and lies superficial to the corrugator; inferiorly, it is connected with some of the muscles of the cheek. The part of the muscle which overlies the lids is called the *palpebral* portion. The action of this is to close the eyelids. Under ordinary conditions the lower lid moves but slightly, the upper being drawn down over the surface of the globe. Exceptionally, as in the act of ' winking ', the closure of the lids is effected by the elevation of the lower lid.

That portion of the muscle which lies around the lids is called its *orbital part*. The lower half of the orbital fibres elevates the skin of the cheek and wrinkles the skin over the outer margin of the orbit, producing the skin folds which, in old people, are often called ' crows' feet '. The upper half draws down the skin of the forehead

and antagonizes the action of the frontalis. It pulls down
the eyebrows and causes them to overhang. The muscle,
as a whole, is employed in forcible closure of the eyes, as
when a blow is expected. The lids are strongly compressed
against the front of the globe, which is slightly pushed
backward at the same time that the lids are carried a little
inwards towards the bony attachment of the muscle (Pl.,
p. 410, Figs. 1, 2, *l*).

The eye is opened by the action of a muscle called the
levator palpebrae superioris (the elevator of the upper lid).
This muscle lies within the orbit, and is attached to the
deep surface of the upper eyelid. Its action is sufficiently
expressed by its name.

The eye plays a most important part in the expression of
the emotions. The changes met with in it are due to several
causes. First, its brilliancy may be increased or diminished
according as there is an increase or decrease in the tension
of the contents of the eyeball. These changes are beyond
our control, and are associated with exalted feelings on the
one hand or a sense of depression on the other which react
on the circulation. In the former state the eye is bright
and sparkling, whilst in the latter it appears dull. An
increase in the tears which bathe the surface of the eyeball
leads to the more ready reflection of the light from the
moist, exposed surfaces. An excessive increase leads to
the shedding of the tears, which takes place in certain
violent and uncontrollable emotions.

The movements of the eyeball, which are distinct from
those of the eyelids, have a definite influence on expression.
The downcast eye indicative of shame, the upturned eye
suggestive of devotion, the averted eye associated with
the expressions of disgust and aversion, the downward
and sidelong look in contempt, are all well-marked ex-
amples.

Lastly, we have the relation of the opening of the eyelids

to consider. In such emotions as surprise, terror, and horror the eyes are widely opened. The partial closure of the lids may be associated with a contemptuous look, in which there is a suggestion that the person is not worth looking at, and that we would experience little loss if we shut him out from our sight. Narrowing of the opening between the eyelids is often seen in people whose attention is concentrated on some thought, or who are gazing steadfastly at some object. Here it is often combined with a slight frown. The purpose of this action may be either to allow less light to enter the eye or to shut out surrounding objects.

The eyelids are forcibly closed when we expect to receive a blow or sudden shock, and one of the first difficulties a novice in boxing has to overcome is to control this tendency. Here the closure of the lids is obviously for the purpose of protection. In like manner, in such violent expiratory acts as sneezing and coughing, the eyeballs are supported by the closed lids. In laughter the orbicular muscle is contracted, the skin around the eye is wrinkled, and the opening between the eyelids is narrowed.

Apart altogether from the influence of the eye on expression, the student should note the delicacy of the skin below the lower eyelid and on the inner side towards the root of the nose. Here the cutaneous vessels exercise a marked influence on the surface colour. In some, a dark tint often enhances the brilliance of the eyes. The general recognition of this fact has led to its adoption by artificial means in the art of 'making up'.

The eyebrows and eyelashes differ in different individuals. The former should be well arched and separated by an interval. The latter vary in their length and in the character of their sweep. Dark eyelashes mask to a certain extent the drawing of the margin of the lids, as they surround the opening of the eyelids with a dark indefinite zone. The colour of the eyebrows and eyelashes need not neces-

sarily conform with that of the hair. It is by no means uncommon to meet with women with fair hair and dark eyebrows and lashes, though it may here be pointed out that the same results may be obtained by the practice of the mysteries of the toilet.

Though man is unable to open and close the nostrils, he yet possesses a considerable amount of control over the size of these apertures. This is effected by the movements of the nasal cartilages. The reader must bear in mind that the nose is not only the organ of the special sense of smell, but is also one of the channels through which air passes to and fro in respiration; hence the muscles which control the movements of these cartilages are concerned with the changes in the form of the nostril which accompany forced respiration, as well as those which are associated with the perception of smell.

Of these muscles the most important are the *compressor naris*, the *levator alae nasi*, and the *depressor alae nasi*.

The compressor muscles are placed on either side of the nose. They arise from the upper jawbone, close to the bony margin of the nasal aperture. Spreading out in a fan-shaped manner on the sides of the nose, they are inserted into a thin aponeurotic expansion which stretches across the bridge of the nose. Overlying, as these muscles do, the cartilaginous part of the nose, when they contract they tend to depress the cartilages and so compress the alae, as they overhang the nostrils (Pl., p. 410, Figs. 1, 2, *j*).

The *levator alae nasi* forms part of a muscle called the *levator labii superioris et alae nasi*. It takes origin above from the bone in front of the orbital margin, and close to the root of the nose; its fibres pass downwards along the side of the nose and are inserted into the wings or alae of the nostril. As its name implies, this muscle raises the wings of the nose and hence dilates the nostril, as in the act of sniffing. Its action is associated with an elevation of the

upper lip at the same time, owing to the fact that some of the fibres which arise from the same bony attachment pass down to be inserted into the upper lip; hence the name given to the whole muscle (Pl., p. 410, Figs. 1, 2, *k*).

The *depressor alae nasi* takes origin from the upper jaw-bone, immediately above the front teeth. Its fibres pass upwards to be inserted in part into the septum of the nose, in part into the posterior aspect of the wings of the nostril. The muscle draws down the septum and assists the compressor in depressing the alae of the nose and narrowing the nostril. Under ordinary circumstances the movements of the alae are imperceptible in respiration. In violent inspiratory efforts, after prolonged muscular exercise, or in conditions of intense excitement accompanied by deep inspirations, the dilatation of the nostrils becomes a characteristic feature. When we wish to analyze more carefully the nature of a particular odour we draw the air up forcibly into the nose and then contract the orifice so as to prevent its escape. These are the sniffing movements, movements which are often the involuntary accompaniment of such expressions as contempt and disdain (Pl., p. 410, Figs. 1, 2, *i*).

Of all the features, the mouth is the most mobile and the most under our control. Though many of its movements are in a sense involuntarily associated with certain moods, yet they may be checked by the exercise of the will. In like manner we can, with a certain degree of success, simulate by the voluntary contraction of some of its muscles the expressions which are habitually dependent on the more or less co-ordinated action of these muscles.

The mouth ranks first therefore as a modifying agent in the appearance of the features. The slight upturning of the angles of the mouth imparts to the face an altogether different appearance from that displayed when the angles

are down-drawn. In support of the view that the mouth is such an important factor in the determination of expression, we have only to take into consideration the number of muscles which surround it.

Generally speaking, the muscles of the mouth may be divided into groups according to their action. There is a closing muscle called the *orbicularis oris.* There are muscles which raise the upper lip, others which elevate the angle; some which retract the angles, and some which draw them down; and, finally, there are those which depress the lower lip.

The *orbicularis oris* consists of an oval sheet of muscle of considerable thickness which surrounds the orifice of the mouth. Its inner edge corresponds to the red margins of the lips. Its outer border spreads upwards towards the base of the nose, outwards towards the cheek, and downwards as low as the furrow which separates the lower lip from the chin. The muscle is connected by slender slips with both upper and lower jaws, above and beneath the front teeth. The bulk of the muscle, however, is made up of fibres which pass across from side to side and turn upwards and downwards at the angles of the mouth. The outer border of the muscle is blended with the various elevators and depressors of the lips and angles, and is also intimately connected with the muscles of the cheeks. The muscle closes the mouth and brings the lips together; it also narrows the mouth and causes the lips to protrude (Pl., p. 410, Figs. 1, 2, *g*).

The elevators of the upper lip are two in number. One has been already in part described, viz. the *levator labii superioris et alae nasi.* The fibres of this muscle which pass to the lip are blended with the orbicularis on either side of the wings of the nostrils (Pl., p. 410, Figs. 1, 2, *k*).

The *levator labii superioris proprius,* or special elevator of the upper lip, arises from the front of the upper jaw-bone,

close to the lower margin of the orbit; it is more or less
united with the preceding muscle, and is inserted into the
tissues of the upper lip (Pl., p. 410, Figs. 1, 2, *s*).

The elevators of the angles of the mouth are the *levator
anguli oris* and the *zygomaticus major* and *minor*.

The *levator anguli oris* arises from the front of the upper
jaw-bone under cover of the levator labii superioris pro-
prius, and passes downwards and slightly outwards to be
inserted in the upper border and outer side of the angle of
the mouth (Pl., p. 410, Figs. 1, 2, *t*).

The *zygomatici* are two muscular slips which arise from
the outer surface of the cheek-bone and pass downwards and
forwards to reach the angle of the mouth, where they are
inserted (Pl., p. 410, Figs. 1, 2, *h*).

All three muscles are elevators of the angles of the
mouth, but the latter tend to draw the angles upwards
and outwards, as in the broad grin, whereas the levator
anguli oris tends to inturn the angle.

We have already seen how the platysma myoides (p. 374)
passes up from the neck on to the face to be connected with
the muscles of the lower lip. Some of its more specialized
fibres have received a definite name, and constitute the
risorius muscle. These fibres arise from the fascia of the
cheek in front of the ear, and, passing forwards, are attached
to the skin of the angle of the mouth. They act as retractors
of the angles and thus widen the mouth (Pl., p. 410, Figs.
1, 2, *h, f*)

The depressors of the angles of the mouth include the
depressor anguli oris and the fibres of the platysma which
are passing to the angle.

The *depressor anguli oris* arises from the lower jaw near
its lower border, on either side of the middle line. The
muscle, which is triangular in shape, and is hence some-
times called the triangular muscle of the chin (*triangularis
menti*), is attached by its pointed extremity to the tissues

of the angle of the mouth on its lower side. The fibres of the platysma have been already referred to.

Both these muscles pull down the angle of the mouth, the platysma at the same time drawing it backward and outwards (Pl., p. 410, Figs. 1, 2, *e*).

The depressor muscle of the lower lip is the *depressor labii inferioris*. It arises from the front of the lower jaw under cover of the depressor anguli oris. Square in shape, and hence sometimes called the *quadratus menti*, it passes upwards and is inserted into the tissues of the lower lip, blending with the orbicularis oris. The action of this muscle is assisted by the fibres of the platysma (Pl., p. 410, Figs. 1, 2, *d*).

The *levator menti* is a small muscle which arises from the front of the lower jaw, below the front teeth. Running downwards and forwards, it spreads out and is inserted into the skin of the chin sometimes causing a dimple there. By raising the chin, as its name implies, it also elevates the lower lip and protrudes it (Pl., p. 410, Fig. 2, *c*).

The action of the various muscles on the form of the mouth has been referred to as each has been described, but a moment's reflection will enable the reader to understand the complexity of form which is the result of their combined action. Not only is this the case when the lips are closed, but an altogether different shape may be given to the open mouth by the squaring of the angles, or the inturning and protrusion of the lips.

Note also how the mouth is, like the nose, associated with a special sense, viz. that of taste, and also with the respiratory function. In association with taste we frequently have movements expressive of pleasure or disgust, movements such as would be performed by the lips on the reception of a tasty bit or the rejection of an unsavoury morsel.

The mouth is not only a channel through which air may enter and pass from the lungs, but also exercises an important influence in speech and voice-production. In making

a violent muscular effort after the chest has been filled with air the mouth is firmly closed, as if to prevent its escape. On the completion of the act the mouth is again opened and the air expelled from the lungs. Under ordinary and healthy conditions the nose alone suffices for the purposes of respiration, but under exceptional circumstances, when the respiratory efforts are much increased, the mouth is often made use of to enable us to get more breath. So delicate and precise are the forms given to the lips in speech, that advantage is taken of this circumstance to enable the deaf and dumb to read by sight the words which fall from the lips of a speaker they cannot hear. A striking example of the characteristic appearance of the mouth and lips in the production of certain notes is seen in the figures on the sculptured frieze executed by Luca della Robbia, in conjunction with Donatello, for the organ gallery of the cathedral at Florence. The visitor to the Uffizi Gallery has little difficulty in determining from the expression of the singers the character of the voice.

The mouth is opened widely in surprise and awe. So also in disgust and laughter, though the forms are very different. A vacant, silly look is often given to the face by an open mouth.

A firmly closed mouth is expressive of determination. The closure of the jaws and the opening of the mouth so as to show the clenched teeth are suggestive of hatred, and hint at the use of the teeth as weapons of offence.

The upturned angles are characteristic of the merry moods, whilst a down-drawn mouth is associated with less pleasant emotions.

In connexion with these alterations in the shape of the mouth it is well to note how furrows, which play an important part in expression, become developed. The most important of these is the *naso-labial* furrow. This separates the rounded form of the cheek from the wing

of the nose, and, sweeping downwards and outwards, fades away imperceptibly towards the angle of the mouth. Coincident with certain movements of the mouth, this furrow is emphasized and altered in its direction. In laughter and crying it is much deepened and curved. It is deepened above, when the skin on the side of the nose is drawn up and wrinkled, and it is straightened when the angles of the mouth are depressed. The furrow may either be carried round the angle of the mouth, or may be replaced by another which continues the curve of the upper lip downwards and outwards.

Reference has been already made to the association of facial expression with gesture and pose of the body. Gesture and pose express the emotions on a large scale, the face being concerned rather with the subtilties and details. As Professor Cleland[1] has pointed out, gesture largely depends on the association of mental with physical conditions. Moral rectitude, as expressed in indignation, is associated with a straightening of the figure; mental depression is indicated by a lack of energy in the movements of the body.

In like manner certain emotions are expressed by gestures which have a purely physical basis. We often convey the meaning that we wish to avoid or shun a thing by putting up the hands as if to push it aside. We bend the body forward and incline towards what pleases us, or indicate by the direction of a wave of the hand whether we desire a person to approach or leave us. These examples are sufficient to enable the reader to appreciate the physical reasons for the gestures so frequently employed.

In providing a short summary of the more striking characteristics of some of the expressed emotions, the details must necessarily be brief and the selection far from complete.

[1] *Evolution, Expression, and Sensation,* by John Cleland, M.D., F.R.S. Glasgow: James Maclehose.

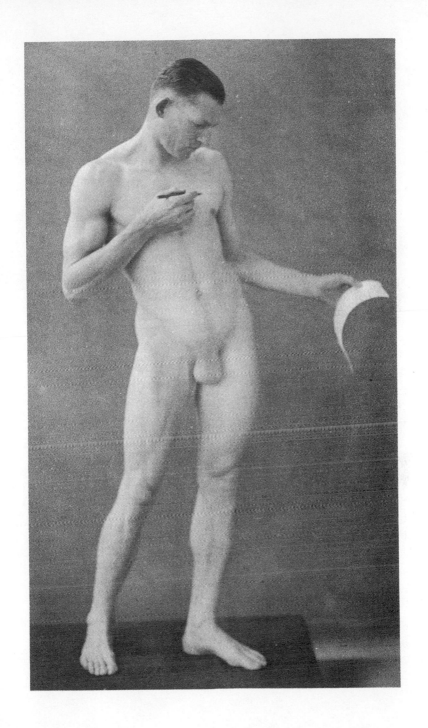

Sir Charles Bell[1] laid it down as a general rule that 'in all the exhilarating emotions the eyebrows, eyelids, the nostrils, and angles of the mouth are raised; in the depressing passions it is the reverse'.

To this may be added the suggestive remarks of Professor Cleland, that 'expression for the information of others is most liable to be made with the mouth, the organ of communication with the world; while expressions that betray thoughts unintentionally to the outer world are most liable to begin in the eye and forehead.'

In the expression of suffering as shown in a crying child we see the eyes firmly closed and the skin around them puckered. The skin of the forehead is drawn down and wrinkled by the corrugators and pyramidales so as to cause a frowning appearance. At the same time the skin of the nose is wrinkled and the upper lip drawn up, and the angles of the opened mouth are somewhat squared by the antagonizing influence of the depressor anguli oris.

Such expression is characteristic of a child 'roaring' with pain or temper, but, as Professor Cleland has remarked, the expression is very much akin to that of an adult 'roaring' with laughter. In proof of which we need only, as he points out, make the experiment with one of Darwin's own illustrations[2] by covering with a card all but the head of the child; then sketch on the card the figure of a fat old man lying back in his chair, and the child's face, without a stroke of change, will be converted into the bald head of the old man convulsed with laughter. Laughter, sobbing, and crying, as Professor Cleland points out, have the feature in common of convulsive breathing; the appearances are not dissimilar, and the value of the above experiment depends on the association of ideas. 'Old men are

[1] *The Anatomy of Expression.* Third edition, 1844.

[2] *Expression of Emotions*, by Chas. Darwin, Plate I, Fig. 2. John Murray, London, 1872.

more given to roar with laughter than to bellow like children.' Hence the very different interpretations placed upon the expression.

In prolonged grief the face is pale, the eyelids droop, and, owing to the flaccid condition of the muscles, the lips, cheeks, and lower jaw all sink down by their own weight. By the contraction of the central portion of the frontalis and the two corrugators the eyebrows are drawn upwards towards the centre of the forehead and assume an oblique direction, whilst the skin of the forehead is wrinkled, with rectangular furrows towards its centre. The drooping of the head on the chest is also characteristic of this form of emotion.

Laughter is expressed by the opening of the mouth, the angles of which are either drawn back, as in the broad grin, or drawn back and upturned. The upper lip is slightly raised, the naso-labial furrow is deepened and curved round the angles of the mouth. The skin over the nose is finely wrinkled, and the eyebrows are slightly lowered. The eyes are partially closed by the contraction of the orbicularis palpebrarum, which also wrinkles the skin around the lids. The eyes themselves are bright and sparkling, due to the acceleration of the circulation within them.

Devotion is associated with an upturned face and eyes, and hands either clasped or crossed on the breast.

Reflection, abstraction, and meditation are characterized by slight frowning movements and a vacant look in the eyes, due to the fact that we are ' staring at nothing in particular'. The eyes are not concentrated on any object, and sometimes are slightly divergent, conveying just the suggestion of a squint.

Ill temper is suggested by a frown and the depression of the angles of the mouth ; sulkiness, by a pouting of the lips, accompanied with a downward turn of the angles.

Determination is indicated by a firm closure of the mouth, accompanied by a deep inspiratory effort, at the same time that the whole muscular system is ready for action. A nod, as when a person says ' I'll do it', frequently accentuates the expression.

Shyness, on the other hand, is often associated with blushing and a desire to avoid looking one in the face, as suggested by the averted or down-turned head. Shyness and shame are very much alike, though the former is often distinguished from the latter by a pouting of the lips.

In rage the circulation is much affected ; the face reddens and the veins of the neck and forehead become distended. In other cases pallor is a marked feature; the person so affected becomes 'white with rage'. The chest heaves with the more violent respiratory efforts, and the nostrils quiver, the mouth is closed, and the teeth are firmly clenched. At times the lips are protruded, or, it may be, retracted, so as to show the teeth. The brows are frowning, and the eye is bright and flashing; the hair may bristle, and the voice is affected—it 'sticks in the throat' and is often trembling and discordant. The fists are frequently closed as if to strike, but in extremes of passion the movements of the hands and arms may be purposeless.

Indignation differs only in degree from rage. The pulse is slightly quickened and the colour heightened ; the eye is bright, and the wings of the nostrils are raised ; the mouth is commonly compressed. Respiration is hurried, and the figure is drawn up and the head thrown somewhat back.

Sneering is characterized by an upturned and averted face, and a retraction of the upper lip so as to expose the ' eye ' or ' canine ' tooth. As Darwin has pointed out, this reveals man's ancestry, for the action is the same as that of a snarling dog when showing his fighting teeth or canines, preparatory to a tussle with his antagonist.

In disdain the expression is accompanied with a partial

closure of the eyelids, as if the person looked at were disagreeable to the sight or unworthy of a glance. In contempt the upturned and wrinkled nose suggests an offensive odour, whilst in disgust the movements of the lips or the clearing of the throat convey the impression that the person so moved is endeavouring to rid himself of an ill taste or some unsavoury mouthful.

Helplessness is usually suggested by elevated eyebrows and wrinkled forehead. The mouth is usually open and the head bent to the side. The elbows are placed by the side, and the palms are upturned and open. A shrug of the shoulders helps to emphasize the expression.

The expressions of attention, surprise, astonishment, and terror are closely allied, and may succeed each other in an apparently natural sequence. In attention the eyebrows are elevated and the forehead is wrinkled, and the opening of the eyes and mouth corresponds to the degree of surprise or astonishment. In admiration the same appearances are seen, but here the mouth expands into a smile, and the eye brightens.

Fear, on the other hand, is accompanied by pallor. A clammy sweat often breaks out on the surface of the skin, the mouth is dry, the heart beats violently, and there is trembling all over.

In terror these phenomena are all accentuated. A deathlike pallor overspreads the surface. The nostrils are dilated and the breathing is laboured. There is gulping of the throat and a convulsive movement of the lips. The eyeballs protrude and roll from side to side; the cheeks are trembling, and beads of perspiration roll down them. The violent contraction of the platysma causes the wrinkling of the skin of the side of the lower jaw and neck, and drags down the angles of the opened mouth. The person so affected is utterly unnerved and bordering on a state of collapse.

Horror, as distinct from terror, is characterized by contracted brows with no loss of energy. The body is in a state of extreme tension, but the victim of this sensation is not unnerved by fear, and has not lost control over his actions.

In conclusion, it is merely necessary to remind the reader that when an expression becomes habitual the cast of the features is moulded thereby. The face of a sleeping child is calm and expressionless; it is as it were the clay on which nature is going to stamp the character of the man, for expression uncontrolled is but the outward evidence of the working of the mind. According to the disposition of the individual, so the features become set. We recognize a morose and ill-tempered man by his look, for in him the habitual mood has become more or less permanently expressed by every feature in his face.

One example is sufficient to enable the reader to recall many others in which the general temperament is as characteristically displayed.

CHAPTER XIV

A CANON of proportion in strict accordance with scientific measurements would result in mere commonplace. Science seeks to attain an average, art an ideal. The artist searches for his models amongst those who display the most graceful and refined types of manly strength and feminine beauty, whilst the anthropologist and anatomist are content to measure all, good, bad, and indifferent, in their endeavours to strike a mean.

As every artist knows, it is impossible to find a model without blemish. The ideal conception depends on the selection from different models of those features which are most pleasing, the combination forming a masterpiece very different from the vulgar average put forward by the anthropologist as typical of the race. The scientific criticism of proportion as applied to art is therefore misleading, and, far from aiding the artist, is like to sink him to the level of the mere chronicler of facts. For such as desire the information there are many works in which the subject is discussed from a scientific standpoint. Here it is neither my intention nor desire to trouble the reader with details which, however interesting, have little to do with his art education.

The main difficulty which has always presented itself in this connexion is the unit of comparison which is the best to adopt. For draughtsmen who are not constructing human figures on geometrical principles with rule and compass it is important that the unit employed should be

easily compared with the rest of the figure. The head, face, hand, foot, and middle finger have all been selected by different artists and anatomists for this purpose.

The history of the subject is by no means uninteresting, and should the reader desire to extend his knowledge further in this direction he may consult with advantage a work entitled *Proportions of the Body* [1], in which he will find a short account of the more important facts.

The scheme proposed by Dr. Paul Richer in his admirable treatise on Artistic Anatomy [2] seems by far the best. It is not too elaborate, and is admirably adapted to serve as a guide to the draughtsman. Dr. Richer's method is based on that of Cousin, in which the head is taken as the unit of comparison. This corresponds to the length between two horizontal lines, the one passing on a level with the top of the head, the other with the point of the chin. The height of the figure is equal to $7\frac{1}{2}$ heads. This corresponds to the proportion of the head to height in the Antinous. The Gladiator and the Farnese Hercules measure 8 heads, as also the Venus of Milo. The tendency in the antique is to keep the head small in proportion to the figure. In this way a sense of height and dignity is attained.

From the chin to the fork measures 3 heads, distributed as follows. From the chin to about the level of the nipples, 1 head; from this level to a point a little above the navel, 1 head; from this to the fork, which corresponds posteriorly to the fold of the buttocks, 1 head. A rough-and-ready method for sketching in the proportions of the trunk is to divide it into thirds, of which the lowest includes the distance from the seat

[1] *Proportions of the Body,* by Prof. B C. A. Windle. Baillière, Tindall, & Cox, London, 1892.

[2] *Anatomie Artistique,* by Dr. Paul Richer. E. Plon, Nourrit, et Cie., Paris, 1890.

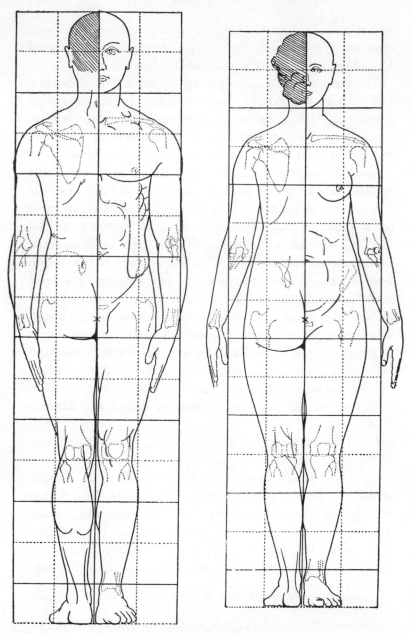

PROPORTIONS OF MALE AND FEMALE FIGURES IN HEADS AND HALF-HEADS

to the waist, the middle that from the waist to the shoulders, whilst the highest is apportioned to the head and neck.

The limbs bear the following proportion to the head. The lower extremity, when straight, measures 4 heads from the heel to the trochanter major, and thus equals in length the head and trunk together. From the under surface of the heel to the articular surface of the knee measures 2 heads. From the articular plane of the knee to the middle of the furrow of the groin the distance is 2 heads; from the plane of the knee to the highest point of the iliac crest, about $2\frac{1}{2}$ heads.

As 4 heads have been measured from the top of the figure to the fork, and 4 heads up from the heels, and as the height of the figure equals $7\frac{1}{2}$ heads, it follows that the distance between the levels of the fork and the trochanters measures half a head. The half of this distance, which overlies a point on a level with the summit of the arch of the pubis, corresponds to the centre of the figure, being distant from the top of the head and sole of the foot $3\frac{3}{4}$ heads respectively.

From the heel to the fork the limb measures $3\frac{1}{2}$ heads, and the centre of the patella corresponds to the middle of the distance between the anterior superior iliac spine and the sole of the foot.

In the seated figure, with the thigh flexed at right angles to the trunk, and the leg bent at right angles to the thigh, the distance from the top of the head to the seat equals 4 heads. The length of the thigh from the back of the buttock to the front of the knee is about $2\frac{1}{2}$ heads or over, whilst the height from the ground to the upper surface of the bent knee equals the distance from the under surface of the heel to the articular plane of the knee (2 heads), plus the thickness of the lower end of the thigh, the total coming to somewhat less than $2\frac{1}{2}$ heads, say $2\frac{1}{3}$ heads.

The arm is 3 heads long from the bottom of the hollow of the armpit to the tip of the middle finger. Of this the fore-arm and hand, from the tip of the middle finger to the tip of the elbow (olecranon), measure 2 heads. The length from the summit of the shoulder (the point where the collar-bone articulates with the acromion process of the scapula) to the bend of the elbow equals the length from the bend of the elbow to the elevation on the palm of the hand overlying the root of the middle finger. With the upper arm by the side and the elbow bent at a right angle the distance from the tip of the acromion to the under surface of the bent elbow is about $1\frac{1}{2}$ heads. With the arm by the side, the wrist lies on a level with the central point of the figure, and the fingers reach a little below the centre of the thigh, taking that as a point 1 head distant from the articular plane of the knee.

In regard to the breadth of the figure the following measurements are approximately correct, though liable to great individual variation. The greatest width of the shoulders is equal to two heads, the greatest width across the hips should be $1\frac{1}{2}$ heads, whilst the narrowest part of the waist is a little more than 1 head. The width between the nipples is equal to, or a little less than, a head; and the distance between the two anterior superior iliac spines is about a head or a little over.

In regard to some other proportions of the trunk, the vertical distance between the collar-bone, when the arm is by the side, and the anterior superior iliac spine of the same side is 2 heads. The waist, or what corresponds to it, the free margin of the ribs, lies $1\frac{1}{2}$ heads below the level of the collar-bone. From the level of the spine of the seventh cervical vertebra on the back to the level of the depressions over the posterior superior iliac spines is 2 heads. The lower angles of the shoulder-blades,

when the arms are by the side, reach a level midway between these two points; in other words, they lie a head below the level of the spine of the seventh cervical vertebra.

The head is divided into two equal parts by a horizontal line passing through the angles of the eyelids : these halves are again equally divided, so that the head is apportioned into four parts, of which the highest includes the hairy scalp, the second the forehead and eyebrows, the third the nose, and the fourth the mouth and chin. This arrangement, as has been pointed out, leaves but a short space for the mouth and chin, and the suggestion of Da Vinci, that the distance between the chin and the eyebrow be halved and made to correspond with the base of the nose, appears to meet with general acceptation. Lanteri gives the distance from the ear to the point of the nose, as equal to that from the chin to the eyebrows. The ear is so placed that the upper border of it lies on a level with the highest point of the eyebrows, whilst its lower edge usually falls on a horizontal line passing through the nostrils. It need hardly be pointed out that great individual variations may occur in the relative proportions of the features.

The breadth of the head on a level with the eyes varies much in different individuals and races ; a good proportion appears to be that this width should equal three-quarters the head length—in other words, the face and forehead. According to Cousin, this width may be divided into five equal parts, of which the central division corresponds to the interval between the eyes. On either side of this the eyes each occupy a division, whilst external to these the outer orbital margins and the temples seen in perspective go to make up the outer fifths. The base of the nose is said to equal an eye in width, and the mouth, which varies greatly, may be stated as equal in width to $1\frac{1}{2}$ eyes. The width of the neck is usually about half

a head, and the length from the chin to the pit of the neck varies from a quarter to one-third of a head. This distance is increased or diminished according as the head is raised or depressed.

The table subjoined, which is mainly taken from Dr. Richer's excellent treatise, will appeal to the student as eminently practical and not unduly detailed.

HALF
HEAD =

The length of the middle finger, including the head of its metacarpal bone, as when flexed.
The height of the flank as seen from the front, i. e. the distance from the anterior superior iliac spine to the free margin of the ribs above.
The furrow between the buttocks.

ONE
HEAD =

The distance from the chin to the line of the nipples.
The distance from the level of the nipples to the navel.
The length of the arm from the hollow of the armpit to a point a little above the bend of the elbow.
The length of the hand, including the wrist.
The height of the buttocks.
The distance which separates the two hollows above the collar-bones.
The height of the scapular region from the superior border of the trapezius to the lower angle of the shoulder-blade.
The width between the two anterior superior iliac spines, which slightly exceeds a head.

ONE AND
A HALF
HEADS =

The height of the chest-wall from the summit of the shoulder to the upper limit of the flank.
The width between the two shoulder-joints.
The width across the hips between the two trochanters.
The distance between the fork and the articular plane of the knee-joint.
The distance from the acromion to the under surface of the bent elbow.

Two Heads =
{
The leg from the sole of the foot to the articular plane of the knee.

The thigh from the articular plane of the knee to a point immediately above the great trochanter, or to the level of the middle of the fold of the groin.

The fore-arm and hand from the tip of the middle finger to the tip of the elbow (olecranon).

The height of the trunk from the collar-bone in front to the anterior superior iliac spine, and from the spine of the seventh cervical vertebra behind to the level of the depressions overlying the posterior superior iliac spines.
}

Two and a half Heads =
{
The distance from the back of the buttock to the front of the knee in the seated figure.
}

Three Heads =
{
The height of the torso from the chin to the fold of the buttocks.

From the top of the head to the navel, or to the upper limit of the buttocks behind.

The length of the upper extremity from the bottom of the hollow of the armpit to the tip of the middle finger.
}

Four Heads =
{
From the top of the head to the fork, or the fold of the buttocks behind.

The length of the lower limb from the sole of the foot to the top of the great trochanter.
}

The centres of the shoulder-joints lie $1\frac{1}{2}$ heads from the top of the head. The centres of the hip-joints lie $3\frac{1}{2}$ heads from the top of the head, or 4 heads from the ground.

Added to the foregoing are the following details, which have been collected from various sources. They do not profess to be absolutely accurate, but may afford the student a ready means of testing approximately the proportions of his drawing.

Height of Figure =
{
$7\frac{1}{2}$ to 8 head lengths.

6 to 7 foot lengths.

9 to 10 hand lengths.

4 cubits (i. e. the distance from tip of middle finger to tip of elbow).
}

BREADTH OF FIGURE $\left\{\begin{array}{l}\text{Shoulder}=\left\{\begin{array}{l}\text{2 heads, or more than one quarter of} \\ \text{height.}\end{array}\right. \\ \text{Waist}\quad=\quad\text{1 foot, or little more than 1 head.} \\ \text{Hips}\quad=\quad 1\frac{1}{2}\text{ heads, or one-fifth of height.}\end{array}\right.$

ONE FOOT $=\left\{\begin{array}{l}\text{One-sixth to one-seventh of height.} \\ \text{Length of ulna.} \\ \text{Width of waist.} \\ \text{Depth of trunk in profile on a level with the nipples.} \\ \text{Twice the length of face from eyebrows to chin.} \\ \text{Circumference of fist.}\end{array}\right.$

Three feet equal the distance from the sole of the foot to the fork.

ONE HAND $=\left\{\begin{array}{l}\text{One-ninth to one-tenth of height.} \\ \text{A face length (three-quarters of a head).} \\ \text{Horizontal depth across profile figure :} \\ \quad(a)\text{ From lips to back of neck.} \\ \quad(b)\text{ At level of navel.} \\ \quad(c)\text{ Across middle of thigh.} \\ \text{Distance along side of chest, from waist to anterior} \\ \quad\text{fold of armpit with arm by the side.}\end{array}\right.$

A HAND (less the terminal joint of the middle finger) $=\left\{\begin{array}{l}\text{Length of collar-bone.} \\ \text{Length of inner border of shoulder-blade.} \\ \text{Breast-bone without ensiform cartilage.} \\ \text{Interval between inner borders of shoulder-blades} \\ \quad\text{when arms are by the side.} \\ \text{Half the length of the humerus.}\end{array}\right.$

It is not necessary to enter into a detailed account of the proportions of the long bones. The following table may serve as a guide, which will for all practical purposes be found sufficient.

The thigh-bone (femur) = 2 heads length.
The shin-bone (tibia) = a little more than $1\frac{1}{2}$ heads.
The bone of the upper arm (humerus) = about $1\frac{1}{2}$ heads.
The outer bone of the fore-arm (radius) = about 1 head, or half the length of the femur.
The inner bone of the fore-arm (ulna) = 1 foot length.

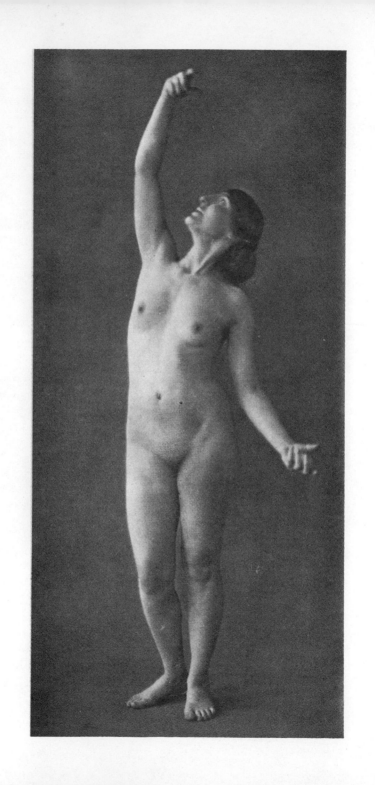

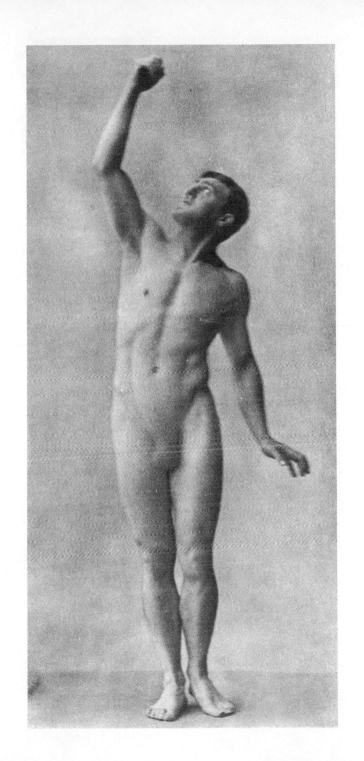

The collar-bone, the inner border of the shoulder-blades, and the
breast-bone without the ensiform cartilage are all of nearly equal
length.

The length of the axis from the top of the head to the tip of the
coccyx is very nearly half the length of the figure.

In passing to discuss the relative proportions of the
male and female figure it will be necessary, in the first
instance, to say something about the characteristic differ-
ences of the female skeleton. The bones of the female are
smaller and more slender, and do not present the rough
surfaces which in the male are associated with a more
powerful muscular system.

The form of the thorax is not only smaller in all its
diameters than that of the male, but is also proportionately
shorter. In accord with this we find that the breast-bone
is proportionately shorter than in the male.

The form and size of the pelvis are amongst the most
distinctive features of the female skeleton. They have been
already referred to (p. 250), but some of the more important
facts may here be recapitulated. It is wider and shallower
than in the male; the sacrum is wider, and projects further
backwards (Fig. 209). The greater width of the female
pelvis accounts for the greater breadth of the female figure
in this region, for not only are the iliac crests and their
extremities, viz. the anterior superior iliac spines in front,
and the posterior superior iliac spines behind, more widely
separated from their fellows of the opposite side than in
the male, but the acetabular hollows for the reception of
the heads of the thigh-bones are further apart, which gives
increased breadth to the thighs below (Fig. 205). Owing
to the pelvis being more shallow in the female than in the
male the distance between the iliac crests and the thoracic
margin is increased (Figs. 210, 211), whilst the dis-
tance from the iliac crests to the tops of the trochanters
of the thigh-bone is diminished; in other words, the

flanks are longer in women, and the buttocks do not reach so high as in the male (Pl., p. 86). Since the anterior

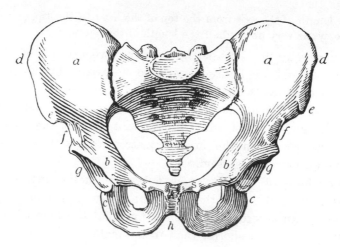

FIG. 204. The male pelvis.

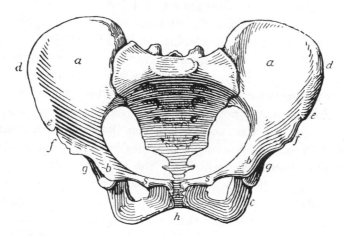

FIG. 205. The female pelvis.

a. Iliac portion of os innominatum.
b. Pubic portion of os innominatum.
c. Ischial portion of os innominatum.
d. Iliac crest.
e. Anterior superior iliac spine.
f. Anterior inferior iliac spine.

g. Acetabulum.
h. Pubic arch.
k. Pubic symphysis.
s. Spine of pubis.
The sacrum is seen wedged in between the two innominate bones behind.

superior iliac spines lie at a lower level and wider apart than in the male, it follows that Poupart's ligament and the furrow of the groin which overlies it are more horizontal than in the male, in whom they tend to more nearly approach the vertical (Pls., pp. 72, 216, 298, 434).

As has been already pointed out, the 'obliquity' of the pelvis (p. 261) is more marked in the female than in the male (Figs. 210, 211). This leads to characteristic appearances in the form of the thighs, back, and buttocks;

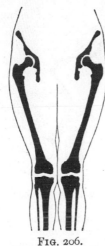

<div align="center">

Fig. 206. Fig. 207.

</div>

Diagrams showing the greater degree of obliquity of the thigh-bones dependent on the greater pelvic width in woman, Fig. 206, as compared with man, Fig. 207.

of these it is only necessary here to mention the more pronounced forward curves in the lumbar part of the vertebral column (Figs. 210, 211, and Pls., pp. 54, 262, 270, 278).

The narrower and more conical thorax supports a shoulder-girdle of which the collar-bones are proportionately shorter and less curved than in the male. Supported as these are by a narrower chest-wall and less powerfully developed muscles, they tend to occupy a horizontal position or may slope somewhat downwards. This imparts

to the female neck an appearance of greater length (p. 376), and detracts from the squareness of the shoulder, which is so characteristic a feature of the male. The upper limb is to the trunk proportionately shorter than in the male. This is solely due, as Marshall has pointed out, to

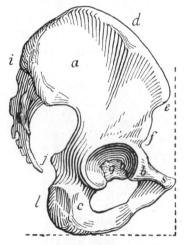

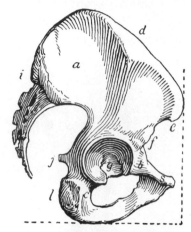

FIG. 208. Haunch-bone (os innominatum) of male seen from the outer side ; it is represented as articulated with the sacrum.

FIG. 209. Haunch-bone (os innominatum) of female. Note that the female bone is more tilted forward than the male, as shown by the relation of the points *s* and *e* to the dotted vertical line.

a. Iliac portion of the innominate bone.
b. Pubic portion of the innominate bone.
c. Ischial portion of the innominate bone.
d. Iliac crest.
e. Anterior superior iliac spine.

f. Anterior inferior iliac spine.
g. Acetabulum (hollow for head of thigh-bone).
i. Posterior superior iliac spine.
j. Spine of ischium.
l. Tuberosity of ischium.
s. Spine of pubis.

a difference in the length of the humerus, that of the female being proportionately shorter than that of the male.

The bones of the leg and thigh are also proportionately shorter than those of the male. In women the length of the leg tends to vary much more than the length of the

thigh. The length of the lower limbs tends to vary more
than the length of the trunk. Thus, when seated at table

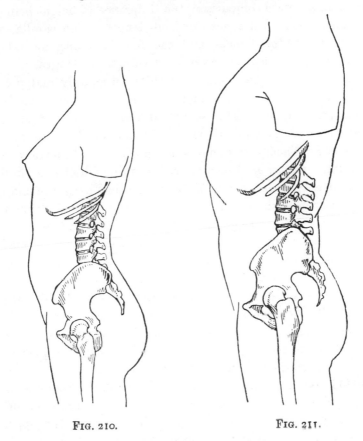

Fig. 210. Fig. 211.

Figs. 210, 211, show the influence of the pelvic obliquity on the
figure of the male and female. In Fig. 210 the pelvis is tilted further
forward than in the male, Fig. 211, as will be seen by noting the position
of the anterior extremity of the iliac crest (anterior superior iliac spine).
As a result of this the lumbar curve is more pronounced in Fig. 210
than in Fig. 211. This reacts on the outline of the figure, the curves
being more pronounced in the female than in the male.

it is very difficult to form an estimate of the heights of
different individuals, as the lengths of the trunks are not

liable to such great variations as the lengths of the legs. It is only when the sitters rise from their chairs that we can form an accurate comparison, the difference in height being mainly due to differences in limb length. The patella is narrower in the female, and the foot is proportionately shorter ; it is also narrower relatively to its length.

The head in the female is smaller absolutely and proportionately than in the male, though it is stated to be relatively higher. The sexual differences of the skull have been already described (p. 388) and need not here be repeated. Though statements are made to the contrary, it is often a matter of difficulty to determine whether a skull is that of a male or female, and in some cases the most expert anatomists will decline to express a decided opinion.

For all practical purposes the rules already laid down for apportioning the several parts of the male figure may be employed in drawing the female so far as they apply to height, bearing in mind always that the trunk in woman is somewhat longer proportionately than in the male. This causes the centre of the figure to fall a little above the symphysis pubis instead of immediately below it, as in the male. Again, the arm in woman is propor-tionately shorter than in man. The tips of the fingers should barely reach the middle of the thighs, and, owing to the fact that the difference in length of the limbs is due to a difference in the proportion of the humerus, the upper arm should be slightly shorter, and the elbow placed a fraction higher than in the male. In regard to the lower limbs, though proportionately shorter than in the male, the difference is not great, and length of limb tends to enhance the elegance of the figure. In this respect sculptors are apt to unduly emphasize the length of the legs, but as the results are much more pleasing from an aesthetic standpoint than the opposite defect the question may well be left to the individual fancy of the artist. As the foot

is relatively shorter in the female than in the male, we find that a woman's height measures about 7 foot lengths, whilst that of a man is about $6\frac{1}{2}$.

It is when the width of the figure is considered that the distinctions between the sexes are most marked ; these are associated with differences in the form of the osseous framework, particularly the chest-wall and pelvis.

Taking into consideration the height of the female, which, on the average, is less than that of man by about $\frac{1}{14}$ of his height, we find that the shoulders are not only absolutely, but also proportionately to the height, narrower than in the male.

In man the width of the shoulders is about 2 heads or over, that is to say it is somewhat more than one-quarter of the height. In woman the width is equal to one-quarter of the height or a little less.

The width of the hips in man should not exceed the width of the chest measured from the fold of one armpit to that of the opposite side, when the arms are hanging ; or, to put it in another way, if we drop two per-pendicular lines from the folds between the arm and the great pectoral muscles these lines should include between them the maximum width of the hips. In the female it is otherwise, for such lines will not be sufficiently far apart to include the width of the hips. How then are we to apportion the width of the hips in the female ? A rule sufficiently accurate for all practical purposes is the following :—Make the width of the hips equal to the distance between the fold of the armpit on one side and the outer side of the shoulder on the opposite side. Ex-pressed in a different way, the width of the hips in the male is equal to the width across the shoulders *minus* the two arms. In the female the width across the hips is equal to the width across the upper part of the chest *plus* the thickness of one arm.

The reader will recollect that in describing the deltoid (p. 135) it was pointed out that the greatest width of the shoulders did not overlie the heads of the humeri, but lay at a somewhat lower level, a level which was seen to correspond pretty accurately with that of the anterior fold of the armpit.

Again, it is important to note that the maximum hip-width differs in its level in the two sexes; as we have seen (p. 308), the greatest diameter in the male is opposite the level of the trochanters, whereas in the female it is somewhat lower, lying on a level with the fold of the buttocks posteriorly (Pls., pp. 110, 142, 216). In the female, not only is the maximum width of the hips greater than the upper thoracic diameter, but the width of the figure taken on a level with the points at which the iliac crests reach the sides is also greater. This contrasts with the condition in the male, in whom this diameter, which is of course less than the maximum hip-width, must also be considerably less than the chest-width taken in the manner described above.

The hip-width in women is not only greater in proportion to the height than in men, but is absolutely greater than in males of the same height. The depth of the female figure is less in all its diameters, if we except the region of the buttocks. There, owing to the greater 'obliquity' of the pelvis, the more pronounced backward thrust of the sacrum, and the increased amount of fat, the width from before backwards is absolutely greater than in the male. The abdominal wall is more rounded, and the thighs are proportionately thicker from back to front (Pls., pp. 86, 104, 124, 262, 318, 434) [1].

[1] For further details in regard to the proportions of the adult the student is referred to a work entitled *A Rule of Proportion for the Human Figure*, by the late Professor John Marshall. Smith, Elder & Co., London, 1879.

The effects of habit and exercise on the form of the abdominal wall must not be overlooked. In a girl of athletic build, or in one who has indulged in gymnastic exercises, the muscles of the abdominal wall are better developed, and in consequence the roundness of the abdomen is less marked. This is well shown in the plate, p. 438, which represents a model of active habits, who professes never to have worn corsets; a comparison of this figure with that displayed on the plate, p. 86, will at once illustrate the difference between the two types referred to.

The surface forms of the female have been already sufficiently described, and the points in which they differ from the male may be ascertained by consulting the chapters under which the various portions of the body have been discussed.

It only remains to say a few words concerning the remarkable changes which take place in the proportion of the human figure from birth to adult life.

The most striking feature about a child at birth is the large size of its head. The entire length of the child, including its trunk and legs, is a little over 4 heads as contrasted with $7\frac{1}{2}$ in the adult. The legs themselves only measure a little more than a head in length, whilst the trunk, including the head, measures 3 heads as compared with 4 in the adult.

At birth the head is just about half the height of the adult head, so that the remainder of the child's length, which equals 3 infants' heads or $1\frac{1}{2}$ adult heads, must grow about four times as rapidly to make up the adult proportion of $6\frac{1}{2}$ heads which it ultimately attains.

Attention has already been called to the fact (p. 389) that in the child the face is small proportionately to the brain-case. During growth, coincident with the changes already referred to, the face gradually enlarges till it attains the adult proportions.

The relation of the size of the head to the trunk at different periods of life may best be expressed in tabular form.

At birth, trunk including head = 3 heads.
At 9 years, trunk „ „ = 3¼ heads.
At 15 years, trunk „ „ = 3¾ heads
At 25 years, trunk „ „ = 4 heads.

With reference to the proportion of height at different periods to that of the adult, it is found that—

Height at birth = about two-sevenths of adult.
Height at 3 years = one-half of adult.
Height at 10 years = three-quarters of adult.

The position of the central point of the figure gradually falls lower as life advances; this depends, of course, on the increase in the length of the legs.

At birth the centre is a little above the navel.
At 2 years the centre is at the navel.
At 3 years the centre is level with the iliac bones.
At 10 years the centre is level with the trochanters.
At 13 years the centre is at pubis.
In the adult the centre is at the arch of pubis (male).

The growth, however, is not uniform throughout. As regards the torso, the parts above and between the nipples grow more rapidly than those which lie between the nipples and navel. In regard to the limbs at birth, the upper arms, legs between knee and ankle, and feet are all of about equal lengths.

In the upper extremity the length of the hand is a little more than the length of the fore-arm. The hand doubles its length about the age of six, and trebles it between that and adult life.

The upper limb in the adult is 3½ times the length of the infant's at birth, and of its different segments the fore-arm grows most rapidly. In the case of the lower extremity

the increase in length is very remarkable. In the adult
it attains a length equal to five times its original measure‑
ment. Its rate of growth may be indicated as follows,
measured from the fork to the sole of the foot :—

At 3 years the lower extremity = twice its original length.
At 12 years the lower extremity = four times its original length.
At 20 years the lower extremity = five times its original length.

The thigh grows proportionately longer and quicker than
the other segments of the limb.

The above details are sufficient to lay stress on the
necessity of strict attention to the details of the model
when representing youth and childhood. We have ad‑
mirable examples of this in the antique, where in the earlier
examples of Greek art we find an utter lack of appreciation
of youthful forms. Whether this was due to a want of
knowledge is difficult to say ; yet the fact remains that the
figures of the youths in the Laocoön are not those of boys,
but are like small men. So also the figure of a youth
praying, the author of which is unknown, has none of
the attributes of youth, but displays all the bodily pro‑
portions of an adult. The figure in the arms of Zeus
has none of the appearances of a child, but resembles more
a mannikin.

Apart altogether from the proportions of infancy and
youth, about which, if he needs more information, the reader
may consult the classic work of Quételet[1], the student
will recognize how much the surface forms are modified
by the abundant layer of fat which underlies the skin
of a healthy infant. He will find here creases and folds of
great depth overlying the joints and crossing the lines
of flexure of the skin. Again, the dimpling of the skin
in other situations may be the only indication of the
existence of deeper structures. These it is not our intention

[1] *Anthropométrie,* par Ad. Quételet. C. Muquardt, Bruxelles, 1870.

to discuss. The reader, if he has had the patience to study the previous pages, will have appreciated the conditions upon which these forms depend, and, having this knowledge, can safely be trusted to select from the model only those details which are in harmony with the spirit of his design.

Only a passing reference need be made to the changes due to the natural processes of decay. The softer tissues are the first to suffer. The absorption of the subcutaneous fatty layer leaves the skin loose and wrinkled. The wasted muscles cover but imperfectly the bony framework, and hence the outline of the skeleton is rendered more prominent on the surface of the body. The forms which were characterized by depressions and furrows in the prime of life are now revealed as prominences and ridges. As examples take the anterior superior iliac spine, the iliac crests, the breast-bone, and the spines of the vertebrae. In addition, the weakened muscles are no longer able to perform efficiently their functions. Especially is this the case in regard to the back-bone. The habitual stoop of the aged is but an indication of this loss of power. As was pointed out in Chapter I, the aged are passing through a stage akin to that of childhood; for now, as then, they have to seek support by the aid of the arms. The bones too undergo a slow process of atrophy; but the most marked changes in them are seen in the face, where the shedding of the teeth has led to an alteration in the form of both the upper and lower jaws. The eyes also have sunk more deeply in their sockets, and, though at times under the influence of excitement they are bright and clear, they lack as a rule the lustre and brilliance of youth. These changes are but the outward indication of processes which must slowly but surely end in death.

APPENDIX

FOR the sake of those of my professional brethren who may be asked to deliver courses of lectures on anatomy in art schools, I have introduced three illustrations as examples of the standard of excellence to which they may reasonably expect their pupils to attain after diligent and intelligent study.

The examples supplied are a selection from the answers given to the following question in a recent examination: 'Make a drawing, from whichever standpoint you choose, of a man in the act of throwing a cricket ball. The sketch must display the main features in the construction of the figure as regards bone and muscle.'

As an examiner of some little experience, I am convinced that the best method of examining art students in anatomy is by setting them some such question, avoiding if possible a position which has been already anatomized in any of the current textbooks, and taking care also that the pose indicated does not closely resemble that of any of the 'antiques' which the students may have been required to anatomize in their school course.

In this way the repetition of a diagram committed to memory is avoided, and the student has an opportunity of displaying an intelligent application of the facts which he has learnt. No doubt the test is a severe one, since all the details are necessarily furnished from memory, though be it noted the candidate is permitted to answer the question without the additional burden of a scientific nomenclature. It matters not whether he knows the name of every process or muscle, provided he is acquainted with their correct form and disposition.

The examples given may be regarded as a type of the work of the better class of student; and speaking as an anatomist, and an anatomist only, they serve to illustrate what one may regard as the most satisfactory application of anatomy to figure construction.

The illustrations, which are of course reproductions on a

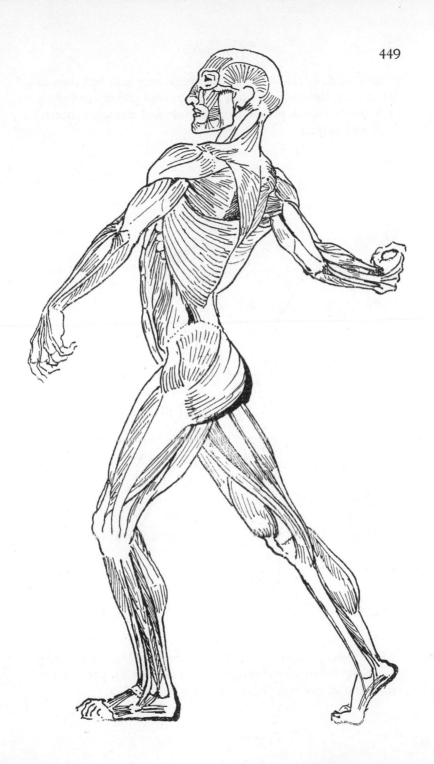

reduced scale of the original drawings, may also be taken as examples of the methods most usually employed in answering such questions, viz. pencil, pen and ink, and a combination of wash and crayon.

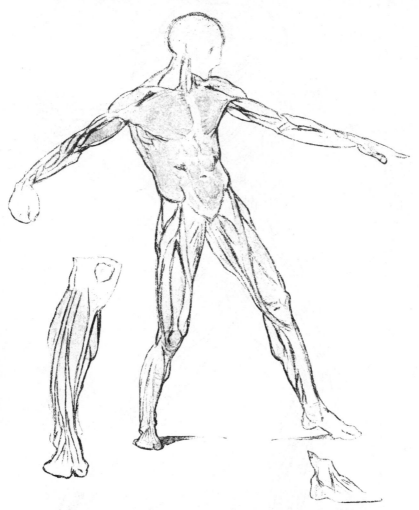

Such work, I hold, is the best answer to those who deny the utility of an acquaintance with anatomy as part of the education of the figure draughtsman or sculptor.

INDEX

THE END